MW00799296

EDGAR BRANDT

EDGAR

BRANDT

MASTER OF ART DECO IRONWORK

JOAN KAHR

HARRY N. ABRAMS, INC., PUBLISHERS

For my mother, Miriam, and my husband, Robert,
whose love make all things possible

To the memory of my father, Harry

Editor: Elisa Urbanelli
Designer: Dirk Luykx

Library of Congress Cataloging–in–Publication Data

Kahr, Joan, 1939–
 Edgar Brandt : master of art deco ironwork / Joan Kahr.
 p. cm.
 Includes bibliographical references and index.
 ISBN 0–8109–4003–5 (hardcover)
 1. Brandt, Edgar, 1880–1960. 2. Artist–blacksmiths—France—Biography.
 3. Ironwork—France—History—20th century. 4. Decoration and ornament—Art deco.
 I. Title.
NK8298.B73K34 1999
739.4'72—dc21 98–30698

Copyright © 1999 Joan Kahr
Published in 1999 by Harry N. Abrams, Incorporated, New York
All rights reserved. No part of the contents of this book may be reproduced without the
written permission of the publisher

Printed and bound in Japan

Harry N. Abrams, Inc.
100 Fifth Avenue
New York, N.Y. 10011
www.abramsbooks.com

CONTENTS

We are living indeed in the true Iron Age, and the powerful means of modern metallurgy, deployed for the execution of a work of art conceived of and elaborated on the scale of those means, will provide an artistic spectacle of imposing grandeur. . . .

Let us rally to the idea of creation; let us add a new page to our illustrious past; let us come together in a unity of effort toward a common ideal. France is a magnificent country, her fruits blessed with incomparable flavor. Throughout the ages, we have preserved the sparkle of these gifts of nature. This is why, having been placed in the first rank of the evolution and the progress of art, we must remain at the head of this worldwide movement, through the elaboration of a style for our century. . . .

The more varied are our technical means, the greater the latitude for expression. . . . In order to create, the artist must make use of all the means that science places at his disposal: conserving or limiting oneself to the methods of times gone by is absurd. . . .

Simple logic and facts therefore bring us to the use of new models, to the steadfast pursuit of modernism in art.

Edgar Brandt
"Lecture to the Graduates of the Technical Professional Schools"
Paris, February 10, 1922

It is obviously a delicate matter for a son to be stating his appreciation of a book whose subject is his own father's artistic career and all the more so when the book in question is so full of praise for the father's exceptional talent.

In this particular case, however, I believe myself qualified to pass an objective judgment—that is to say one uninfluenced by any sentimental considerations—on this book's quality. It was given to me often to be present at the side of that talented artist who was my father: Edgar Brandt, of whose at once surprising and remarkable career I have been blessed with such wonderful memories.

While still in my teens, for example, I was often able to watch him as he labored in the evening at his artistic creations in his office at home. It was working like this, alone and undisturbed, that my father liked best. In later years, when I came to share his technical design work, I admired the inventiveness and the know-how with which my father could draw up such precise blueprints. It was his creativeness that was the indispensable basis for my father's success in all the diverse fields of his activity. If the circumstances of historical events to some extent brought Edgar Brandt to follow his triple vocation of talented artist, inventor, and industrialist, he yet amply proved his stature, building up an international reputation practically from nothing. His spectacular achievements were those of an entirely "self-made man."

It affords me particular pleasure that the initiative to produce a book about my father should have originated in the United States of America. He always admired this great, modern nation and ally immensely, and during his lifetime he developed a large number of business connections there. Edgar Brandt made his first and only visit to the United States just before the outbreak of the Second World War. He would have remained there for considerably longer than two months if rumors of war had not obliged him to return to Europe. He loved America and it afforded him real satisfaction not only to have delivered artistic commissions to his American clientele (principally in New York) but also to have been able to contribute on several different occasions to the reinforcement of America's defense.

I must express my sincerest gratitude to Joan Kahr for writing this book. She has managed so very well to communicate her enormous enthusiasm for the works of the great Parisian ironworker. Relying on her considerable artistic sensibility, her vision, and her style, she has been able to analyze his work in such a way as to allow its spirit to be revealed and explained. She has done honor and justice to my father's memory.

The author is to be warmly congratulated for her consistently interesting and elegant presentation, as is the publishing house of Abrams for the production of this superb book.

François Brandt
August 1998

NINETEENTH-CENTURY IRONWORK: EMILE ROBERT RELIGHTS THE FIRE

During the Second Empire (1852–1870), the years in which Napoleon III held power, the art of hand forging ironwork suffered a major decline in France. The emperor's great program of rebuilding Paris was undertaken by Baron Haussmann (1809–1891), who transformed the ancient city with a precedent-setting plan.[1] During the redevelopment contractors turned away from wrought iron for the ornamentation of buildings, preferring to cast molten metal into a variety of standard patterns. The mass production that casting made possible supplanted the art of blacksmithing. As a result, many buildings throughout France, and particularly Parisian Beaux-Arts buildings, were decorated with retardataire iron balconies and gates in Baroque (seventeenth-century) and Rococo (eighteenth-century) styles. These decorative elements were made of molded sections that were often put together with traditional wrought-iron joining techniques of rivets and screws. Edgar Brandt (1880–1960), a man who would play an important role in twentieth-century metal arts, grew up at a time when progressive steps were taking place that would leave behind these *vieux-style* designs and change the way iron and steel were used in both artistic and commercial applications. Brandt, who linked the best hand-forging methods with technological and mechanical advances that gave wrought iron a renewed importance in the history of decorative arts, was the beneficiary of these changes. Before Brandt began his career, however, the groundwork for a revival of hand forging was laid by Emile Robert (1860–1924), regarded as the father of modern wrought smithery.

Following the time-honored tradition of French trade guilds, the young Robert traveled throughout France marveling at the beauty of the wrought work. Some of the old ironwork had been remade, as in the case of the Gothic cathedrals of Notre-Dame de Paris and Sainte-Madeleine de Vézelay (Yonne). The architect Viollet-le-Duc, during his restoration of Notre-Dame in the 1840s, had the locksmith Boulanger refurbish the strap-hinges of the main portals, marvels of ironwork of the thirteenth-century smith Biscornette.[2] In contrast, nineteenth-century wrought work was sparse.[3] Arriving in Paris just when the Exposition Universelle of 1878 was causing great excitement, Robert found to his disappointment little wrought iron on display.[4] Instead, he saw massive cast-iron pastiches of medieval and Gothic bronze and wrought-iron styles.[5] Forgotten were the finely wrought gates of the eighteenth-century French forging masters Jean Tijou (active 1690–1712) and Jean Lamour (1698–1771). (The former had worked at Hampton Court and St. Paul's Cathedral in London and the lat-

ter created Place Stanislas in Nancy.) Aside from Ernest Larchèveque,[6] with whom Robert had apprenticed for two years, the artisan with hammer in hand had almost been obliterated.[7] Mass-produced iron casting took precedence over hand craftsmanship as foundries yielded cast objects that merely mimicked wrought iron. Even ubiquitous shop signs were being cast. Many foundry workers commixed and/or misinterpreted the past styles, compromising them further by the less costly casting process. Disdaining these methods, the young Emile Robert visited museums, admired especially the craftsmanship of the eighteenth century, and resolved to create hand-forged work of inspired design and aesthetic merit.

Original artistic wrought work was not to be found at the Exhibition of 1878. However, architectural advances in the use of structural iron, mostly due to the fairly new Bessemer pneumatic process of converting iron to steel, were highly visible.[8] Robert scrutinized the Galerie des Machines, an industrial space designed by the engineers Gustave Eiffel and De Dion. Undoubtedly, after viewing this structure, Robert realized that steel, an alloy of iron, was being made into beams that were replacing inelastic cast-iron columns for structural use.[9] Robert felt that the more tensile wrought iron would still have an artistic role in the building trades, as well as in the design of decorative and useful objects. He decided that his life's work would be to restore wrought ironwork to the place of honor that it had held in previous centuries.

After a blacksmithing apprenticeship with the Moreau brothers, who were working on the banisters for the château at Chantilly (1880), Robert then opened his own little shop on the rue Miromesnil in Paris. He supported himself by making repairs on metal objects and locksmithing.[10] During periods when business was slow, he gave free rein to the imaginative ironwork projects germinating in his head. In 1887, he was able to exhibit examples of wrought iron at the Union Centrale des Arts Décoratifs.[11]

Two years later at the Exposition Universelle of 1889, Robert, one of 32 million people who attended the fair from May 5 to November 5, observed that public attention was focused on two new iron structures: Charles Dutert's Galerie des Machines and the Eiffel Tower, both technological keystones of ferrous architecture.[12] Because of the success of the tower, for both its prefabricated construction and its importance as a symbol of modernity, a new canon of iron architecture was anticipated. Unfortunately, at the Exposition Universelle of 1900 the only new and progressive exhibit was the ironwork for the decorative-arts pavilion[13] by Emile Robert in collaboration with Georges Hoentschel (1855–1915) after the designs of Karboivsky. In addition, Robert set up a forge in the Salle des Métaux in the main display area of the Grand Palais, where the public could see him work and learn about the ancient art form. Reporting on this beautiful room devoted to the metal arts, the critic Pierre Calmettes stated

that Robert offered "a note of art in the midst of automobiles essentially devoid of aesthetic sense."[14] Robert captured a grand prix for his efforts. "The possibilities of iron as a medium of the designer's art are ably shown in nearly everything produced by M. Robert," said another observer.[15] At age forty he had achieved complete command of his craft, creating freely in a precise and pleasing manner works that reflected a conservative aspect of the prevailing Art Nouveau, the new decorative movement that broke with modernism and led to Art Moderne. It lasted until the eve of World War I.

The sinuous, asymmetrically flowing lines of Art Nouveau grew out of several sources. In England, the Pre-Raphaelite art of Edward Burne-Jones (1833–1898) and the work of Aubrey Beardsley (1872–1898) influenced the decorative arts and the designs of William Morris (1834–1896) and Arthur Mackmurdo (1851–1942). Playing a part in the genesis of Art Nouveau, Morris's Arts and Crafts was an idealistic movement for reviving handcrafts and encouraging craftsmen toward better design standards.[16] The Arts and Crafts aesthetic of stylized designs based on nature was an important precursor of the characteristic organic forms of Art Nouveau. The attenuated geometric designs of Charles Rennie Macintosh (1868–1928) and his wife, Margaret Macdonald (1865–1933), as seen at the Vienna Secession in 1900 and the Turin Exhibition of Decorative Arts in 1902, had an enormous influence on Viennese architect and designer Josef Hoffmann (1870–1956) and other Europeans.

Two pioneering Art Nouveau designers came from Belgium: Victor Horta (1861–1947) and Henri Van de Velde (1863–1957). In his stair hall at the Tassel House (1892–93) in Brussels, Horta combined open iron beams and an iron column whose sinuous branching lines were repeated on the rounded walls and floor. Van de Velde, a painter turned prolific designer, especially for metalwork, decorated an office in La Maison Moderne, a modern furniture shop begun by Julius-Meier Graefe. A growing awareness of Eastern art and the resulting aesthetic known as Japonisme also provoked designers to turn away from formulaic Western historicism.[17]

For a short time the anticlassical Art Nouveau movement radically transformed architecture and the applied arts; however, on the whole the genre made a greater impact on the decorative arts than on architecture. Emile Robert gradually took his place among a group of artisans such as Emile Gallé (1846–1904), Louis Majorelle (1859–1926), and René Lalique (1860–1945), as well as the artists Eugene Grasset (1841–1917) and Maurice Verneuil (1869–1942), who were the proponents of this aesthetic mode.

However, if Art Nouveau succeeded as a movement in France it was largely due to two men. The first was Siegfried Bing (1838–1905), a collector of Oriental art who promoted a new design style integrating features of Eastern and Western art. His shop, L'Art Nouveau (opened 1895), and his pavilion at the Paris Exposition Universelle of 1900 presented to the public

objets d'art and entire room settings by a host of talents such as Louis Comfort Tiffany (1848–1933), Edouard Colonna (1862–1948), Georges De Feure (1868–1928), and Eugène Gaillard (1862–1933). All the artists involved in this movement were united in their rejection of historicist styles and in their desire for artistic originality in the applied arts.

Hector Guimard (1867–1942) was the other major force behind the Art Nouveau practitioners.[18] Emile Robert had seen Guimard's electricity pavilion at the Exhibition of 1889. In later buildings such as the Hotel Jassedé (1893) and the Castel Béranger (1894–98) Guimard employed a rationalist style with Art Nouveau ornament. In the heyday of Art Nouveau, Guimard used cast iron and glass for the abstract, serpentine portals of the Métropolitan transit system in Paris (1900–1913), which helped to inspire the appellation "Le Style Guimard." This term became synonymous with undulating shop fronts, signposts, and restaurant interiors. While Robert and Guimard shared a love of ironwork, the Art Nouveau mannerisms of the *ferronnier* were quite different from those of the architect. Robert used particular flowers and leaves in loose but mostly symmetrical patterns. Conversely, Guimard's works in wood or iron made bold and powerful abstract statements. Robert's beautifully crafted work was marked by understated good taste. In leaving behind the ubiquitous acanthus form and substituting cheerful flora and fauna, Robert refreshed his craft and prepared the way for the eclecticism of the modern school of ironsmithing. As a naturalist, the *ferronnier* was particularly fond of cornflowers, nasturtiums, thistles, and poppies, which he worked into finely modeled pieces that managed to combine delicate, graceful motifs and a strong overall pattern. Among his works are the entrance grille of the Musée des Arts Décoratifs, and the exterior and interior *fer forgé* for the Hôtel Lutétia, on Boulevard Raspail.

Historically, luxury goods and small industries were promoted and developed by individualistic, highly skilled artists and artisans. Robert was more interested in enhancing the ironsmith's place in the decorative arts than in dictating any single style of decoration. Even though the *ferronnier* worked in the French commercial tradition, he was intent on creating a greater appreciation for his craft. Ironsmiths were not as well paid or as highly praised as stone sculptors or painters. Robert helped to educate architects as to the possibilities that wrought iron presented, spreading awareness that the heavy cast iron they ordered from foundries would often rust and crack when exposed to the elements, and that although wrought iron cost more, it was of finer quality and longer lasting. All of Robert's proselytizing helped to create a ready market by the time Brandt started working with architects.

Recognizing the need for public education about his field, in 1896 Robert founded *La Revue de la Ferronnerie ancienne et moderne*. As the designer, editor, and director of this publication, Robert provided step-by-

1. The artist-blacksmith Edgar Brandt in front of his drafting table, 1925

step lessons for young metal-arts students.[19] In 1905, he established a school for iron forging, thus paving the way for a new generation of artisans. The master was a diligent teacher, a perfectionist who often followed his criticism with the optimistic words of a devoted educator: "In three years my apprentices will be as good as me."[20] While Edgar Brandt did not study with Robert, he was very much influenced by his ironwork philosophy and took up where Robert left off, focusing on the alignment of artistic products with industry. For the last twenty years of Robert's life the two men were *confrères*. Emile Robert was indeed an educator, an innovator, and a first-class artisan who rekindled the flames of French wrought iron, and should be so acknowledged. However, it was left to his younger colleague, Edgar William Brandt, to forge not only the most prominent style and methodology of his generation but a celebrated place in the history of the decorative arts.

CHILDHOOD AND SCHOOLING

Edgar Brandt was born at 46 rue Bergelais (17th arrondissement) in Paris on Christmas Eve of 1880 (fig. 1). His mother, Betsy Emma Bas (1851–1925), one of six surviving children of Jérémie Bas and Emilie Courtois Bas, came from the village of Nouroy near Saint-Quentin, in the department of the Aisne, and spent her childhood there. Betsy's father, Jérémie (1826–1902), a justice of the peace and the director of two boys' schools (one in Paris and one in Nouroy), practiced homeopathy as an avocation. He fathered a Huguenot family of ten children, two of whom— Edgar and Jules—died of typhoid fever. The religious Protestant family never forgot their loss and to honor the memory of her siblings, Betsy named her two sons Edgar and Jules.

Charles Haag Brandt (1860–1935), Edgar's father, was the son of Louise Haag (1835–1911), an Alsatian born in Pfastatt, a small village in the Haut-Rhin, and Emile Brandt (1836–1901), a Mulhousian wallpaper designer, some of whose works are still on display in the Mulhouse Museum at Rixheim. Emile and Louise moved to Paris in 1870 during the Franco-Prussian War (1870–71). After relocating to the capital, Louise, a talented seamstress, managed the shop of the English couturier Charles Frederick Worth (1825–1895) near the Gare Saint-Lazare and made clothes for the nobility under Napoleon III and later during the republican regime. Louise must have been quite a technician to please Worth, who was responsible for establishing Parisian haute couture as a national enterprise. Louise and Emile sent their son Charles to board at the Paris school of Jérémie Bas where he met Betsy Bas, whom he married in 1879.[21]

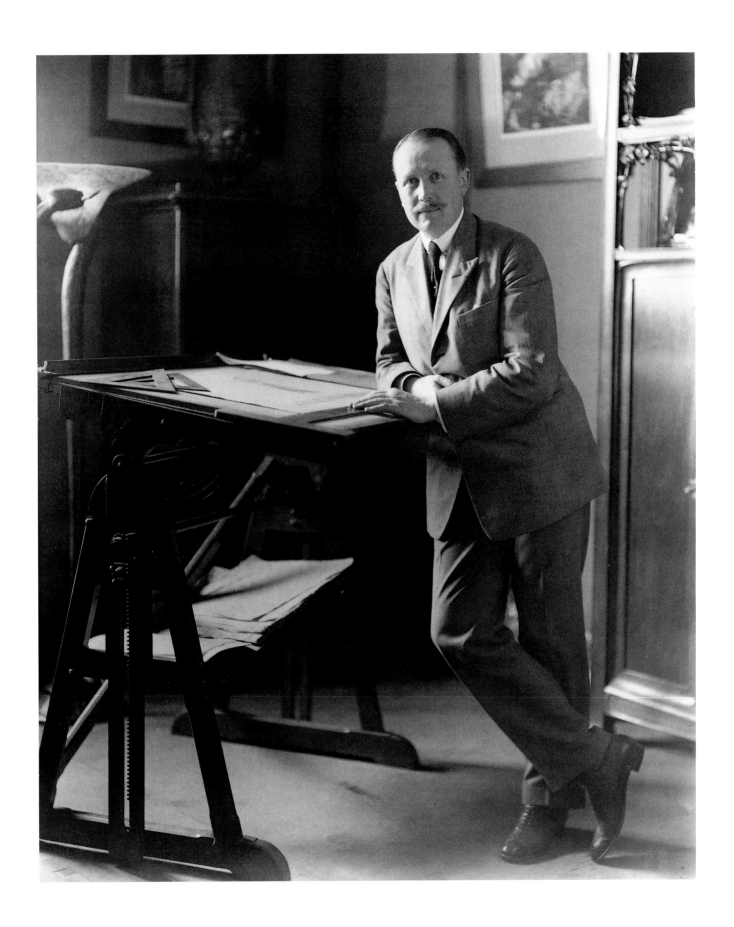

Betsy, a religious and practical Protestant, was devoted to Edgar and his younger brother, Jules. Charles was a stern but kind man who worked as an engineer in the firm of Guillot-Pelletier, where he designed and built large portals and greenhouses for botanical gardens.[22] By the end of his career, Charles had become the company's director, working both in Paris and in Orléans. An avid reader, Charles was a cultivated and exacting man whose many interests made lasting impressions on his sons. Because one of his avocations was carpentry, his sons were imbued with a sense of pride in handwork. Most probably Charles made little wooden toys for his sons, just as he did for his grandson François years later.

In 1886, when Edgar was six years old and Jules was four, the family moved to Orléans.[23] There Charles became an amateur gardener, enjoying the cultivation of roses and vegetables; consequently Edgar and Jules grew up with an interest in plants, learning to love and respect nature. This fact may account for the beautiful and sensitive way that Edgar later rendered plant life in his metalwork designs. Charles owned a large number of horses and dogs. He and his children often fished in the Loire River, and during these excursions a lifelong bond was established between them.

Following the typical household arrangement of the late nineteenth century in France, Betsy Brandt let her husband have the familial limelight,[24] but in her unobtrusive way she taught her sons cooking, drawing, reading, and the Protestant principles of hard work, courage, sobriety, modesty, and, due to her memories of the Franco-Prussian War, thrift. She sang to her sons while playing the piano and taught them some English. Edgar and Jules grew up in a protected and affection-filled atmosphere, and were strongly influenced both by their mother's work habits and their father's methods of analyzing and facing problems (fig. 2).

The Brandt house, on the Faubourg Bannier, was spacious and unpretentious, affording lots of room for two growing boys and their cousins. Edgar's son François Brandt remembers: "The furniture was heavy and ugly and influenced by Art Nouveau." Decoration, per se, did not interest Charles and Betsy but they did own some paintings by Adolphe Monticelli, an artist whose use of impasto is said to have had an influence on Vincent van Gogh.[25]

Orléans was very different from Paris, the epicenter of European culture and politics. The open countryside of Orléans provided an outlet for the energetic Brandt boys, and this was balanced by more serious pursuits at school where they explored their developing technical and intellectual interests. Edgar had passed his *certificat d'études primaire* at age thirteen (1893). Jules, an advanced pupil, passed his at age eleven. Since Edgar and Jules were both qualified, Charles Brandt decided to enroll his sons at the École Nationale Professionnelle de Vierzon, a technical high school about fifty miles south of Orléans and seventy miles from Paris, one of four such schools in France, the other three being the École d'Armentières, the École de Nantes, and the École de Voiron.[26]

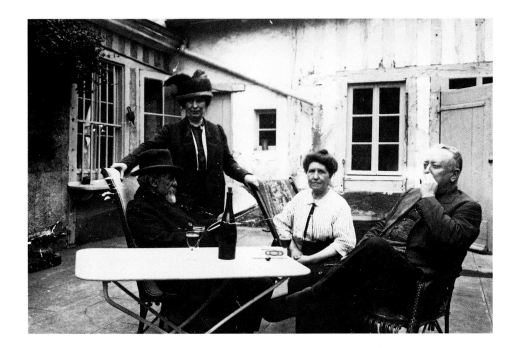

2. From right to left: Brandt's parents, Charles Brandt and Betsy Bas Brandt; and his aunt and uncle, Aline Bas Largaud and Dr. François Largaud, in Orléans, 1914. Courtesy the Brandt family

Admission to the school was decided by a comprehensive national examination, and since the instruction in these state-supported schools was free, admission was difficult and competitive. The Brandt brothers were fortunate, passing their examinations with ease—only one out of five student applicants were accepted to Vierzon. In keeping with the intensity and thoroughness of French technical education young people were generally admitted at age thirteen and remained for three to five years. Edgar entered the school on January 8, 1894, Jules in 1895. Awaiting them was a fine group of instructors who had been chosen by competitive examination as well. The task of this staff was to turn out skilled workers and industrial designers, factory supervisors, and foremen. Therefore, the curriculum was that of a trade school as opposed to that of an art school such as the École Boulle or the École Nationale des Arts Décoratifs in Paris, which were established to train decorative artists, painters, modelers, and designers for the industrial and applied arts. Vierzon graduates had the option of moving on to the École des Arts et Métiers or other establishments of higher learning.

Since the era when Louis XIV established the Manufacture Royale des Gobelins, bringing together various craftsmen to furnish his palaces, the French had continuously earned their reputation as leaders in art, design, and decoration. With his admission to Vierzon, Edgar Brandt was a fortunate beneficiary of the long-standing government policy of fostering the fine and decorative arts. Before long, France was to be amply rewarded for its investment in the fledgling artisan.

L'IFE AT VIERZON: EDGAR BRANDT'S TRAINING

The town of Vierzon, situated on the Cher River and the Berry Canal, attracted manufacturers of agricultural machines and pottery. For the students, however, the name Vierzon represented only one thing—the institute where they had to prove that they were worthy of the education for which they had been selected.

The school was divided into two large ateliers, one devoted to ironwork and the other to woodworking. Approximately sixty boys worked in each department; those in iron were concerned with *ajustage* (fitting), *tour* (lathe work), and the forge. The suitably equipped *atelier du fer* contained six ventilated (blower) forges and two that were portable. There were fifty-two vises, six motorized metal lathes, two hand lathes, three drilling machines, one polishing lathe, one filer, one planing machine, and the standard anvils and hammers that are the staples of any such workshop. The young men in the woodworking atelier learned *menuiserie* (joinery) and *modelage* (modeling) and were equally well supplied.

In order to learn the ancient forging methods taught at Vierzon the students had to have many tools to work with, not the least of which was patience. Like a glassblower who shapes the plastic material in accordance with the concept in his head, the smith must work the hot iron, malleable and alive, within a given time frame. Brandt learned the nuances of his craft: when to coax the iron gently and when to give it a stronger blow. He learned the chemistry of the fire. How much charcoal or coke should be added? How much air from the bellows should be blown into the flames? The young artisan learned to read the color of the iron, when to pull it from the fire and place it onto the anvil. When bright yellow the iron is at a good forging temperature; white hot is fine for forging quality wrought iron, but overheated iron, too close to the melting point, cannot be worked. The smith must concentrate fully and hammer quickly before the iron cools and needs to be placed in the fire for reheating. The process of heating and hammering continues until the pattern is achieved.

Bernard-Jean Daulon, who was a student there just before World War I, described some of the work at Vierzon:

> We were taking important courses in industrial design, drawing plans and parts of machines where each letter and number was drawn. We took courses in Gothic script and less intensive courses called *Ornement* in which the subjects were very classical, acanthus leaves, and volutes, with emphasis on shadow and relief. The math that we used allowed for curves and spirals.[27]

According to Daulon mathematics were viewed as the key to organizing the relationships of shapes and dimensions. This had been true since 1865 when a convention of the Union Centrale had decreed that the study of linear design based on geometry should be the foundation of the program in industrial schools. The Union Centrale's objective was that the French excel in art like the ancient Greeks and the Japanese. An important factor was the study of the Greek formula known as the golden ratio, expressing the relationship between the length and width of a rectangle, thought to be especially beautiful, which could forever be subdivided into a square and yet another golden rectangle. This ratio was used as an aesthetic guide for 2,500 years by artists and architects. Designated by the Greek letter *psi,* the proportion leads to a specific numerical progression in which each number is the sum of the two numbers preceding it.[28] Edgar Brandt applied the principles of the golden section later when he developed spiral designs for stair railings and other objets d'art. Early in his career Brandt came to believe that designs geometrically proportioned in this way are infinitely more pleasing to the eye and therefore more satisfying to the soul.

Whether the students were involved in the practical application of their craft or pondering its theoretical principles, they took their work seriously. Discipline was rigorous, with silence demanded during study hours as well as in the dining room and dormitories. Any insolence or lack of respect toward professors resulted in severe punishment and the risk of expulsion. The students led a cloistered, almost monklike existence, but they were proud of their velour uniforms, their school song, and their yearly promotions.

The school year at Vierzon began on October 1. The school day was long and intensive. A siren awakened the boys at five in the morning. Two hours of study preceded breakfast. This was followed by one and a half hours of workshop (atelier) beginning at eight. Second-year students began the atelier at 10:30 and third- and fourth-year students began at noon.

The morning atelier was followed by other classes until six o'clock in the evening. These consisted of French language, history, geography, arithmetic, geometry, algebra, and either English or German. The Brandt boys learned the rudiments of English at Vierzon but did not speak the language. In addition, there were classes in mechanical theory, technology, chemistry, industrial economics, industrial design, and ornamental design. Dinner was followed by two more study hours and bedtime.

At the end of the arduous day the boys washed with cold water, except on Saturdays, when hot water was provided for the evening bath. On Sunday mornings the students were allowed to sleep until six o'clock, but later in the day additional study was expected, followed by a course in music and a lecture of choice. Although occasionally permission was granted for several students to play ball in the main courtyard, sports per se were not part of the curriculum. It was felt that the long hours of labor at the forge and in the workshops provided all the physical exercise necessary for

forge and in the workshops provided all the physical exercise necessary for these young boys. Sunday afternoons permitted opportunities for accompanied walks in the forest or to the canals. By the third year, the boys were free to go out alone, but if they were late in returning they had to pass the concierge's pavilion and run the risk of receiving a bad-conduct note or a flunking from the feared *surveillant général*, M. Felix.

Although Edgar and Jules were boarders at the school, they spent every chance they got with their grandparents, Jérémie and Emilie Courtois Bas, who lived in Vierzon. During vacations, their grandfather took them swimming in the Cher. Both Edgar and Jules reported to their children many years later how much they had enjoyed having their grandparents close by, and also that they had made good use of a tandem bicycle to visit their parents in Orléans. Both boys were highly competitive and ambitious. Quite simply, they wanted to be better than anyone else, and as teenagers they were already hard at work to achieve this.

The Brandt brothers were the only students who were strong enough to make a bar of iron red-hot using only the force of their hammers. Although two years younger than his brother, Jules Brandt advanced very rapidly in the blacksmith shop, but his strongest interest was in electricity, and after his graduation from Vierzon that was to become his chosen field.[29] Edgar, however, loved the forge. By the age of fifteen, he was the most accomplished ironsmith in the school.[30] His precocious gifts must have interested his professors but the busy curriculum kept them from giving him special attention. Still, both at school and later in the business world, Brandt's superior aptitude for mathematics and technology allowed him to excel over other excellent competitors.[31] In fact, one could argue that Brandt's talent was inborn and would have blossomed regardless of the scholastic program.

In his third and fourth years, Edgar's weekly curriculum consisted of three hours of mechanics,[32] three hours of technology, six hours of industrial design, and twenty-four hours in the workshop, which was intended to bridge the gap between school life and the real life of a factory.[33] It would appear safe to say that any artistic achievement on Edgar's part came to him instinctively, as artistry was not emphasized in the tutelage at Vierzon. The Brandt brothers worked at the same forge, learning to read the state of their material: cherry red into blood orange until they could see the iron sweat. For their separate graduation masterpieces, each boy forged a wrought-iron rose.[34] Their choice of forging and assembling the petals of a rose may have been meant to please their father, who cultivated these flowers. Jules, having worked on an accelerated level, was able to graduate with his brother; both received the B.T.S. (Brevet Technicien Supérieur). After four and a half years, Edgar received his diploma from Vierzon on July 31, 1898.

Vierzon was dedicated to providing a superior education for students who wanted to work in the mechanical and scientific side of industry—as, for instance, foremen and factory directors, as well as fitters, assemblers, and repairers. His professors, then, could not have known as they called the roll—"Appert, Audion, Bechu, Brandt Edgar, Brandt Jules, Brivain"[35]—that they had among them a truly multitalented pupil who would one day help to align industry with art. Nevertheless, this was to be the essence of Edgar Brandt's achievement.

Early in his career, Brandt realized that manufacturers and artists were operating from different points of view. Artists did not understand that men of industry were more interested in the number of sales a product would generate than in process and technique. A manufacturer, visiting an artist's studio, might be confronted with many fine pieces, but more often than not, all he would see would be the complexity and the difficulty of reproducing the work. Quickly he would lose patience with the artist, whose work was often too costly to process. If the two professions should happen to join forces, the artist would generally be forced to compromise his total artistic conception, knowing that its full value could not be reproduced due to lack of proper techniques and facilities. Not always in possession of good taste, manufacturers chose models that were the easiest to produce or the ones that had the most commercial potential. Yet by his own example, Brandt would prove that art could be united with industry in the production of well-conceived and well-realized objects. At a time when fine craftsmanship in France was primarily looked upon as work carried out by a single artisan with one or two apprentices, Brandt had a different idea and one that was not typically French. He realized that a differentiation of work stations with either hand or machine operations could lead not to mass production, but to serial production.

It is interesting to contrast the ideas that Brandt put into practice with the theories that had been set down by John Ruskin (1819–1900), the Oxford-trained medievalist who was opposed to machine work and Renaissance-style ornament. These beliefs greatly influenced the designer William Morris, as well as the painters and architects who formed the Arts and Crafts movement.[36] While it was true in the mid- to late nineteenth century that many industrialized products that Ruskin found so objectionable were ugly and poorly made, their low cost made them affordable for more people. Handmade products, by comparison, took much longer to create and were far more expensive. Thus, in espousing Ruskinian craftsmanship, laboriously producing high-priced objects, Morris practiced an idealism that failed to take into account the pragmatic concerns of his firm. Edgar Brandt did not make that mistake.

Brandt realized that his art could be aligned with industrial methods if he made the effort to understand the necessary steps and implement them. He said: "The artist must utilize the means that science has placed at his disposal; to preserve or hold on to the old methods is an absurdity."[37] Brandt did not forsake handwork; he merely allowed the machine to simplify the preparation of parts and their assembly. In the end, however, it is still Brandt's handwork and hand finishing that give charm and individuality to each piece. This innovation, which made the fabrication of numerous and varied objects possible, eventually led the way to the general aggrandizement and industrialization of *ferronnerie* itself.

1900: A CAREER BEGINS

After graduation from Vierzon, Edgar served his two-year army obligation with the 153rd Infantry in Nancy, where undoubtedly he was much impressed by the marvelous ironwork in the Place Stanislas (1751–59). It was fortuitous that he should have been exposed to the great work of Jean Lamour, the eighteenth-century blacksmith who created the Rococo gates of the town square named for the former king of Poland, Prince Stanislas Leczinsky, the duke of Lorraine.[38] Brandt must have taken pride in his return to Nancy ten years later to help embellish the new theater with his superb ironwork.

After Edgar's military service he and Jules joined their parents, who had moved in 1898 to rue de la Goutte d'Or in Paris. The artistic community of Paris was in an exciting period of growth; the Exposition Universelle of 1900, which was open from April to November, was inspiring young architects and designers. While the great Impressionists Claude Monet and Auguste Renoir were still painting, Auguste Rodin dominated sculpture with an exhibition at the Place de l'Alma, and younger artists such as Pierre Bonnard and Edouard Vuillard were producing compositions of rhythmic, low-keyed tones that were nevertheless filled with vividly contrasting patterns. Paul Cézanne was being given a retrospective at Galerie Vollard, just as Pablo Picasso came to Paris for his first visit.[39] As the nineteenth century came to a close, Edgar and Jules entered adulthood and their professions in this invigorating atmosphere.

The decorative arts were featured prominently at the Exposition Universelle. Emile Gallé was awarded a Grand Prize for his glass exhibits. Furniture designers of note at the exhibition included Louis Majorelle of Nancy, Richard Riemerschmid (1868–1957) of Munich, and Georges De Feure of Paris. Riemerschmid designed a "Room for an Art Lover" and De Feure designed part of "Le Pavillon d'Art Nouveau" for Siegfried Bing.

The performing-arts section of the Exposition Universelle featured the dancer Loie Fuller, who had a theater built especially for her performances, and Sarah Bernhardt, who enjoyed a full season of acting in *Hamlet, L'Aiglon,* and *La Dame aux Camélias.*

In 1900, the Paris Métropolitan underground rail service began to operate. The Société Générale des Téléphones, which had originally been a private company, was taken over by the government in 1889; by 1900 the telephone was part of modern life. Electricity, a recent invention, along with improved roads and motor cars and the emerging rationalist path of architecture, helped to reinforce the reputation of Paris as a modern city of international stature.

In the midst of this activity, Jules Brandt began to work for the Edison telephone company, and Edgar Brandt began his career. When the opportunity to open a small atelier presented itself in 1901, Edgar seized it, buoyed by parental guidance and faith in himself. The atelier where Brandt set up his first forge was at 76 rue Michel-Ange in the 16th arrondissement, quite close to the Saint-Cloud gate. It was a very modest workshop in terms of space and equipment, but Edgar's design ability, strength, and manual dexterity always compensated for whatever was lacking materially. The men in his employ (mostly older) were stimulated by his example to work to the optimum within their specialties.

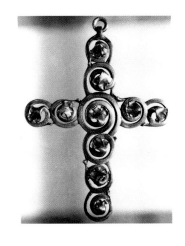

ABOVE:
3. Cross, c. 1903–05. Wrought iron, $2\frac{5}{8}$ x $1\frac{7}{8}''$. Courtesy the Brandt family

LEFT:
4. Pendants, c. 1903–06. Wrought iron and/or silver, some with gold accents; "Crown of Thorns" cross (no. 1139), $2\frac{5}{8}$ x $2\frac{1}{8}''$; Heart-shaped pendant (no. 1148), wrought iron, gold, and opal, $1\frac{7}{8}$ x $1\frac{3}{4}''$

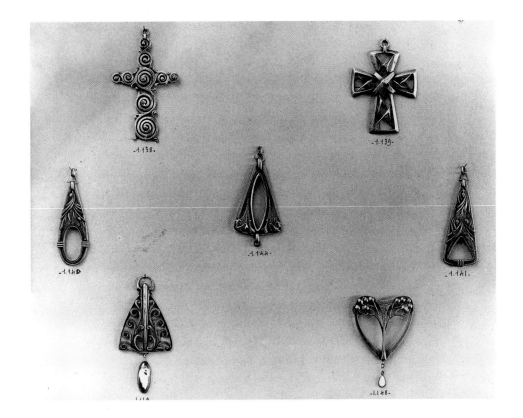

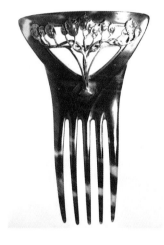

5. Hair comb, 1905. Tortoise-shell and wrought iron, 4⅝ x 2¾". Stamped "E.Brandt". Courtesy the Brandt family

Edgar began by designing, silversmithing, and forging small items such as rings, crosses, pendants, and brooches. Most of his jewelry items were made of iron with silver or gold embellishments. An iron crucifix fashioned by Brandt during this period (c. 1903–05) features ten ginkgo leaves delicately placed within ten round frames (fig. 3). The variations in the circles and leaves are evidence of the ironsmith's careful handwork; the entire piece reflects his ability to imbue this religious symbol with quiet strength.

Another wrought-iron cross from this period, which remains with the Brandt family today, uses the crown-of-thorns motif worked around a tied or crisscrossed center (fig. 4). Imbued with visual tension, the recti-linear cross appears timeless. Yet its angled edges, pointed spokes, and flat straps are elements that incorporate symbols of Christianity. Passion and strength blend easily to make this one of Brandt's seminal works. Interestingly, it is reminiscent of the work of the Barcelona architect-designer Antoni Gaudí i Cornet (1852–1926), who used iron on furniture and for exterior embellishments.[40] The aesthetic of Brandt's cross is quite different from that of the prevailing Art Nouveau.

Brandt enriched a 1905 tortoiseshell comb by mounting iron leaves of *monnaie du pape* (pope's coin) on it, small and delicate additions (fig. 5). This piece exemplifies Brandt's restraint: his works were not exaggerated by Art Nouveau mannerisms but rather were simplified. Although his jewelry pieces in silver or gold appear as dainty little ornaments, their design is based on the more succinct discipline of ironwork. To make this comb, Edgar used a tiny anvil and hammer, and a blowpipe that replaced the usual fire of his forge. The delicate work he produced suggests that he was looking closely at the jewels of René Lalique when they exhibited together at the Salons.[41]

Master goldsmith René Lalique was highly original in his designs and choice of stones and decorative technical achievements such as *plique à jour*. Since 1894, when he exhibited at the Salon, and later in 1897, when he was made a chevalier of the Legion of Honor, Lalique was considered one of the greatest jewelers in Paris. Although he worked for only a few choice clients, his influence was seen in much European jewelry from 1895 to 1910. Lalique was one of the few designers who would shift successfully from Art Nouveau to Art Moderne and from goldsmithing to glass-making.[42] As a glassmaker, Lalique was quick to see the growth potential of the commercial market and thus was one of the first major designers to make use of mass production. The well-established Lalique was twenty years older than Brandt and would have been the perfect role model for the ironsmith, especially around 1919 when Brandt was reorganizing his company. They worked together on at least one table lamp, which featured a cast white glass Lalique shade with flowers and Brandt's wrought-iron base, and on an iron chandelier with molded Lalique glass panels of nudes.[43] Often clients purchased Lalique glass vases and then brought them to Brandt's atelier for mounting in iron.

Like Lalique, Brandt possessed a solid technique that was transferable from small to large pieces. Edgar could work easily in iron, bronze, copper, gold, or silver. From 1904 on, as he grew in confidence, he expanded his line to include fireplace equipment, vase supports, mirrors, dresser sets, door knockers, cane handles, and trade signs. Like Lalique, Brandt's early career featured jewelry; however, Brandt's jewelry designs were most successful when they reflected his training as an ironsmith. They are best described as costume pieces, not precious but wearable and affordable. This is easily seen in the two wrought-iron crosses. Brandt's small-scale pieces, marked by accuracy and precision, were a starting point for a design-and-process formula that would slowly lead him to large-scale works in iron that were also meticulously crafted. Along with jewelry, Brandt was also involved in locksmithing (serrurerie). Like Emile Robert, who had begun his career with this proficiency, Brandt manufactured both inner works and casings of locks and continued this throughout his career.

TO SEE AND BE SEEN: THE SALON EXHIBITIONS

During Brandt's formative years and early career, the Parisian art world was evolving into an environment that would be uniquely receptive to the interests and talents he was to bring to it as a young professional. For example, the character of the primary fine-art societies was changing in ways that boded equally well for the decorative arts.

The Salon des Artistes Français, the first of the Paris salons, was founded in 1673 under the auspices of Louis XIV's Academie Royale de Peinture, and its influential exhibitions included jury-selected works by academy members only. With the 1789 revolution a movement to democratize the fine arts began. By 1791 all jury-accepted artists could exhibit. Although the return of the monarchy in 1816 also brought a return of state control over the Salon (through the Academie des Beaux-Arts), by 1848 the protests of the excluded artists were heard, and in 1881 the state gave over the control of the Salon to the Société des Artistes Français (S.A.F.). In 1890, when Brandt was ten, a faction of the S.A.F. broke away and formed the Société Nationale des Beaux-Arts, which became a platform for artists and designers working at the end of the century.[44] Significantly, two years later both organizations had begun to include decorative arts in their showings. All of these changes helped create an environment in which the individual artist was freer than ever before to find exposure and build a clientele for his work.

In the meantime, the decorative arts had also been evolving—into a prestigious area of enterprise that would strive for a solid standing in the marketplace and among the professions. Since the early seventeenth century craftsmen had plied their trade in workshops set up in the Louvre under the protection of Henry IV and Louis XIII. Louis XIV and his minister Colbert established the Manufacture Royale des Gobelins (1662), joining cabinet-makers, ceramists, silversmiths, and tapestry specialists to provide accoutrements for the royal palaces. This became, in 1667, the Manufacture Royale des Meubles de la Couronne, which not only provided palace and court furnishings but addressed and set standards for native French craftsmanship. Under Louis XIV French decorative arts surpassed those of Italy and continued to set the standard into the nineteenth century. Slowly old techniques of handwork were losing ground to machine tools, as manufacturers relied too much on copying the past. Preeminence was losing to mediocrity. In 1881, the Société de l'Union Centrale des Beaux-Arts Appliqués à l'Industrie (1863) joined with the Société du Musée des Arts Décoratifs (1877) to form a new organization, the Union Centrale des Arts Décoratifs, which would place its emphasis on objects that were both useful and beautiful. Its members included architects, artists, industrialists, and amateurs. The union applied itself to refining contemporary taste, especially that of manufacturers and consumers, through the auspices of its library, its museum, its school, the École des Arts Décoratifs (1887), and through exhibitions held in the Pavillon Marsan of the Louvre (from 1905).[45] In 1889 the state founded the Société d'Encouragement à l'Art et à l'Industrie in the hope of increasing professional standards and most importantly showing the work of the artisans and designers.[46] The Union Centrale wanted a museum that would rival the South Kensington Museum, the present Victoria and Albert Museum, in London.

Even more growth was soon to follow for the decorative arts. A year after the Exposition Universelle of 1900, when it became apparent that the major emphasis of such shows was still being put on fine art, the Société des Artistes Décorateurs (S.A.D.) was founded to provide a voice for the integration of the fine and applied arts. The new S.A.D. (March 1901) exhibited each spring and fall at the Pavillon Marsan in the Musée des Arts Décoratifs. In addition, in 1902 several decorative artists broke away from the Société Nationale des Beaux-Arts (1890), founding the Salon d'Automne (debut 1903) for the purpose of showing their work directly to the public. From then on the decorative arts were represented in this more progressive salon, which exhibited twice a year at the Grand Palais. In addition, a show was held four times a year at the Musée Galliera, featuring a special field of decorative art such as glass or iron.[47] In view of the fact that there were now four annual Paris Salons, it was a highly propitious moment for Brandt to launch a career in the decorative arts.

When Brandt began in his profession the Art Nouveau movement was at its peak. It was a truly variable and controversial movement. Some

proponents, in an attempt to reject historicism in favor of stylizing nature, became mired in overblown swirls and contorted details. The unprecedented criticism was vehement. One writer, Camille Mauclair, labeled the style "a lamentable torment of ugliness" and called for a return to simplicity.[48] However, as exemplified by the buildings and furnishings of Hector Guimard, the jewelry of Lalique, and certain of the School of Nancy artists and artisans, Art Nouveau proffered works of imagination and fantasy.

At this time Brandt was probably familiar with the 1856 publication by the Welsh architect and theoretician Owen Jones, *The Grammar of Ornament*, which depicted historic decorative motifs from Egypt, Assyria, Persia, Turkey, and China, as well as examples from the medieval and Renaissance periods.[49] Most definitely Brandt was familiar with Eugene Grasset's 1897 publication, *La Plante et ses applications ornementales,* a folio-sized volume containing seventy-two color plates showing every aspect of a plant, as well as stylized segments of those plants and how they could be adapted to various decorative projects.

Certainly Brandt was aware of the opulent furniture designs of Louis Majorelle,[50] who exhibited at the 1900 Paris Exposition Universelle. Majorelle showed an outstanding suite of salon furniture that was embellished with marquetry and gilt-bronze mounts of orchids and water lilies. The high quality of his woods and bronzes caused a sensation.

Inspired especially by the iron and bronze work of Majorelle, Brandt was eager to tackle several aspects of metalwork. Shortly after opening his atelier, Brandt began to exhibit, making his debut in 1903 at the Salon des Artistes Décorateurs.[51] At this exhibition Brandt had undoubtedly been impressed with Majorelle's furniture display, including a vitrine decorated with wrought iron that was part of the School of Nancy's presentation at the Musée de l'Union Centrale des Arts Décoratifs. Majorelle had a separate metal workshop, where he made ormolu furniture mounts and wrought-iron garnitures and elements. Brandt must have been struck by the idea of using his forging abilities to ornament a furniture line of his own.

While the young *ferronnier* was busily preparing for the summer and fall salons of 1904, he embarked on a new furniture-making venture, and his personal life took an important turn. On June 16, 1904, Edgar William Brandt married Renée Largaud, a young woman whom he had known since childhood.[52] Perhaps domesticity turned his attention to furniture. That fall in the applied-art section of the 1904 Salon d'Automne, Brandt's heavy but wholesome mahogany dining-room furniture was exhibited[53] alongside the sculpture of Rodin, the drawings of Toulouse-Lautrec, and the bronze sculptures of Prince Paul Troubetzskoy. Brandt had been experimenting with two lines of furniture, one more costly than the other. The cheaper line, geared to middle-class customers, utilized less costly woods and simpler hardware. Some of his finer library bookcases and cabinets were made of walnut and embellished with delicate wrought-iron ginkgo leaves (figs. 6, 7, 8). A desk designed by Brandt and executed in his atelier also mixed

6–8. Bookcase, c. 1904–07. Carved walnut with wrought-iron decoration, 75 x 66 x 16″. Details show the ironwork. Courtesy Calderwood Gallery, Philadelphia

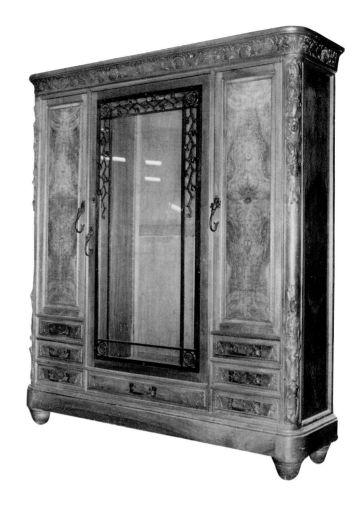

BELOW:
9. Dining room designed by Brandt, 1904. From *L'Art décoratif* (July–Dec. 1904), figure 22

wood with bands of decorative wrought work. These embellishments were distinct from the drawer pulls and other hardware, which were either cast or forged. Clearly, in this endeavor the *ferronnier* was opening up another area of production that would combine ironwork and woodcarving.[54]

The concept behind the furniture was that its manufacture should require as little time-consuming handwork as possible. Brandt was preoccupied with finding ways to industrialize the work and minimize the labor without sacrificing the integrity of the design or its construction. Probably the *ferronnier* came to realize that his wood pieces were more derivative than original, especially when compared with his many ingenious pieces of ironwork. Aesthetically, his dining-room furniture seems to show the influence of Charles Plumet (1861–1928) and Tony Selmersheim (1871–1971), whose work was popular at the time, having been exhibited at the Exposition Universelle of 1900, and seen in stores and in magazines.[55] A dining room that Brandt made in 1904 shows many stylistic similarities to their work (fig. 9). An upper-middle-class domestic atmosphere is apparent in both rooms. The furniture was fabricated extensively by machine. The decoration flows from the furniture to the walls and the dado, very much in the manner of William Morris. Probably Brandt was familiar with Morris's early furniture design and was also looking closely at the Viennese designer Josef Hoffmann, who had founded the Wiener Werkstätte in 1903.[56] Although these two designers were aesthetically different, their work would have provided him with important conceptual stimuli: both emphasized craftsmanship and the interrelationship of the applied arts in an overall design approach.

Brandt was also an exhibitor at the 1904 Salon of the Société des Artistes Français, where he showed numerous items, such as silver buttons, a silver mirror frame decorated with sycamore fruit, a silver brush holder, book markers, forged key tops, table crumbers, and a variety of rings, brooches, and necklaces adorned with plant motifs. At the Salon d'Automne Brandt's sinuous wrought hat pins, curving letter openers in both bronze and iron, and wrought-iron drawer and door handles were in the Art Nouveau mode (figs. 10, 11). By 1905 this stylistic tendency changed and the work became simpler and more individual in form. One of his necklaces from that show has a triangular pendant of iron that was strung on a delicate iron chain strewn with loops of gold ginkgo leaves.[57] The idea of crafting inexpensive wrought-iron jewelry and brightening the pieces with touches of gold or silver was novel. In contrast to the platinum, gold, and precious stone settings employed by Henri Vever, Louis Cartier, or the Maison Fouquet, Brandt was offering "costume" jewelry. In his iron pieces the material spoke to his conception more than the addition of costly stones.

A 1905 iron buckle featured in the Salon des Artistes Français displayed nine broad water-lily leaves in an arrangement that was more Arts and Crafts in feeling than Art Nouveau (fig. 12). By this time Brandt had

10. Wrought-iron and bronze letter openers, c. 1906

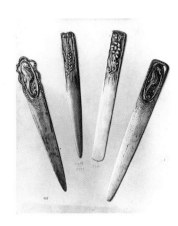

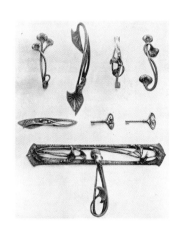

11. Wrought-iron drawer and door pulls, 1904. From *L'Art décoratif* (July–Dec. 1904)

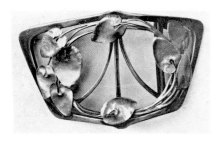

ABOVE:
12. Wrought-iron buckle with silver or copper water-lily leaves, 1905

BELOW LEFT:
13. Pendant necklace, 1905. Silver and baroque pearls, 2⅛ x 1¾″. Stamped "E.Brandt". Courtesy Moderne Gallery, Philadelphia

BELOW CENTER:
14. Pendant, 1908. Iron with gold and opal, 2½ x 1¼″

BELOW RIGHT:
15. Pendant, c. 1909. Silver, gold, and turquoise, 1⅜ x 1⅜″. Courtesy Moderne Gallery, Philadelphia

OPPOSITE, TOP:
16. Copper lamp and shade worked around a copper armature, 1904. From *L'Art décoratif* (July–Dec. 1904), figure 25

OPPOSITE, BOTTOM:
17. Wrought-iron lamp by Emile Robert, 1904

trained a number of his workmen to execute models like this one in order to free himself for the designing and researching of motifs, which he did late at night at the dining-room table. The early work reveals that the ironsmith was drawn to several plant themes: maple, sycamore, oak, and ginkgo leaves; and pine cones and needles. The double-lobed, kidney-shaped ginkgo with its almost parallel lines of veining was perfect for reproduction in iron. The ginkgo plant was to become one of the ironsmith's signature motifs. An ancient tree, the ginkgo, which Darwin spoke of as "a living fossil," survives today as the ginkgo-biloba. It is sacred to Buddhists and has been used in Eastern medicine for ailments.[58] Possibly Brandt learned about these fan-shaped leaves from his grandfather, Jérémie Bas, a homeopathic hobbyist, or through his father's horticultural interest. However, this plant form was also used by other Art Nouveau jewelers and ironsmiths, such as Lalique and Adalbert Szabo. Brandt emphasized the wheat, the ginkgo, the oak, and the pine motifs as opposed to the time-honored classical forms of the eighteenth century such as the acanthus, the rosette, the spiral (also known as the birdcage), the lyre, the twist, and the crown.

At this time Edgar was often seen pedaling his bicycle to a jewelry shop on the Place d'Auteuil to sell his wares. The artist/critic Maurice P. Verneuil, reviewing the decorative arts at the Salon of 1905, mentioned that "Brandt does not restrict himself to forging iron, moreover, but he also attacks silver."[59] A beautiful silver pendant depicting the seeds and seed pods of the maple tree reveals the original approach of the ironsmith to jewelry (fig. 13). It was much different from the lavish diamond-encrusted maple seed pod pin *(parrure de corsage)* that Philippe Wolfers had shown

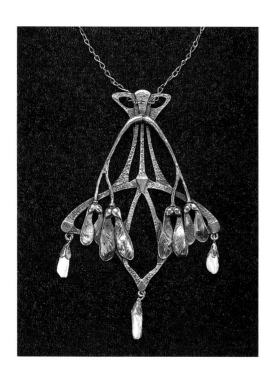

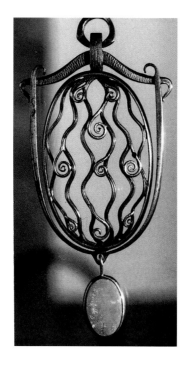

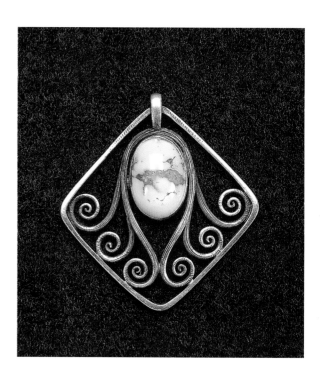

at the Salon of 1900.[60] It is the pendant of a *forgeron*, and Brandt displayed a similar piece on his advertisement that announced: "Artistic Ironwork (Chandeliers, Lighting, Heating, Furniture), Precious Metalwork (Ceramic Mounts, Artistic Fantasies, Silver- and Goldsmithing)." Verneuil described Brandt's jewelry at the 1907 Salon des Artistes Français as having "a cold harmony and a definitive pleasantness."[61] Pendants made by Brandt before 1909 reveal his increasing confidence as well as his ability to produce timeless designs such as the heart-shaped iron pendant adorned with gold (see fig. 4). A view of seven pendants grouped together reveals Brandt's superlative command of his materials combined with an innate artistic imagination. Two of the most timeless pieces are a pendant with wavy bars of iron touched with gold and another work of silver, gold, and turquoise with a subtle curve (figs. 14, 15).

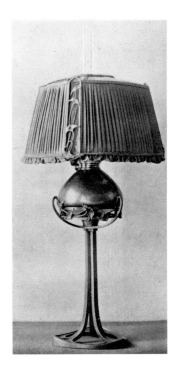

While responding to the contemporary movement in his early works, Brandt did not copy the fin-de-siècle formulas of Grasset or Verneuil; rather, he adopted a known form in nature and applied it to decorate a useful object. His application of ornamental forms was every bit as important as his craftsmanship. Brandt, in these early years, was more aligned in his approach with Emile Robert's contained use of natural forms for ironwork. At best, Art Nouveau was artificial. It would become outmoded as changing lifestyles, especially after World War I, negated its fussy, convoluted character.

In 1904 Brandt produced several forged copper gas lamps, round in shape and deftly hammered to offer a wonderful play of light on the surface. In one particular example the copper frame for the silk shade allowed visible parts of the copper to show off the ginkgo decoration between intervals of the silk (fig. 16). This idea of mixed materials for lampshades was in vogue. It is interesting that Brandt's lampshade integrates the copper and silk, whereas Emile Robert's iron table lamp with an embroidered shade of taut parchment featured iron decoration on the top of the shade (fig. 17). At the base of his lamp Robert used a snail-shell motif that was to become a popular form for Brandt as well.

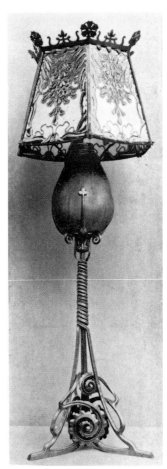

Brandt, at twenty-four years old, was turning out a great variety of objects. For example, he forged copper and iron into a beguiling shovel, tongs, and poker set for the fireplace. Sinuous curved handles lead the eye to the bottom of the rods where the motif is repeated on a smaller scale. Perhaps most original of all were the wrought-iron mounts that he made for French stoneware. Here the wrought iron either mimics the vase's shape or has been forged to hold the vase, basketlike, ending in elaborate, somewhat elongated handles. In other examples, the vases rest on iron legs that resemble little katydids (fig. 18). Brandt may have been emulating the prevalent use of this entomological theme by School of Nancy designers such as Emile Gallé and Almeric Walter. All these designs have a compelling zoomorphic quality. It is conceivable that this quality was derived from Lalique's insect- and butterfly-inspired jewelry (c. 1900–05). By 1905

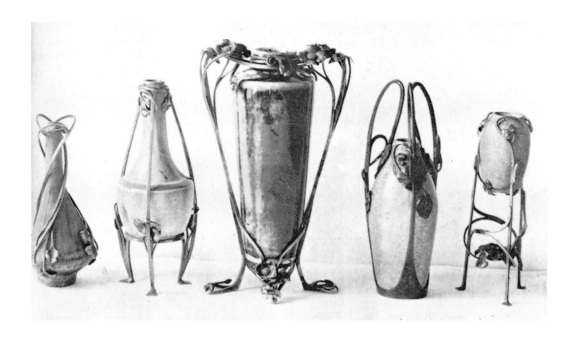

RIGHT:
18. Vase mounts, 1904. From
L'Art décoratif (July–Dec.
1904), figure 28

BELOW:
19. Stair rail with acorns and
oak leaves for the town hall of
Euville, France, 1907. Joseph
Hornecker, architect

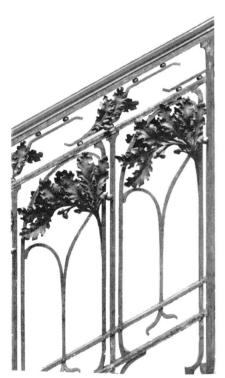

Brandt was furnishing wrought and chased mounts for La Manufacture Nationale de Sèvres, and some of these were in a show of wrought iron, brass, and pewter at the Musée Galliera.[62]

In 1905 Renée Brandt gave birth to their first child, Jane, and in celebration Edgar won a third-class medal. By 1907, the year his second daughter, Andrée, was born, Edgar won a second-class medal. Brandt's work was beginning to be reviewed more seriously by the decorative-arts critics. In June 1907 he was paid 6,000 francs for work on the *escalier d'honneur* of the Hôtel de Ville in Euville (completed 1906–07) designed by the architect Joseph Hornecker (1873–1942).[63] Strewn with hand-forged oak leaves, acorns hot-formed in a die, and squat balls, the balustrade reveals Brandt's particularly delicate touch. The leaves are realistic in form but veer toward conventionalization in their placement (fig. 19).

Although at this time Brandt's influence on his peers was minimal, the critics were predicting a bright future and clients were knocking on his door. His early success with forged jewelry and small-scale pieces allowed Edgar to expand his workshop capacities, investing in a larger plant that enabled him to take on larger-scale projects and to hire more workmen. As time went on, therefore, it became less feasible and effective for him to be occupied with the forging of small objects, yet by necessity the delicate handwork was mainly carried out by Brandt himself, as most of the workmen were not sufficiently skilled to undertake it. Architectural commissions, such as the stairway in Euville, would slowly take precedence over smaller-scale pieces. More of his time was taken up with the draftsmanship and the design work related to his larger projects. The jewelry fashioned from 1903 to 1908 had been well received, but the *ferronnier* was seen less frequently bicycling to the jewelry boutique with his wares.

THE WELD THAT HELD: THE OXYACETYLENE TORCH

Well schooled in traditional methods of blacksmithing, Edgar Brandt benefited not only from the groundwork laid by Emile Robert but also from the newest technology. The most important innovation in his field was the invention of the oxyacetylene welding torch.[64] Brandt was quick to see the possibilities inherent in the use of the torch. His mastery of this tool, as well as of power hammers, drop-forging machines (replacing hand stamping), mechanical milling, and drilling machines, led him to a personal style. However, several of his contemporaries disavowed these procedures. In fact, the *ferronniers* Adalbert Szabo and Richard Desvallières disdained the use of modern tools, feeling that the only worthwhile ironwork was that done by a single artisan using the ancient methods, mainly working hot iron with a hammer and anvil. Even Emile Robert felt that overuse of the torch could change the natural aspect of the material. That Brandt's commitment to these new methods was justified can best be seen in a work of 1908. An influential client, M. Barbedienne, owner of a foundry renowned for its bronze casting and granite editions of sculpture, commissioned Brandt to forge the main stairway banister in his house (fig. 20).[65] Fashioning a profusion of pine cones and needles that resemble the splendid tail of a peacock, Brandt proved what could be accomplished with the torch.

Also known as the autogenous gun, the oxyacetylene torch was responsible for revolutionizing ironwork during the first two decades of the twentieth century. The gun consumes two gases, oxygen and acetylene. Oxygen is essential to the combustion of most substances, and acetylene is a highly flammable gas made by mixing water and calcium carbide. In 1895, when the French chemist Henri Le Châtelier put these two gases under great pressure, they reacted by producing high temperatures of approximately 3,300° C. Another Frenchman, Edmund Fauce, realized how to use the gases and their intense heat for both the cutting and the joining of metals.[66] In 1903, he made the first workable and safe welding torch. Eventually the size of the torch nozzle was made in such a way as to control the flame size, so that the heat could be adjusted for a variety of thinner or thicker metals. The welding gun allowed two pieces of iron to be joined quickly. Isolated small areas of the iron could be raised to high enough temperatures to allow the metal to become its own joining material, often with a filler rod introduced into the molten base material. This procedure, if done correctly, allowed for a perfect fusion of metallic parts and

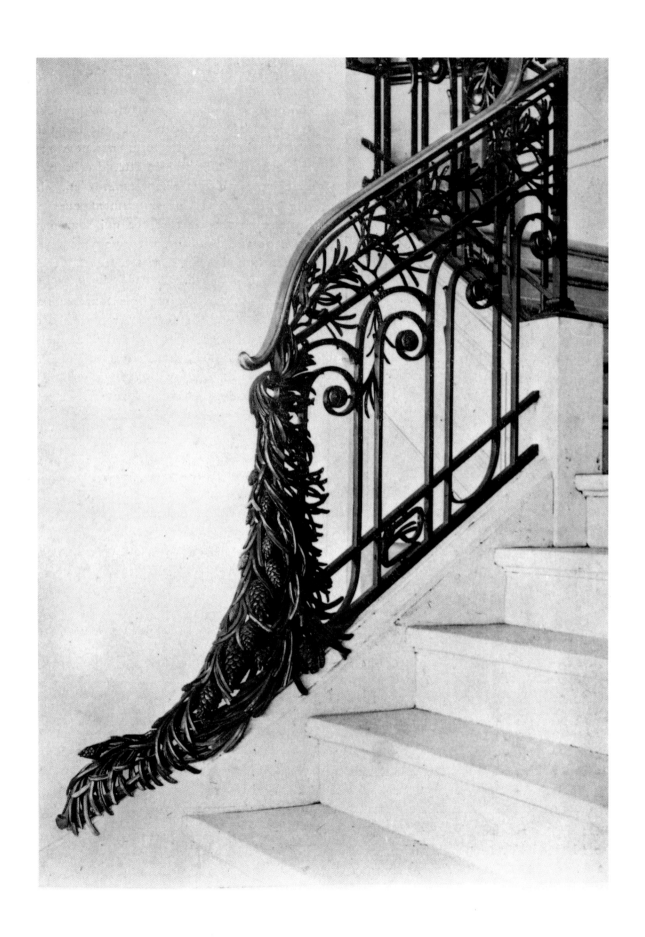

eliminated the older methods of hot and cold forging, collaring, or riveting.[67]

20. Wrought-iron stair rail for M. Barbedienne, 1908

A prescient Edgar Brandt mastered the autogenous welding gun and was one of its earliest champions. The Barbedienne banister, with all its individual components, would have been an arduous technical challenge to a smith using forge welding, a process of heating two metals in the fire and then joining them by compression. The pine cones and needles were made first and then applied to the railing, building from the ground up. Using the torch required a special skill, and Brandt pioneered its use very early on. In fact, it was not until 1918 that the École Barbouze opened for the sole purpose of teaching this technique.

The *ferronnier* would be enamored of the pine bough throughout his career, but torch welding enabled him to create, in the Barbedienne banister, one of his greatest realizations of the theme. Most probably the large pine cones were made by forging individual petals and then gas welding them in layers. The small cones, which have less definition, were made from sheet iron formed into a cone shape and then hot-welded to secure the open side. The ridges were applied, gas-welded, and then chiseled in place and peened to texture the tightly closed cones. Careful examination of the latter cones reveals slight variations in the texturing of the ridges and at the closures of the tops and bottoms.

The pine needles would have been made by hammering a round bar in a bottom swage, thus creating the individual shape and grooves at the same time. Then they were gas-welded to the cones. The brass used for the handrail added to the colorful richness of the work. The banister's sumptuousness is visible today in a black-and-white photograph, but the effect must have been dazzling in person as the light played off the contrasting iron and brass. With the Barbedienne banister, Brandt realized the possibilities offered by the autogenous welding gun, for it allowed a complex tour de force like this one to be assembled with a great savings of time. While the works of his eighteenth-century predecessors Jean Lamour in Nancy and Jean Tijou at Hampton Court Palace and St. Paul's Cathedral in London were rich and complex, they had been achieved through countless hours of backbreaking effort.

In spite of Brandt's success with the autogenous welding gun, his contemporaries Desvallières and Szabo remained disdainful.[68] The Hungarian Szabo had been trained in Germany, a nation long known for metalwork, and although he was a consummate technician he was not a naturally gifted designer. Perhaps the reluctance of Desvallières and Szabo to embrace the newer mechanical forging techniques was due not only to a purist philosophy but also to a reluctance to compromise the material and the traditional methods in which they had been indoctrinated.

In 1908 jewelry was the principal focus of the annual exhibition at the Musée Galliera. Here again, Brandt found a chance to show the strengths of his work, which was featured alongside that of René Lalique,

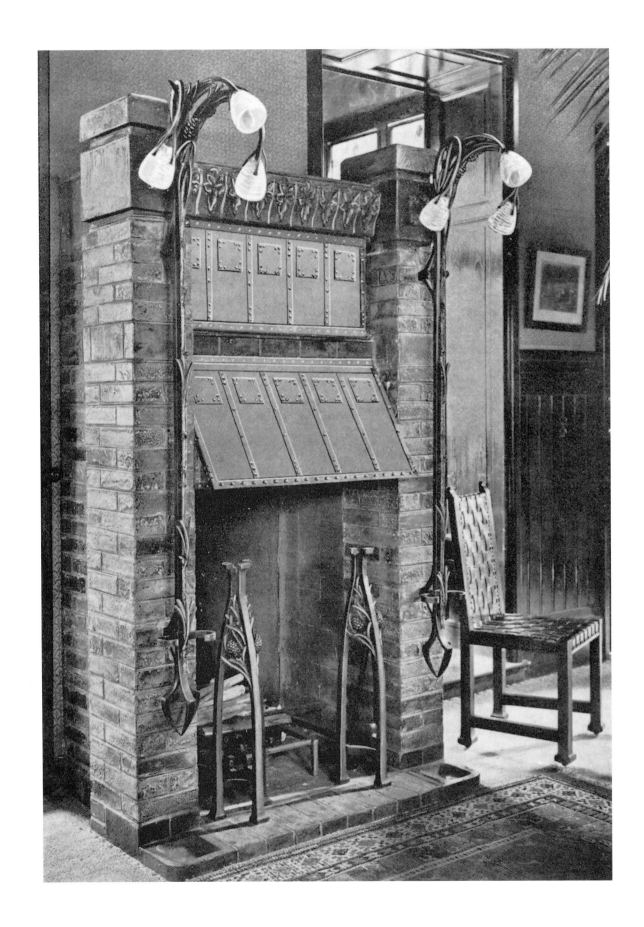

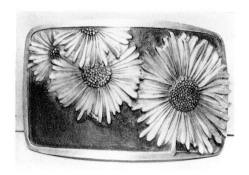 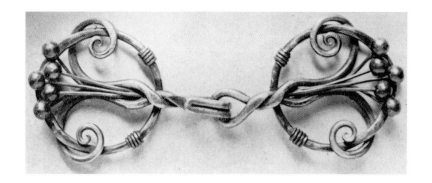

Henri Vever, and the Maison Boucheron. The review in *Art et Décoration* was encouraging.

> Monsieur Edgar Brandt is exhibiting a series of jewels in forged and repoussé gold and silver. These are admirably composed with a very sober and very supple execution. The motifs are simple, leaves of the plane tree, the eucalyptus, the maidenhair, and pope's coin combined with the most discrete stones, pearls, or opals in graceful arrangements. M. Brandt is one of our young artists, who specializes in metal work, one of those on which we can place our greatest hopes.[69]

Even though Lalique was heralded as the genius of the hour, and deservedly so, Brandt's designs were distinctive. Especially fine examples of his work included a cast- and chased-silver buckle in a particularly modern design awash with daisies (fig. 21) and a slightly medieval-looking narrow belt clasp worked in opposing scrolls and berries (fig. 22).

At this time Brandt was being sought out by some of the best French architects for large-scale work. For example, Henri Sauvage and Pierre Sarrazin commissioned Brandt to provide decorative metalwork elements for a large country house they were building for the wealthy French financier M. Leubas on his property in Biarritz.[70] Brandt fabricated the ceiling lights of hammered copper embellished with an arum-plant motif. During this period the public was enthralled with the new development of central heating, but a fireplace was still included in most every interior plan. This country house was no exception; a great fireplace was planned for the center of the large entry hall. The highlight of this hearth was Brandt's forged iron, gothicized andirons, with faithful renditions of pine cones nestled together. Along with the andirons Brandt forged long thin wrought-iron wall lights that ran up either side of the brick fireplace wall. At their base these noteworthy lights doubled as holders for the firetools (fig. 23). Pleased with Brandt's products, the same architects would commission him frequently in the future. Each satisfied client and architect for whom the *ferronnier* worked helped to spread his reputation.

ABOVE LEFT:
21. Cast- and chased-silver daisy buckle, 1908

ABOVE RIGHT:
22. Wrought-iron belt clasp with hammered, faceted gold balls, 1908

OPPOSITE:
23. Fireplace and andirons for a house in Biarritz, 1908. Wrought iron, height of andirons approx. 28–30″. Sauvage and Sarrazin, architects

24. Gold medal of the Société des Artistes Français, awarded to Edgar Brandt in 1908. Courtesy the Brandt family

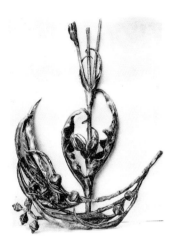

25. Study of thistles, 1908. From *L'Art décoratif aux Salons de 1908* (Paris, 1908), plate 28

26. Study of grapes and leaves (possibly a lampshade frame), 1909. Wrought iron, 13½" diam. Courtesy Sotheby's, Inc.

In 1908 Brandt also exhibited at the Grand Palais with the Société des Artistes Français, for which he was awarded a first-class gold medal, as well as a jury membership in the society (fig. 24).[71] Two items shown at the S.A.F. Salon that year are worth mentioning. One was a stair railing composed of simple diagonal and vertical iron bars. Every other vertical bar was decorated with different tree-branch motifs (pine, maple, thistle, and ginkgo). The second display piece was an objet d'art composed of two branches of thistle, one straight branch with open thistles surrounded by cupped, slender leaves; the second branch, resplendent with eleven closed thistle buds and long C-shaped leaves, lies curved on its side (fig. 25). Stunning in its simple visual poetry, the latter piece is akin to the flower studies that were crafted so beautifully by Emile Robert when he began his career. In any case, Brandt's emerging signature style is readily apparent in such works, which make it apparent why he won early recognition by the critics.

While grape clusters, vine tendrils, and grape leaves were an ever popular concept, no one before Brandt had achieved such luscious fruits and sculptural form in iron (fig. 26). The same can be said for his stylized studies of pine cones and needles. Although realism predominated in the grapes, leaves, and cones, most of Brandt's favorite motifs were twisted, turned, rotated, and pivoted to span a variety of iron bars and frames on a multitude of imposts, gates, fire screens, and consoles. Yet, whether molded, forged, or chiseled, these natural motifs appear real enough to be plucked directly from a tree or a flower, bearing Brandt's telltale mark of delicacy and perfect proportion.

For the 1910 Salon des Artistes Français, Brandt offered a simple bronze vase subtly adorned with seaweed that meandered down two sides and spread out around the base (fig. 27). A bronze charger *(Les Algues)* with similar decoration, dating from this period, captures a subtle underwater quality by merging the motif and the bronze surface through a rich brown patina (fig. 28). The graduated circles can be likened to ripples of water that form when a pebble is thrown into the water, in this case revealing the underlying seaweed. Although related in style to Art Nouveau, these two pieces demonstrate a more serene aesthetic and the charger, particularly, exhibits the influence of Japonisme.

In 1910 the Deutscher Werkbund exhibited at the Salon d'Automne in the Grand Palais in Paris, showing German designers such as Adalbert Niemeyer and Karl Bertsch.[72] These Germans had a way of displaying the pared-down essence of a design,[73] and at this time they were ahead of the French in the exportation of decorative arts. Probably Brandt, like all the French, was surprised by the Germans' use of flat, linear forms. Their furniture was simple and mostly devoid of ornamentation.[74] Significantly, the interiors created by these industrial designers were coordinated, blending walls, floors, and furniture to create an ensemble. This temporary German exhibit must have left Brandt with much to think about concerning the collaboration of artists and industrialists.

Luckily his thoughts were eventually disclosed twelve years later. On February 10, 1922, while lecturing on the union of design and industry, Brandt exhorted the French to work together in the creation of an appropriate style for the 1920s. He felt that the means of producing art then were the same as in the past, but that the ideas had become weaker just at a time when the tools had gotten better. If France wanted to regain her prominence in the arts, she must, he cautioned, gain time by using new machinery to facilitate the production of art.[75] People will always want luxury items because it is human nature, he stated. "Even if in the future there might be less need for luxury products I would still find a reason to say that it's in this area that our efforts will have the best realization and chance of success."[76] Brandt's comments seem more democratic than the related remarks of Emile-Jacques Ruhlmann: "We must make deluxe furniture. . . . It would be preferable to educate the masses but it is necessary to proceed otherwise. . . . It is the elite that launches fashion and determines its direction. Let us produce, therefore, for them."[77] The French traditionally had been strong individualists, working in family units or small entrepreneurial setups.[78] When it came to the industrial sphere they could never compete with England, Germany, or the United States.

Even before World War I, Edgar Brandt tried diligently to combine French design standards with the energetic German example of modern production values. He pointed out that the French had been too reliant on imitating the old styles of furniture and accessories found in their museums and palaces. Counterfeiters of these great models had no need for living artists; rather, they bastardized the past, created snobbism among naive bargain-hunting buyers. Brandt opined that dealers of fake antiques and uninformed manufacturers were operating on the false assumption that there was no need to try to create the "new" because nothing could surpass what had already been done. Opposed to repeating the artistic patrimony, Brandt wanted to augment that heritage, an enterprise he felt would give a vital boost to the French economy. After World War I, as industrialists slowly recognized the importance of artists and designers, Brandt helped to accelerate artistic change by disseminating his concept of design and manufacture—and, in the process, introduced a new aesthetic. Possibly Brandt, as a student, became familiar with Leon de Laborde's 1856 discourse, *De l'union des arts et de l'industrie*. Laborde felt that only state interference, through the establishment of many applied-arts schools operating on the order of old seventeenth-century guilds, could raise the level of public education.[79] He welcomed the machine and advocated model factories and workshops, whose output would stimulate national manufacture and help to fend off foreign competiton. Brandt was to become living proof of Laborde's ideal. This was in keeping with the writings of the influential designer/architect Eugène Viollet-le-Duc (1814–1879), who stated: "the first law of art . . . is to conform to the needs and customs of the times."[80] This desire for modernity of purpose and of execution would not be

27. Vase with seaweed motif, 1910. Bronze, 20 x 10″ diam. Courtesy Calderwood Gallery, Philadelphia

28. Charger with seaweed motif, 1910. Bronze, 19⅛″ diam.

29. The door of the French
Embassy, Brussels, 1911.
Georges Chedanne, architect

achieved overnight, but slowly Brandt and others would develop a new
market and new standards for their field.

Meanwhile, at the 1911 Salon des Artistes Décorateurs, Brandt dis-
played a large entrance door destined for the French Embassy in Brussels.
Georges Chedanne, the celebrated architect, was in charge of the embassy
and he chose the young ironsmith to execute his design.[81] A M. Maignon,
reviewing the Salon exhibition, criticized Chedanne by saying that without
the architectural drawings one could not judge the commissioned door for
the purpose for which it was designed. In other words, he felt that where an
object is placed is as important as its appearance. Amusingly contradictory,
the critic did acknowledge that "the isolated door showed a superiority."[82]
The monumental door exhibits a lavish display of pine cones and needles
(fig. 29). An arch frames a double door and establishes a recurring motif.
The letters "RF," which stand for the République Française, are superim-
posed on each of the smaller arched doors, which open independently of
the larger doors that frame them. The upper section, with its meandering
peacock scrolls, is a final concession to the Art Nouveau movement, while
the trompe l'oeil panels within panels suggest a flatter, more geometric ten-
dency. The effect of a raised window shade in the two lower panels offers a
welcoming aspect to visitors approaching the embassy. Stylistically this
door and matching window guards, abundant with pine cones, were related
to the Barbedienne stair rail. While this was Brandt's most prestigious
assignment to date, and probably his first major work outside of France,
the design appears to reflect more the architect's penchant for Art Nouveau
than the *ferronnier*'s aesthetic.

The ever present pressure to stand out from the competition must
have been a factor for many of the decorative artists who displayed their
work regularly at the salons. As of 1912, France was preparing a decorative-
arts exposition to be held in 1915 in order to reaffirm the preeminence of
French art in international circles, and artists must have been thinking
ahead to the proposed event. Even though the critics by and large were not
astonished by what they saw at the Salon of 1912, they noted interesting
contrasts in the work of several individual ironsmiths. Fred Perret offered a
wrought-iron lamp embellished with leaves and berries; M. Kovacs pro-
duced an old-style circular chandelier decorated with ginkgo, one of
Brandt's favorite motifs. The adept smith Adalbert Szabo displayed an inte-
rior wrought-iron gate in which tall vine stems wound their way in and out
of a simple grid, fanning out at the top with leaves and fruit. Emile Robert,
the esteemed senior smith who had done so much to revive metalwork,
interpreted in *fer forgé* the fable of "The Fox and the Stork" with fine
repoussé work. Robert was known for his iron animal sculptures. Edgar
Brandt's iron table lamps with Daum and Gallé glass shades conveyed ani-
mated, transitional concepts whose simple lines speak to a new elegance.
The two smaller lamps, trimmed with ginkgo or coral branches, were
topped by caplike shades supported by tripartite iron branching. The larger,

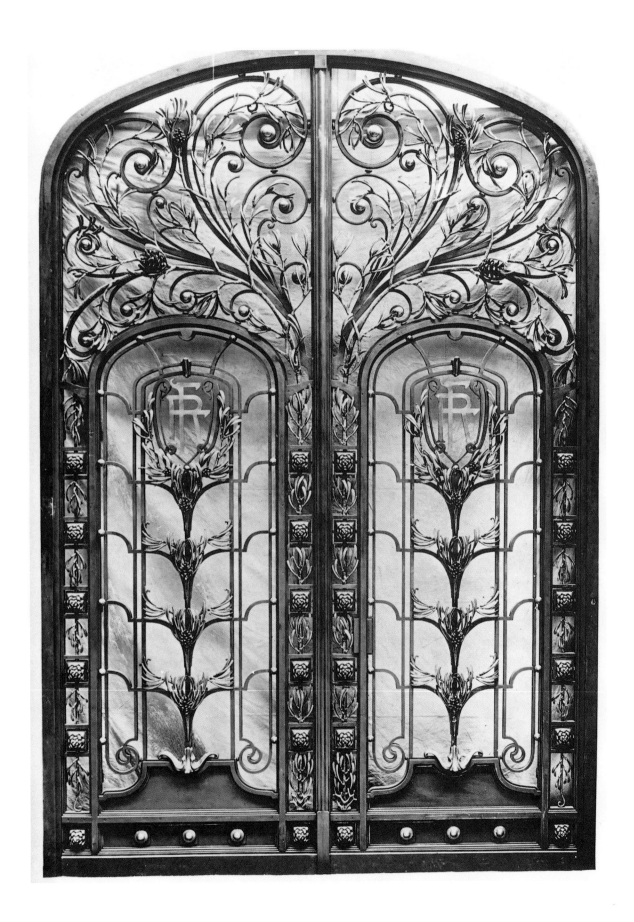

39

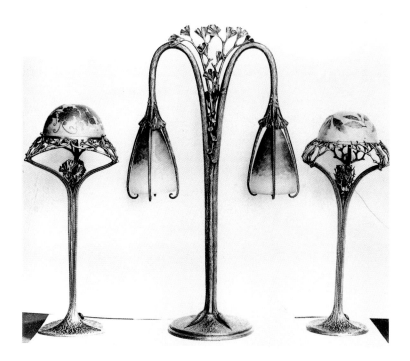

30. Three lamps, 1912. From
*L'Art décoratif aux Salons de
1912* (Paris, 1912), plate 10

31. Bronze charger with
starfish frame, 1912. From
*L'Art décoratif aux Salons de
1912* (Paris, 1912), plate 7

32. Starfish charger, c. 1912.
Bronze; made in two sizes,
19⅝″ and 9⅞″ diam.

single-stemmed lamp split at the top supports bell-shaped shades of Daum glass. Delicate ginkgo leaves fill the space at the fork of the stem (fig. 30). Perhaps a last gasp of Art Nouveau, this jewel-like lamp reveals how well Brandt made the transition from *bijoutier* to *ferronnier*.

The real revelation of the 1912 Salon was a Brandt charger that combines the best of both disciplines. Swirling striations form the center of the platter, while the rim is made of six pairs of starfish that are separated by six handles that appear to spin off from the center (fig. 31). The dynamism of the center mirrors beautifully the radial symmetry of the sea stars. The charger is a complete artistic conception. In a later example, another charger, whose well is filled with a single starfish and seaweed, takes the viewer's eye effortlessly underwater (fig. 32). Brandt's iron planter (in which iron ginkgo leaves were mimicked by natural cascading ivy) was praised at the seventh Salon de la Société des Artistes Décorateurs (fig. 33), while a Szabo chandelier was deemed a war machine *(une machine de guerre)* by the critic Gabriel Mourey.

Edgar Brandt and Emile Robert had presented revelatory work at the Salon of 1912, and they were soon to compete for a very prestigious assignment. In 1910 the consulting committee for civic buildings and national palaces (Comité Consultatif des Bâtiments Civils et des Palais Nationaux) met to consider the refurbishing of the grand staircase for the Pavillon Mollien in the Louvre.[83] A request was made for a beautiful new wrought-iron stairway. Nothing was done until Victor-Auguste Blavette (1850–1933), chief architect for the Louvre and the Tuileries, planned a double stairway that went up two landings, leading to a gallery devoted to seventeenth- and eighteenth-century French painting. The upper story was to be decorated with pilasters, columns, and huge windows that looked out on the Place du Carousel. The consulting committee met for three years

before any real action was taken. Finally sometime in
1913 Blavette approached Robert and Brandt and
asked them to make sketches for the proposed project.
On July 3, 1913, Blavette placed the sketches of both
designers before the bureau members for their exami-
nation and deliberation. After a two-hour meeting, the
committee awarded Brandt his most important com-
mission to date.

Most probably Brandt and Blavette had several
consultations about this important wrought-iron stair
railing. Certain amendments to Brandt's original design
were made in favor of simple foliage and branches that
were more in keeping with the ideas of Blavette.[84]
Although receipts show that on June 25, 1913, a bank
note for 58,000 francs had been put in reserve for the
purposes of realizing the wrought-iron railing, this
figure probably does not represent the actual amount
paid to Brandt. In any case the work on the Mollien,
which was the culmination of a thirty-year renovation
campaign, took eleven months and was unveiled on
June 4, 1914.[85]

The resulting banister and the railing suggest
that the architect and the *ferronnier* were trying to pro-
duce a modern version of a great eighteenth-century
staircase (fig. 34). They eliminated the cold grandiosity
of the older prototypes, creating instead one that is
warm and approachable. The Escalier Mollien is com-
posed of S and C scrolls of iron with classical gilded
acanthus surrounding gilded rosettes. At the foot of the
stairs, the railing is a masterful horizontal S shape of
gilded acanthus leaves. However, its sprays of branches and berries—
among Brandt's favorite motifs—are not of the classical tradition. The
jewel-like branches are the work of a modern iconoclast armed with the
welding torch. Brandt was justifiably proud of this state commission, and
he used an illustration of the Escalier Mollien on his early 1920s advertis-
ing brochure.[86]

The Brussels and the Mollien commissions, among others, were ful-
filled at Brandt's new atelier at 101 Boulevard Murat in the Auteuil section
of Paris. Around 1905 Edgar, aided financially by his brother, Jules,[87] had
purchased the property, which was back-to-back with Brandt's earlier
workshop on the rue Michel-Ange. This area had formerly been the site of
a ceramic factory. At first the new atelier was makeshift but functional. As
of 1912, the workshop operations were primarily rooted in the French
commercial tradition; work was carried out by skilled workers under
Brandt's supervision as principal designer and merchandising impresario

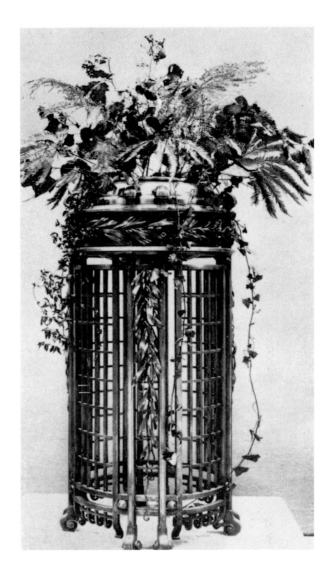

33. Wrought-iron planter,
1912. Exhibited at the Salon
des Artistes Décorateurs,
Paris, April 1912

34. The Escalier Mollien, Musée du Louvre, Paris, completed 1914. Gilded and patinated wrought iron

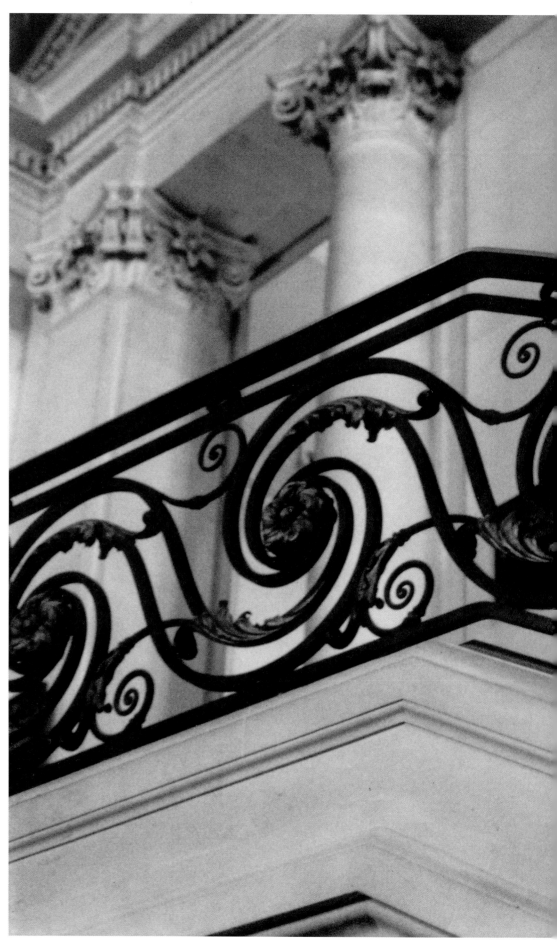

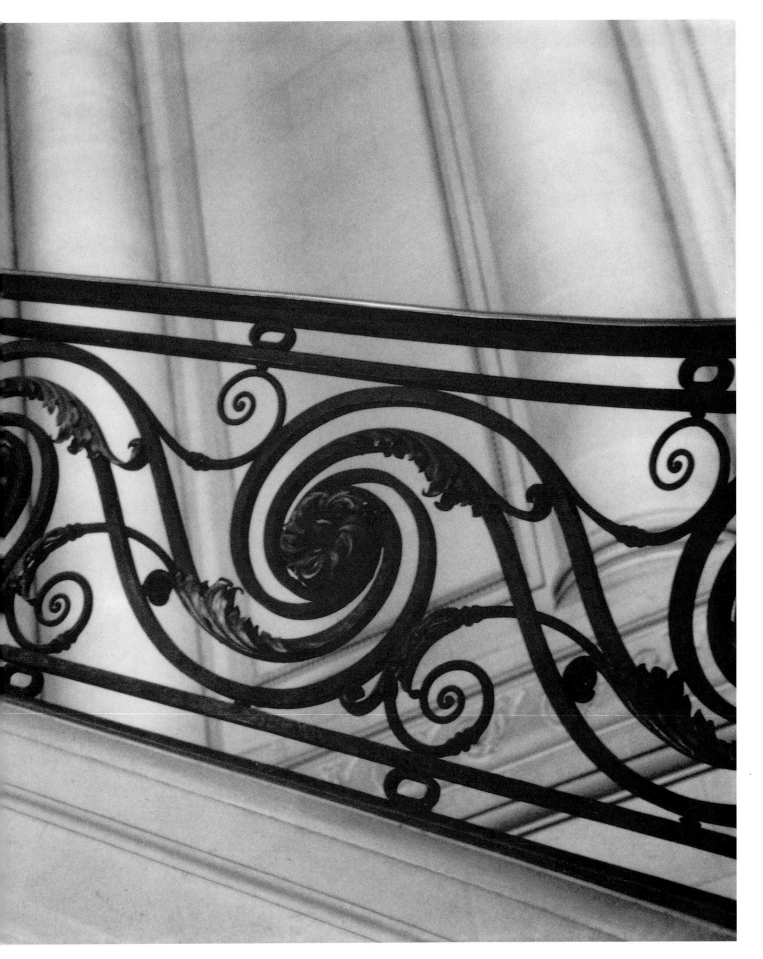

35. Edgar Brandt and his staff in the jewelry department of the Boulevard Murat atelier, c. 1906. Note the leaves (possibly ginkgo) on the wall. Courtesy the Brandt family

(fig. 35). Edgar began the process by envisioning an entire design in his head. He would then draw the work to actual size on a piece of paper. Next he would forge one or two small sections of the design. Interestingly, he used his right hand for drawing and writing and his left hand for the forge. This differentiation, which saved the muscles of the left hand for the ponderous blows of the hammer and the right-handed muscles for drawing, was a natural pattern and not consciously planned, according to François Brandt. When his model was forged into several sections, Brandt would analyze the piece again, either approving it or making changes. In later years Brandt posed for publicity shots that showed him at the forge and anvil. In his immaculate smock he was the antithesis of the typical blacksmith of the time (fig. 36).

Articles stamped "E.Brandt," such as the lamps shown at the Salon of 1912, were luxury items. Like other endeavors of artistic manufacture, these wrought-iron (or metal) fabrications were sought after by well-to-do customers, such as industrialists and bankers.[88] It can be said that Brandt was a couturier of iron, sometimes preparing one-of-a-kind pieces for the offices and homes of the elite.[89]

However, the general notion that only one realization of each design would be produced by artisans in this marketplace is a myth. Paul Fehér (1898–1990), the designer for the *ferronnier* Paul Kiss, has stated that usually twenty examples were made of a new design. Some companies would do only one example of a certain design and twenty of another. Some would produce larger editions or variations of a certain form in order to fulfill the needs of different clients. It is well known that the *ébéniste* Emile-Jacques Ruhlmann issued his work with serial numbers. It is also known that glassmaker François-Emile Décorchemont (1880–1971) reused the molds of basic designs in pâte de verre. Brandt, too, must have been willing

44

to repeat designs, since in the early 1920s he printed a brochure that pictured a sampling of his works. Later on in his career, Brandt issued a catalogue of his designs, which were available upon request. A client might order from a photograph or specify certain changes. Of course, in the case of forged iron, each execution of a given design would be slightly different due to the fact that every hammer blow hits the hot iron differently. In addition, many designs and motifs were, in fact, altered and adapted to a variety of commissions. Every piece emerging from Brandt's atelier was therefore sure to be unique.

In the creation of a new piece Brandt used the power hammer, the hot stamping machine, and other presses. Machine tools were also used in assembling the various parts. For instance, if a piece employed sixteen

36. Edgar Brandt, artist-blacksmith, at the forge, c. 1925

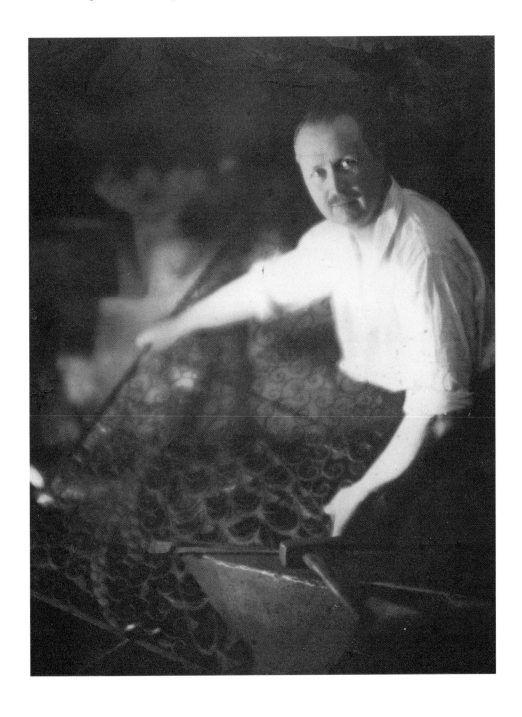

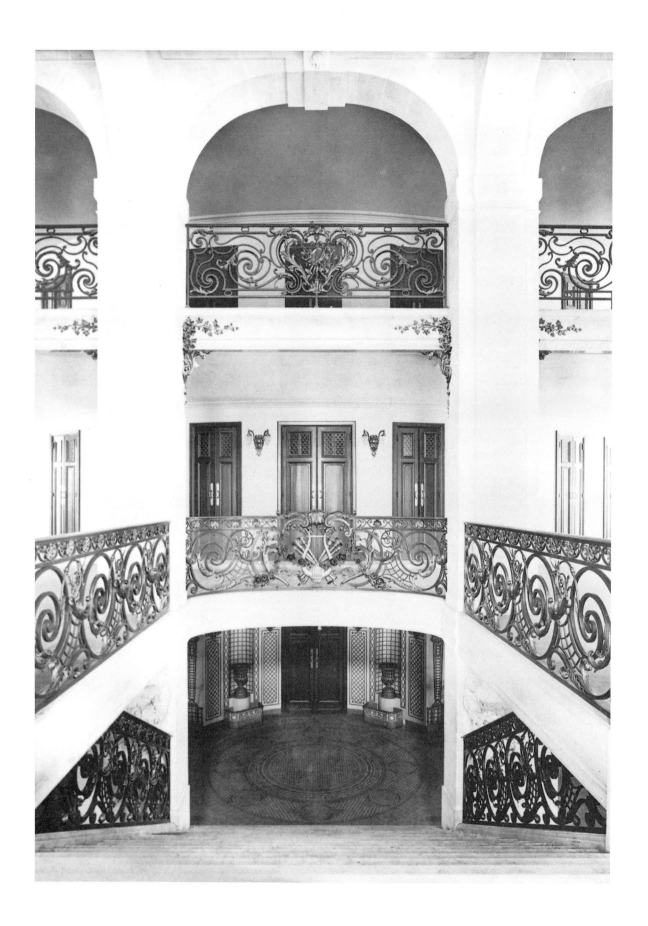

C scrolls, they were made in one area and then sent to the welding shop for attachment. The various motifs were sent to yet another shop for final assembly. Thus, in Brandt's atelier no one man created a gate or a lamp. Brandt saw to it, however, that all of the artisans worked together to invigorate their ancient craft within the fundamental principles of good design and appropriate proportion.

Around 1913, the ironsmith was occupied not only by the Mollien project but by two other important commissions: the ironwork for the Grand Théâtre Municipal in Nancy, which was under the direction of architect Joseph Hornecker, and the communion and choir grilles for the architect Ewald's new church in Paris, the Église Saint-François de Sales.

In 1906 the city of Nancy had lost its theater in a fire. The new Grand Théâtre (Place Stanislas and rue Sainte-Catherine) was begun in 1909 and inaugurated in October 1919. One of many collaborators on this huge project, Brandt fabricated the theater's bronze and wrought-iron balustrade, which featured a repeating cornucopia of delicate leaves and large scrolls (figs. 37, 38, 39). Marble stairs and columns, crystal chandeliers, furniture (by Majorelle and Gautier-Poinsignon), and facade sculptures (by Eugène Vallin and Ernest Bussière) complemented Brandt's ironwork. A 1921 book about the history of the theater states that "the master Brandt personally executed the banisters of the main staircase."[90] Brandt's joint efforts with Hornecker enhanced other projects in Lorraine between 1901 and 1914, including the Hôtel de Ville d'Euville (stair rail; see fig. 19); the houses of Paul Luc (1902–06) and Philippe Houot (1905–07); the Société Nancienne banks in Nancy (1907–08), Reims, and Longwy; La Banque Paul (1911–14) in Nancy; and the Réunis department store in Epinal (later destroyed).

Iron screens were first used in churches as early as the twelfth century to protect reliquaries and yet allow them to be seen. The custom of using iron to create decorative demarcations also helped to produce special spaces of mystery and awe. Thus, Brandt's work for churches was part of a long tradition passed down through the centuries, but Brandt brought to it a fusion of many technical advances and aesthetic developments. The Saint-François de Sales choir grille took a twelfth-century pattern and rendered a slightly more sophisticated version of it, in which a multitude of C scrolls are bound together in pairs. Brandt achieved this effect through collaring, the ancient method of linking two or more bars of iron together with a small piece of iron enclosing the other two as a ring. A painting by Jean Jouvenet in the Louvre shows that many chapels in Notre-Dame de Paris were enclosed with grillework of this sort.[91] The Saint-François communion gate, called *The Bread and the Wine*, was anecdotal in nature, combining vertical sheaves of wheat with scrolls covered by grapes and grape leaves. The design was judiciously rich in detail.

Brandt's influence was increasing. The Escalier Mollien commission had garnered much publicity, and the decorative-arts community as a

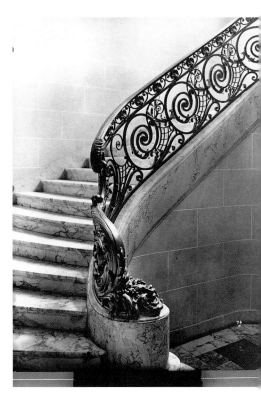

OPPOSITE:
37. Iron stair and balcony railings of the Grand Théâtre Municipal de Nancy, 1909–19. Metalwork by Brandt. Joseph Hornecker, architect

ABOVE:
38. The beginning of the stair railing of the Grand Théâtre Municipal de Nancy

39. The main balustrade of the Grand Théâtre Municipal de Nancy

whole was becoming familiar with his work. He was expanding, collaborating with a number of architects, the Daum Frères glassworks, and the suppliers of marble and alabaster. In the midst of his increasing confidence and growth, war was declared. Suddenly no one had any need for *ferronnerie d'art*.

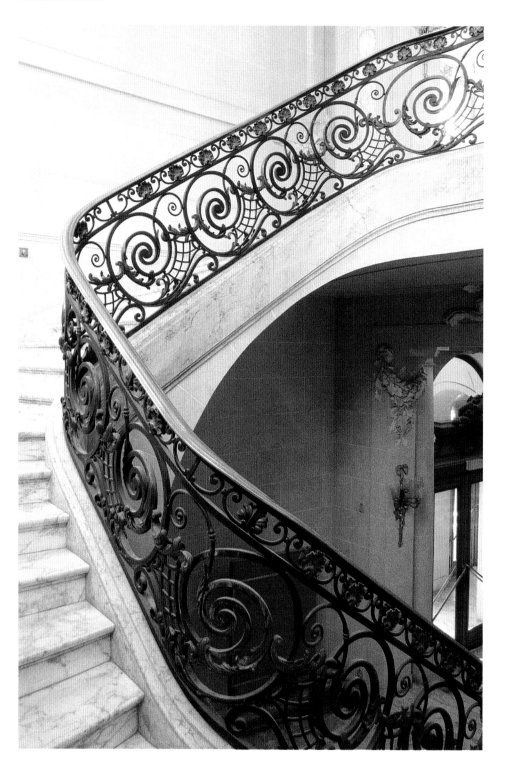

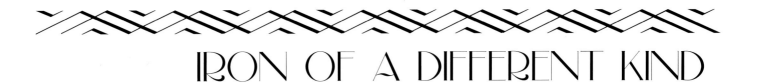

IRON OF A DIFFERENT KIND

When Edgar Brandt began decorating Nancy's Grand Théâtre Municipal he did not know that war would soon send him back to the Nancy area for a different mission. In 1914, Edgar and Jules were mobilized and Edgar was sent, with the 153rd infantry, to Toul, in the prefecture of Meurthe-et-Moselle not far from Nancy. During 1901 Edgar had been a "crack shot" first marksman with his regiment, part of the famous "Division de Fer" of Nancy.[92] This divisional name referred to the unit's location—the rich iron-ore region of Lorraine. In 1914, at age thirty-four, Brandt's role was of an *observateur* in keeping with his age and status.

Brandt did not conform to the model of an average infantryman, and he was soon applying his restless curiosity and ingenuity to the particular problems confronting the soldiers in the trenches. The French were unprepared for the war—and especially in the area of armaments. Brandt realized that, aside from the artillery, the French infantry were in desperate need of a maneuverable lightweight weapon of their own that would have a longer range and greater accuracy than a simple hand-thrown grenade.

Brandt spoke to his superior officers about his ideas, and they—recognizing his capacities—agreed to allow him a chance to put them into practice. From the end of 1914 onward he was back in Paris, occupied with the conception and manufacture of a portable 60mm mortar and its ammunition. Brandt mounted the mortar on a tripod and presented the advantageously lightweight finished product to his commanders.[93] The new mortar, an intermediate weapon—falling in between rifles and heavy artillery—filled a pressing need.

Brandt's mortar employed compressed air to launch low-velocity projectiles that could hit a trench or machine-gun emplacement at a range of four hundred yards with great accuracy. After successful testing on the fields of Maisons-Laffitte, the mortar was adopted by the French army. Part of the work necessary to fill the army's orders was carried out at Jules Brandt's factory at Crosne. Between 1915 and 1918, a large number of women were employed there making shells for the mortar.[94]

A letter from Brandt to his parents affords insight into his war work:

29th March, 1916
My Dear Parents,
 I am sending the first examples of the brochure [a technical army manual concerning a mortar] that I have just printed. It occurred to me that you might enjoy discovering its contents. You are the first therefore to have seen it.
 I tested the new 1916 model cannon yesterday at Issy-

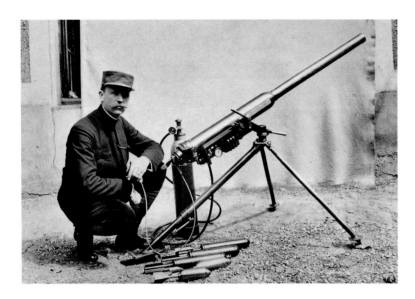

40. Brandt kneeling beside his prototype of the mortar he designed in 1915. Note the various projectiles. Courtesy the Brandt family

les-Moulineaux; the firing range was not long enough to enable me to fire the gun to its maximum range (about 1 kilometer).

Using the new model shells I think I will be able to extend the range to practically 1,200 meters as well as down to 30 meters if I should so wish.

As you see this new weapon is going to present some significant improvements over the old one. One could go so far as to say that they will not even be comparable.

Jules and I are also working together on another 60mm gun for airplanes which should be coming out in a few weeks now. What a shame that we don't yet have enough ammunition for our small guns to be able to use them at the front; they would be useful there.

The big cannon, "the monster" (190mm caliber), is also going to be built; it will be out in a month and a half. It's going to be quite something, as it will fire a shell 150 times more powerful than that of our small cannon at the moment (15 kilograms of explosive). I shall not say anything about the war, nor about what is going on at the moment, but it can never be said often enough here in France that war must be waged with hardware and not with manpower and that sadly we are wasting the lives of more poor devils than needs be just to make up for our lack of materials. Will we never understand that human "material" is our most precious asset?

If we can hang on at Verdun so much the better, but I think it's going to be bloody.

Better news soon. Much love to all.

Your very affectionate

Edgar

That same year, 1916, the newly perfected mortar was used at the Battle of Verdun and in Champagne (figs. 40, 41).

Contrary to previous accounts, Brandt was never seriously hurt in battle, but in January of 1918 he was badly wounded due to a misfiring while demonstrating a new mortar. Making use of his convalescence, he developed pouches for use by dogs (whom he trained) to bring food, sup-

plies, munition, and messages to the soldiers.[95] Brandt also invented a luminous sight for the LEBEL gun, which facilitated night firing by soldiers in the forward trenches. In helping to defend his country, he had discovered yet another side to his mechanical abilities. Before long, Brandt was appointed a technical adviser to the Secretary of Inventions. He would continue to play a role in the field of munitions for the rest of his life.

41. Brandt in uniform with his wife, Renée, and their daughters, Jane and Andrée, rue Michel-Ange, Paris, 1915. Courtesy the Brandt family

In November of 1918, Germany surrendered. Edgar Brandt returned to 101 Boulevard Murat as a reawakening, war-weary public was turning its thoughts back to buildings, offices, homes, and art. He was now able to switch gears and refocus his energy from weaponry and the future of his country to the future of his ironwork business.

Wartime production had changed French industry. The France of 1918 was much more industrialized than the France of 1914.[96] While an inflationary franc caused difficulties for the middle class, the wealthy were once again interested in redoing their apartments and villas. In line with the accelerated commercial expansion generated by the postwar economy, a new aggressiveness was being seen in the business world.[97] In the decorative arts, the importance of designers was being recognized as never before, especially in department stores. The Au Printemps design studio, Primavera, headed by René Guilleré, began the trend before the war. Louis Süe (1875–1968) and André Mare (1887–1932), who founded the Compagnie des Arts Français in 1919, offered a complete decorating service, including the collaboration of ironsmith Richard Desvallières and others. In 1921 the Galeries Lafayette opened their design studio, La Maîtrise, headed by Maurice Dufrène (1876–1955). Beginning in 1923 Paul Follot (1877–1941) directed the Pomone design studio for the Au Bon Marché department store. And there were many more designers available to serve the wealthy clientele.

For his services to the national defense, Brandt had been showered with testimonials.[98] His circle of acquaintances was now greatly expanded. Bankers, ship owners, department-store magnates, textile manufacturers, and civil and religious organizations all sought his expertise. Consequently, his wrought-iron business increased, and he regained the optimism and self-confidence that he had before the war. His business acumen now told him that the time was ripe for expansion. Paris was about to become the decorative-arts capital of the world, and his timing could not have been better.

101 BOULEVARD MURAT

ABOVE:
42. Brandt holding his son,
François, at Boissy-Saint
Léger, near Paris, 1921.
Courtesy the Brandt family

BELOW:
43. The facade of 101
Boulevard Murat, Paris, 1920.
Metalwork by Brandt. Henri
Favier, architect

On August 15, 1919, Renée Brandt gave birth to a son, François (fig. 42).
Now the father of three children, Edgar Brandt entered into one of his most
productive years. Already very busy exhibiting every year in the Salon des
Artistes Décorateurs and the Salon d'Automne, Brandt now also played a
part in the building of many war monuments (some of which will be dis-
cussed in the next section). And it was also in 1919 that Brandt sought out
the services of the architect Henri Favier to create a completely new set of
buildings to house the Brandt company.[99] A commercial building was need-
ed that would accommodate three distinct functions: the proper reception
of clients, as well as production and administrative matters. On the corner
of the Boulevard Murat and the rue Erlanger (today's rue du Général
Delestraint) Favier constructed a magnificent rationalist building reminis-
cent of a Renaissance palazzo. It earned first prize in an architectural con-
test for the city of Paris and is today classified as a historic monument. The
exterior of the building is clad in buff-gray brick, which is imbricated at the
top story and at the roofline (fig. 43). The principal facade, on the
Boulevard Murat, is rendered with imaginative asymmetry that captivates
our attention through its variety of rectangles, stilted arches, mullioned
windows, and iron grilles. This building was designed to serve as a visual
advertisement for *ferronnerie* and perhaps no extant work of Brandt's is a
greater testament to his
artistic sensibilities.

The Boulevard
Murat and rue Erlanger
facades were harmoniously
designed, yet each express-
es, architecturally, its spe-
cific function. On the main
facade, three separate
doorways present a hierar-
chy of entrances. On the
extreme left is the door
that was used for principal
clients and gallery visitors.
To its right is a large door-
way through which vehicu-
lar traffic passed. To the
extreme right is a small
staff entrance, which fea-
tured a scrolled and elon-
gated wrought-iron door

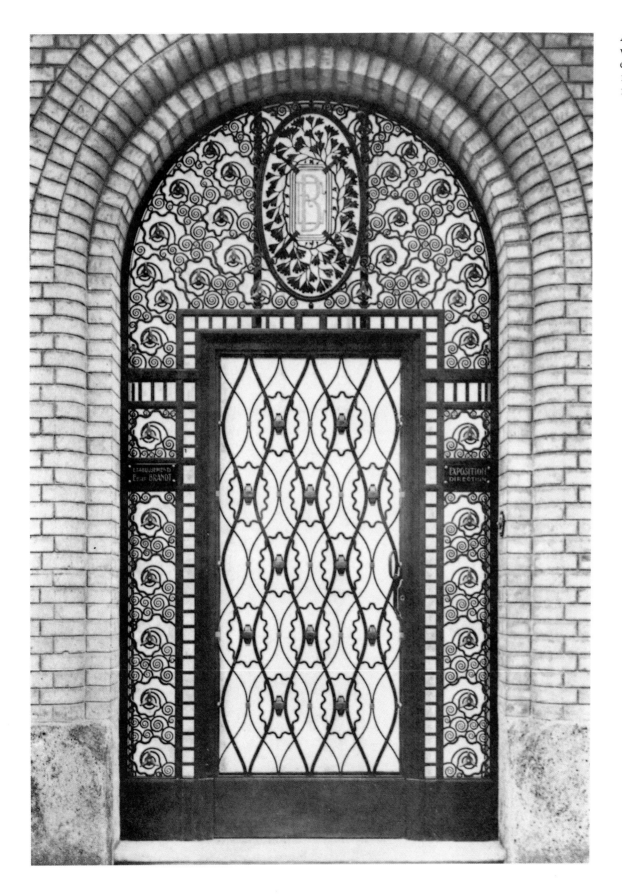

44. The main
wrought-iron and gilt
entrance door to
101 Boulevard Murat,
1921

53

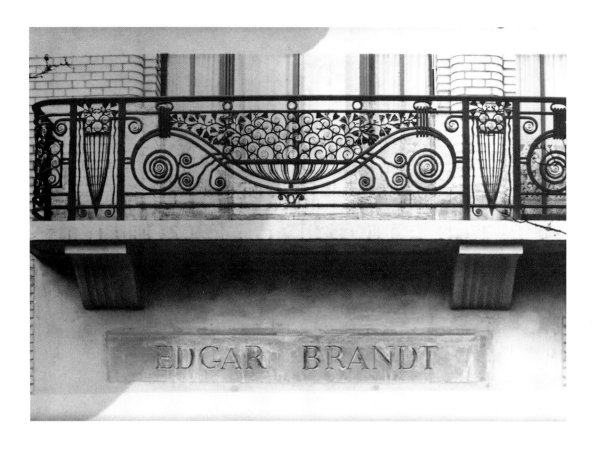

45. The exterior wrought-iron
and gilt balcony railing at 101
Boulevard Murat, 1921

handle. Every morning members of the design studio, the draftsmen, and
the secretaries entered by this door. The blacksmiths entered the workshops
on the rue Michel-Ange nearby.

The main wrought-iron entrance door to 101 Boulevard Murat is a
paradigm of richness and complexity (fig. 44). Its composition features a
tympanum and side panels composed of sections of tightly forged scrolls
whose pattern is broken up by wavy bars. In between these scrolled sec-
tions are raised and gilded tripartite shapes, mechanical representations of a
swarm of hovering bees. Superimposed on the center of the tympanum are
the initials "E. B.," framed by branches of the strikingly elegant ginkgo
plant, now ubiquitous in his work. The straight wrought-iron bars, of
many different lengths and thicknesses, provide patterns of contrasting light
and shadow and a geometric counterpart to the lacelike scrolled tracery.
The central rectangle is rendered with wavy lines that appear to recede and
protrude due to the width of the bars, a perfect foil for the tight scrollwork
on the side panels. Three motifs give this doorway an unusual place in
Brandt's oeuvre: the ginkgo leaves, the scrollwork, and the undulating lines.
This combination of naturalism and abstraction is not often found in his
work. Alluding to both Art Nouveau and the mechanistic elements of mod-
ernism, the design is a benchmark for the new style that would emerge
from Brandt's atelier in the next eight years.

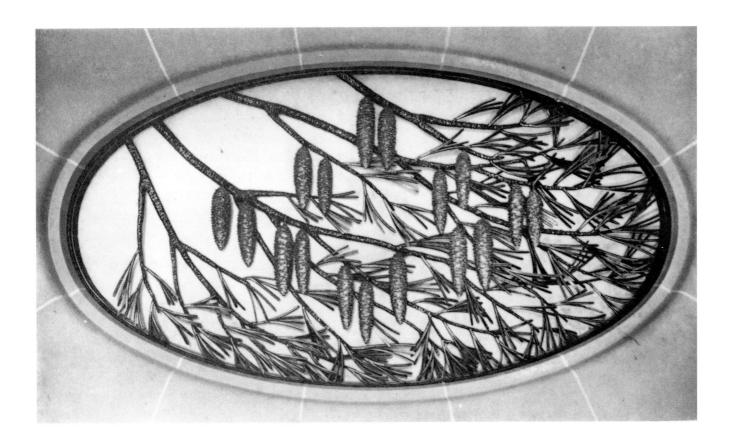

Visitors and clients passing through this principal door found themselves in a small entryway. To the right an iron balustrade led to the second-floor exhibition salon, the director's office, the head ironsmith's quarters, and the design services. A cashier's desk near the salon made it easy for clients to leave deposits for finalized orders.

The truck doorway is cast iron and divided into eight panels. In the center of each panel is an oval design in which sixteen snail formations surround a horizontal bar passing through a bound circle. These distinctive faux-looking handles belied the complex of modern workshops beyond the heavy door. At the end of the interior courtyard were a warehouse complete with a loading zone, the warehouse chief's office, and the center-punch room.[100] At the back of this building were a stairway for the personnel and the freight elevator. In addition, the complex included a garage, a staff kitchen and dining room, a sitting room, and an infirmary. The third floor incorporated a large area used for tracing huge designs onto the iron and an archive of the firm's records.

The exhibition salon on the second floor is marked on the facade by a bay of three arched windows that are fronted by a wrought-iron balcony depicting vases of flowers. The balcony displays the neoclassical vocabulary that dominated the more conservative decorative arts of the era. The pattern of stylized amphora, low bowl-shaped vases, partially gilded C scrolls

46. *Les Pins,* the wrought-iron bull's-eye window in the stair landing at 101 Boulevard Murat, 1921

47. Chandelier (similar
to *Résille,* made for
101 Boulevard Murat), 1921.
Wrought iron and glass,
30 x 26″. Courtesy Christie's
Images

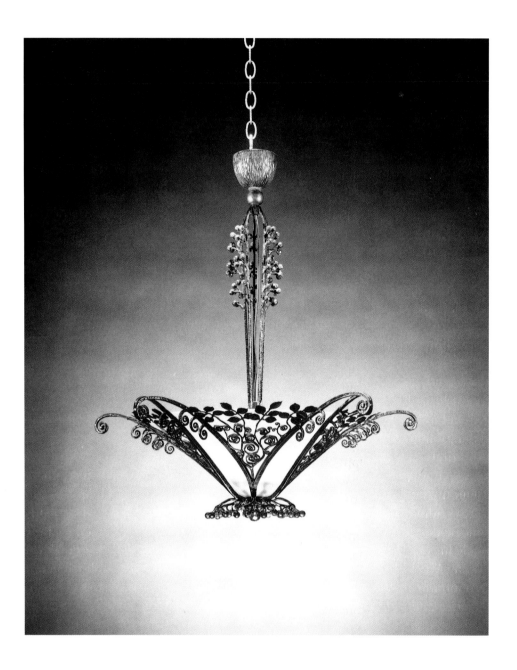

recalling Ionic volutes, as well as flowers and delicate ginkgo leaves with gilded berries is stunning in its simplicity (fig. 45). The stripped classicism is reminiscent of the work of the Viennese designer Josef Hoffmann in his Palais Stoclet (1904–11).

Another striking element of the building is the bull's-eye window on a landing of the main stairway, a poetic yet realistic study in iron of sugar pine cones and needles (fig. 46). Its realization is a feat of iron craft and a testament to the unique capabilities of the autogenous welding torch, while its composition of cropped elements and windblown delicacy appear to be derived from classical Japanese design. Under the influence of Siegfried Bing, the great Japanese art collector and dealer, Japonisme had become a

primary source of inspiration for artists and designers. In fact, it is possible that Brandt saw Bing's 1903 exhibit, "Trois Maîtres Japonais," which featured the work of Ando Hiroshige, Katsushika Hokusai, and Kuniyoshi.[101] Japanese prints were also exhibited at the Musée des Arts Décoratifs from 1909 until the war. Furthermore, we know that Japanese art books were kept in Brandt's design studio. Hiroshige employed the idea of tree branches as seen through the window of a tea house in his 1857 print, *View from Massai of Suijin Shrine*. It is conceivable that Brandt and his colleagues were looking at other works by Hiroshige, such as *Hawk in a Pine Tree*, in which the prickly pine needles zigzag across the picture plane. Brandt's bull's-eye features the elongated cones of the sugar pine, but the print and the ironwork share the intimate feeling of nature fleetingly captured. Brandt knew well the work of René Lalique; he had undoubtedly seen the impressive cast-glass entrance door with a pine-bough motif that Lalique made for his home and atelier at 40 Cours la Reine in 1902.[102] Brandt's bull's-eye was equally successful, capturing the eyes of visitors as they paused on the landing to admire a vitrine full of Brandt's objets d'art. Near the window hung a chandelier of orange Daum glass cradled by iron leaves and scrolls (fig. 47).

Similar naturalistic designs were found in four flower-filled parallelograms, each of which was placed at the center of an octagonal frame forming one of the four contiguous stair railings: clusters of grapes, the pine theme, the ginkgo plant, and olive tree branches (figs. 48, 49). Here again, we encounter a striking mix of realism and abstract geometric forms. The complex and unusual structure of the planar stairway sections appears to be an attempt to try out the Cubist syntax in iron and subtly combine it with a touch of the Empire style. Using a palette of patinated iron and gilded and polished steel, Brandt achieved an exciting assemblage of metals.

This extant stairway offers proof that Brandt was one of the first ironsmiths to exploit the easy blending of metals made possible by the autogenous welding torch. As such, he carried into twentieth-century technology the eighteenth-century practice of gilding wrought iron to achieve a variety of rich tones. Each metal accepted a slightly different patina, thus adding to the palette. The handrail was made of brass, which after years of polishing has taken on a rich yellow-gold tone. The baluster is topped by a finial swirling with a constellation of scrolls that are suggestive of the way the planets revolve around the sun (fig. 50). The design of the baluster is related to the Japanesque curvilinear decoration found in works by such Art Nouveau practitioners as Eugène Gaillard, Louis Majorelle, and Hector Guimard.

The stairway has an air of boldness that must have heightened the excitement of visitors as they made their way to the exhibition salon. On the inside, the three large arched windows were covered with fine lace curtains that echoed the floral scrolls that tumbled out of the vases (fig. 51). These embroidered net curtains were made using the "point-de-Nice" tech-

48. The wrought-iron, brass, and gilt stair railing of the second-floor landing at 101 Boulevard Murat, 1921. Note the *Résille* chandelier and the Chabert-Dupont curtains.

49. Detail of a grape section of the main stair railing at 101 Boulevard Murat

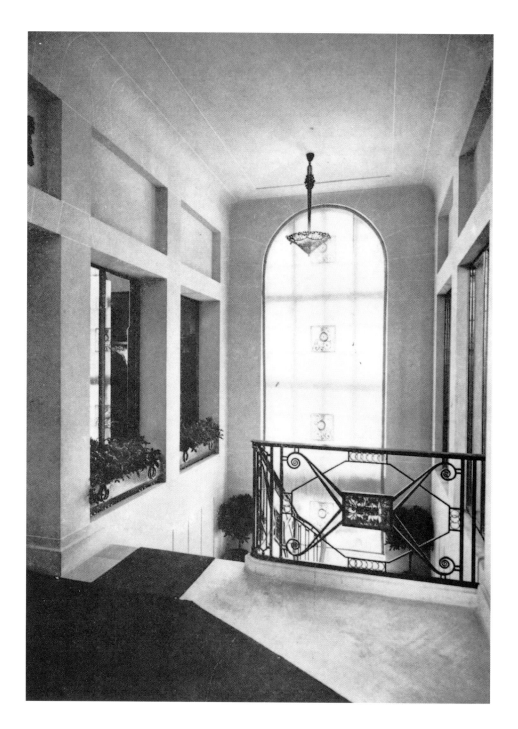

nique developed by Alice Chabert-Dupont in Nice during the protracted years of the war.[103] Orderly and strongly defined, the point-de-Nice lace was able to hold its own with the wrought iron, whereas Alençon or Valencienne lace would have been too fine, too delicate.[104] The idea of transferring the wrought-iron design onto lace was brilliant; the curtains complemented the ensemble of patterns flowing through the room, and yet were open enough to allow the balcony decoration to be seen.

50. The brass newel post of the main stair railing at 101 Boulevard Murat

51. Point-de-Nice lace curtains by Alice Chabert-Dupont in the exhibition salon at 101 Boulevard Murat, 1922

Viewed from the street, Favier's facade was deceptive, much like a flat in a movie set, disguising a large complex of utilitarian buildings behind. The facade and exhibition salon of 101 Boulevard Murat functioned as public presentations of great distinction; the atmosphere of the salon can be seen in figure 52. Beyond, functionality reigned. With the completion of this showcase and atelier, Brandt and Favier set a standard not only for the Brandt firm but for the approbation of *ferronnerie* in general.

At 101 Boulevard Murat, Brandt set up an artistic industrial complex. Between 1919 and 1920, he installed the latest machinery to facilitate an extensive production schedule. Mechanical lathes, drilling and stamping machinery, power hammers (both mechanical and pneumatic), and electrolytic and oxyacetylene welding apparatus helped the ironsmith bring ironwork even further into the light of twentieth-century technology. Power hammers (*marteau-pilons*) facilitated the heavy forging when large bars of iron were worked; the hammers' capacity ranged from hard to soft blows depending upon the amount of force called upon for each specific strike.

With industrialization in mind, Brandt divided the work at the Boulevard Murat atelier into stages. Each subsequent phase went to a different workshop. Brandt had always admired the efficient serial production of the motor-car industry and tried to emulate the system somewhat in his atelier.[105] The first important task was to choose the form of iron to be worked, such as a bar, a sheet, or a rod. Then the iron was heated in the forge. Next, the anvil, the power hammer, the stamping machine, or the mechanical press might be used. Multiples of the same motif were forged and then sent to the welding shop. Around this time (1920) arc welding (electric welding), in which an arc of electricity is struck between an electrode rod and the parts being welded, became feasible. Brandt enthusiastically used this method in the late 1920s and 1930s for joining large parts, such as sections of window frames and doors. Arc welding was extremely fast since there was no longer a need to heat the iron first, as is necessary in oxyacetylene welding. When all the pieces were assembled, they were forge-welded or torch-welded to form a complete object. All the parts that needed riveting would end up in the center-punch room. The punch enabled an exact placement to be indicated for the holes that were drilled by machine. Within this mechanistic setup, there was almost no design that could not be realized.

In the final stage a piece would be highlighted by polishing or darkened where necessary to achieve contrast. The oldest method for smoothing and polishing iron utilized a flat-bottomed tool, the flatter. Striking the flatter against the dull red-hot wrought iron was done quickly. The flatter, which was kept wet or moist, would produce a smooth and even surface, eliminating scale (the oxide coating) and unwanted hammer marks. Another method to bring out the highlights of the forged objects was burnishing, in which lime or a grindstone would be rubbed on the iron object after it was blackened with fire.[106] Brandt also employed electroplating of silver, brass, or gold. He may have electroplated with zinc, nickel, chromium, and cadmium as well. Pieces intended for indoor use would be given a coating of wax; those meant for the outdoors would be varnished. Photographs of the assembling and polishing workrooms give evidence that a great deal of handwork was involved when the pieces came to the finishing stages (figs. 53, 54, 55, 56, 57). They offer rare glimpses into the various stages of working the malleable wrought iron.

52. The exhibition salon at 101 Boulevard Murat, showing *Equilibre*, a pâte-de-verre aquarium and wrought-iron stand, and part of the grille *Floraison*, c. 1923

61

ABOVE LEFT:
53. Workers using the oxy-acetylene torch in the assembling atelier at 101 Boulevard Murat, 1925

ABOVE RIGHT:
54. The patination atelier at 101 Boulevard Murat, 1925. The woman is working on the chandelier *Japona.*

Henri Favier headed Brandt's design staff—his *créateurs*—which included, as of 1925, Favier, Henri Martin, Pierre Lardin, and Gilbert Poillerat.[107] The latter three younger men were graduates of the École Boulle, from which Brandt always recruited the best students. These men concentrated their efforts on the shop drawings, which were then sent to the atelier for execution. Working under the *créateurs* were thirty model makers and fifty draftsmen; the remainder of the men were technicians.

Favier's job included the design and production of exhibition salons and stands, the decoration for wall surfaces, lighting plans, the choosing of colors and materials, and advising on catalogues, publicity, and photographs. In short, he provided the most alluring environment for the presentation of his employer's work. He regularly conferred with Brandt on the state of current commissions and coordinated with Eugène Grisard, the director of commerce, on the financial matters.

Martin, Lardin, Poillerat, and their mentor Favier developed Brandt's previously conceived ironwork designs, turning them into working drawings. Brandt, the master *ferronnier*, as the overseer of hundreds of projects, made certain that his style and methodology were adhered to by his designers and technicians. In a sense, he was like the director of a film who leaves his imprint on every frame. Although the design team brought their own talents and predilections to the work, they adapted themselves to Brandt's vocabulary.

After a design was completed, draftsmen enlarged the renderings and the *ouvriers* made the models full-size in iron. In the case of designing a large work, such as a stairway railing, a different method was used. A long piece of tole (sheet metal) was painted white and then drawn upon by the designer in India ink. This tole then became the full-scale mock-up used by the ironsmith to obtain the necessary shape.

ABOVE LEFT:
55. Five men forging iron volutes in Brandt's atelier, c. 1925

ABOVE RIGHT:
56. An iron stair rail in progress, c. 1925

BELOW:
57. One half of a completed iron door in Brandt's atelier, c. 1924

Many of Brandt's ironsmiths were Hungarians, who trained in Germany after World War I. They came to France in search of a better life and increased earning power. These craftsmen were usually not capable of designing. Some of them were skilled in most of the workshop operations but others, for instance, were specialists at engraving or doing fine repoussé

or sculpting. There was one *fraiseur* (the man who worked the milling machine; one who works the metal cold), and only one *cisailleur* (the man who did cutting and snipping of metals). It made no difference to a competent blacksmith whether he was working on the iron decoration for a building or for a small object such as a lamp. A skilled ironworker could go from adjusting the iron on a folding door to forging the leaf of a rose. Very often, a principal designer would execute a small piece on the anvil or with the welding gun just to clarify his design idea. He might have made some acanthus leaves or a volute but never a complete work.

There was always a great distinction between creators and workers in these workshops. In the 1920s many of the workers or technicians would divide their time between Brandt and his competitors Raymond Subes and Paul Kiss. If one atelier was slow they would move on to the next. At this time there was not much job protection for workers; when things were slow, they were simply told to go on vacation. Most of the time Brandt had about thirty *ouvriers* in the atelier; however, more workers were hired when the projects on hand increased.

Brandt was a tenacious overseer of his establishment. From his office he would speak on the phone to clients and architects. Next he might draft some letters—he was well versed in the legal language for patents, banking, and loans and corresponded on such matters regularly. Working at his desk, he would augment a design that he had begun at home the previous night. An aide would bring him sketches or models in iron. Quickly he would indicate his approval, sketch out a modification, or call attention to a detail. Usually late in the day he would go to the design studio to confer with his staff and check up on the works in progress. The designs of Favier, Lardin, Martin, and Poillerat always reflected the Brandtian motifs so judiciously formulated by the *ferronnier*. From 1920 to 1925, this signature style grew in elegance, sophistication, and quality, becoming the standard of its day. Brandt and his work were considered *hors concours*—beyond excellence, beyond competition.

Eugène Grisard, the director of commerce, was a capable man who was very much appreciated by the other employees, as well as by the Brandt family, to whom he was very close. During an interview in 1925, Edgar Brandt praised his fellow workers:

> I don't hesitate to tell you about my very interesting, very capable and devoted collaborators, such as Henri Favier, for example, not being able to name them all, and my excellent commercial director, Grisard, whose assistance has greatly facilitated everything since the beginning of my business.[108]

Brandt could afford to be magnanimous since his name was well known, and it appeared on almost every item that was made. He was willing to give partial credit, knowing in the end he would retain total recognition.

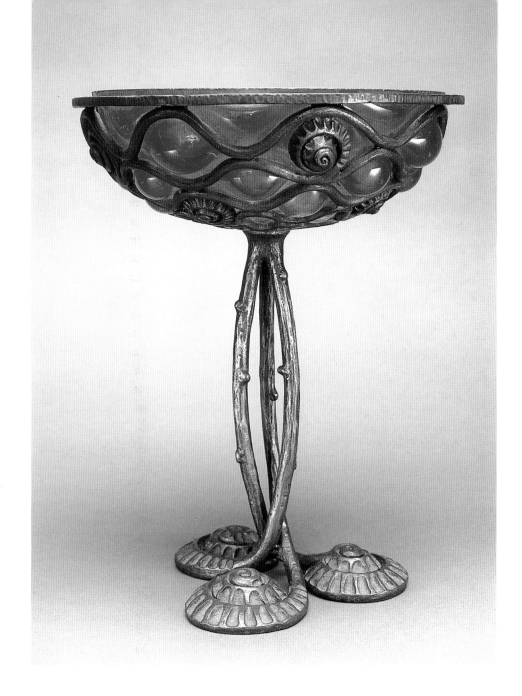

58. *Coupe,* 1919. Wrought iron with Daum glass bowl, 10⅝ x 8½″ diam. Stamped "E.Brandt"; glass inscribed "Daum, Nancy, France" with the croix de Lorraine. Private collection

Apparently Brandt's attitude was not shared by all of his peers. The designer Paul Follot raised a public complaint when the magazine *L'Art et Les Artistes* gave credit for a bedroom ensemble to one of his designers, M. Léon Parvillée. While he approved of the ancient custom of masters being expected to have assistants for large and complex works, he did not feel that it should be at the expense of failing to credit that master for the original plan and conception of the work.[109]

In a similar incident Paul Fehér, the chief designer for the Hungarian *ferronnier* Paul Kiss from 1923 to 1929, overheard an interview between Kiss and a reporter for *Le Figaro*. Kiss asked that Fehér's name not be mentioned in the newspaper, as he would get too much credit. Fehér immediately left Kiss's employ. Brandt's ability to praise his employees undoubtedly helped to foster camaraderie and high-quality work.

Since Kiss was an important competitor of Brandt's, his smaller atelier affords an interesting comparison. Kiss himself had been trained in Transylvania (then part of Hungary) in a horse-shoeing shop that also made small ornamental pieces. He could forge anything with great competence but was less skilled than Brandt as a designer. His distinctive style was marked by heavily hammered bars of iron. His shop, at 2 rue Léon Delhomme, included an exhibition room, which also housed the receptionist and the bookkeeper, and work area of roughly 750 square meters that had four forges and several different anvils. In the 1920s approximately twenty-five ironworkers were employed there. Aside from Fehér, the most important worker was the *contremaître*, who would be in charge of framing out a grille or a gate. He can be likened to a carpenter in iron; however, he did no forge work. In essence, he acted as foreman of the shop.

According to Fehér, Kiss made sample pieces to show his smiths the technical method for fabricating various designs. The pieces were then cut and passed on for heating, shaping, forge welding, or torch welding. A *ciseleur* would cut out metal forms to be hammered on a *bigorne* (beak iron)[110] or to be used for repoussé work. While Kiss did use torch welding for assembling pieces, he did not use the power hammer. He felt that it was too dangerous, and he never changed his mind. Kiss employed three finishers—two men and one woman. Brandt also employed women, particularly for polishing (see fig. 54). A finisher's job entailed brushing off the iron scale and then buffing the iron with emery cloths of varied softness. The buffing served to highlight the raised areas of the surface, making them contrast with the more indented darker areas. Linseed oil would often be applied to or burned into the iron to prevent rusting.

At the Kiss shop, black shoe polish was often used for the patina. After the diluted polish dried, a very fine emery cloth would be used to rub it into the metal and at the same time wipe off the excess. This method produced a surface that looked oxidized. In addition, gold and silver leaf were used to gild iron objects. Similar patination processes were used at 101 Boulevard Murat.

The essential difference between Kiss and Brandt involved their policies on the signing of their work. Kiss only signed pieces that were going to be shown in exhibitions or exported to foreign countries. He would not sign other works unless a client asked him to, feeling—as many *ferronniers* did—that his individual style was a signature in itself. Brandt, on the other hand, wanted every piece to be stamped, usually "E.Brandt" or "E.Brandt/France," as protection against smaller ironwork shops copying his designs. In the early years of his career, Brandt's stamp had a slightly curved quality *à la* Art Nouveau. Recently an umbrella stand was seen with this mark, but such items are not often found. Several small paperweights have turned up that are stamped "Edgar Brandt." Gifts, such as mistletoe paperweights given to friends, were occasionally marked with the *ferronnier*'s full name.

Another difference between Brandt and Kiss involves the cost of their goods. Under normal economic conditions Brandt had no set pricing policy; however, François Brandt recalls that a unique piece would have been priced at a higher ratio than multiples. Kiss operated differently, with a pricing policy of one hundred percent over cost.

Sometime between 1918 and 1919, Brandt stamped one of his most sophisticated designs. In conjunction with the Daum brothers, glassmakers from Nancy, Brandt designed a wrought-iron *coupe* in two parts: a bowl and a stand. After completion of the ironwork, the bowl frame was unscrewed from the stand and sent to the glassworks in Nancy, where butterscotch-colored glass was blown into it; one can turn the piece upside-down and it remains intact, the glass caught within the iron frame. The result was an original piece of great visual interest (fig. 58). The stand consists of three branches of iron. Thorns running along the branches are asymmetrically placed, rendering each branch unique. Twisted at the bottom, the branches form snail-shell feet, reiterating the snail motif on the frame of the bowl, where they are coiled in the opposite direction. The glass that was blown into the undulating frame forms permanent bubbles. Together the snails, waves, and glass bubbles are evocative of the foamy sea.

The marine motifs so beautifully developed in the *coupe* reflect a long lineage of seashell motifs in the decorative arts since the Renaissance. These themes, *rocailles* and *coquillages*, were identified with the Rococo period, especially the reign of Louis XV.[111] The artists Mathurin Meheut and M. P. Verneuil did many drawings of seashells and underwater plant life, some of which appeared in *Art et Décoration* in 1910.[112] Brandt's spiral shell shapes and starfish-adorned chargers owe much to the scalloped-shell ornament of the past, as well as the return-to-nature movement that took place during the early years of his career. The *coupe* was shown to the public at the 1919 Salon des Artistes Décorateurs, alongside several chiseled bronze letter openers, one of which also featured the snail-shell motif (fig. 59).[113] In the early 1920s Brandt also forged torchères, chandeliers, and lamps along the marine theme. In a graceful table lamp, seaweed forms a lacy umbrella above the bell-shaped glass shades (fig. 60). *Les Algues*, a seaweed-decorated torchère, is one of Brandt's most successful designs (fig. 61). In the banister for the headquarters of the shipping company Chargeurs Réunis, Brandt surrounded seahorses with seaweed and swooping C scrolls simulating a snail's body (fig. 62), and starfish and dolphins were forged for the front door. For the Bordeaux home of industrialist Henri Frugès, Brandt forged a stair rail with seaweed flowing out of the grasping tentacles of an octopus. Just like a seaweed-decorated barometer (fig. 63), many successful commissions in the early days of 101 Boulevard Murat predicted fair weather ahead for Edgar Brandt.

When Brandt opened his new atelier in 1920, it included a beautiful exhibition salon for his wares. One wall held a three-sided vitrine with three shelves. The top shelf was reserved for the *coupe*. The tripod base of

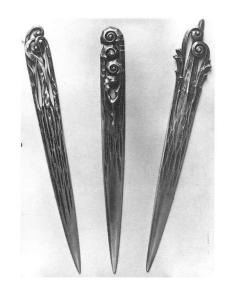

59. Letter openers, 1919. Bronze, length approx. 9½–10½″

BELOW:
60. Seaweed umbrella lamp,
c. 1920–21. Wrought iron with Daum
glass shades, height 25½". Stamped
"E.Brandt"; glass inscribed "Daum
Nancy". This lamp was also made
with a faux-porphyry base. Courtesy
Christie's Images

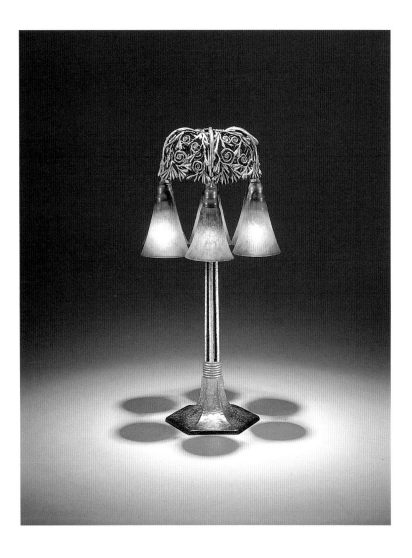

RIGHT:
61. *Les Algues*. Torchère, 1922.
Silvered wrought iron with Daum
glass shade. Stamped "E.Brandt Made
in France"; glass inscribed "Daum
Nancy". Courtesy Christie's Images

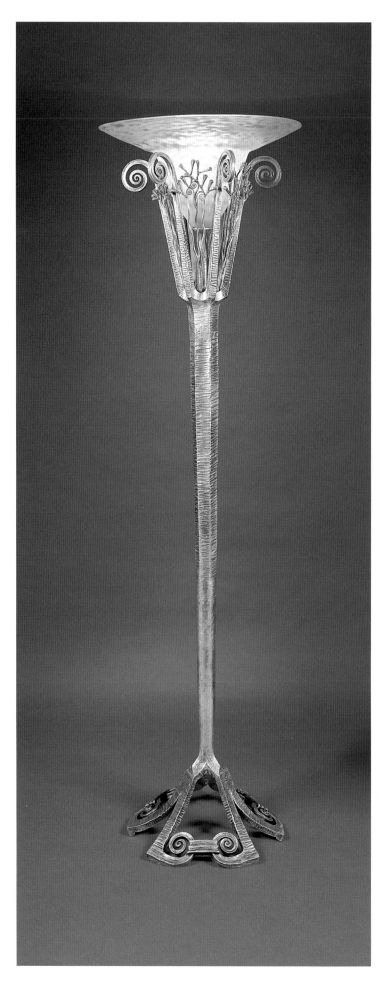

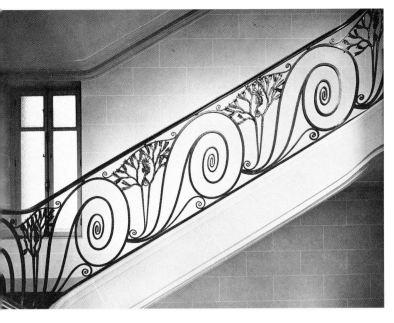

62. The wrought-iron stair railing of the shipping company Chargeurs Réunis, Paris, c. 1921

63. Wrought-iron barometer with seaweed decoration, c. 1921

64. Table lamp, 1922. Wrought iron with amber alabaster shade, height 15″. Note raised snail shells at the base. Courtesy Christie's Images

65. Table lamp, c. 1921.
Wrought iron and glass,
height 13¾″. Note flat snail
shells at the base.

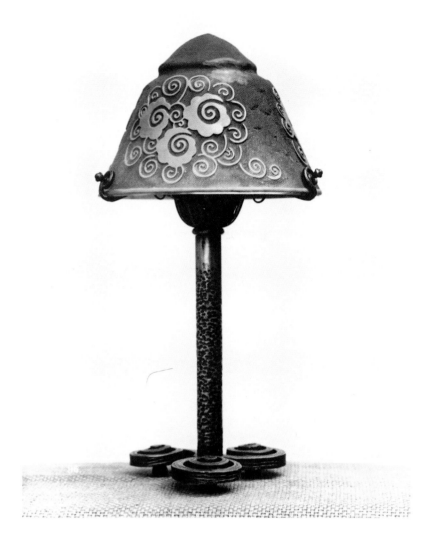

the *coupe* became a preferred form for Brandt and was used repeatedly for lamp bases between 1919 and 1925 (figs. 64, 65). The lamp *Les Algues* sold for $80 in 1925, and most table lamps of this type ranged in price from $80 to $140, which was considered expensive at the time.

At the time that Brandt set up his new headquarters, there were at least twenty established competitors in Paris. They included: E. Borderel and E. Robert (rue Damremont); Fred Perret (rue de la Réunion); Bouy & Co. (Hôtel Diane de Poitiers); Bataillard (rue Desrenaudes); Schwartz, Haumont & Bergeotte (rue du Hameau); Adalbert Szabo (rue Emile-Dubois); Edouard Schenck (rue Vergeneaud); and Sabino (rue de Sevigné). Within three years, seventy-eight decorative iron companies would be working in Paris. Postwar reconstruction and the growing upper class provided enough work for ironsmiths in every category. The 1923 commercial telephone book listed Brandt's business in the largest typeface among all the advertisers.

After World War I hundreds of sculpture monuments were placed all over France to honor the nation's fallen soldiers. Brandt's contributions to such projects were important to him personally and professionally. One existing monument, that glorifying edifice of the French Republic, the Arc de Triomphe, became the site of an additional memorial, transforming it into a symbol of the great suffering caused by the war.

In 1920, André Maginot (1877–1932), who had been seriously wounded at Verdun and held the post of minister of colonies, pensions, and war, proposed that the French create a monument to an unknown soldier—one that would represent all the unrecognized who had died for their country.[114] He called for the exhumation of one unmarked coffin from each of eight battle sites: Verdun, Champagne, Lorraine, Chemin-des-Dames, Île-de-France, the Somme, Artois, and Flanders. Then Maginot picked one soldier, survivor Auguste Thin, out of the honor guard accompanying the coffins and instructed him: "Soldier, here is a bouquet of flowers cut from the battlefield of Verdun. Lay it down on one of the coffins and that one will become the unknown soldier."[115] On November 10, 1920, under cover of darkness, the solitary coffin was interred and covered by a granite slab under the Arc de Triomphe.

As there was no ornamented marker for the tomb, its significance might have been forgotten had not journalist/poet Gabriel Boissy (1879–1949) proposed, in an article in *L'Intransigeant* on January 21, 1921, his idea for an eternal flame to be placed at the head of the tomb. The suggestion was well received. Brandt was commissioned to design the metalwork for the flaming circle at the head of the tomb and the surrounding bronze. On November 11, 1923—three years after its conception—the monument was dedicated.

Since Brandt and Maginot had known each other during the war and were friends, it is not surprising that the *ferronnier* was put in charge of the monument along with Henri Favier, the architect who planned the space. The resulting work is reflective and dignified. The stone slabs shielding the coffin are covered by a square bronze plaque, upon which is a raised circle of bronze covered with laurel leaves and berries, on top of which radiate twenty-four swords. From the circle's center the sacred flame poignantly emanates from a sawed-off cannon head. A scalloped band of bronze that surrounds the circle is reiterated by the radiating grooves on the square plate. This running band is a Brandt signature. An inscription below the plaque reads: "*Ici repose un soldat français mort pour la Patrie* [Here lies a French soldier who died for his country], 1914–1918" (fig. 66). The entire ensemble presents a powerful symbolic message and is quite

66. The Eternal Flame burning
at the Tomb of the Unknown
Soldier, Arc de Triomphe,
Paris, completed 1923.
Metalwork by Brandt. Henri
Favier, architect

moving, particularly on Armistice Day when the spot is covered with flowers, and veterans, dignitaries, and other visitors come to pay their respects.

For Edgar Brandt, every November 11 revived the memory of a painful loss, the death of a close childhood friend in the war. In fact, he told his son, François, that for him the Unknown Soldier *was* his lost friend. The need to honor the memory of his friend was Brandt's major impetus for the monument. According to his wife, Renée Brandt, Edgar spent many hours under the arch trying to devise a method for fueling the flame. Originally alcohol was used but later he switched to propane gas. At the opening ceremonies Maginot himself lit the flame. Brandt's implementation of the torch gave the French an eternal, passionate, palpable reminder of all those who made the ultimate sacrifice for freedom. Dignitaries and official visitors, who pay their respects at the tomb, sign the *livre d'or*, for which Brandt forged an iron cover.

In 1914 Verdun (Meuse), along with Toul, was the most powerful French fortress, and it became the site of a fierce and terrible battle to which it gave its name. The story of Verdun's Bayonet Trench Monument began on June 11, 1916, and ended two days later when some of the French 137th Infantry were buried alive in their trench after it caved in from German bombardment. At the close of the battle all that was visible

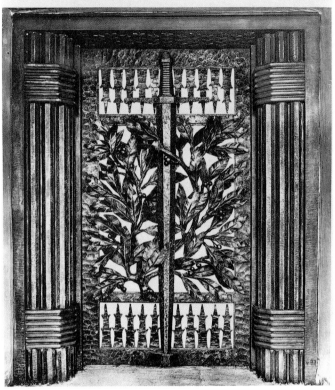

67. The entry side of the Bayonet Trench Monument, Plateau of Thiaumont, Verdun, 1920–21. Wrought-iron and bronze door by Brandt. André Ventre, architect

were the rifles' bayonets sticking straight up out of the earth on the plains of Thiaumont. Three years later George F. Rand, an American banker from Buffalo, was deeply moved by a visit to the battlefield. He offered the French a half-million francs to ensure that the site, northwest of Douaumont on the plateau of Thiaumont, be protected for future generations to pay homage to the 300,000 soldiers who had died there for France. Plans for a monument were drawn up by André Ventre, chief government architect for French historical monuments, and he chose Edgar Brandt to execute his design for the monument's imposing principal door.[116] Brandt's entry door features a laurel tree bordered above and below by deeply hammered bayonets. A long medieval two-edged broad-sword pointing downward bisects the door. Heavy vertical side panels add a strengthening balance to the lighter but mournful branches and reiterate the vertical line

of the sword (fig. 67). Surrounded by Ventre's mausoleum-like building in austere reinforced concrete, this imposing portal poignantly alludes to the terrible battle while it protects and pays homage to the memory of the brave men who died there.

For this door Brandt used *fonte malléable,* a type of cast bronze that could be welded, cut, or pierced. It was strong but it could also be worked, allowing Brandt to produce a door that looked completely handwrought but was not. The story goes that only one small sprig of the laurel branch was wrought and the rest done in *fonte malléable* because, at 5 francs a piece, it was half the price of wrought iron. When polished, it accepted a patina that made it look very much like wrought iron. Brandt was in the forefront of using this new casting technique, which originated in the railroad and automobile industries, and paradoxically in armaments manufacturing.

The epilogue to the Bayonet Trench story is ironic. The day after Rand pledged his money to the French, he left by airplane for London. The plane crashed and Rand was killed instantly. However, when Rand's children learned of his wishes they saw to it that the monument was erected, and they attended the opening ceremonies on December 8, 1920.[117]

Almost seven years later yet another war memorial to which Edgar Brandt had contributed was dedicated. This story began on November 11, 1918, in the forest of Compiègne (Oise) where Marshal Foch and the Germans had signed a cease-fire treaty. Some time later, a public subscription for a Compiègne monument was set up in the Paris newspaper *Le Matin.* Money was raised and on November 11, 1922, the edifice, called the Monument des Alsaciens-Lorrains, was planned for a site named La Clairière de Rethondes (The Clearing in the Glade) at Compiègne.[118] The designated architect, M. Mages, chose the spot: the site of the railroad car in which the treaty had been signed. At the same time, however, *Le Matin*'s front page stated that the paper itself would offer the monument as its gift to France. Gray Alsatian stone was used for the tall rectangular frame enclosing Brandt's wrought-iron grille, which features a medieval broadsword whose cruciform handle evokes the cult of the holy warrior and the virtue and rightness of his cause.[119] The double-edged sword, surrounded on either side by laurel branches, appears to pierce the body of a bronze eagle, symbol of the German nation, fallen over and conquered (fig. 68). The inscription reads: "Here, on 11 November 1918, succumbed the criminal pride of the German Empire, vanquished by the free peoples it sought to enslave."[120]

In reality it was Brandt's plan to finance the front-page coverage and the monument, excluding the stone and the construction costs, which he persuaded the stone merchant to cover. In addition to his technical contributions during the conflict, Brandt's modest generosity was prompted by a desire to give something more to his country. He did not forget that he had profited financially out of the war effort.

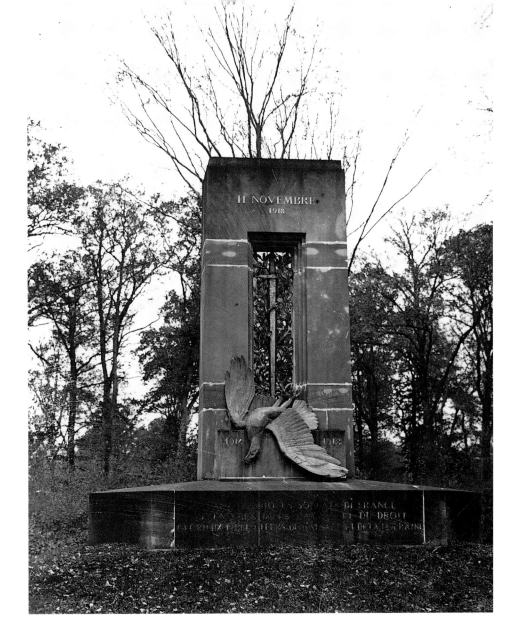

68. The bronze, iron, and stone Monument des Alsaciens-Lorrains at Rethondes, near Compiègne, planned and executed by Brandt. Inaugurated November 11, 1927

A ceremony attended by President Millerand and Prime Minister Raymond Poincaré was held in 1922 to celebrate the parklike site. The completed monument was inaugurated on November 11, 1927, in the presence of Marshal Foch and General Weygand, both of whom had been present in the railroad car when the armistice with the Germans was signed in 1918.[121]

Brandt had earned recognition for his inventions for the defense of his country and for the wounds he sustained during the war. He was duly honored when he was named chevalier of the Legion of Honor on February 14, 1921.

Just as the public was noticing the revival of iron forging, World War I began. The same iron that decorated the emerging modern house went into torpedoes, machine guns, and mortars. When the trench fire and field battles were over, that iron went into war memorials. In spite of this horrendous juxtaposition, the work of the modern forge was slowly turning into an evolutionary art form.

PROGRESS COMES WITH PEACE: FORGING ART IN THE EARLY 1920S

Each year the critics actively assessed the artist-decorators of the moment. In 1920 one critic accused modern decorators of continuing to mourn after the war.[122] Louis Vaucelles, writing in *L'Amour de L'Art* in 1921, was very critical of the excessive decoration used by the School of Nancy—Louis Majorelle, Emile Gallé, and Victor Prouvé: "the school of William Morris has been forgotten; we want a less tormented art." He felt that decorative artists should revolt against Romanticism and Impressionism and veer toward a sensible form of classicism. "Fantasy, caprice, and freedom are eternal but the need is for a sensible beauty that is invincibly aligned with our nature."[123] In contrast, the more disciplined German work was admired.

As in all periods of the fine and applied arts, the dissention among some critics was balanced by moments of mutual accord. The same can be said for the artists themselves. Around 1921–22, a new spirit of cooperation was emerging in the decorative arts. French artists and manufacturers resolved to follow the example the Germans had set before World War I in the Deutscher Werkbund, founded in Munich in 1907 as an alliance of artists, manufacturers, and designers. The Werkbund promoted clean design with a decidedly industrial point of view.[124] In 1921 the French held a meeting of the trade unions of the various artistic branches and the manufacturers. The war had taken a toll in both manpower and economics; now all participants gathered to develop a new direction.

The artists and the manufacturers felt that it was their duty to ameliorate all areas and schools of French decorative art and to continue traditional values, while at the same time promoting a new direction for French taste and originality. In order to combat foreign competition, they felt it was necessary to renovate form and style. In order to preserve the French reputation as the leader of "good taste," it was necessary to force modernism to blossom.[125] At the meeting it was decided that the only way to accomplish this was to ultimately display French wares side by side with those of other countries in a large exhibition. If the fair was to succeed, artists and manufacturers would have to join together with trust and ambition. The artists would create innovative schemes if the industrialists would give their financial resources and economic expertise in order to realize the new creations.

Meetings were held at the Pavillon Marsan with the unions of the furniture trades and the bronze workers. Basic policies were written up for cooperation between the artists and the industrialists. The meeting of March 1922 augmented the number of professional trade unions. Nine cat-

egorical sections of artistic endeavor were set up: 1) architecture; 2) wood; 3) metal; 4) ceramics; 5) fabric; 6) paper arts and flat decoration; 7) precious arts (jewelry, silver, toys, fancy goods, morocco leather goods, inlay work); 8) books and bindings; 9) theater, cinema, public displays, couture, and fashion. The members of each union established guidelines for participation in exhibitions; for sales, patents, and advertising; and for educational reforms in schools. The conference adopted fundamental principles about the production of new models, their prices, their dispersal, the treatment of special models, and the rules of serial production. The conferees, joined together in defense of the moral and material interests of French artists, sculptors, designers, and artisans, wanted to prove that they were committed to effecting an artistic renaissance.

Edgar Brandt, in his February 10, 1922, speech to graduates of the École Vierzon, had urged such cooperation and renewal. He pointed out that the Germans were again succeeding in heavy industry but were also trying to do well in the artistic industries. Once again the German artists were in the news; their upcoming August 1922 decorative-arts show would comprise ceramics, glass, leather work, and religious tapestries.[126] In his speech Brandt cited the German exhibition's objectives. The major goal was to show that architects, clients, workers, manufacturers, and artists must work together to provide mass-produced objects of beauty and quality. Brandt, who had reviewed their exhibition manifesto, told his audience: "This document is clear, it shows us the importance Germany places on industrial art and how necessary it is to call France into action." He then went on to remind the audience that a Paris exhibition of decorative arts and modern industries was planned for 1924. Furthermore he said that "it is indeed a true battle and if we are beaten the consequences of the disaster will be of great importance to our country. . . . This [French] superiority must not only manifest itself in appearance and surface, but must especially reside in artistic and technical qualities, in the conception as well as the actual manufacture."[127] In his own experience as an artisan and businessman, Brandt proved that he was on top of the two major tasks of decorative artists. He would continue working to align art with industry and, at the same time, help to create *le style moderne* that was to aid France in retaining her world-renowned reputation in the arts.

In the early 1920s Edgar Brandt's ironwork answered a multiplicity of needs: iron light fixtures continued to be popular, radiator covers gained importance with improved indoor heating, and special projects such as war memorials and ship decoration were individually challenging.

The door of the Bayonet Trench Monument was impressively displayed at the entrance to the twelfth Salon des Artistes Décorateurs in 1921. Visitors stood transfixed before the work, which was described as giving an impression of boldness and virility tempered by simplicity.[128] Critic Guillaume Janneau was overcome by the door: "Rarely has a decorative composition evoked such powerful emotion, an impression of religious austerity, an idea for eternity."[129]

69. Grape chandelier, c. 1920.
Wrought iron and glass, 36″
diam. Stamped "E.Brandt"

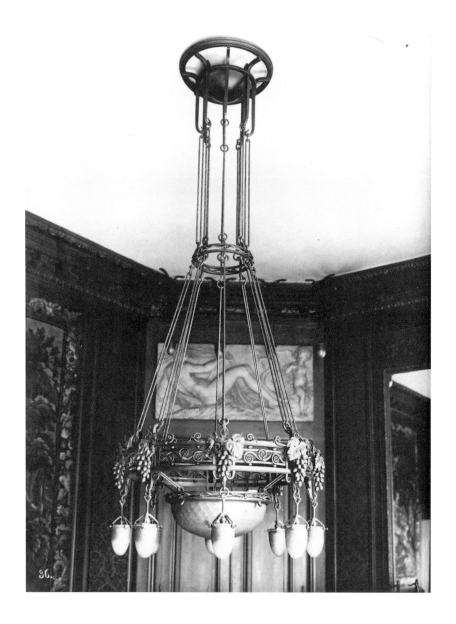

Brandt also showed a very inventive lighting collection: sconces, chandeliers, and portable lamps that he had been working on for two years. *Ferronniers* were the first to craft fixtures to accommodate the new electric light,[130] eagerly designing pieces for homes, offices, and shops. After the war, Brandt became fond of employing a crown shape for chandeliers. One early example—extremely large in diameter—was heavily laden with grape clusters and leaves (fig. 69). In another example from 1920 a simple band shape contained the wire-work outlines of storks flying between spirals of clouds (fig. 70). Long rods suspended from the ceiling held the crown, which was backed with an orange-yellow fabric and edged with beaded fringe. This detail became very popular after Sergey Diaghilev's Ballets Russes performed *Shéhérazade,* the ballet with exotic Eastern decor by Léon Bakst.[131] According to the scholar Henry René D'Allemagne, the precedent for crown-shaped chandeliers goes back to a sixth-century votive lamp made for the oratory of St. Hilaire.[132] The earliest circular candle holders were used in catacombs, and later these vestigial circles gave way to

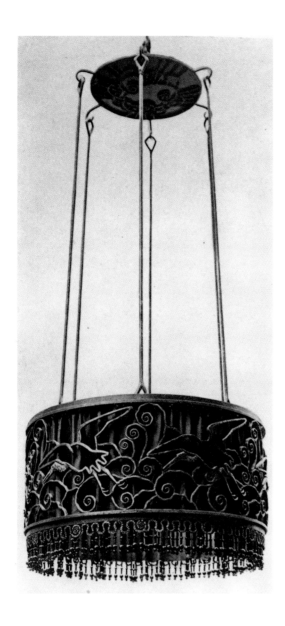

70. Crown-shaped chandelier, 1920. Wrought iron; shade originally backed by yellow-orange fabric

larger gilt-bronze examples that kept pace with the expanding size of churches. Brandt's tambour-shaped chandelier calls to mind the crown of King Recceswinth, a celebrated seventh-century example of goldsmithery that the ironsmith could have seen in the Musée Cluny.[133] In 1910 one observer had criticized this ancient shape, feeling that only a truly new and rational style would keep the public from searching for Louis XIV or Gothic models.[134] Nevertheless, the Boulevard Murat crown chandelier shows off new wirelike motifs, light and airy in appearance, an effect that became almost a signature in itself.

Thanks to the technical range of his atelier, Brandt's chandeliers combine many diverse pieces of iron—scrolls, rods, bars, fine sprigs of ginkgo, and wavy flat coils that represent roses. The final products are graceful and harmonious. At the beginning of his career Brandt forged standing lamps with ratchets for gas or kerosene; however, by 1921 electric torchères were a major item for the Brandt firm. Numerous models were made in the 1920s such as *Vieux Style, Simplicité, Les Crosses, Les*

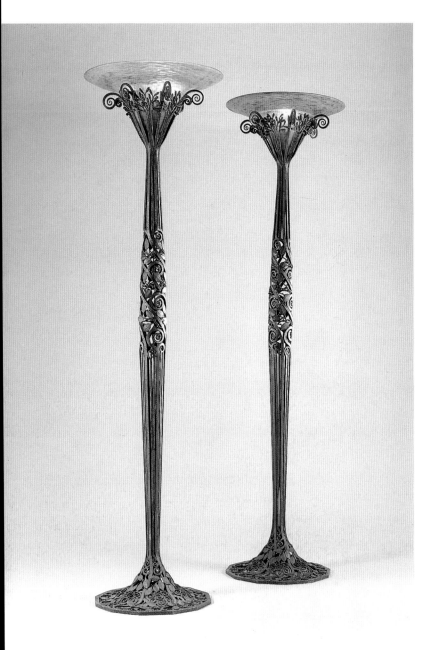

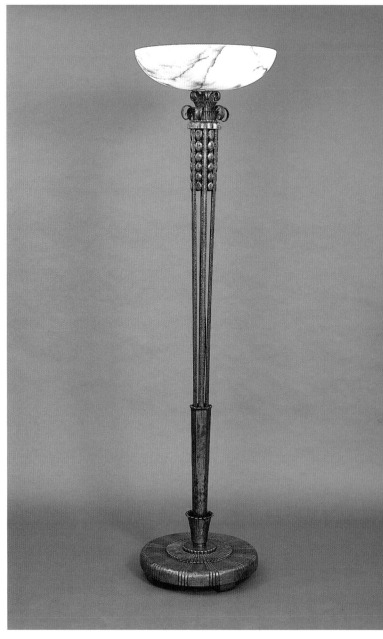

ABOVE LEFT:
71. *Les Roses*. Torchères,
c. 1922. Wrought iron and
Daum glass; height 5'7¼",
shades 17¾" and 18¾" diam.
Stamped "E.Brandt France";
glass inscribed "Daum Nancy
France" with the croix de
Lorraine. Courtesy Sotheby's,
Inc.

ABOVE RIGHT:
72. *Les Crosses*. Torchère,
1924. Wrought iron and
alabaster, 64" (71" with shade)
x 16" diam. of base. Private
collection

Graines, L'Orient, Les Roses, Les Algues, and *Le Lys* (figs. 71, 72, 73). The bases were circular and flat, or made with four pedestal feet or six turned under flat scrolls, as in *L'Elégance* of 1925 (fig. 74). The vertical rods were single or double bars, or rounded with openwork in the middle or at the top. The shades of blown glass, alabaster, or pâte de verre either were held by four iron clips or rested in elaborate forged frames or simple sockets. At the 1920 Salon d'Automne the standing lamps were very plain and austere and featured faux-porphyry bases, no doubt copying the bronze and real porphyry used during the reign of Louis XV. Because torchères could be moved easily from room to room, they were·often preferred to chandeliers.

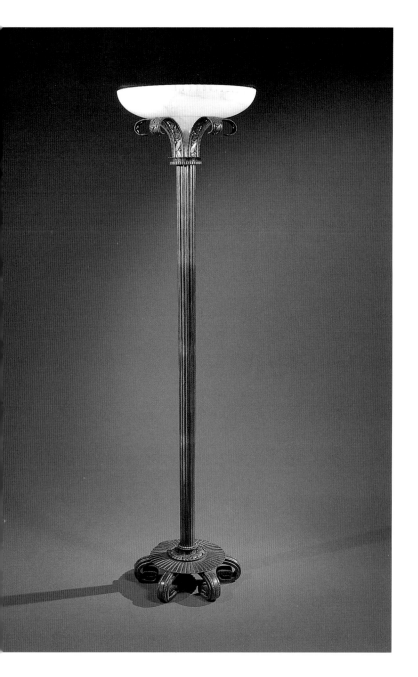

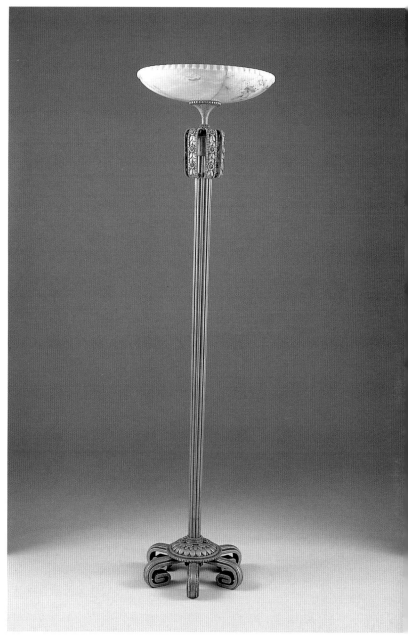

The table lamps shown in 1921 were markedly different from those of 1912. Gone were the filigreed tendrils; the ginkgo leaves were not as delicate and bell-shaped shades were used less frequently. In their place were lamps of iron and/or copper, a part of the shades being made of the same material as the base (fig. 75). Either the glass was blown into the frame of the shade, as was done for the *coupe* of 1919 (see fig. 58), or plain glass liners were made to fit into wrought-iron frames, then held by finials or attached with iron clips (figs. 76, 77). Several blown-glass effects were used by Daum for Brandt's iron lampshade frames. One style, *Le Ministre*, sold at the time for $130; most Brandt table lamps were priced between $80 and

ABOVE LEFT:
73. *Le Lys*. Torchère, 1924. Wrought iron with alabaster shade, 70 x 20″ diam. of shade. Stamped "E.Brandt France". Courtesy Phillips Son & Neale Auctions Limited

ABOVE RIGHT:
74. *L'Elégance*. Torchère, 1925. Gilt wrought iron with alabaster shade, 71 x 20″ diam. of shade. Stamped "E.Brandt". Shown in Brandt's stand at the 1925 Exposition, Paris. Courtesy Sotheby's, Inc.

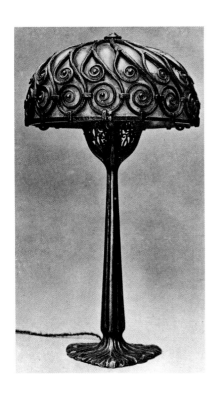

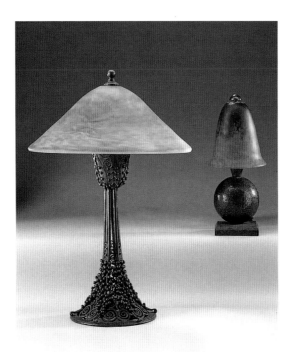

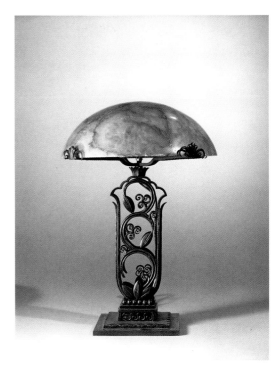

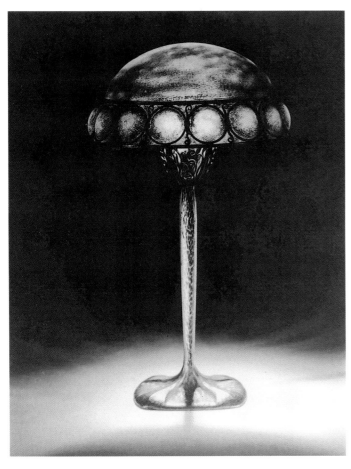

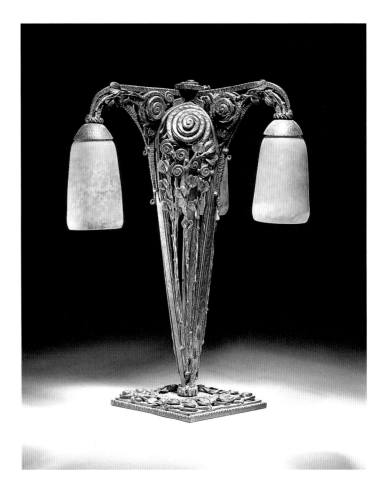

$200 (fig. 78). Some offered branched arms with two or three bell-shaped glass shades (fig. 79).

Gabriel Mourey, who critiqued the twelfth Salon des Artistes Décorateurs, felt that although Brandt's wrought-iron light fixtures were prodigious works, they were overdone by the *ferronnier*. In fairness to Brandt, the critic also pronounced a Szabo chandelier as overdone. Among the ironwork, only Marcel Schenck's radiator grilles were considered perfect in all regards.

Brandt forged a positive trend at the 1921 Salon d'Automne by showing a console with a gilded fruit motif, a gilded oval mirror *Les Roses,* and *Les Mouettes,* a globe-shaped glass vase blown into an iron frame depicting clouds and flying gulls. Particularly admirable was the torchère *Canards,* featuring an openwork iron shade sitting clochelike over a blown-glass undershade that was pleated to look like silk (figs. 80, 81, 82). On another wall *Japona* lanterns, adorned with delicate gingko garlands and tassels, hung above two vitrines. The latter displayed vases, an unusual *coupe* with a tall iron base, and small lamps (fig. 83). The Japonisme of *Japona* and *Canards* was reiterated in a bombé-shaped fire screen (fig. 84).

OPPOSITE, TOP LEFT:
75. Wrought-iron and glass table lamp with scrolled iron shade, 1920

OPPOSITE, TOP CENTER:
76. (front) Table lamp, 1921–22. Wrought iron with Daum glass shade, height 18½". Stamped "E.Brandt"; glass inscribed "Daum Nancy"; (back) Night light, c. 1920. Wrought iron and Daum glass, height 11¾". Stamped "E.Brandt". Glass inscribed "Daum Nancy France". Courtesy Christie's Images

OPPOSITE, TOP RIGHT:
77. Table lamp, c. 1924–26. Wrought iron with alabaster shade; 16¼ x 12½" diam. Stamped "E.Brandt" on base. Courtesy Sotheby's, Inc.

OPPOSITE, BOTTOM LEFT:
78. *Le Ministre.* Lamp, 1920. Wrought iron with Daum glass shade, 20¼ x 12¼" diam. of shade. Stamped "E.Brandt" on base; glass inscribed "Daum France". Courtesy Christie's Images

OPPOSITE, BOTTOM RIGHT:
79. Three-branched table lamp, c. 1922–23. Wrought iron with Daum glass shades, height 19½". Stamped "E.Brandt" on square base; glass inscribed "Daum Nancy". Courtesy Christie's Images

LEFT:
80. Brandt's stand at the 1921 Salon d'Automne, Paris

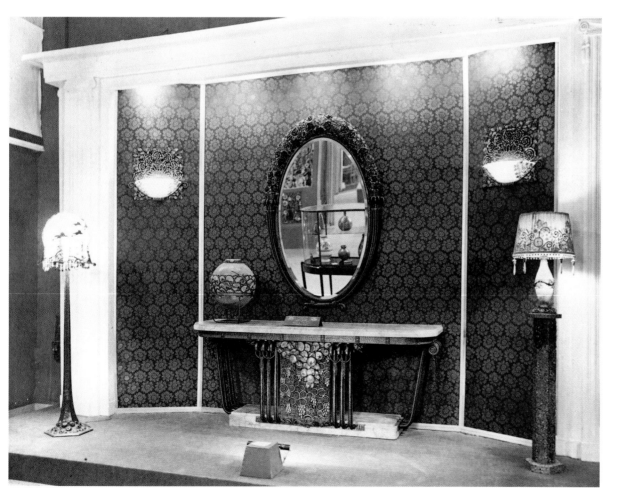

81. *Les Mouettes*. Vase, 1921.
Daum glass blown into
wrought-iron frame of clouds
and gulls. Exhibited at the
1921 Salon d'Automne, Paris

82. *Canards*. Torchère, 1921.
Wrought iron with under-
shade of blown glass, height
68⅞″. Exhibited at the 1921
Salon d'Automne, Paris

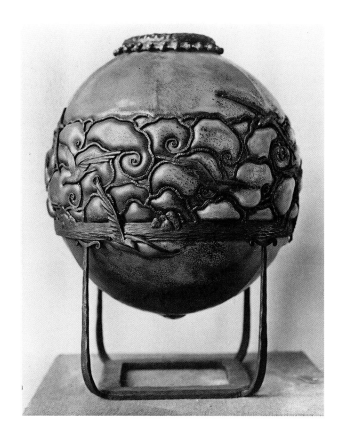

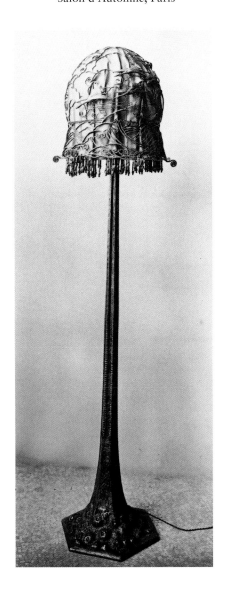

Edgar Brandt received the good notices along with the bad and kept on producing new work. Whereas Robert, a perfectionist, had been interested in forging cornflowers and other naturalistic motifs, Brandt and his design staff were more flexible and daring. Whereas Robert guarded against the overuse of torch welding, Brandt embraced welding, using it with creative intelligence.

Torch welding, electrolysis, and gilding allowed Brandt to achieve color by mixing metals in a single work, thus broadening the palette of *ferronnerie*. Instinctively, Brandt was working synchronously with the subtle changes under way in other applied and fine arts.

Abstraction was creeping into the world of progressive decorative arts, although in general a great respect for the representation of nature was retained. While Brandt never totally embraced abstraction, he did, in fact, develop a repertoire of stylized and conventionalized designs based on nature. Iron could never be treated with the same freedom of expression that was found in painting; however, both media involved composition and the rhythmic relationships of color, proportion, texture, and massing. Wrought iron could be shaped into perfect, concentric circles, or it could be forged into irregular spirals that evoked organic forms.

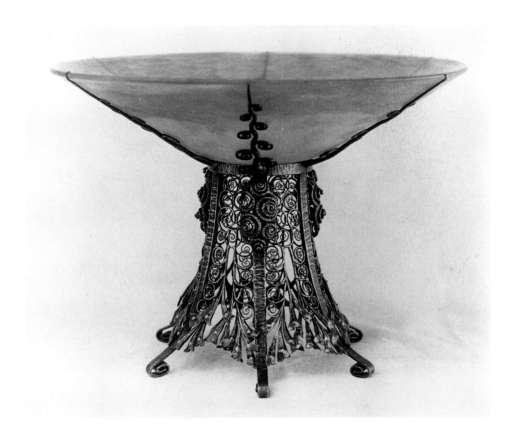

83. *Coupe*, 1921. Wrought-iron frame by Brandt, glass by Daum Frères, Nancy. Exhibited at the 1921 Salon d'Automne, Paris

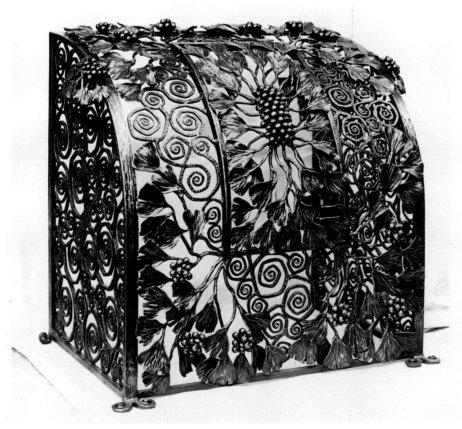

84. Bombé-shaped fire screen, c. 1921

85. Wrought-iron radiator cover, 1921

85. Wrought-iron radiator
cover, 1921

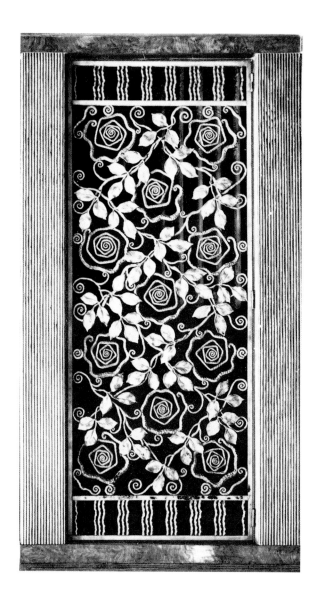

During World War I, designer Paul Iribe's cabbage rose became a ubiquitous applied-art motif in France.[135] Brandt's version of Iribe's roses are found on a radiator cover that was made for 101 Boulevard Murat (fig. 85).[136] It appears as if Brandt opened up the cabbage rose, petal by irregular petal, through his "potato peeling" forms,[137] creating the impression of movement. The wavy bars at top and bottom echo the visual tension of the flowers.

These decorative motifs cross-pollinated from one applied art to another. A dress fabric design from 1911 by Georges Lepape (1887–1971) would also seem to be an inspiration for the flowers on the Brandt radiator cover.[138] The center of the rose spirals outward and gradually forms a lopsided square that keeps repeating; heavily hammered lines invade the beautifully rendered leaves. This important design of conventionalized nature offers realism in the leaves combined with stylized, almost abstracted flowers.

In the 1920s progressive designers exhausted the cabbage-rose motif on a variety of objects such as fabrics, carpets, and accessories. By the same token, intrinsic wrought-iron shapes, such as the spiral or the C scroll, were to be found in fabric and rug designs. In 1921 Maurice Dufrène (Poillerat's professor at the École Boulle) used an upholstery design that could easily have been conceived while looking at wrought-iron grilles or fixtures (fig. 86).[139] Even the low spiral arms of the upholstered chair reiterate the scroll form. All the various decorative-art forms were interrelated in this period. Paul Follot created a romantic pattern of scrolls and flowers for a 1920 rug design. In contrast, André Mare's 1920 toile, awash with yellow and red flowers, was yet another variation on a theme. Such was the atmosphere when Brandt's Paris workshop was solidified.

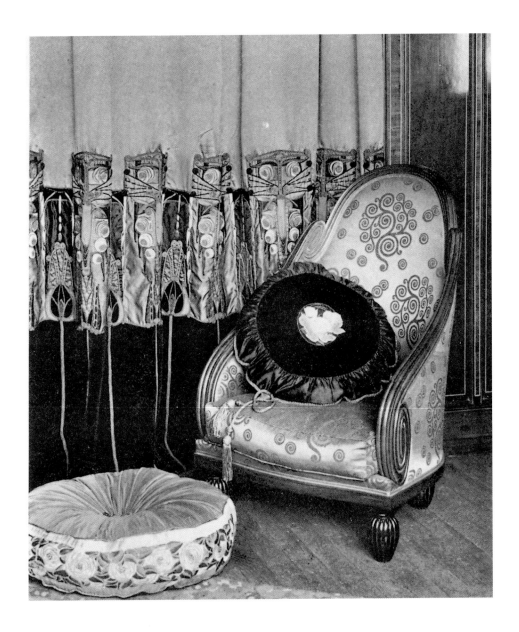

86. A Maurice Dufrène chair upholstered with scrolled roses similar to those in fig. 85, 1921

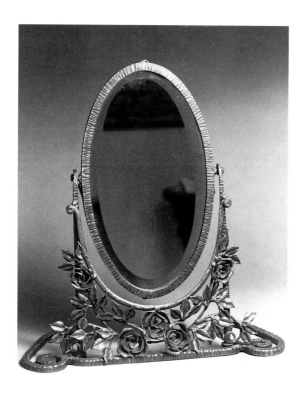

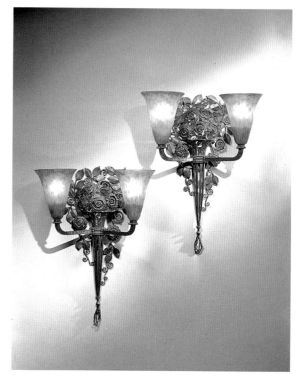

For years, in the case of wrought work, the technical factors had limited the forms. With the imaginative use of modern tools, Brandt and his company set a new standard, and the possibilities of the medium suddenly seemed endless. Brandt found a multitude of techniques for forming flowers. For example, for the base of a bureau mirror stand, the roses were fashioned from "potato peelings" that were coiled to form five roses (fig. 87). There is no better way to describe this wrought-iron technique. (When

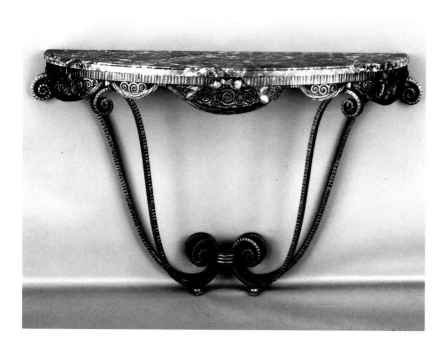

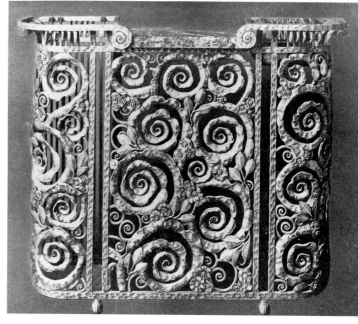

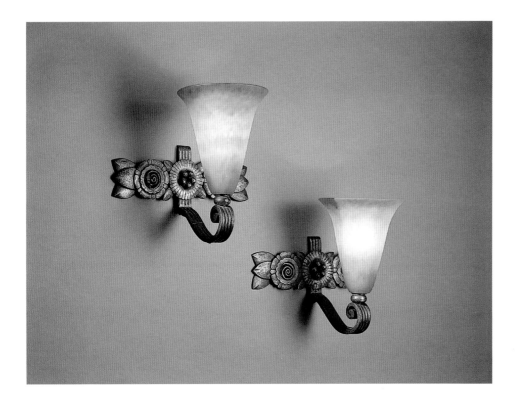

the blacksmiths were told to forge these forms, they knew that they might materialize as clouds or flowers in the final work.) For a pair of sconces, *Simple Bouquet/Les Roses,* the flowers were formed by smaller and more tightly bent "peelings." *Simplicité* of 1922, a console table with flower motifs, offers a good comparison of early 1920s style, employing an apron of "peelings" for roses. In a later radiator cover, *Fantaisie* (1923–24), the flowers are flat and more abstracted (figs. 88, 89, 90). Generally, when flowers were not made using this technique, they were a composite of stamped forms filled at their centers with iron balls or scrolls (fig. 91).

Emile Robert and Edgar Brandt crossed paths when they both worked on stair railings for the ship, *Paris,* a national commission for the Compagnie Générale Transatlantique.[140] Brandt created a wrought-iron railing (1920) for the ship's Grand Salon, which was designed by the architect Richard Bouwens de Boijen (1863–1939). Here a swirling marine motif of stylized octopuslike waves, emanating from a circular starfish, carried the eye swiftly from the bottom of the richly carpeted steps to the top of the stairs (fig. 92). Brandt's vortical ironwork was surrounded by a Moorish decor, featuring a succession of mosaic-tiled arches that led the eye up toward an illuminated dome of glass and tendrils of iron radiating like ripples of water (fig. 93). The central panel of the balustrade featured an ancient ship with unfurled sails, a double row of fleur-de-lis, and the Latin inscription *Fluctuat Nec Mergitur* (It is tossed on the waves, it is not submerged) (fig. 94). This strategically placed image and motto—the insignia for the city of Paris—provided a reminder of the impregnability of the ship *Paris* and a metaphor for the ship of state that had endured during World War I.

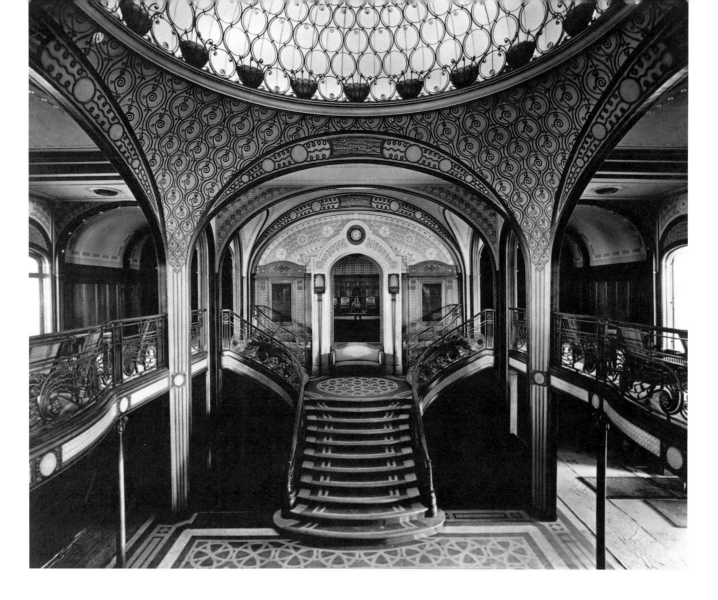

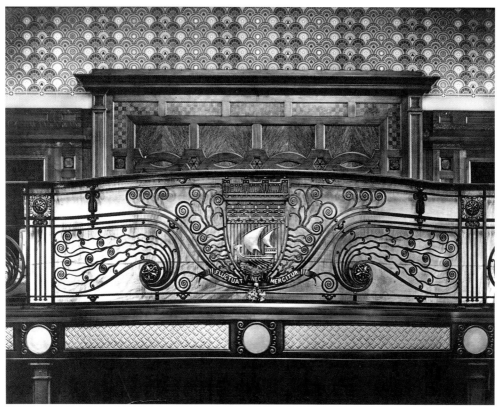

Robert's commission was for a stairway leading to the first-class smoking room. In comparison to Brandt's rhythmic work, it is dainty. Divided into vertical sections incorporating soldier-straight flowers, the work promotes a narrowing effect, while Brandt's is expansive. The Brandt–Bouwens de Boijen collaboration for stairways that provided "grand entrance" opportunities to salons and dining rooms set a standard for French ship decor. The *Paris* was refurbished after a fire in 1929 but Brandt's iron railings, grilles, and domed ceiling were retained. The Moorish arches and tiles, a reflection of earlier Art Nouveau tendencies, were obliterated in favor of the prevalent geometric pillars and lighting fixtures in the Art Moderne style. Another fire, in 1939, finally destroyed the ocean liner, but Edgar Brandt's main stairway survived.[141]

OPPOSITE AND BELOW:
92–94. The interior of the ship *Paris*, 1920. Metalwork by Brandt. Richard Bouwens de Boijen, architect

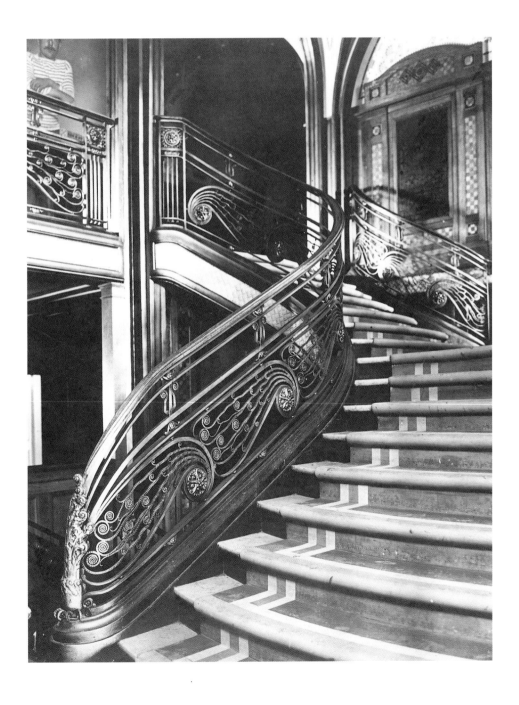

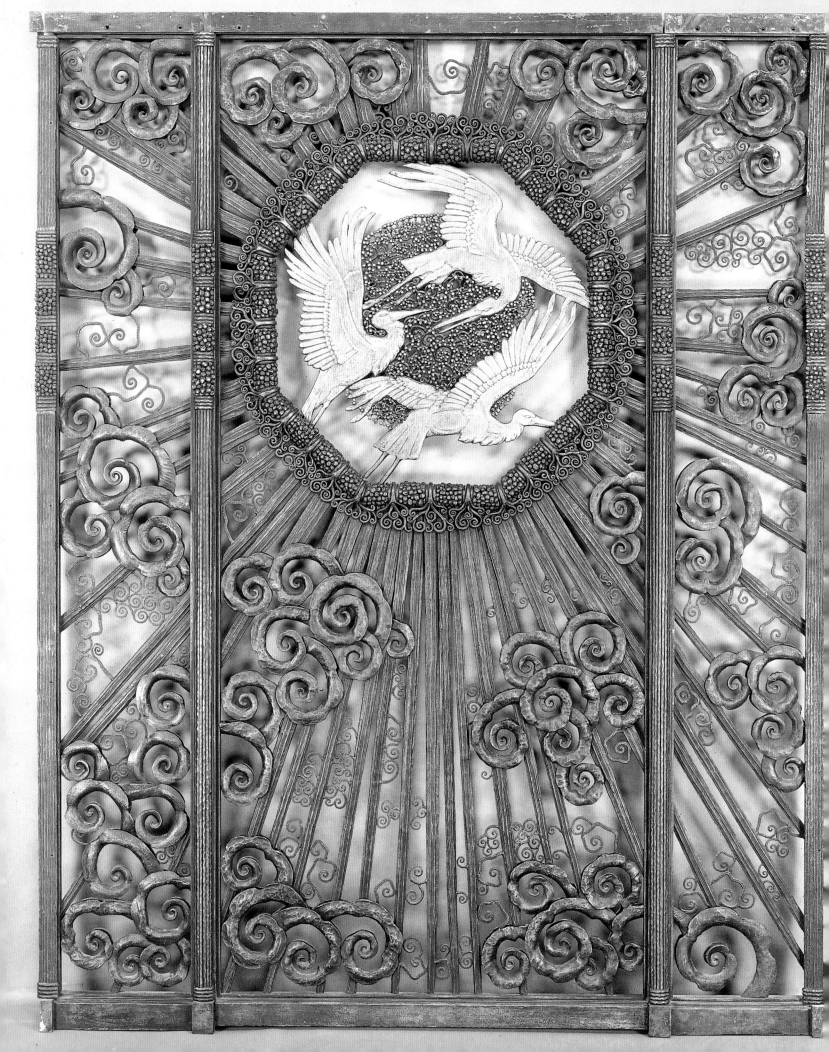

JAPONISME AND OTHER MOTIFS

The talent of Brandt and his design staff, combined with the changing nature of ironwork commissions, resulted in an eclectic style that included Japanese, Egyptian, Neoclassical, and eventually the geometric forms of modernism.

 At the Salon des Artistes Français of 1922, Edgar Brandt's stalls just off the center hall of the Pavillon Marsan, contained a work that was to become one of the most widely known images of twentieth-century ironwork. This impressive wrought-iron grille, called *Les Cigognes d'Alsace,* contains a central motif of three gilt-bronze storks flying in front of a scroll-filled sun (fig. 95). The shooting rays of the sun intermingle with large and small clouds made from C scrolls. These clouds are yet another variation of the "potato peeling" form. The hammering on the clouds and the incised lines chiseled into the rays emphasize the two-dimensional quality of the grille. The octagonal frame of the storks, juxtaposed against the rays and scrolls, offers a richness of contrasting shapes and colors. Probably the stork design in this work was suggested by a Japanese textile that had been reproduced in the journal *Le Japon Artistique,* in June 1888 (fig. 96). This could easily have been one of the art books that the Brandt firm kept on hand for reference. The birds depicted in the Japanese book were actually cranes; a similar triad of cranes appeared on a piece of eighteenth-century Japanese silk that was purchased by the Musée des Arts Décoratifs in Paris in 1906. It had previously been in the collection of Siegfried Bing, the German art collector who popularized Japanese art with the aforementioned journal and through his collection, shops, and exhibitions.[142] Louis Gonse (1846–1921), author of *L'Art Japonais* (1883), declared that "the Japanese are the best designers in the world."[143]

 Perhaps because of his Alsatian heritage on his father's side, Brandt named the storks after the province of Alsace; nevertheless, their stylization was definitely Oriental. It seems fair to suppose that the name given to this work offered a cautious allusion to the French reconquest of Alsace after the war.[144] In Europe, storks were traditionally held to be harbingers of good fortune; perhaps the name was prophetic, for *Les Cigognes d'Alsace* proved to be one of Brandt's greatest designs.

 The enormous influence of Japonisme on late-nineteenth- and early-twentieth-century art—in paintings by Claude Monet and many other artists, and in certain applied arts such as silversmithing by Tiffany and Gorham—has been well documented. The Japanese aesthetic prevailed in France, not only because of Bing but because of inventoried private collections and public exhibitions. In the spring of 1922, seventy-three cases of ancient and modern Japanese art were sent to Paris by the Japanese government to be shown at the Salon de la Société Nationale des Beaux-Arts in the Grand Palais.[145]

OPPOSITE:
95. *Les Cigognes d'Alsace.* Grille, 1922. Wrought iron, 8′2½″ x 6′7″ x 3½″. Exhibited at the 1922 Salon des Artistes Français, Paris. Courtesy Sotheby's, Inc.

ABOVE:
96. *Triad of Cranes.* Detail of an eighteenth-century Japanese silk of the type that served as a model for Brandt's *Les Cigognes d'Alsace.* From Siegfried Bing's *Le Japon Artistique* (June 1888)

97. *Les Pins*. Radiator
cover, 1922. Wrought iron,
59 x 29½ x 11¾". Exhibited at
the 1922 Salon des Artistes
Décorateurs, Paris

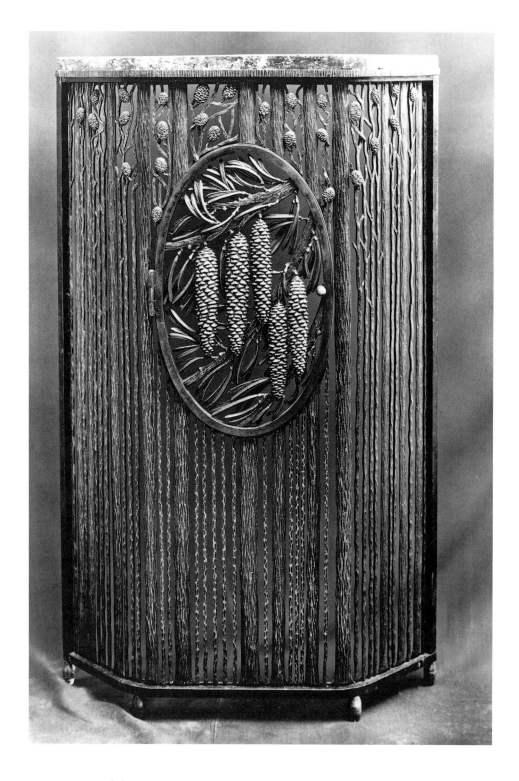

One of the visitors to the Brandt stand at the 1922 Salon exhibition
was the American steel manufacturer John Woodman Higgins, a collector
of medieval arms and armor, modern steel products, and decorative metal-
work. Higgins never forgot the stork screen, recognizing it as a tour de
force for the artist and a major work of the modern era; however, he felt
that it was too costly. Years later, on July 8, 1935, under vastly different
economic conditions, he purchased *Les Cigognes d'Alsace* from Brandt for
$375. *Les Cigognes* was part of a package of twelve pieces totaling

$2,191.61. Fortunately Higgins put the grille on display in his museum, which had opened to the public in 1931 as the Higgins Armory Museum in Worcester, Massachusetts. It remained there for fifty-six years until it was deaccessioned in 1991.

Another person who visited Brandt's 1922 installation was Gordon Selfridge, the flamboyant English entrepreneur who owned Selfridge's department store on Oxford Street in London. He found the design of *Les Cigognes d'Alsace* so appealing that he commissioned Brandt to adapt the design for the elevator carriages of his store. Since the cost of refabricating the 1922 grille would have been prohibitive, the design was made from raised and formed sheet steel and wrought iron that was mounted on plywood and painted with a mixture of varnish and bronze powder.[146] From 1928, when the panels were installed, Selfridge's customers were "lifted" from floor to floor surrounded by a modified version of this beautiful stork design.

At the thirteenth Salon des Artistes Décorateurs, of 1922, both Brandt and his younger competitor, Raymond Subes,[147] exhibited radiator covers. *Les Pins* by Brandt utilized pine cones and needles as a central motif, reminiscent of the bull's-eye window at 101 Boulevard Murat. However, on the radiator cover, long bars of iron were hammered to look like tree bark, with delicate pine cones interspersed between the bars (fig. 97). While Subes's work appeared to be more modern, with its layers of pattern, Brandt's cover is superior in its concept and execution.[148] The same motif could easily change character in the ironsmith's hands. For example, a rather stiff design of a circular mirror frame conveys considerably less Japonisme than the cover (fig. 98), while in a fire screen Brandt arranged long pine cones and needles more freely and contrasted the motif with plain

98. Mirror frames, c. 1920. (left) Wrought iron; (right) silver or wrought iron with niello treatment. Sold for $100 and $150 in 1925

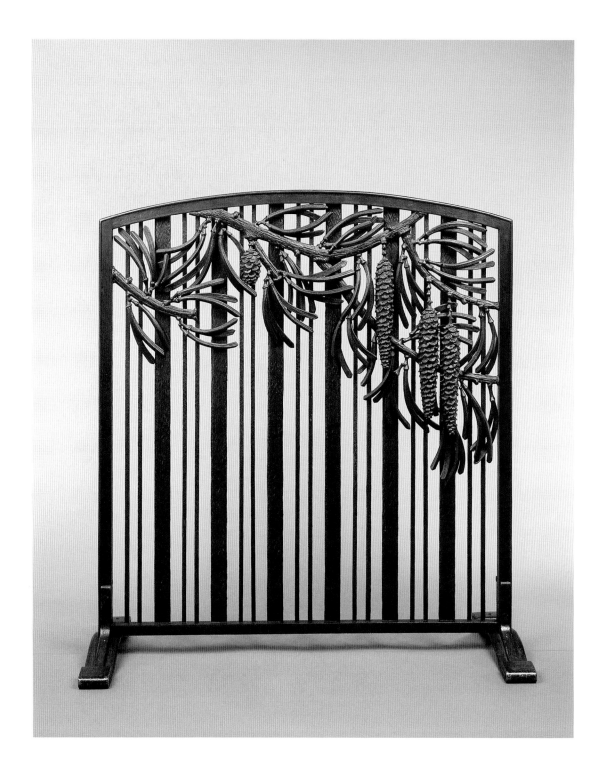

99. *Les Pins II*. Fire screen, 1924. Wrought iron, 33½ x 31½". Collection Robert Zehil, Monaco

iron bars (fig. 99). *Les Fruits,* another radiator cover, offered an elegant basket of fruit and vines on a pedestal. Closely related to it was *Les Marguerites,* depicting a *coupe* filled with daisies resting on an Ionic column (fig. 100). Pine cones and needles, columns and pedestals—the combinations and contrasts were endless.

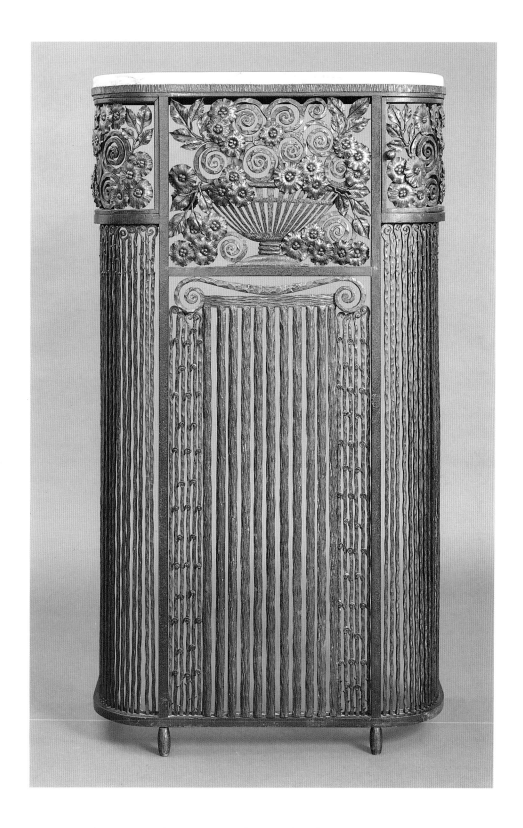

In the spring of 1922, Brandt completed a commission for the entrance and stairway for the Hôtel de la Société Centrale des Banques de Province. The entrance door (designed 1920) appears impregnable, with its grid of square bars augmented by large rosettes and large rivets, and its classical iconography. Inside the building, the stair rail repeats the grid pat-

100. *Les Marguerites.*
Radiator cover, 1922.
Wrought iron, 50 x 27½ x
12¼". Private collection

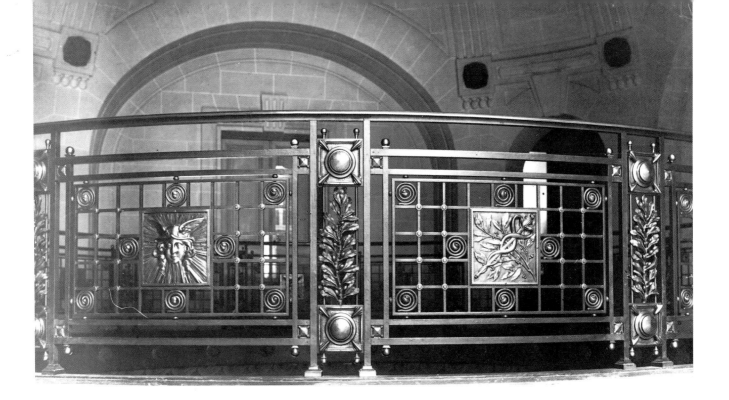

ABOVE:
101. Wrought-iron and bronze railing for the Banques de Province, 1920–22. Metalwork by Brandt. Richard Bouwens de Boijen, architect

OPPOSITE:
102. Wrought-iron stair railing and light fixture for the offices of the newspaper *Le Merle blanc*, Paris, c. 1922

OPPOSITE, INSET:
103. *Le Bénitier*. Sconce, 1922. Wrought iron, 20⅞ x 21⅛ x 11″

tern of the entrance door, but substitutes scrolls of iron in place of rosettes (fig. 101). Laurel leaves appear on vertical rectangles that alternate with the grid pattern. The balcony railings appropriately feature classical plaques of the Greek god of trade and riches, Hermes, with his symbol, the caduceus. Here Brandt utilizes classical themes but forges them with fluidity and spirit. The grid may be austere but the scattering of circular scrolls alters this aspect.

The architect for the Banques de Province was Richard Bouwens de Boijen, with whom Brandt had joined forces previously on the ocean liner *Paris*. Bouwens de Boijen, the son of a prominent architect, was courted by bankers to design classical edifices.[149] Brandt worked with him again on the building for La Société Maritime des Pétroles. It is important to note that not every Brandt commission called for his idiosyncratic modern style. For example, for the Banque de L'Indo-Chine, Brandt produced a classical entrance door that blended perfectly with the elegant facade of the building by Patouillard and Demoriane. However, when he could work in his own manner, as he did for the stair railing and chandelier he designed for Eugène Merle, the owner of the weekly newspaper *Le Merle blanc*, the result was charming. Playing on the fact that *merle* is French for blackbird, Brandt offered an engaging silvered, cawing bird perched among various scrolls (fig. 102).[150]

At the 1922 Salon d'Automne, Brandt's display consisted of a four-panel grille, *Floraison* (see fig. 52), which was composed of scrolls and roses backed by a velvet curtain, as was the custom. On either side of the grille were two rectangular sconces of wrought iron and pâte de verre. Shaped like holy-water basins, they were aptly named *Les Bénitiers* (fig. 103). The entire ensemble was completed by two majestic torchères with

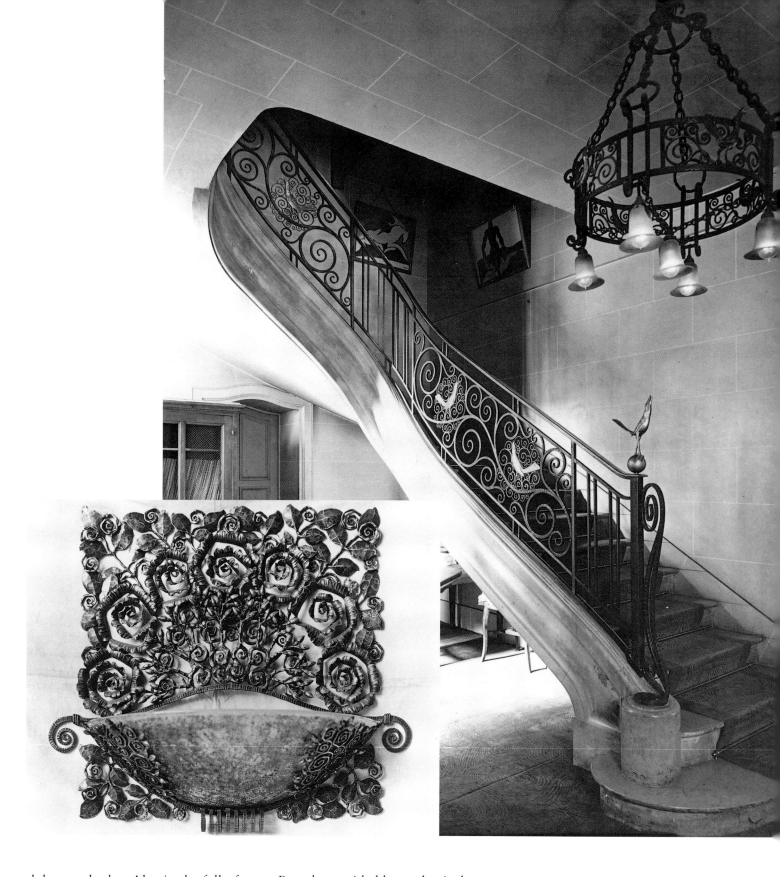

alabaster shades. Also in the fall of 1922 Brandt provided huge classical torchères, serving tables, and an entrance door and marquee for the Hôtel Chambord. Working with the proprietor M. Rouger and the artistic director for Les Galeries Lafayette, Maurice Dufrène, Brandt provided tradition-

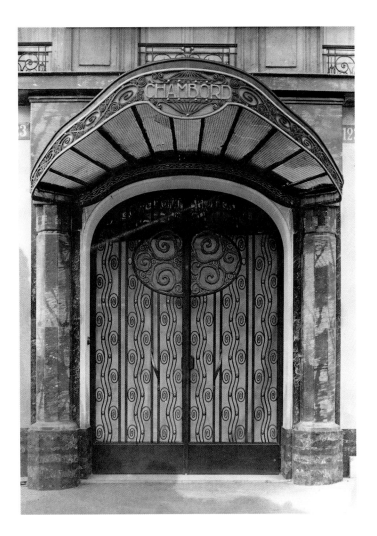

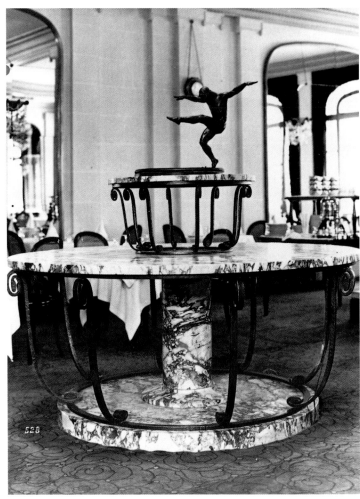

ABOVE LEFT:
104. Hôtel Chambord, Avenue des Champs-Elysées, Paris, 1922. Wrought-iron and glass entrance door and marquee by Brandt

ABOVE RIGHT:
105. Wrought-iron and marble serving table, Hôtel Chambord, 1922. Table by Brandt. Maurice Dufrène, decorator

ally useful *ferronnerie*. He had reached a level at which his association with a project was synonymous with quality, elegant modernity, and a visual definition of the era (figs. 104, 105).

Edgar Brandt's contribution to the world of design and manufacture was officially recognized once again on July 6, 1923, when he was awarded the Applied Arts Medal of Honor by the members of the Salon des Artistes Français. He was praised for the overall body of work that he displayed at the Salon, which was deemed to exceed first prize.[151]

The decorative arts were enjoying a renaissance, and French artists were not afraid to show a certain amount of collective pride. The committee that was responsible for the fourteenth Salon des Artistes Décorateurs, in June of 1923, inscribed a very positive statement at the beginning of its exhibition catalogue. It read: "There is not a branch of manufacture that can not feel the vigor of our creations, there isn't an object, from the most simple to the most sumptuous, that we are not able to work, not a residence, not a public monument that we cannot decorate."[152] For those who could afford sumptuous objects, there was no end of choices. When Gabriel Voisin, the motor manufacturer, or the silk manufacturer M. François Ducharne went to Emile-Jacques Ruhlmann, they knew that they were buying deluxe furniture. They would wait patiently for exquisite pieces—made

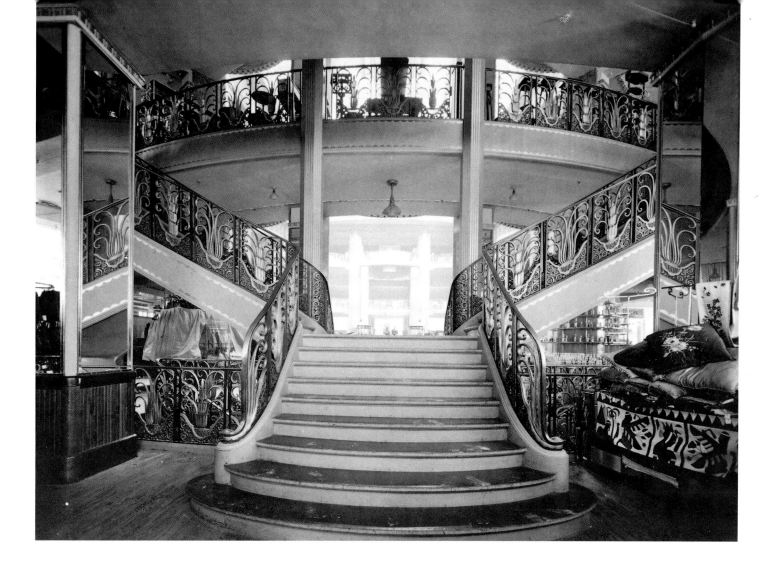

from rare woods embellished with tortoiseshell, ivory, *galuchat* (snakeskin), and bronze—whose fine workmanship required time and great skill.

For those with smaller pocketbooks there were alternatives. In the late teens and early twenties, department stores became involved with the promotion of home decoration by setting up in-house ateliers. In so doing, they followed the example of Louis Süe and André Mare, who, in 1919, founded Compagnie des Arts Français, a collective interior decoration firm. Paul Follot headed La Pomone, the design studio of Au Bon Marché, the oldest department store in Paris, while Maurice Dufrène was in charge of La Maîtrise, the studio for Les Galeries Lafayette. Two other large stores, Au Printemps (its design studio was known as Primavera) and the Grands Magasins du Louvre (its design studio, Studium Louvre, was headed by Kohlmann and Matet), were also involved in promulgating modern design. They were winning public approval.

The Au Bon Marché department store, an 1876 collaboration between Louis Auguste Boileau (1812–1896) and his son, Louis Charles (1837–1914), and Gustave Eiffel, had been framed in iron and supported by cast-iron columns and steel beams. In 1923 Louis Hippolyte Boileau inherited the job of refurbishing the great department store. He called upon Brandt to provide new ironwork that was both decorative and functional

106. Au Bon Marché department store, Paris, 1923–24. Gilt bronze railings and balcony grilles by Brandt. Louis H. Boileau, architect

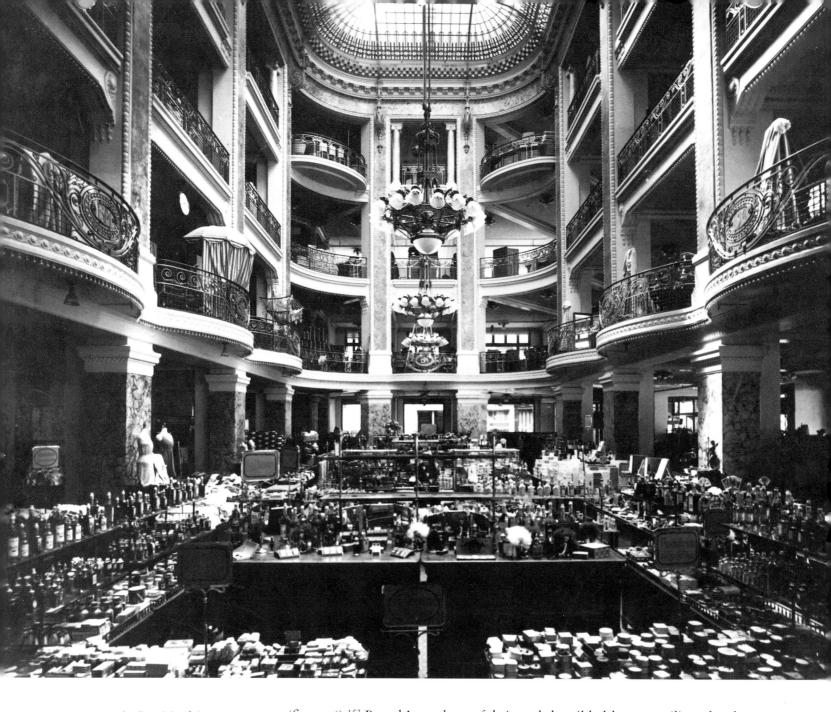

107. Au Bon Marché department store, Algiers, c. 1923–24. Wrought-iron railings, grilles, and domed glass-and-iron skylight by Brandt. Petit and Garnier, architects

(fig. 106).[153] Brandt's workmen fabricated the gilded-bronze railings for the stairway and upper galleries, as well as the iron-and-glass ceiling dome and the facade balcony railings. The grilles consisted of two curvilinear vasi-form patterns. A file photograph from the Brandt company's archives confirms the time frame for the completion of this commission—it shows a large banquette covered with an Egyptian-style spread. The discovery of King Tutankhamen's tomb in November of 1922 provoked a craze for things Egyptian that flooded the decorative arts. Brandt also provided more classical iron railings for the Au Bon Marché store in Algiers (fig. 107).

Brandt offered clients a great variety of ironwork, ranging from blotters and letter openers to console tables and clocks. There was something for everyone's taste, if not every bank account. A client in 1923 might have chosen a decorous wrought-iron radiator cover like *Les Fleurs*, con-

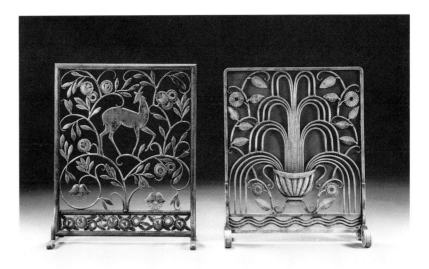

ABOVE LEFT:
108. *Les Fleurs*. Grille, 1923.
Wrought iron, 33¼ x 29⅞".
Courtesy Sotheby's, Inc.

ABOVE RIGHT:
109. (left) *La Biche dans la
Forêt*. Fire screen, 1924.
Wrought iron, 36⅝ x 30¼ x
10¾"; (right) *La Fontaine*. Fire
screen, 1924. Wrought iron,
36 x 29¼ x 10¾". Courtesy
Christie's Images

BELOW:
110. *Les Gazelles au Bois*, a
fabric designed by Pierre Pozier
in 1926 for F. Schumacher and
Co. The 1927 damask was
inspired by Brandt's *La Biche
dans la Forêt*. Courtesy
Schumacher Archives

sisting of scrolled branches replete with more than thirty-five flowers and richly veined leaves (fig. 108).[154] This grille, also made with fewer flowers, was very popular.

A client who responded to two fire screens of the same era, *La Biche dans la Forêt* and *La Fontaine*, identified quintessential examples of Brandt ironwork—works that stylistically define French Art Deco iron (fig. 109). In the first example, the disparity in size between the gamboling deer and the flowers bestows on the screen a fantasylike quality reminiscent of decorative Rococo pastoral scenes depicting smaller figures among large-scale flora. The iron feet at the base of the screen are rectangular, folded-under scrolls that resemble flattened Ionic volutes. This was a distinctive Brandt trademark, which he used on a great number of his fire screens. A version of this deer screen came to the United States with a traveling exhibition of objects from the 1925 Paris Exposition.[155] *La Biche dans la Forêt* inspired the American textile firm F. Schumacher & Co. to bring out the popular design *Les Gazelles au Bois* (fig. 110). Designed in 1926 by Pierre Pozier and produced in 1927, this fabric was advertised as "a new damask with the spirited beauty of modern wrought iron."[156] Subsequently, the fabric was used in the Waldorf-Astoria Hotel ballroom and by the Hearst family in their Northern California hunting lodge, Wyntoon.[157]

In a seminal variation of the floral-vine formula for a screen, the ironsmith replaced the deer with a flowing fountain, probably Brandt's most popular Art Deco motif (see fig. 109).[158] Four stylized flowers were strategically placed to balance the progressive jets of water, yet close examination reveals that they were not mirror images of each other. The flowers, probably machine-stamped, were then gas-welded and finished by hand.

Whereas the fountain and the deer were on the same plane as their floral background, a radiator cover called *Les Fruits* (1922–23) featured grapes, apples, pears, and a pomegranate superimposed on a background of

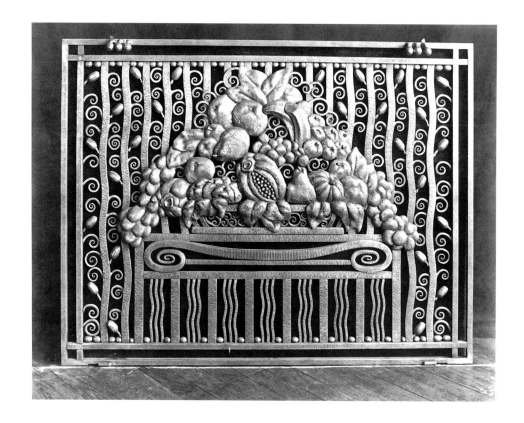

111. *Les Fruits*. Radiator cover, 1922. Gilded and silvered wrought iron, 37⅜ x 45¼″. Made for a private home in Nice

wavy lines and C scrolls (fig. 111). Gold and silver tones emphasized the three-dimensional quality of the fruit. Although the idea of fresh fruit in front of a warm radiator is somewhat jarring and even unappealing, the less flamboyant use of fruit on another radiator cover *(Les Fruits II)* was more successful (fig. 112).

Les Fruits, however, was favorably reviewed in the American journal *Architectural Record,* after the author had seen the work on exhibit at the Paris Exposition in June 1925. Although the author discussed the piece as a work by "O. Brandt" [*sic*], his critique included the following:

> The modeling of the central feature is hand wrought with gold and silver beaten into the metal to enrich it and produce color interest: its technique is individual in feeling and thoroughly consistent with the nature of the material displayed. Tonal quality has been produced in the composition by a skillful adjustment of pattern, scale and direction. In design and technique Brandt's work is a welcome departure from the Renaissance tradition which has so long been in vogue in this country.[159]

This cogent review was perhaps a foreshadowing of the influence that Brandt was to gain in America. Due to his work at the Paris Exposition of 1925, followed by several commissions and exhibits in New York City, Brandt's aesthetic conceptions and industrial methods would become known in the United States and Great Britain. Sometime in 1925 he opened offices, known as Ferrobrandt, in London and New York.

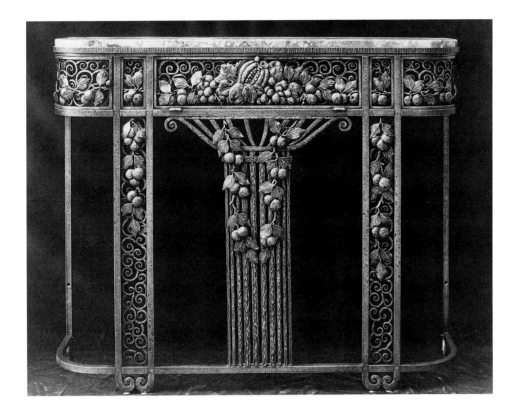

112. *Les Fruits II*. Radiator cover, 1922. Gilded wrought iron, 37⅜ x 45¼". Exhibited at the 13th Salon des Artistes Décorateurs, Paris

In 1925 Joseph Breck, a curator at the Metropolitan Museum of Art, went to Paris to see the Exposition. Elated by what he saw, Breck reported favorably to the president of the museum, Robert De Forest. In the following year, an exhibition of selected objects from the Paris fair at the museum gave Americans a taste of current European decorative arts.[160] Brandt's fire screen *La Forêt* was seen there. Following the museum's lead, in 1927 department stores began to take a prominent role in developing an American taste for fine French goods; John Wanamaker and Abraham & Strauss joined the bandwagon with special shows in the following years. Five countries brought more goods to American shores when an International Exhibition of Art in Industry opened at R. H. Macy's in May 1928.[161] Three hundred thousand people passed through a vast array of six thousand objects offered by three hundred exhibitors, and they even stayed on to listen to pertinent lectures. In order to better inform and guide the public, Macy's progressive exhibition committee arranged for fifteen discourses on various aspects of Art Moderne. Earlier in 1928, the Lord & Taylor department store had mounted an exhibit of European decorative objects, some of which were copies of French pieces, but at more affordable prices.[162] For example, reproductions of the furniture of Emile-Jacques Ruhlmann and Jules Leleu (1883–1961) were selling for one-third the cost of the Paris originals. Brandt's own American firm, Ferrobrandt, though short-lived, helped to promulgate the work of the artist-blacksmith and expose the sophistication of French design. The result led American decorators and manufacturers to consider the wonderful effects of wrought iron, where previously they might only have considered using wood.

TWO SIDES OF THE DRAWING BOARD: 1923-1924

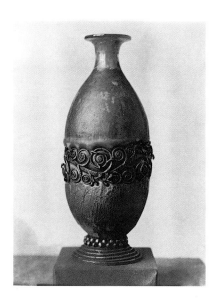

113. Vase, 1921. Wrought iron with glass by Daum Frères (Nancy) blown into the frame, 17⅜ x 6¾″ diam. Courtesy the Brandt family

The year 1923 was busy for Edgar Brandt. He moved his family to larger quarters at 88 bis Avenue Mozart, which was just down the street from Hector Guimard's residence.[163] François Brandt describes the apartment as harmonious but not decorated per se. Renée Brandt had purchased Puiforcat silver for the family table, as well as some Lalique vases. The family had a few pâte-de-verre and ironwork vases and chandeliers in the salon and the dining room. One of a pair of vases that combined gray-green Daum glass and Brandt ironwork is still owned by the family (fig. 113).[164] There were also Brandt sconces and lamps, but not in every room. They had several Brandt serpent lamps and a bronze panther by the sculptor Edouard Sandoz. At their Avenue Mozart home, the Brandts entertained several times a year. They also attended the opera, but most of the time Brandt's focus was on his work. He continued his longtime habit of working at the dining-room table late at night, reviewing large-scale plans, toiling over designs and technical problems. Often he worked alone at a desk in his study in order to maximize his concentration. According to François Brandt, his father could quickly draw the essential sketches for a new creation. He did not need to delegate his creative designs to anyone. This process entailed the use of reams of drawing and tracing papers. The next morning Brandt would give his drawings to a draftsman to elaborate and develop his plans into 1:1 clear blueprints, which he would then check and correct before they would be executed in the atelier.

In 1921 Brandt had been asked by the French military to invent and produce a more powerful mortar than the 60mm mortar that he had developed during World War I. At that time Brandt refused but the government played upon his patriotism; much later Brandt acquiesced. In 1923 a competition was announced between a number of manufacturers and the Arsenal of the State to see who could deliver an improved mortar. Even though Brandt was thoroughly occupied with the plans for the coming 1925 Exposition des Arts Décoratifs et Industriels Modernes, as well as his regular business of commissions and salon showings, the ironsmith took on this important four-year project in the hope of rendering further service to the national defense. Using as his base the Stokes mortar invented by the British arms inventor Sir Wilfred Stokes during World War I, Brandt improved the precision and the munitions of Stokes's original patent. Later, Brandt wrote of his profound satisfaction at having the army adopt the successful new mortar that he, a civilian, had created in peacetime. Furthermore, his technical victory garnered him orders from numerous allied armies. Had the army not insisted that Edgar work on a new mortar, he might never have gotten involved again in the armaments industry. One

can only contemplate what more Brandt might have accomplished artistically had he not been involved with munitions.

Brandt's technical ingenuity continued to find its way into many other areas. He fashioned a metal clip to hold his pant cuffs when he rode his bicycle, and he invented a screwdriver that is similar to the one known as a Yankee in America. This patent is a push-type spiral screwdriver with a rachet stem and spring-loaded handle that permits rotations to drive in or withdraw the screw. That the *ferronnier* had an enormous capacity for hard work is evident, but he also had a lighter side. During the mid-1920s when visitors came to his atelier he delighted in taking them to the forge. There he would hammer a bar of iron ten times on the anvil and then proceed to light his guests' cigarettes with the reddened bar. A consummate publicist, Brandt knew well that word of his little show would travel.

In 1923, in collaboration with a good friend, the sculptor Max Blondat (1872–1926),[165] Brandt completed a five-panel hall gate, *L'Age d'Or* (fig. 114). A precursor to the "1925 style," the great wrought-iron gate was exhibited at the entrance to the Salon d'Automne's decorative-arts rooms. Blondat's gilt-bronze medallions of nude figures in octagonal frames offered the perfect counterpoint to the gate's stylized flowers arranged in overlapping circles, which Brandt executed to look like mechanical gears. The sculptor's neoclassical figures—an athletic male and a long-haired maiden flanking the Three Graces—with their exaggerated poses and hand-held garlands, blend masterfully with the wrought-iron circles that appear to effervesce like bubbles around them. The more floral "gears" on the narrow side panels were made from flat pieces of iron that were stamp-cut and then shaped and scalloped on a *bigorne*.

An enormous work weighing several tons, *L'Age d'Or* is finished cleanly on both sides; therefore, the five figures can be seen in reverse on the opposite side of the screen, although that side appears to have been fitted with screws that at one time held a drapery (figs. 115, 116). The patina surrounding the figures is a marvelous brown-gold that blends exquisitely with the gilt-bronze figures. *L'Age d'Or* is one of many works of the era that offer an appealing duality, combining classical iconography with the modernist Art Deco aesthetic. Brandt and Blondat were clearly making reference to "The Golden Age" of the Renaissance—perhaps creating a metallic homage to Sandro Botticelli's fifteenth-century painting *Primavera*. The male and female figure flanking the Three Graces may refer to Mercury and Venus; thus, the five figures in the grille are arranged as they appear in the painting. Blondat's octagonal bronze frames set off the classical figures in a manner reminiscent of the Renaissance ceiling frescoes, such as those by Baldassare Peruzzi (c. 1511) in the Sala di Galatea in the Villa Farnesina in Rome. With *L'Age d'Or*, a grand achievement in wrought iron, Brandt equated the artistic rebirth of his own era with that of the past.

Henri Favier's salon setting for *L'Age d'Or* was impressive—the large grille was set into a fluted wall, a subtle allusion to classical Greek

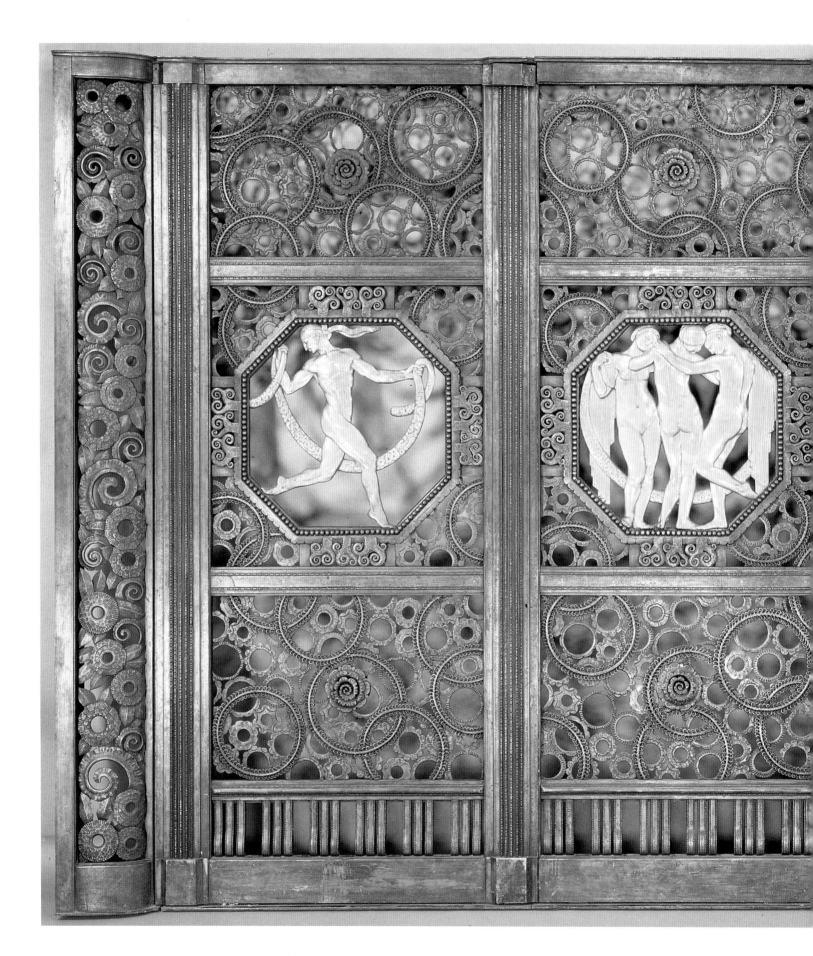

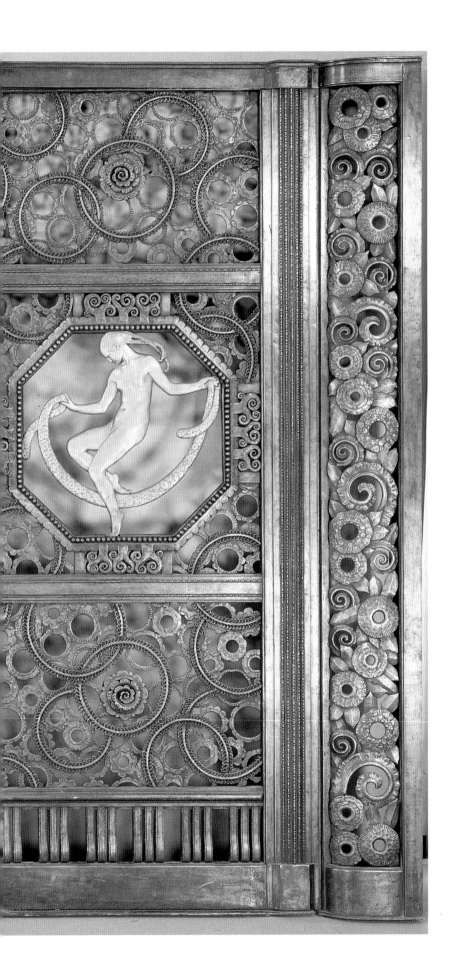

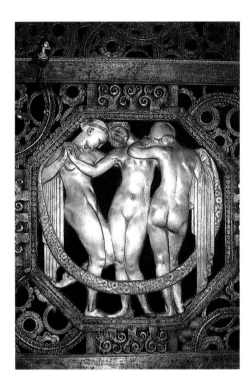

LEFT:
114. *L'Age d'Or*. Grille, 1923. Wrought
iron and gilded bronze, 8′8″ x 13′3″ x 7″.
Designed by Brandt. Max Blondat, sculptor.
Exhibited at the 1923 Salon d'Automne,
Paris. Courtesy Sotheby's, Inc.

ABOVE AND BELOW:
115 and 116. Details of the back of
L'Age d'Or

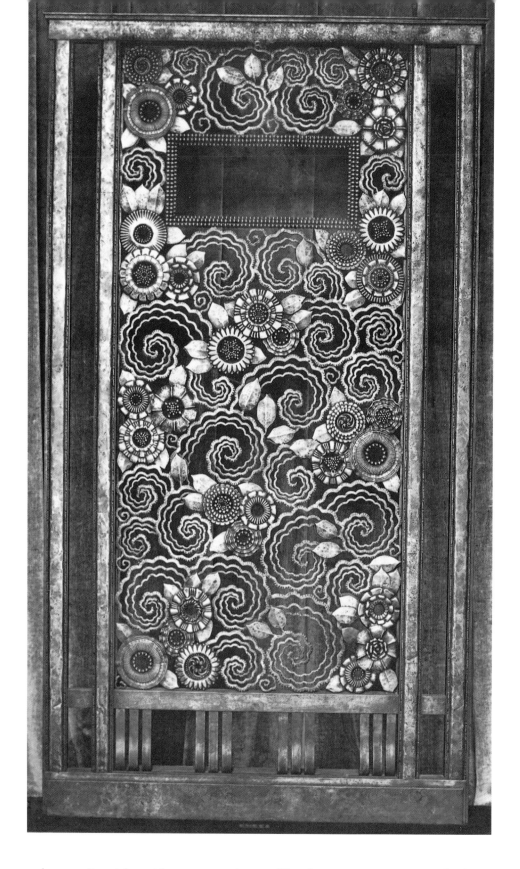

117. *La Perse*. Grille, 1923.
Wrought iron, 80¾ x 44½".
One of two grilles exhibited
on either side of *L'Age d'Or* at
the 1923 Salon d'Automne,
Paris

columns. On either side were two iron grilles, known as *La Perse*, which
were adorned with stamped gearlike flowers and wavy scrolls (fig. 117). A
soffit of stylized lotus buds framed the trio. Not far from *La Perse*, a com-
plementary ensemble, *Siam*, consisting of an Eastern-inspired mirror, con-

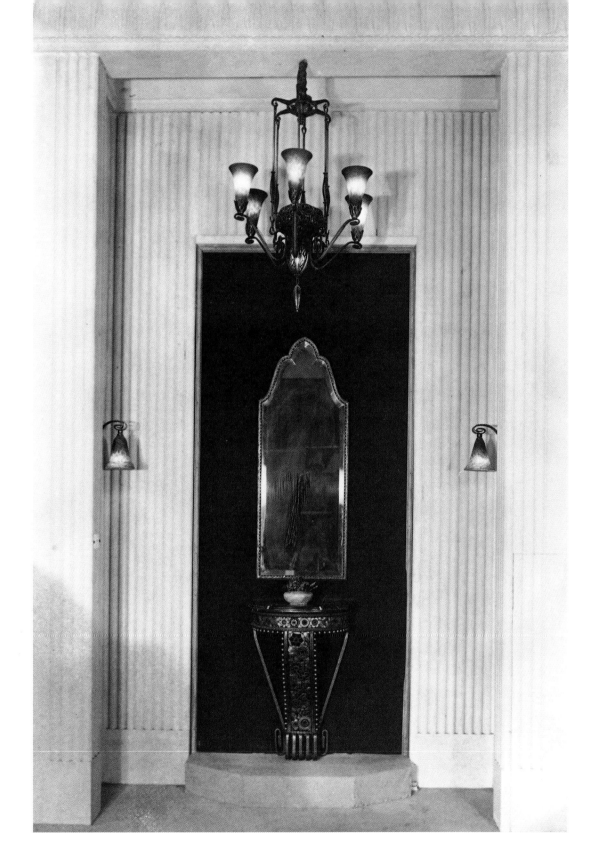

118. *Siam*. Console table, chandelier, and mirror, 1923. Gilded and silvered wrought iron and marble. Exhibited at the 1923 Salon d'Automne, Paris

sole table, and chandelier, contributed to the exoticism of the entire display (figs. 118, 119).

 L'Age d'Or, which was meant to be used as a divider between a salon and a hall, was exhibited by Ferrobrandt at the International

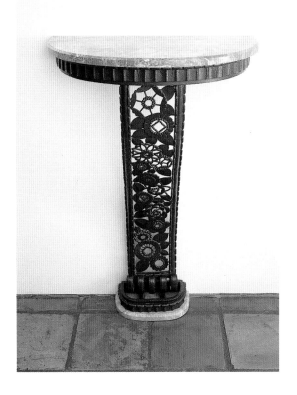

Exposition of Architecture and Allied Arts in New York in 1925. In 1935 it was purchased by John Woodman Higgins, who had previously purchased *Les Cigognes d'Alsace* for his museum in Worcester, Massachusetts. Probably Higgins had seen the grille in Paris many years earlier but passed it up because of its high price. With the economic downturn in the mid-1930s Higgins paid only $1,450 for *L'Age d'Or*, considerably less than Brandt was asking nine or ten years earlier. The grille was on continuous display in the Worcester museum until 1986 when it was put in storage due to renovation at the museum. In 1991 it was deaccessioned and sold at Sotheby's in New York to an anonymous buyer for $240,000.

Max Blondat and Edgar Brandt not only combined their artistry on many decorative works, but were the closest of friends from the time they met in 1918 until the premature death of the sculptor in 1926 at age fifty-four. Known for his portrait busts, war memorials, statues of children, fountains, and decorative panels for the Sèvres Pavilion at the 1925 fair, Blondat was a leading figure in the art of decorative low-relief panels. The gilded radiator cover *Le Feu* was another Brandt/Blondat collaboration (fig. 120). It depicted a visual pun of burning logs, curling flames, and smoke. With the advent of central heating many people had no use for the hearth. A hot-air duct cover, known as a *bouche de chaleur*, was placed in front of the fireplace of clients in Boulogne-sur-Seine. Perhaps Blondat was enjoying another play on words when he

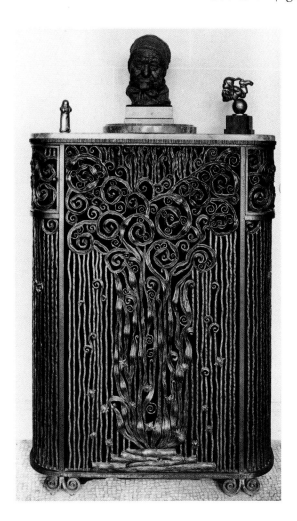

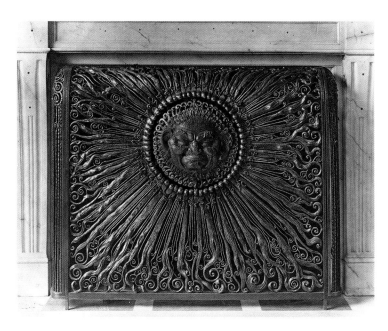

designed the hot-air cover with a puffed-up grotesque—possibly the sun or the wind—enhanced by radiating bars of iron that ended in curls and scrolls (fig. 121). With the passing of Blondat, Brandt lost a great collaborator. Had fate not intervened, these *confrères* would undoubtedly have produced more remarkable designs together.

Another great loss came quite unexpectedly, at the end of May 1924, when Emile Robert died at age sixty-four in his atelier in Mehun-sur-Yèvre.[166] Thereafter Edgar Brandt, at age forty-four, assumed the unofficial status of *ferronnier* of the day. There is no doubt that Brandt was inspired by the accomplishments of Emile Robert. Certainly, he carefully read Robert's article of 1913, *L'Apprentissage des Métiers d'Art*,[167] because he culled from it an important phrase that he used as the motto for his firm: "*Qui peut le plus, peut le moins*" ["he who is capable of doing the most difficult things can do them in the simplest way"]. It was printed on the company's brochures in the 1920s. Possibly the entrepreneurial ironsmith was also taking a cue from the successful couturier Coco Chanel, whose advertising adage was "*Le Luxe dans la Simplicité.*"

In 1924, the *ferronnier* was at the top of his profession and very busy with many projects, not the least of which was the upcoming Exposition des Art Décoratifs and Industriels Modernes. One precious small inkwell that may have been crafted for the exhibition reveals a high level of *ferronnerie*, and the date, March 1, is a reminder that the ateliers had only one year and six weeks left to prepare for the opening of the long-awaited fair (fig. 122). For the opera-loving Brandt, there was always time to help out with the rebuilding of the Marseilles Opera House, the original having been destroyed by fire in 1919. The architect André Castel, along with Ebrard and Raymond, planned an Art Moderne building with ironwork by Brandt, and sculpture by Antoine Bourdelle (1861–1929) and other artists. Still in use today, it is the largest opera house in France.

By the summer of 1924 Brandt had completed his part on the new offices of the politically influential newspaper *L'Intransiegeant* on the rue Réamur (Pierre Sardou, architect). Above the iron entrance doors, imbedded between iron C scrolls, was an oval plaque depicting the printing presses; the side panels featured gilt-bronze medallions depicting a ship, a car, a train, a railroad car, an airplane, a hot-air balloon, and even a zeppelin—in short, the modes of modern transportation that would ensure quick coverage of world news.

OPPOSITE, TOP:
119. *Siam II*. Console table, 1923. Wrought iron and marble, 34 x 23 x 12½". Private collection

OPPOSITE, BOTTOM LEFT:
120. *Le Feu*. Radiator cover, c. 1923. Gilded wrought iron and marble, 53⅛ x 31½ x 11¾". Designed by Brandt and Max Blondat. Blondat sculptures on top, from left to right: *Bebé bouillotte, Head of a Peasant*, and *Le Petit Paucet* (car hood ornament)

OPPOSITE, BOTTOM RIGHT:
121. *Bouche de Chaleur*. Heat register, c. 1923. Wrought ironwork by Brandt. Max Blondat, sculptor. Made for a private home in Boulogne-sur-Seine

ABOVE:
122. Wrought-iron and marble calendar inkwell, 1924

123. Edgar Brandt and his son, François, with a friend on the beach at Étretat in Normandy, c. 1924. Courtesy the Brandt family

124. Mistletoe paperweight, 1921. Wrought iron, height 3¾". Stamped "E.Brandt" on base. Private collection

Meanwhile, Brandt needed time off from his busy schedule and found time to be with his family. He enjoyed, for instance, walking on the beach in northern France with his five-year-old son, François (fig. 123). At this fecund period of his career, Brandt enjoyed good health and reputedly was strong enough to carry an anvil that weighed four hundred pounds. In his forties he was about five-foot-ten, thin yet muscular, and always well groomed. He had an oval-shaped face that supported a wide forehead, with blond hair and eyelashes that complemented his penetrating blue eyes. Today Brandt would be called a workaholic, or at least a man with a mission. Physical well-being and mental fitness allowed him to run the well-integrated enterprise that was necessary to accommodate the great variety of commissions. Even though business was excellent, the ironsmith was always cognizant of public relations. He often gave gifts of ashtrays, blotters, letter openers, and bookends. At Christmas, valued clients and visitors of distinction received wrought-iron paperweights in the form of balls decorated with mistletoe (fig. 124). Often the recipient's initials were engraved on the gift along with the name of the maker.[168] Like the mistletoe plant, which is slow in growth but very persistent, Edgar Brandt fashioned his career one step at a time, steadfastly believing in his ability and his purpose.

The stamp "E.Brandt" stood for total design conceptions that were well wrought and finely finished. While not every design was successful or perfect, a great percentage were superior, as evidenced by *L'Age d'Or*. The craftsman in Brandt was not a faddist or a crowd pleaser but a man with belief in himself who was never dissuaded from his ideals. When he received good reviews he was pleased, but his modesty ruled in the face of awards and honors. François Brandt reports that only occasionally would his father relate the important events of his day to the family; however, a secretary automatically collected and duly recorded Brandt's reviews.

Many designers received good notices at the June 1924 Salon of the Société des Artistes Décorateurs. In fact, the show was said to be equal to the 1911 Salon in which Dufrène, Jallot, Selmersheim, Follot, and Gaillard had ruled the day. Brandt showed several important new pieces. One was a seemingly simple console table, *Les Acanthes*, whose vertical supports consist of two overscaled acanthus leaves made up of multiple palmlike ribs and accented with beads and chiseled grooves (fig. 125).[169] This exaggerated, mannerist piece can be compared to a desk (exhibited 1925) with enormous ormolu mounts by Louis Süe and André Mare. Brandt's majestic console table was one of the best pieces to come out of his atelier. Two other important showpieces were interior doors, *Les Jets d'Eau* (fig. 126)

LEFT:
125. *Les Acanthes.*
Console table, 1924.
Silvered wrought iron and
marble, 37 x 78¾ x 23⅝".
Exhibited at the 1924
Salon des Artistes
Décorateurs, Paris.
Sold for $900 in 1925

BELOW LEFT:
126. *Les Jets d'Eau.*
Door, 1924. Wrought iron,
90½ x 59". Exhibited at
the 1924 Salon des Artistes
Décorateurs, Paris

BELOW RIGHT:
127. *Les Cocardes.*
Door, 1924. Silvered
wrought iron, 90½ x 57⅛".
Exhibited at the 1924
Salon des Artistes
Décorateurs, Paris

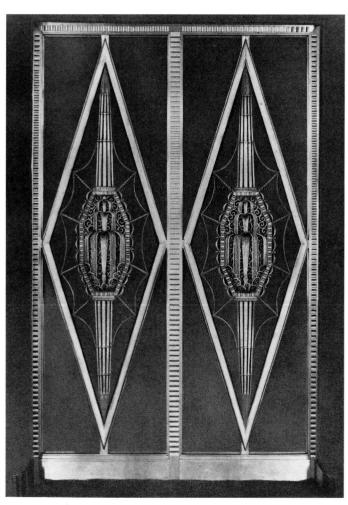

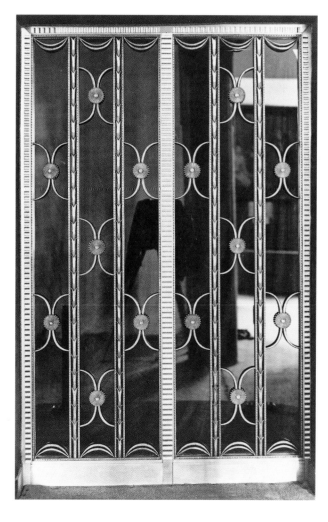

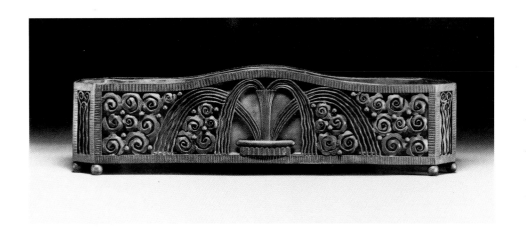

128. Jardiniere with fountain motif, c. 1924. Wrought iron, 6¼ x 11½ x 6¼″. Courtesy Christie's Images

and *Les Cocardes* (fig. 127), which were also rather simple designs exemplifying the mid-twenties penchant for stylized realism within geometric frames. In the first set of doors, the fountain motif is framed by an elongated octagon. Surrounding the octagon is a web joining it to an outer diamond-shaped frame. The progression of these shapes from small to large offers an exciting visual rhythm. The *Jets d'Eau* motif was also found on a small, charming jardiniere (fig. 128). The rhythmic pattern of *Les Cocardes* consisted of three basic elements: rosettes, curves, and straight bars.[170] The understated elegance of this door was a product of modern manufacturing. The rosettes were stamped or forged; the half-elliptical rods were hot-cut, chiseled, and tapered out of one iron bar. The scalloped straight bars were patterned by stock removal using a milling machine or hot-formed using a specially shaped die. All the parts were then welded with the oxyacetylene torch. Brandt's entire display at the Salon, which consisted of the two doors, the console—complete with a mirror and sconces—and two Grecian-style standing lamps with alabaster shades (*Les Crosses;* see fig. 72), was a successful neoclassical study. Just like Emile-Jacques Ruhlmann, Louis Süe, and André Mare, Brandt oriented his new work through studies and reflections on the past.

The architect Jean Badovici wrote the following words in 1924 about Ruhlmann, but he could just as easily have been talking about Brandt:

> The old disciplines are dead but they should not be ignored. What we need is an equilibrium between the old and the new. One must control and choose in order to form a new intelligence. . . . The artist must know the man of his time, and himself, that is his first task, and it is necessary to know all of the past in order to better understand the present.[171]

Yet another paean to neoclassicism was a 1924 console to which Brandt gave the lofty name *Altesse* (fig. 129). Made in two sizes, this silvered wrought-iron design sported a simple apron of leaves and flowers between two rows of beading.[172] The gracefully curved legs read as elongated vases topped off by stamped-iron flowers. The legs rest on round pedestals resembling bottle caps and the whole is supported by a beautiful Algerian marble plinth. While exhibiting a richness appropriate for royalty, the table's outstanding elements are the thick tassels of iron that appear at

the top of each leg. The
folded iron, visible behind
each tassel, reinforces the
idea of material or bunting.
A small gueridon also fea-
tured a draped fabric effect
(fig. 130).

Console tables were
either patinated, silvered, or
gilded. Wall mirrors and
dressing-table mirrors were
popular items, along with
gueridons, fire screens,
aquariums, umbrella stands,
jardinieres, and all manner
of lighting. All these items
could be ordered or pur-
chased at Boulevard Murat
and later at La Galerie
Edgar Brandt, both of
which were important centers for architects, designers, and their clients.
Whatever the object, its design always revolved around the thinness or

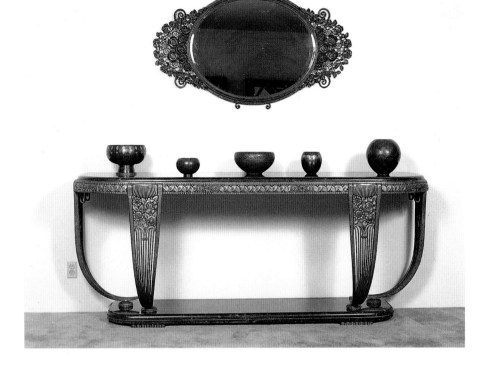

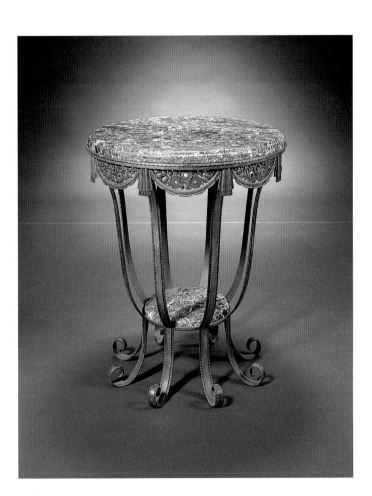

ABOVE:
129. *Altesse.* Console table,
1924. Silvered wrought iron
and marble, 37⅜ x 93¼ x
27⅝". Stamped "E.Brandt".
The Brandt mirror *Les Roses*
hangs above the table. Copper
vases by Claudius Linossier.
Collection Robert Zehil,
Monaco

LEFT:
130. Gueridon, 1924–25.
Gilded wrought iron and
marble, 29 x 24½" diam.
Courtesy Christie's Images

thickness of the iron, the proportions of each section, and how the play of light and color could be arranged to give the best effect.

In the summer of 1924 the critic Georges Denoinville wrote:

> The personality of Edgar Brandt reaffirms itself each day.
> This great worker renews himself constantly. His originality
> finds in the elements of nature, among the plants, the flowers,
> the fruits, an inexhaustible source of documentation. And the
> iron bends under his power.[173]

In a 1924 review of the Second Exhibition of Contemporary Decorative Art at the Pavillon Marsan, Henri Clouzot stated that painters such as Henri Matisse, K. X. Roussel, Albert Marquet, Pierre Laprade, Valtat, Charles Camoin, and Marie Laurencin had opened the eyes of the decorative artists to bold colors. He said: "the painters have provided a vibrant spirit to replace the faded soul of antiques."[174] He went on to praise the couturiers Madeleine Vionnet and Jeanne Lanvin for breaking into the decorative-arts scene with a "jaunty frivolity." Both women had dressed wooden mannequins that were set up in the decorated rooms throughout the show. In addition, the new ethnographically inspired line of silks by Bianchini, Ducharne, Rodier, and Chatillon coordinated very well with the contemporary furniture of 1924. Clouzot felt that "all the above augured well for the Exposition of 1925." He added:

> We ignore the fact that there will be a line of nations who are
> responding to the invitation of France. But I doubt that we
> will find any dangerous rivals for the luxurious goods, with
> the hand work, and with the choice production; especially
> where art and taste, the qualities of our race, are supplement-
> ed by factory methods for a greater output and serial produc-
> tion. This is not to say that we could not be better organized,
> or make more judicious use of the machine. But that is anoth-
> er story.[175]

Clouzot's review alludes to the fact that not all the decorative artists were as efficient as Edgar Brandt at taking best advantage of what the machine could offer. In general, the French decorative artists were relying on their good taste and on impressive displays to dazzle viewers at the exhibition the following year. Because Brandt was to have an extremely active role in the forthcoming enterprise, as both exhibitor and judge, he and his workers began the planning, designing, and forging well ahead of time. The plans for the fair probably generated a new sense of commitment for Brandt and the members of his atelier. This spirit paved the way for some of the best ironwork designs of the century.

THE EXPOSITION OF 1925: BACKGROUND

The Exposition des Arts Décoratifs et Industriels Modernes was the result of lobbying efforts that began as early as 1909. Even earlier the Société des Artistes Décorateurs had tried year after year to inaugurate plans for an international decorative-arts exhibition. Finally, the French Chamber of Deputies agreed that such an event was needed to reaffirm the French as leaders of *le bon goût* and to promote the export of French products. Although plans were begun in 1911 for a fair to be held in 1915, World War I interfered, and its aftermath delayed the event for ten years. Scheduled to open in 1924, the exposition was postponed one last time and finally debuted in April of 1925.

With the grimness of the war behind, the French government hoped that the fair would enhance public morale. Paris had previously been the design capital of the world; it was felt that she could prove herself to the world once again. The rules of the fair were clearly stated:

> Works admitted to the Exposition must show new inspiration and originality. They must be executed and presented by the artists, artisans, and manufacturers who have created models and by editors who represent the modern decorative and industrial arts. Reproductions, imitations, and counterfeits of ancient styles will be strictly prohibited.[176]

The directors of architecture and landscaping for the fair were Charles Plumet and Louis Bonnier, respectively. They initiated a vast program designed to increase the honor of French art and artisans. In 1922 a contemporary critic articulated the goal of the exhibition for the country, which was still hurt by war memories.

> Under the threat of failure and ruin, France owes it to herself to prove to the world that her artists, craftsmen, and manu-facturers have not lost their innovative ingenuity, the quality of balance and logic, especially allied to gifts of grace and fantasy, that have earned her, in the past, a universal sover-eignty surer and more durable than that which flows from the power of arms.[177]

France's painful war memories brought about a debate posed by the fair organizers—whether or not to display French works alongside those of German artists. In 1922, many prominent artist-decorators were asked whether or not Germany should be included in the exhibition. Emile-Jacques Ruhlmann felt that German participation would force the French to do better work. He added: "a contest is stimulating, educational and in spite of the momentary dreams that it carries with it, it is better than sleep. I am for the contest." André Mare was of the same opinion: "One must invite the Germans. It is only by their presence that we can demonstrate that our art is indeed French and that it is superior to theirs." Brandt also believed the Germans should be invited: "excluding our enemies from this exposition would be equivalent to protectionism, which too often leads to inaction and impoverishment. Competition is the main reason for research and effort."[178] In spite of these favorable opinions, many people were opposed; in the end, Germany was not invited to participate in the exhibition because of lingering animosity.[179]

Although a prestigious site between the Pont Alexandre III and the Place de la Concorde was set aside for the United States Pavilion, America declined to participate because, in the opinion of Herbert Hoover, then secretary of commerce, American designs were unoriginal and retardataire.[180] Aside from skyscraper architecture, he felt that American design did not qualify. The truth is that the United States took too long to form a committee to deal with the application and therefore had to decline.

After much debate, the center of Paris had been chosen for the fairgrounds. The area included the Grand Palais, the Cours la Reine, the Esplanade des Invalides, the Pont Alexandre III, and the Pont des Invalides. The two bridges allowed for exhibits on both sides of the Seine and for boutiques of individual exhibitors on the Pont Alexandre III. The natural beauty of the river combined with lavish architectural plans were sure to mesmerize visitors from all over the world.

Eighteen gateways enclosed the fairgrounds. On the right bank, between the Porte de la Concorde and the Porte Victor Emmanuel III, were placed the large pavilions of twenty-one nations and some French buildings, which housed fine and applied art from several regions. The most important buildings were placed on the left bank, bordered by the Place des Invalides, the Rue de Constantine, and the Seine. Between the audacious Sèvres Pavilion—with its six giant urns—and the river was an avenue of pavilions representing the design ateliers of the great department stores: Au Bon Marché, Les Grands Magasins du Louvre, Les Grands Magasins du Printemps, and Les Galeries Lafayette. Three long pavilions on the esplanade featured seventy-eight furnished rooms, including "l'Ambassade Française," an imaginary French embassy in twenty-five rooms. These were decorated and furnished by collaborating members of the Salon des Artists Décorateurs in order to create total room ensembles. On the right bank the Grand Palais, that huge survivor from the Exposition of 1900, was a show-

case for French and foreign exhibits arranged under group classifications. The second floor displayed the work of applied-art schools. The building served as the dividing line between France and the invited nations.

While there was no specific landmark for the fair, as the Eiffel Tower had been for the fair of 1889, its rectilinear architecture was striking and made an indelible impression on the visitor. In 1988 the designer Paul Fehér, an eyewitness, looked back at the buildings as "Disneyland architecture," considering them to be artificial and gaudy. These temporary structures did not sit quietly on the street; rather they seemed to shout that architects had left behind the old world of classical columns and egg-and-dart moldings. Inexpensive reinforced concrete was the perfect building material for the fair's pavilions—wood, a sought-after commodity for wartime use and postwar rebuilding, had become scarce.[181] Many architects tried to break with past styles; however, old themes did reappear in both subtle and overdone forms.

Egyptian art and design came to the fore in the early twenties due to a historic event. Brandt must have been fascinated, as was the world, by the discovery of Tutankhamen's tomb by Howard Carter on November 4, 1922.[182] Carter's stupendous archaeological achievement was revealed in photographs of the tomb's treasures, and their publication coincided with the ironsmith's preparations for the Paris Exposition. In fact, in February 1924, a year and two months before the Exposition began, the lid of the boy king's sarcophagus was pried open for the first time in thirty-three centuries.[183] Not only was the gold face of the king revealed, but also diadems and hundreds of pieces of jewelry. Newspaper headlines spewed out details of the latest discovery, reigniting the public excitement of less than two years before when Carter first came upon the tomb. Edgar Brandt and his design team could not have avoided exposure to the newly discovered Egyptian artifacts. Brandt's predilection for the fan motif (which will be looked at in more detail later) had many historical precedents, including Assyrian, Persian, and Greek. But the lotus, lily, and papyrus forms that decorated Tutankhamen's throne, vases, boxes, and even his shoe buckles were a major stimulation for Brandt's iconography.

Although this important archaeological trove infused the art world with a heightened interest in Egypt, Egyptology had been a major preoccupation of the French academic community from Napoleon's time. In fact, interest in Egyptian and Assyrian art, which had flourished in the nineteenth century, was rekindled in January 1919 when the rooms in the Louvre were reopened for the first time since the war.[184]

Periodicals often featured articles about Egyptian art and artifacts. One example was an article in *L'Amour de L'Art* of 1921, which presented the jewelry of ancient Egypt from 2500 B.C.[185] In addition, a Mr. Vernier had already published a book, *La bijouterie antique en Egypte,* in 1921. In a short time Carter's discovery in the Valley of the Kings made Vernier's book incomplete. *The Tomb of Tutankhamun* (vol. 1) by Carter and Arthur

Mace was published in 1923 and by February of 1924 it was a best-seller in Paris. The journal *L'Illustration* serialized four articles on Egypt by Myriam Harry. This type of reportage was stimulating fare, especially for a design studio like Brandt's.

Artists in every medium were attracted to the subject. In 1924 Maurice Rostand's *Le Secret du Sphinx* played at the Sarah Bernhardt Theatre. Ida Rubinstein, who had danced the role of Cleopatra in Michel Fokine's *Cléopâtre* in 1909, was the voice of the Sphinx, whose secret becomes known to a poet's brother and causes his death.

Journalists and tourists, the famous and the curious flocked to the Valley of the Kings. Carter was besieged with requests for the "exclusive style rights" as the commercial value of the King Tut craze stimulated entrepreneurship.[186] Egyptian-style souvenirs, fine and costume jewelry, and textiles revealed the exotic appeal of the discovery, while architects and designers replayed the themes of the sphinx, the lotus, and the scarab on the facades of movie theaters and apartment houses. The effects of the Egyptian trend reverberated throughout the design community.

The six-month-long fair was visited by more than 16 million people from all over the world.[187] In the Cour des Métiers (Court of Trades), which housed the S.A.D.'s individual room ensembles, the public was able to see some of the finest applied-arts designs of the twentieth century. The graceful lines that had been a feature of royal furniture in the past were still visible in the curvilinear forms of Süe and Mare and the neoclassical designs of Ruhlmann. However, there were other designs for those inclined to more modern styles, such as the rectilinear furniture of Jean Dunand (1877–1942) and Léon and Maurice Jallot, and the innovations in Le Corbusier's Pavillon de l'Esprit Nouveau, which included a tubular steel staircase and table and cabinets raised on steel legs.

The appearance of certain avant-garde interior and exterior works caused some visitors to feel that French artistry had gotten out of hand. One reporter grumbled that no one would have been shocked if the committee had covered up the majestic, old-fashioned Grand Palais, had it been feasible.[188] Certainly the atmosphere at each display was varied, as were the predilections of each designer. This great public event had something for everyone. Even Raymond Duncan, the eccentric brother of the modern dancer Isadora Duncan, had his own stand. William Franklyn Paris summarily wrote: "A work of art is modern if it looks absolutely like nothing else in the world." At the same time logic, truth, and harmony were the qualities the modern French style was said to possess.

BEAUCOUP BRANDT: EVERYWHERE AT THE FAIR

Although Edgar Brandt enjoyed a fine reputation as a *ferronnier* par excellence in France in the 1920s, it was his participation in the Exposition of 1925 that gained him an international reputation. The first thing that visitors saw on passing through the main gate was a set of grilles designed by Brandt. Planned in conjunction with the architects Henri Favier and André Ventre, Brandt's Porte d'Honneur was an entrance as distinguished as its name implied (figs. 131, 132). As an architectural device for delineating space, the gate and its grilles set a tone of modernity and technical virtuosity. Its stepped profile created three separate entrance portals on each side to facilitate admission. The grilles, resembling jets of water, encompassed a repetition of forms that was in keeping with the theme of honoring the machine. The frozen fountain motif was reiterated at the top of the

131. La Porte d'Honneur, the main gate of the 1925 Exposition des Arts Décoratifs et Industriels Modernes, Paris. Wrought-iron central gate and staff panels by Brandt. Glass fountain fixtures by René Lalique. Reliefs by Henri Navarre. Henri Favier and André Ventre, architects

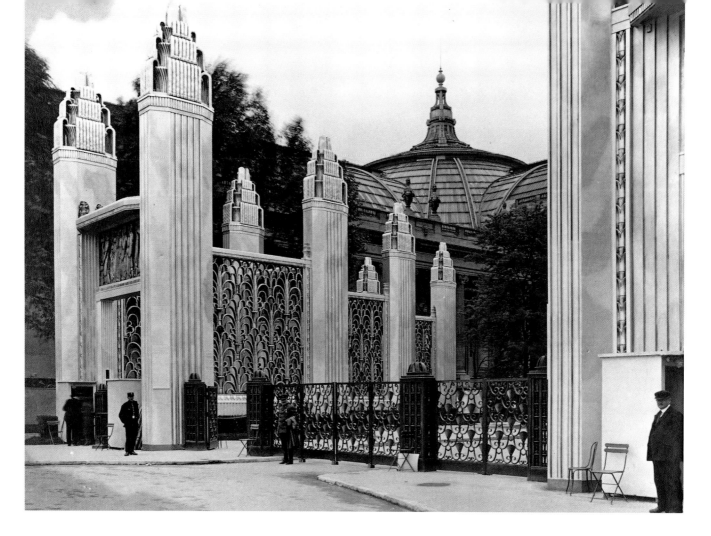

132. Central gate of the Porte
d'Honneur of the 1925
Exposition, Paris

columns in molded glass by Lalique, and was a fitting allusion to the fertile
ideas represented at the fair. Above the ticket takers' portals were Henri
Navarre's relief sculptures.[189]

The design of Brandt's central horizontal roadway gate is equally
captivating.[190] Pleated bronze fan motifs, secured by back-to-back wrought-
iron scrolls, create a striking pattern. The side posts that enclose the gate
are more rigidly designed. With their seven rows of spools stacked in three
columns, they project strength; the overall result enhanced the view toward
the esplanade of the Invalides, where many interesting pavilions were
located.

While all of Brandt's Porte d'Honneur grilles were supposed to be
fashioned of wrought iron, only the central gate was. The others were actu-
ally made of staff, a mix of plaster, flax, and gelatin that was painted to
give a metal-like patina.[191] Even the pylons that held Lalique's frozen glass
fountains were made of molded plaster.[192] The critic Georges Denoinville,
having seen a maquette of the Porte d'Honneur in 1924, decried the fact
that there was not enough money available to fabricate the gates in
wrought iron and have them permanently set up as a monument to the
upcoming exposition and its importance in the annals of French decorative
arts.[193]

Yet the effect of the gates, even in staff, was imposing. *Vogue* had
this to say about them:

124

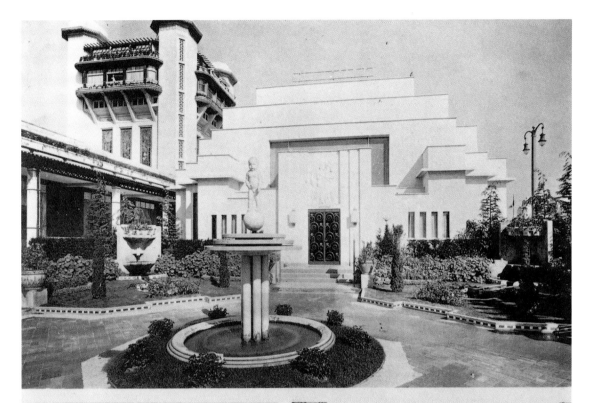

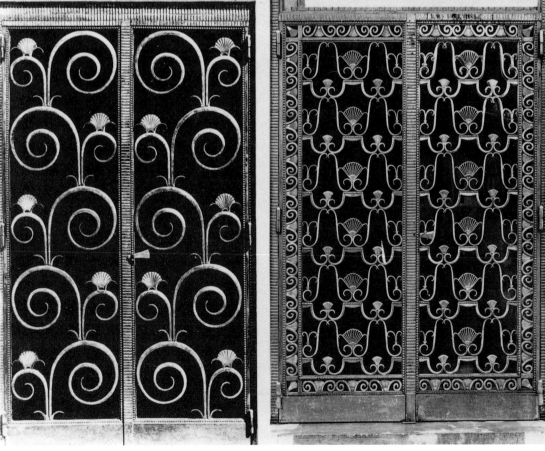

133. Wrought-iron entrance and exit doors by Brandt for Emile-Jacques Ruhlmann's "Hôtel d'un Collectionneur" at the 1925 Exposition, and a view of the garden facade. Pierre Patout, architect

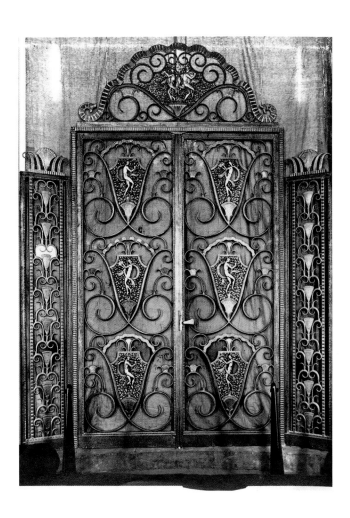

What nobility there is in the doors which enter upon this exposition! One knows that something new surges in front of one. The grillings of the Palais de Justice, where lies all the grace of the eighteenth century, make one comprehend the richness of the decorative art of that time; the doors of the entrance of the International Exposition proclaim to Paris the advent of the decorative French art of 1925.[194]

Brandt's interior and exterior wrought-iron work was found throughout the fair. It was featured, for example, in Ruhlmann's pavilion, "Hôtel d'un Collectionneur." This eight-room house, made of brick, iron, and staff and designed by architect Pierre Patout, was the imaginary home of a wealthy art patron. The same idea had been used in the Exposition Universelle of 1900

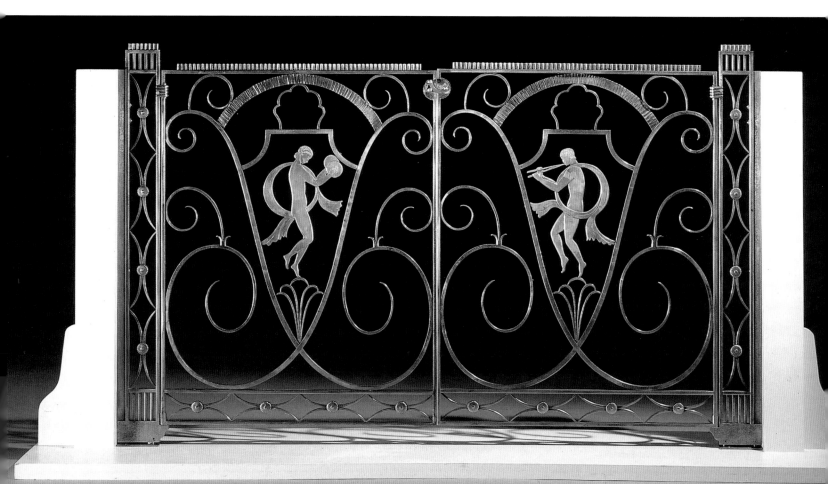

for a building that was called "The House for a Lover of Art." For his "Hôtel" Ruhlmann designed a great deal of the furniture as well as chandeliers, fabrics, and countless other items; however, he also commissioned various works from some of the finest artists of his time.[195] He particularly liked to use the paintings of Jean Dupas, the carpets of Gaudissard, the lacquered work of Jean Dunand, the sculpture of François Pompon and Antoine Bourdelle, and of course the ironwork of Edgar Brandt. The exit door, commissioned from Brandt, was a slightly modified version of the central gate of the Porte d'Honneur. The scrolls were elongated and the half-drop repeat of the Egyptian fan alternated large and small forms. With these changes, the design became more sophisticated and elegant (fig. 133). A variation of the same fan motifs was also used for the exterior window grilles.

For a door to Ruhlmann's *grand salon,* the ironsmith created *Musiciens et Danseurs,* playing with the forms of the classic amphora for the panels and Ionic volutes for the tympanum—a variation on the balcony design of 1920 for 101 Boulevard Murat (fig. 134). The six vase forms incorporated nudes, references to Apollo and Aphrodite, which show the influence of 1920s sculptors such as Bourdelle, Joseph Bernard (1866–1931), and Max Blondat. Neoclassicism abounds here in the chiseled bronze flutists and cavorting cymbal players. Brandt used the same female and male musicians for a gate (fig. 135) and even affixed these same panels to the inside doors of a client's custom-built car.

In another interior grille that Brandt created for the "Hôtel," Diana, the Roman nature goddess, is depicted with her mythological companion, the deer, and surrounded by stylized flowers, which the ironsmith used extensively at this time (fig. 136).[196] This work, *Diane et la Biche,* illustrates a pattern of development in Brandt's designs. For instance, the flower-branch motif in this work is vastly different from its 1905 counterpart (see fig. 5). Brandt's 1905 tortoiseshell comb displayed naturalistic pope's money leaves that were softly rounded and delicately veined. Twenty years later, the ironsmith's flowers are sharply delineated and stylized: several examples are variations on the form of the Egyptian fan and another a tripartite composition of ribbed petals. The sinuous vines seen on the comb have been replaced by an irregular pattern of flowers and scrolls. The grille encompasses a great many of Brandt's signature motifs: the figural plaque, the lily, the layered flower, the Egyptian fan motif, the delicate scrolls, and the scalloped running band at the base. The incised bands that border the gate were achieved by the use of a dulled chisel called a fuller.

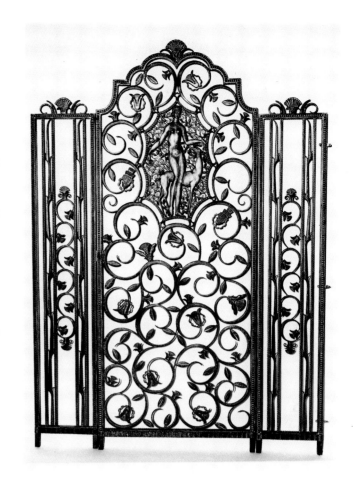

OPPOSITE, TOP:
134. *Musiciens et Danseurs.* Door, 1925. Wrought iron and gilded bronze, 11′9¾″ x 9′1¼″; height of fixed side supports 8′10¼″. Made by Brandt for the *grand salon* in Emile-Jacques Ruhlmann's "Hôtel d'un Collectionneur" at the 1925 Exposition

OPPOSITE, BOTTOM:
135. Gates, 1925–26. Wrought iron and bronze, 30½ x 78″. Design based on the *grand salon* door in Ruhlmann's "Hôtel d'un Collectionneur" at the 1925 Exposition. Courtesy Christie's Images

ABOVE:
136. *Diane et la Biche.* Interior grille, 1925. Wrought iron and gilt bronze, 79¼ x 59″. Made for Brandt's stand at the 1925 Exposition des Arts Décoratifs et Industriels Modernes, Paris. Gift of George G. Booth, Accession No. 27.151, The Detroit Institute of Arts

BELOW:
137. Wrought-iron entrance
door to Paul Poiret's couture
house, Rond-Point des
Champs-Elysées, Paris, 1924

OPPOSITE:
138. Wrought-iron stair rail-
ing at Paul Poiret's couture
house, 1924

The nude Diana as an ideal of beauty has roots in archaic and classi-
cal Greek art, as she is the counterpart of the Greek goddess Artemis, a vir-
gin huntress. Both goddesses are associated with wildlife and fertility.
Diana appears as a young maiden surrounded by dense flora and fauna, as
in medieval tapestries. She is also related to the mythological subject of cer-
tain School of Fontainebleau paintings, such as *Diana the Huntress*, in
which artists disguised Diane de Poitiers (1499–1566), the beautiful mis-

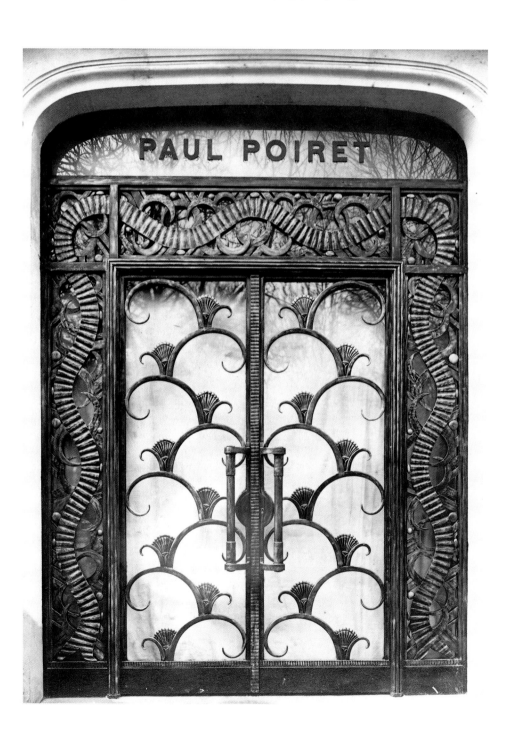

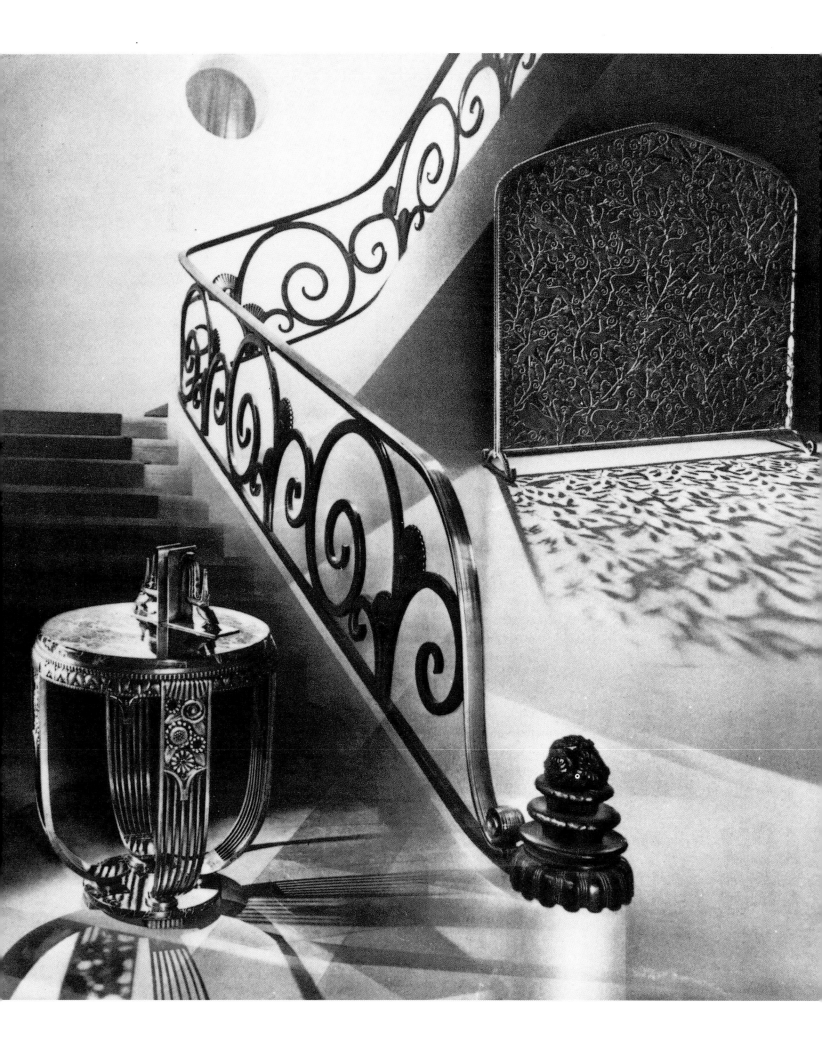

139. Egyptian, Assyrian, Persian, and Greek versions of the lotus, lily, and palmette. Drawings by Frances Besner Newman

tress of Henry II. *Diane d'Anet*, the mid-sixteenth-century Renaissance sculpture of Diana leaning on a stag that was part of the west courtyard fountain at Diane de Poitiers's Château d'Anet, was on view at the Louvre in the 1920s, as was Antoine Houdon's famous 1777 sculpture of Diane. The continuing appeal of the Diana theme can be seen in the work of the symbolist poet Stéphane Mallarmé, whose 1876 poem, *L'Après-midi d'un Faune*, inspired Claude Debussy's 1894 Impressionist tone poem by the same name. In the rich tradition of these antecedents it is fitting that Brandt's *Diane et la Biche* became the quintessential Art Deco grille, combining fantasy with joy and elegance.

For the exterior garden entrance to the "Hôtel d'un Collectionneur," a lighthearted design was achieved by reversing C scrolls of two different sizes. A mirror image of this pattern made up the second door panel. Pleated fan shapes perched on top of the smaller scrolls add to the door's whimsical quality (see fig. 133).[197] Brandt had used a different scale but a similar scroll-and-fan pattern for the entrance door of Paul Poiret's couture house and the elegant stairway of his atelier, which opened on January 1, 1925, at 1 Rond-Point des Champs-Elysées (figs. 137, 138). In addition, Brandt designed an elaborate tympanum and side panels with a ribbon motif, which helped to make a more feminine statement for the entrance door of the renowned dressmaker.

The fan shape, slightly suggestive of plumage, was derived from stylized Egyptian lotus and lily blossoms, which were transmuted into Assyrian, Persian, and Greek palmettes (fig. 139). There were two types of lotus flowers in Egypt that were frequently rendered in art: the white, tropical, water lily *Nymphaea lotus*, which when depicted sideways formed a semicircle (fan) at the top; and the blue *Nymphaea caerulea*, which was depicted as triangular when seen from the side. Associated with both Ra (Re), the sun god, and with fertility, the lotus was the flower most frequently portrayed in Egyptian art, particularly in wall paintings and jewelry.[198] In wall paintings, Egyptian artists conventionalized the lotus into a palmette— a simplified version that consisted of a calyx, two scrolled forms called volutes, and a fan shape that was half a rosette. Egyptologists call this version of the lotus flower a lily.[199] They do not believe it was a real plant but rather an emblem or flower symbol seen only in art. The Egyptian artists

used the lily or lotus three-dimensionally on column capitals, in a flattened form on friezes, and in rows with smaller triangular buds nestled in between; the components harmoniously joined in curved or linear patterns. The flower-and-bud composition became more conventionalized, and in time the lotus was combined with the Greek palmetto and rosette shapes.[200] When these motifs are used in a lengthwise manner, one nested on top of the other, it is said to be a stem bouquet (fig. 140).[201] The Egyptians wove and stacked flowers, fruits, and leaves into bouquets and wreaths (tying various parts together with split palm fronds), a remarkable custom that began in the Old Kingdom. It is worthwhile to compare this Egyptian artistic convention and Brandt's use of it on a console table that was made for

LEFT:
140. Egyptian stem bouquets. Drawing by Frances Besner Newman

BELOW LEFT:
141. Console table, 1925. Silvered wrought iron and marble, 35⅜ x 63″. Made for the "Salon de l'Ambassade Française" at the 1925 Exposition des Arts Décoratifs et Industriels Modernes, Paris

BELOW RIGHT:
142. Box with Egyptian lotus fan finial, c. 1925. Silvered metal, length 8″. Stamped "E.Brandt". Courtesy Sotheby's, Inc.

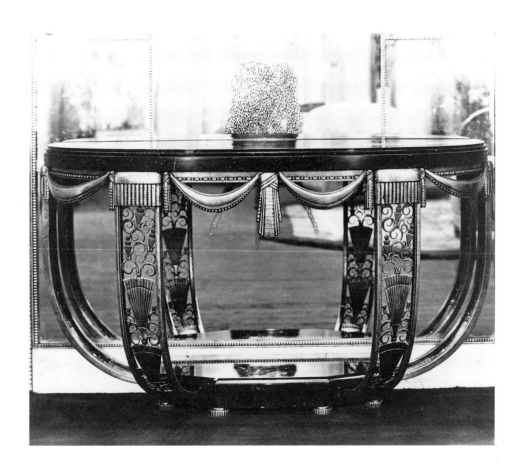

BELOW LEFT:
143. *Les Bouquets*. Grille, 1925. Silvered wrought iron, 78¾ x 28″ (each panel). Exhibited with two *Elégance* torchères in Brandt's stand at the 1925 Exposition

BELOW RIGHT:
144. Silvered wrought-iron door for the "Salon de l'Ambassade Française" at the 1925 Exposition

the "Salon de l'Ambassade Française" at the 1925 Exposition and as a three-dimensional motif on a silvered metal box (figs. 141, 142).

Brandt was one of many decorative artists to adopt the lotus and the lily. For instance, in 1899, René Lalique had used lotus flowers as a motif on a dog-collar plaque of chrysoprase, enamel, and gold.[202] Brandt's work as a jeweler would surely have made him cognizant of the Egyptian motifs used in French jewelry design during the great era of Egyptian archaeological excavations in the nineteenth century. However, Brandt pared down the elements to a concise form that was visually pleasing and translated well into the new ironwork techniques. What probably appealed to Brandt was the flat and sharp geometry of these ideograms based on nature (see fig. 133).

François Brandt has said that his father esteemed Greek art throughout his life; however, as we have seen, the ironsmith's work reveals a thorough knowledge of Egyptian art, as well as Assyrian and Persian art. Surely one source book with which he would have been familiar was Owen Jones's *Grammar of Ornament*, which first appeared in 1856. Jones states in Chapter IV: "Greek Art . . . though borrowed partly from the Egyptian and partly from the Assyrian, was the development of an old idea in a new direction."[203] Among the illustrations of

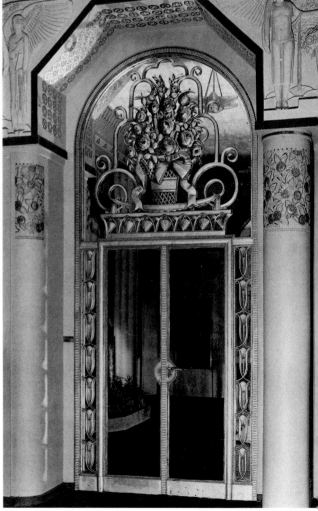

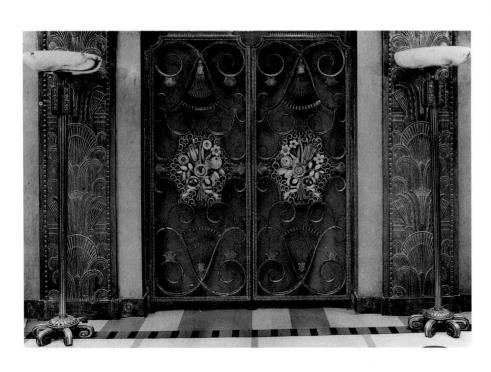

Greek art that Jones provides are several examples of the fan-shaped lotus motif, which corresponds directly to the door that Brandt designed for Ruhlmann's "Hôtel d'un Collectionneur."

The fan motif reappeared in *Les Bouquets,* another interior door (fig. 143). Brandt combined a small fan within a larger, elongated one, which provided a vase motif for a silvered bouquet of flowers (anemones, tulips, and sunflowers) suspended in the middle. *Les Bouquets* was displayed in Brandt's stand at the exposition and is today part of the collection of the Musée des Arts Décoratifs. Another magnificent floral bouquet with greater detail and complexity appeared on the tympanum of the silvered wrought-iron door of the "Salon de l'Ambassade Française." The door panels are glass with simple beaded and incised frames. The two side panels contained elongated vase forms gracefully enclosing an Egyptian fan motif on a stem (fig. 144). At the lintel, a row of larger fans supports an open-work basket overflowing with roses and tied with rippling ribbon. The door was set off in an alcove flanked by columns with floral relief. The walls above the columns displayed plaster reliefs of (Greco-Egyptian) winged maidens standing next to huge lotus-patterned baskets of flowers. These baskets closely matched a Sèvres "Egyptian Service" fruit basket (1810–12), designed by Dominique-Vivant Denon, that was in the Louvre. Brandt's lotus-fan and vase forms were leitmotifs that reverberated with both delicate and commanding beauty.

Elsewhere at the fair Brandt executed the design by architect Albert Laprade (1883–1978) for a balustrade in the Studium Louvre Pavilion. It was striking with its simple, large-scale calligraphic arabesques. The same graceful swag design was repeated in wrought-iron embellishments at the top of tall windows on the exterior of the pavilion, where it complemented the huge floral sculpture placed directly above each window. The unusual plan of this octagonal building included a second-story outdoor café that also featured an iron railing by Brandt. Laprade and the *ferronnier* enjoyed a long collaborative relationship.

Brandt designed an enclosure grille for the courtyard of Charles Plumet's Court of Trades with yet another vase motif that was reminiscent of his balcony design at 101 Boulevard Murat. Lighthearted balusters such as these were created by the Brandt studio for the fair, as were majestic consoles. One such oval table, made for the reception room of

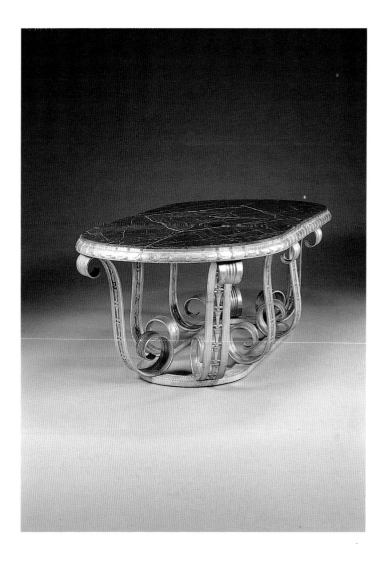

145. Oval table with lotus motifs, 1925. Wrought iron, marble, and chiseled gilt bronze, 5′8″ x 40″. Made for "l'Ambassade Française" at the 1925 Exposition. Courtesy Christie's Images

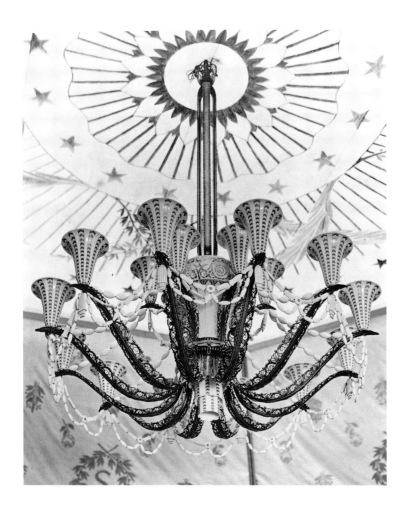

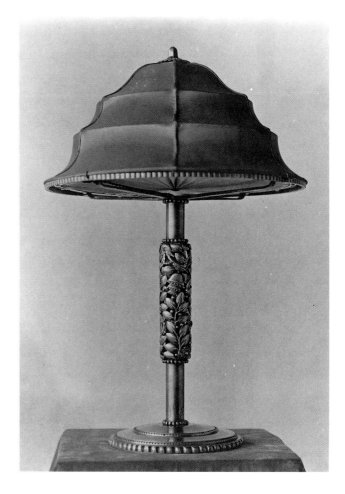

ABOVE LEFT:
146. Chandelier, 1925.
Wrought iron and Sèvres
porcelain, 78¼ x 70⅞" diam.
Made for the Sèvres Pavilion
at the 1925 Exposition. Note
the Egyptian fans on the iron
arms and the layered porcelain
tulips hanging from the bell-
shaped shades.

ABOVE RIGHT:
147. Table lamp, c. 1926.
Silvered wrought iron,
height 22"

"l'Ambassade Française," has eight S-shaped legs, each one incorporating lotus fans (fig. 145). A swag border (with upside-down lotus fans) just below the marble table top provides a classically formal look. Brandt used a similar table in the center of his stand at the exhibition, and a circular version was placed inside the pavilion for the newspaper *L'Intransigeant,* for which Brandt also forged the entrance door.

Brandt had a long-standing association with Sèvres, and the great colorful porcelain-and-iron chandelier that graced the Sèvres Pavilion was one of the most beautiful lighting fixtures of his career (fig. 146). The porcelain bell-shaped flowers under each shade can be compared with Brandt's wrought flowers on a table lamp and in a pair of sconces (figs. 147, 148), which recall the floral metalwork of the Wiener Werkstätte. It is interesting to note how Brandt used the same wrought-iron fan motifs of the Sèvres chandelier to embellish a circular marble table (fig. 149).

In a totally different vein Brandt worked with architect Jules Medecin on the Monegasque Pavilion. The resulting door design was composed of squares and triangles softened by small C scrolls and thin iron bars. This door is atypical of Brandt's work in the early 1920s, but it fore-

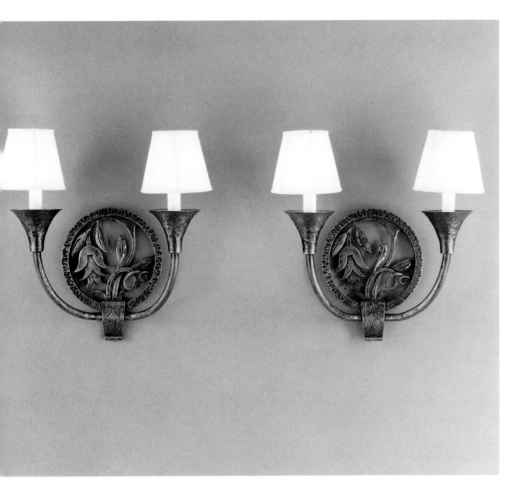

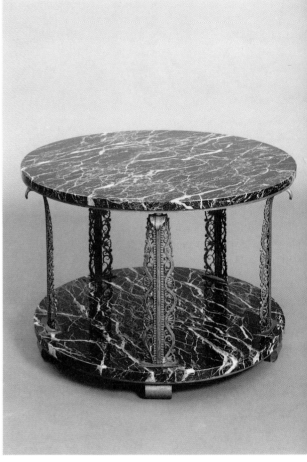

ABOVE LEFT:
148. Sconces, c. 1926–27.
Wrought iron, height 14½".
Stamped "E.Brandt".
Courtesy Christie's Images

ABOVE RIGHT:
149. Table, c. 1926. Wrought
iron and marble, 18 x 27".
Private collection

shadowed the more abstract style that was to come at the end of the decade. The eclectic nature of these numerous projects at the fair reveals the collaborative, and yet distinctive, efforts of Brandt's design team. They knew how to take a historic motif and bend it, literally and figuratively, into a sophisticated elegance reflecting the tastes of their time.

Brandt was also commissioned to create two figurative designs for the 1925 fair. For the pavilion of the magazine *L'Illustration*, Brandt forged an entrance door; its cogent visual impact must have attracted many visitors and led to numerous new subscriptions. The focal point of the door is a circular plaque featuring two females standing back-to-back while reading the magazine, surrounded by scrolls and flowers (fig. 150). The combination of the toga-clad figures against small-scale patterns of iron was the essence of Brandt's aesthetic in 1925. The figures are so compelling in their preoccupied poses that no other embellishments were needed, but the rosettes on the door frame reinforce the circular theme. This frame design is the same one that had been used for *Les Cocardes,* a door exhibited in 1924 (see fig. 127). The managers of *L'Illustration* were so pleased with Brandt's door that they later used it for the entrance to their Paris office.

150. Wrought-iron door for
the pavilion of the magazine
L'Illustration at the 1925
Exposition

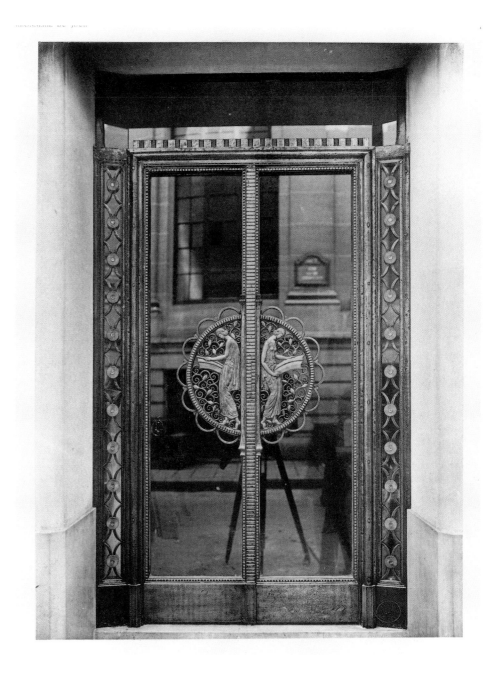

150. Wrought-iron door for the pavilion of the magazine *L'Illustration* at the 1925 Exposition

The second figurative work, an advertisement sign for Max, a prominent Paris furrier, is another neoclassical evocation, but with a difference. Brandt often used the theme of Diana and the deer as an affirmation of the feminine ideal; in this work, the nude goddess gamboling in the forest has been turned into a soignée femme fatale in a fur coat (fig. 151). There is a surreal quality to the design: a sophisticated lady against the unexpected background of twenty small, leaping deer. The sign marked the Max shop at the fair, located on the Pont Alexandre III. Ruhlmann originally designed the linear Paris shopfront near the Faubourg Saint-Honoré in 1925 and he worked in concert with Brandt on the Max sign, which was

imbedded into the glass entrance door. Based on the woodblock and pochoir drawings of Eduardo Garcia Benito (b. 1891) in a book of Max fur designs, the final cartoon was given to Brandt to forge in iron (fig. 152).[204] A. Leroy, the proprietress of the fur house, used the sign to advertise Fourrures Max for shops in Biarritz, Cannes, and Deauville as well, for a long time after the fair.

Brandt's able competitors who showed their work at the exposition included Raymond Subes, Richard Desvallières, Jean Prouvé, Vasseur, the Raingo brothers, the Nic brothers, the Baguès brothers, and the Schenck brothers. Paul Kiss, the Hungarian smith, worked on the Pavillon Savary (Robert Mottelay, architect). Kiss won a First-Class Medal for a peacock grille at the exposition, but he was always being compared to Brandt, who was *hors concours,* meaning that his work was considered as exceeding the first prize. An English observer commented: "Paul Kiss had a series of grilles on the Pont Alexandre, but admirable as it was it was second to Brandt."[205]

BELOW LEFT:
151. Sign for Fourrures Max, 1925. Wrought iron and brass, 32½ x 21¾". Made for the furrier's boutique at the 1925 Exposition. Private collection

BELOW RIGHT:
152. Eduardo Garcia Benito. Woodblock and pochoir from a book of twelve fur designs for Fourrures Max. Private collection

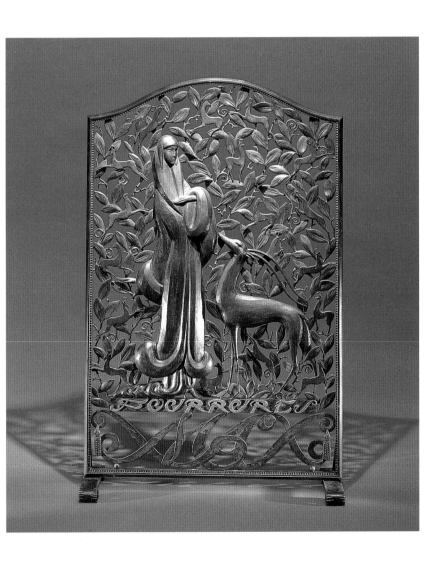

BRANDT'S STAND:
A TREASURY OF *FER FORGÉ*

One of the highlights of the 1925 Exposition was Edgar Brandt's own display room, stand no. 45 in the Salon d'Ameublement (fig. 153). In an unusual octagonal room, conceived as an entrance hall, Brandt and his architect Favier created a veritable tribute to the metal arts, just as they had done at 101 Boulevard Murat. Understandably, the exhibit offered great contrast to the work of other *ensembliers,* who displayed primarily wooden furniture and merely accented their rooms with glass, metal, or marble. Brandt's wrought-iron objects were luxurious, as was the architecture of the stand itself. Favier placed great emphasis on the walls and ceiling in his choice of silver-gold and silver-gray tones. The sumptuous wall material appeared to be metal but was, in fact, plaster that had been disguised by gilded lacquer. A light application of gold leaf gave the patterned walls a slightly reddish undertone, which was picked up in the yellow-orange Daum glass shades in the chandeliers and sconces. A vertical composition of the Egyptian fan motif, a lily, and a variation of the two formed a highly sophisticated pattern on the faux-metal walls. This embossed design exhibits the same rich quality and characteristics found on both the first state chariot and the golden throne of King Tutankhamen (Cairo Museum), and bears characteristics of many Egyptian designs executed in vertical or columnar fashion, such as the stem bouquets discussed earlier. Such a stem-bouquet pattern was reproduced on the cover of the second edition of James Breasted's *A History of Egypt* (1925), a book that may well have been brought into Brandt's studio by one of the designers.[206] Whatever its exact derivation, this wall gives us yet another wonderful example of Brandt's ability to elicit the past in his work, while adding just enough original inspiration to make it appear fresh and current.

The majestic, coved ceiling was recessed in three steps, which emphasized the octagonal shape of the room. A mottled, patterned vellum covered the coved areas, filtering light from above. Illumination from a two-tiered, iron-and-glass chandelier, from sconces, and from torchères was complemented by the concealed ceiling light.

One of the two long walls of the room supported a large sectioned mirror. In front of it stood a long console table supported by four simple S-scrolled legs that appeared to double in number in the mirror's reflection (fig. 154). Also reflected in this mirror was the now famous five-paneled screen *L'Oasis,* which in a home setting would have separated a foyer from a grand salon.

Niches at the far end of the room contained monumental neoclassi-

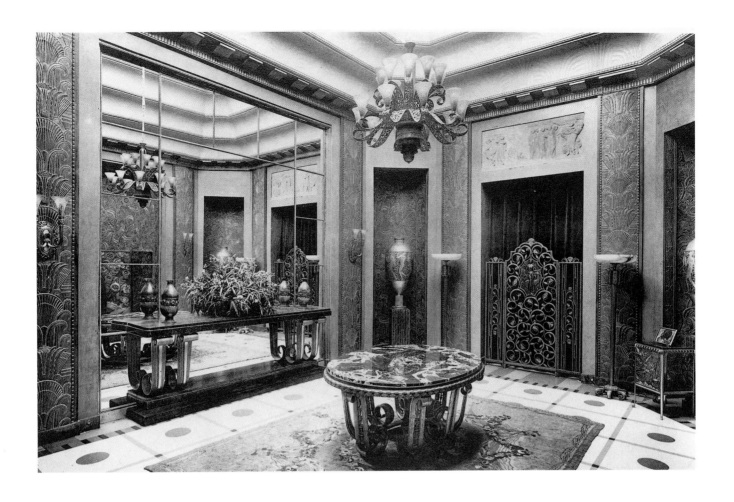

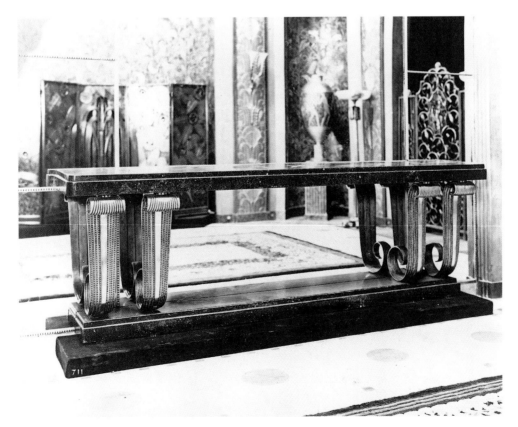

ABOVE:
153. The Brandt stand at the 1925 Exposition des Arts Décoratifs et Industriels Modernes, Paris. Ironwork by Brandt. Joseph Bernard, sculptor. Henri Favier, architect

LEFT:
154. Console table, 1925. Silvered wrought iron and marble, 35⅜″ x 8′10¼″. Exhibited in Brandt's stand at the 1925 Exposition

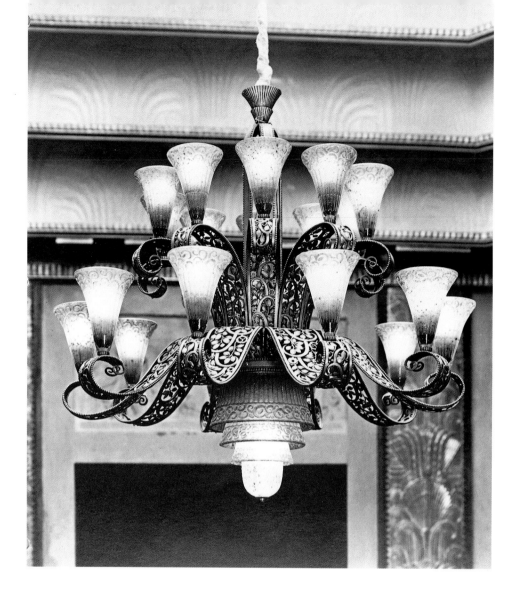

155. Chandelier, 1925. Wrought iron and acid-etched Daum glass, 43¼ x 43¼" diam. Exhibited in Brandt's stand at the 1925 Exposition

cal vases, or potiches. The corresponding openings on the opposite side of the room functioned as entry and exit doors, and flanked the grille *Les Bouquets*, which was also on view in Ruhlmann's "Hôtel" (see fig. 143). Above the iron grille was a Joseph Bernard frieze of female musicians and dancers. The walls behind the niches and the wall opposite the mirror were decorated with a different design. Here the embossed plaster contained large stylized flowers, curved veined leaves, and elongated fan-shaped flora. While it beautifully enveloped the neoclassical potiches, this second wall pattern was a brilliant foil for the lush tropical design in the screen *L'Oasis*.

The floor was covered with India rubber, on top of which was placed a Paul Follot rug awash with swags of drapery and flowers. The central cartouche of the rug was the perfect spot for Brandt's oval wrought-iron table with a mottled marble top (see fig. 145). The elegant iron S scrolls of this table and of the long console table were reiterated in the large twenty-light chandelier, the arms of which appear to open like the petals of a giant flower (fig. 155). Smaller, less labor-intensive chandeliers and matching sconces were for sale later that year at La Galerie Edgar Brandt (fig. 156). Brandt employed C scrolls along with stamped flowers and leaves in the

140

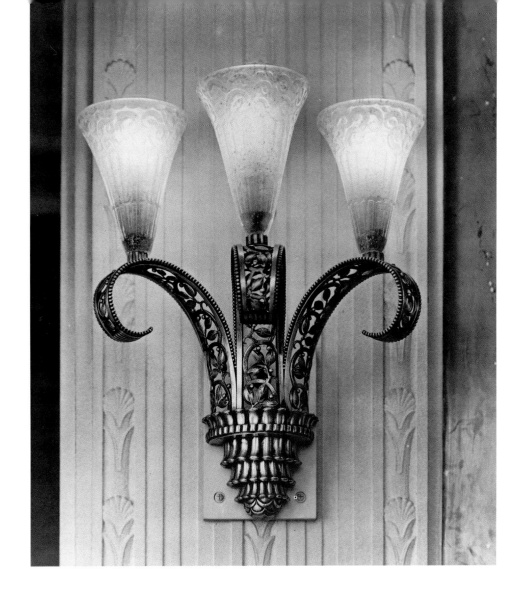

156. Sconce, 1925. Silvered wrought iron and acid-etched Daum glass, 20 x 17½ x 8". Exhibited in La Galerie Edgar Brandt

grille *Diane et la Biche,* which was also in the room (see fig. 136).[207]

Several fire screens appeared in the Brandt display: among them were *Danseur* (also known as *Les Plumes*) and *Le Nid. Danseur* depicts a female dancer balancing on one leg above a series of Egyptian fan motifs, a tambourine held high above her head (fig. 157).[208] The background of the figure is densely packed with C scrolls and sixteen fluffy, feminine feathers. The feathers defy reality: although forged of iron, they look so delicate that it seems quite possible they could be blown away by the wind. Eminently successful in this example, the feather motif was repeated in two pair of decorative grilles that Brandt forged for the Folies-Bergère, probably in 1926. These later works, commissioned by the owners of the night club, either for permanent display or for a specific revue, also employed a composition of feathers in a rectangular frame with dancers forming the central motif. While the feathered costumes worn by beautiful chorus girls in Paris night clubs may have been the inspiration for this iron design, an image of Josephine Baker in one of her scant bikinis with great pink ostrich plumes affixed to it is so immediately conjured up that one cannot help entertain the notion that she was the specific inspiration.

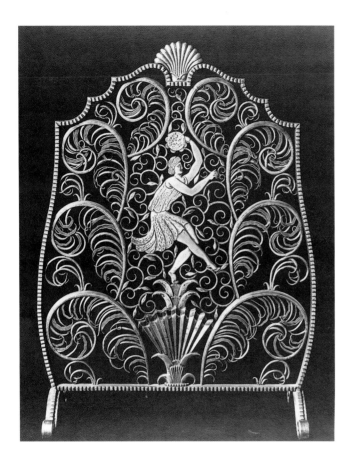 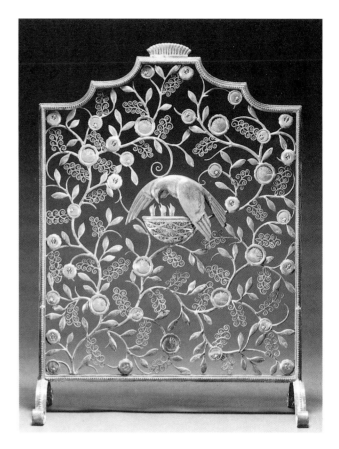

ABOVE LEFT:
157. *Danseur*. Fire screen,
1924. Patinated wrought iron
and bronze niello, 39½ x 30″.
Exhibited in Brandt's stand at
the 1925 Exposition

ABOVE RIGHT:
158. *Le Nid*. Fire screen,
1925. Wrought iron, 40 x 29
x 10½″. Exhibited in Brandt's
stand at the 1925 Exposition.
Courtesy Christie's Images

Le Nid shows a mother bird hovering over her nest of three young chicks against a background of stylized roses, buds, and leaves (fig. 158). In 1926, the same screen was used for the display of Cheney silk in an American exhibition at the Louvre.[209] In 1927 the fire-screen design, lengthened and augmented, became a door that was photographed for the magazine *L'Amour de L'Art* (fig. 159).[210] In the 1925 screen, the mother bird spreads her wings protectively over her nest. In the larger version, the story occurs in three vignettes. At the top of the door the male and female doves perch on the nest they have made. The central scene depicts the male placing food into the female's beak as she sits on her eggs. In the final episode, the mother feeds her newly hatched chicks, repeating the design of the 1925 fire screen. A careful examination of the two works reveals subtle differences in the woven bars of the nests, as well as changes in the flowers and leaves. Even the framework was altered; the earlier screen employed beading while the door frame featured incised and flat bars with sets of three horizontal bars in between. The additions to the door—graceful scrolls that link the three maternal episodes—were thoughtfully arranged. The depiction of successive scenes in one work is rare in ironwork; however, this door, Brandt's potiche, and his vase *Olympie* (the latter two to be discussed below) are all meritorious examples of this ancient narrative device.

Gilbert Poillerat described the Brandt stand as exuding an air of openness due to the narrow dimensions of the objects presented. The pieces were limited in number, but each one exemplified the very best work of the Brandt firm. In particular, the screen *L'Oasis* and the two neoclassical potiches are worthy of closer examination.[211]

The huge, five-paneled screen, *L'Oasis,* was a masterpiece of *ferronnerie* (fig. 160). It was inspired by the lacquered screens of Jean Dunand, as well as ancient Japanese screens. The idea for the screen was Favier's, the design was Brandt's.[212] The center panel of the screen depicts a stylized fountain, which was made from heavy pieces of iron that were welded at certain points and then grooved to resemble streams of water. Smaller jets of water were made of thinner, wavy bars that were welded to thicker, solid bars; the welding lines are visible upon close examination. On each side of the fountain are two panels in which the flow of water continues while encompassing huge tropical flowers and leaves. The small flowers at the bottom were copied from a pattern that Favier found in a book of ancient Chinese fabric designs from the Ching dynasty.

The formal symmetry of the screen (which was finished on both sides) and the small scrolls reflect Brandt's early, classically feminine repertoire, while various newer elements allude to the emerging *style moderne*. The ripples of falling water and the crimped gearlike flowers also show the influence of a machine-inspired aesthetic, with its emphasis on movement and speed. The boldness of Brandt's design invites comparison with the powerful images of modern technology that were being seen in contemporary architecture (Le Corbusier) and painting (Fernand Léger). And yet, with its decorative vocabulary, *L'Oasis*—a transitional work—demonstrates a different achievement: its homage to older decorative motifs fuses harmoniously with the modern focus on the machine through the use of stylized repetitive forms.

The lush tropical atmosphere of *L'Oasis* is brought out by the stylized croton leaves, which were cut from sheet iron and veined down the middle, their edges rolled to accommodate a fixing clip. They are overlaid with a chevron pattern in brass plating. The brass finish was achieved by a technique called electrolysis.[213] It is accomplished by using an electrochemical plating solution, similar to that which was developed to plate silver in the late nineteenth century. A wax resist was applied to the iron chevrons where the brass was not wanted. The flowers between the leaves were shaped on a *bigorne* (beak iron), a silversmith's tool made of horn and hardwood. This mounted tool, used with a hammer, allows the smith to crimp and shape from the front, in a method different from repoussé, which is primarily worked from the back of the material and finished on the front.

The beguiling foliage these techniques yielded evoked the idea of Africa, which had been captivating the Parisian artistic community for twenty years. Artists such as Pablo Picasso, Henri Matisse, André Derain, and Maurice Vlaminck had collections of indigenous African art. In 1925,

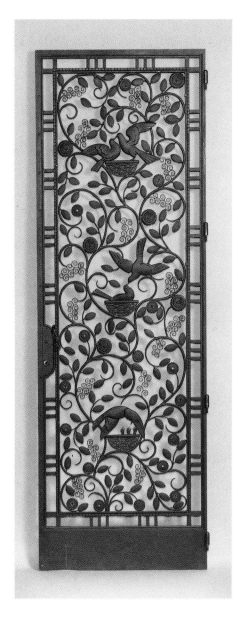

ABOVE:
159. *Le Nid.* Door, 1926. Wrought iron, 6′3″ x 38″. Courtesy Sotheby's, Inc.

FOLLOWING PAGES:
160. *L'Oasis.* Screen, 1924. Wrought iron and brass, 70⅞″ x 8′9″. Exhibited in Brandt's stand at the 1925 Exposition. Collection Robert Zehil, Monaco

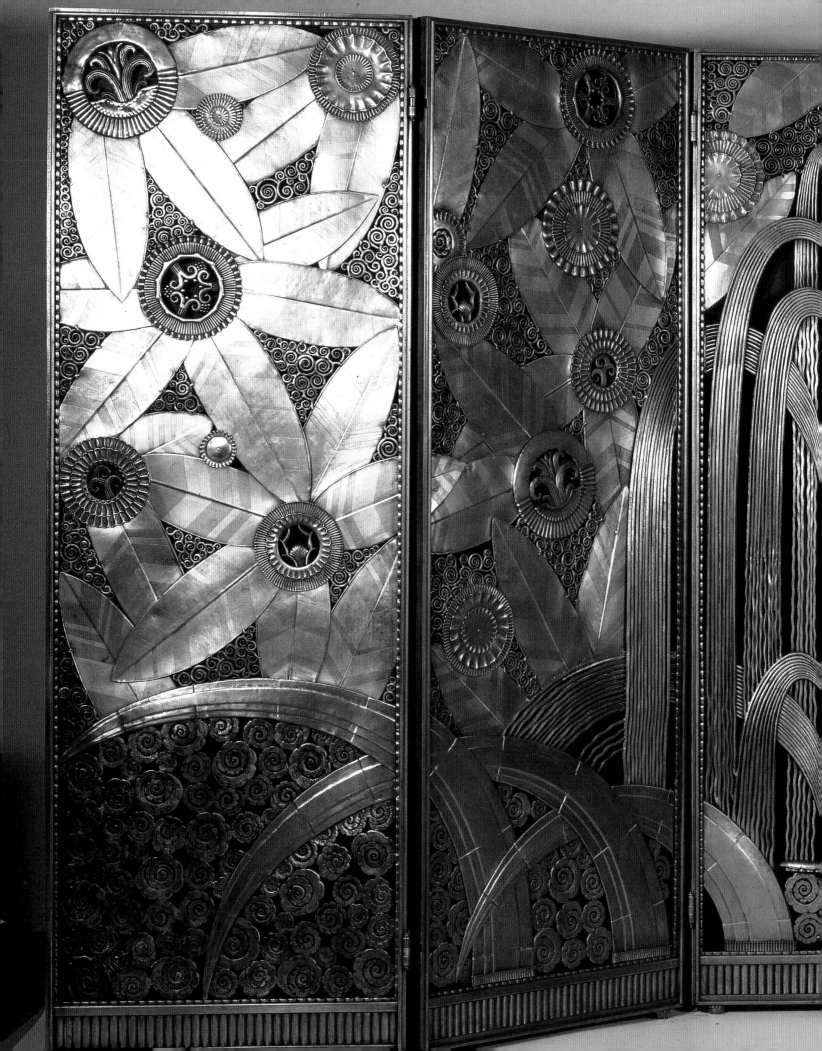

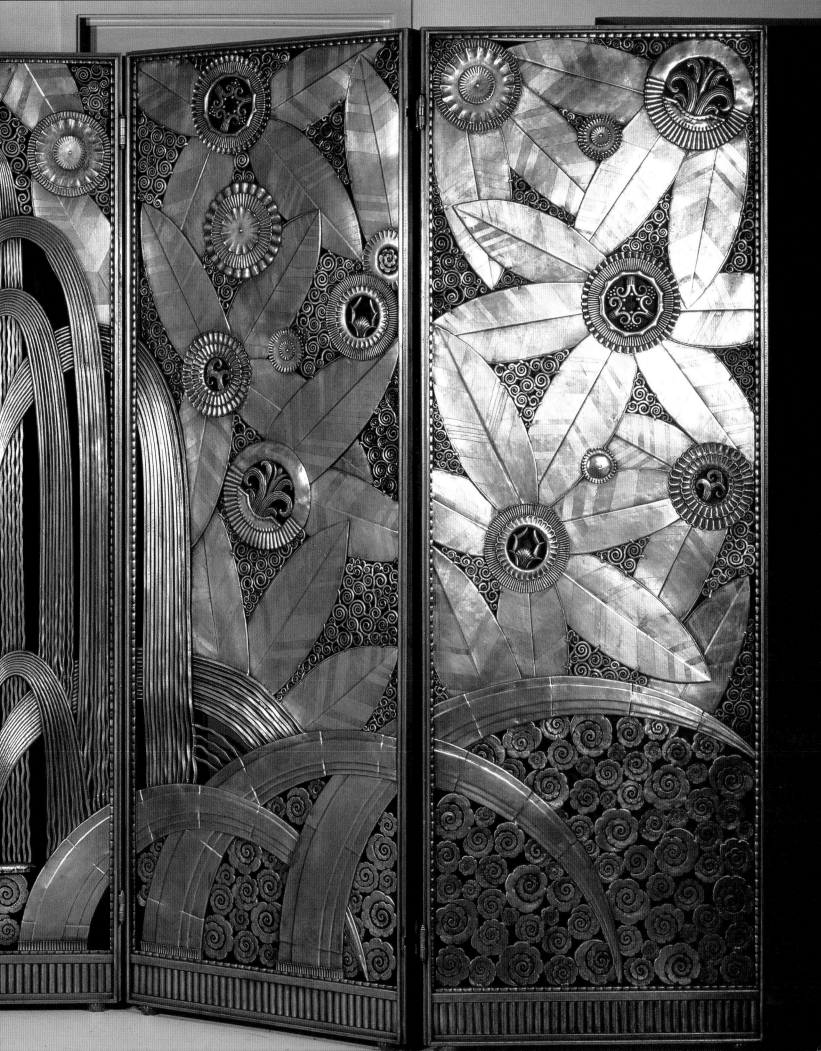

when Josephine Baker opened at the Bal Tabarin, the American jazz singer-dancer and her Revue Nègre were soon ruling Parisian nightlife. A plethora of ethnic influences—including the Egyptian craze already detailed—infiltrated the artistic community, many of them coming from the French colonies of West Africa.[214] It was only natural that *L'Oasis,* encapsulating the exoticism of Africa as it did, would become a well-known visual entity in its day. A facsimile of the screen was used in the set at the Folies-Bergère when "La Baker" was the star attraction in 1926. The central fountain motif was copied almost exactly for the show.[215] The fountain motif and the foliage of *L'Oasis* were also used by the perfume house of Guerlain after 1925 on the label and box of the popular scent "L'Heure Bleu."[216]

The work of the painter Fernand Léger, especially his attention to the role of man in a mechanized society, is also reflected in *L'Oasis.* Familiarity with Léger's Synthetic Cubist technique of overlapping, precise planes may well have played into the mechanistic development in *L'Oasis.* It is interesting to consider that Léger's painting *Le Balustre* appeared in Le Corbusier's Pavillon de L'Esprit Nouveau, a controversial paean to mass production, which caused a sensation at the 1925 fair. Its architectural imagery, full of mathematical, geometric themes, and its rooms furnished with machine-made craft objects reflected the philosophy of Purism. The premise of Purist doctrine that was beginning to influence ironwork was that form was more important than subject.

L'Oasis demonstrates that the machine aesthetic and a move toward greater abstraction had already taken root in Brandt's atelier. When *L'Oasis* was first exhibited in the Salon d'Automne of 1924, it was immediately praised. In his review for the *Gazette des Beaux-Arts,* Louis Hautecoeur said: "it is works such as the screen that will count in the history of the decorative arts."[217] Henri Clouzot called it a work of extraordinary virtuosity (*"une virtuosité inouie"*). He went on to say: *"Travail de forge? Il serait impropre de lui laisser ce titre."*[218] He felt it was improper to label *L'Oasis* a work of the forge, as such prowess was accomplished with the autogenous welding gun and power tools.

The fact remains that *L'Oasis* is Brandt's most renowned work. The technical superiority of the two-sided screen, with its complex riveting, hot and cold welding, electrolysis, clasps, and overlaid components, provides proof of the sophistication of Brandt's atelier.

Aside from the screen, the most intriguing objects shown in Brandt's stand at the exhibition were two silvered bronze potiches. Quintessentially Art Deco, each was decorated with figures that move among stylized flowers and, in their static dance, capture for all time the sculptural aesthetic of 1925. One of the two vases was purchased by a Dr. José Iraola in 1927; it was sold by his daughter fifty-three years later. For many years it was owned by the dealer/collector Anthony DeLorenzo in New York (figs. 161, 162). The second potiche remains hidden away in a private collection, probably in South America.

The design of the potiche is divided horizontally into three sections. The central section consists of a classically inspired frieze with eight figures, two male and six female, sculpted in low relief against a background of flowering vines. Beading above and below the frieze separates it from the top and bottom portions. The neck of the vase is fluted, as is its columnar base.

The two back-to-back male nudes take center stage in the vase's monumental design. The male on the right is in complete profile. His back is rounded as he lifts his arms to strike the cymbals strapped to his hands. His head is slightly bent and his hair tied with a fillet in the Greek manner. One large, slanted eye gives expression to the face. The planar representation of the eye recalls ancient Egyptian and archaic Greek examples. In the slight muscular delineation of the figure's chest and stomach, Brandt achieved a quality of modeling similar to that of the Greek vase painter Exekias.[219] Whereas Exekias hinted at musculature with a few painted lines, Brandt could take advantage of undercuts to create contrast of light and shadow. The cymbal player's knees are bent and he is balancing on the ball of one foot, indicating a sense of movement. The same sense of suspended movement is captured in the male figure on the left, which is depicted in a three-quarter frontal position from the waist up. His raised arms hold a flute, while his head bends forward to blow into the instrument. The way his upper body bends toward the cymbalist, combined with the close position of the feet of the figures, results in a visual relationship that is both sensual and poetic.

To the left of the flute player, three nude females move in dancelike steps away from the males. They hold hands, as in a circle dance, with each figure assuming a slightly different position. The first female faces away from her companions and is looking back toward the flutist, thus establishing a link with the musicians. She has the characteristic Egyptian eye, and her wavy hair is arranged in a chignon at the nape of the neck. The second female offers the spectator a three-quarter view of her back. The line of her spine and buttocks is gently incised to add dimension. The third figure is in profile. In front of her there is a break in the chain. Then the same three dancers repeat, eventually meeting up with the cymbal player.

Most likely Brandt meant us to see the three dancers in two phases of their procession around the male musicians. The break between the sets of dancers strongly suggests that the piece was meant to have a defined front and back. Furthermore, a careful look at the original photograph of the installation shows the males in the central position facing the viewer.

The floral background, made up of many stylized vines, leaves, roses, and tulips, offers a great contrast to the highly polished, essentially smooth surface of the large figures. While the floral work is also very shiny it is modulated by many undercuts, which slightly reveal the dark bronze base of the vessel. Brandt may have cast the potiches at his atelier by the lost-wax method; or he sand-cast the piece in three sections; or he farmed them out to a goldsmith (for casting), which was a common practice at the

161. Potiche, 1925. Silvered
bronze, height 48⅜". One of
a pair of vases exhibited in
Brandt's stand at the 1925
Exposition. Courtesy
DeLorenzo Gallery

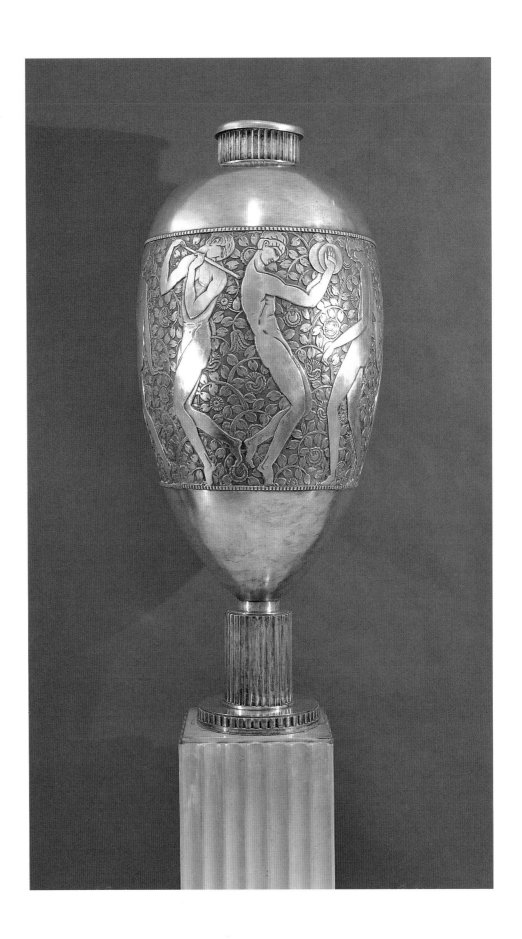

time.[220] Since the top of the vase is sealed shut, the secrets of its construction remain hidden inside. However, a careful examination revealed certain imperfections—pits and bubbles that can occur when the molds are broken.[221] Thus any method other than casting in bronze has been ruled out. The silvered patina, still in wonderful condition, was most likely applied in a bath by chemical or electrolytic reduction of silver ions, or alternatively by boiling off mercury from a silver amalgam.[222]

The composition within the central figurative frieze, the beading, and the fluted columnar elements all point to a neoclassical mode. Like many of his colleagues, Brandt was well versed in the long history of classicizing figurative and architectural forms. Brandt, Ruhlmann, and other artists of their time had returned to the classical tradition for the inspiration of its pure form.

One sculptor who may have directly influenced Brandt and the design of his potiche was Joseph Bernard, who was responsible for the wall relief *La Danse*, placed above *Diane et la Biche* in Brandt's exposition stand. The subject of dance was popular at the exposition; indeed, both Brandt and Bernard had used the dance processional theme. Both artists also worked on Ruhlmann's "Hôtel d'un Collectionneur." For the garden facade, Bernard sculpted another frieze called *La Danse,* and an earlier work called *Young Girl with a Jug* (1912) was placed in the salon. Other Bernard bronzes were placed throughout the rooms, including the bathroom.[223] There is a resemblance between Bernard's figures and the body types of the females seen in the bronze potiches. Although Brandt's women are more elongated, a sense of captured and pending movement is present in both works. As an ironsmith, Brandt was not used to rendering detailed faces, and may have looked at Bernard's work for inspiration. For many years the sculptor's work was always close at hand, and there is evi-

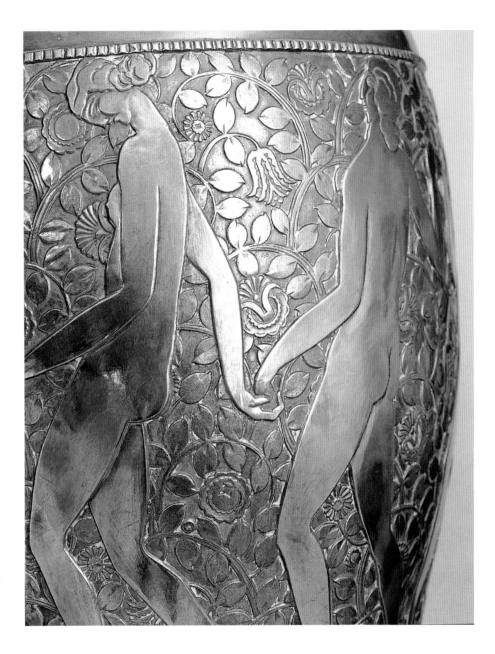

162. Detail of the silvered bronze potiche

163. A Joseph Bernard draw-
ing of dancers in the antique
style, 1919

dence that Brandt paid close attention to it. In Bernard's drawing of
dancers (1919), a design for a bas-relief, the dancer on the right of the
trio exhibits a profile that can be compared to the faces on the potiche
(fig. 162).

Art Nouveau was in full bloom when Brandt began his career; his
early jewelry showed that he was only mildly influenced by this movement.
Instead he slowly developed a vocabulary that included neoclassical ele-
ments, nature themes (both realistic and stylized), Japanese components,
and Egyptian motifs. By the Exposition of 1925 Brandt had achieved mas-
ter status as a *ferronnier*. Deemed *hors concours*, he was a member of sev-
eral juries for the exhibition. Brandt's wrought-iron flowers had transmuted
from delicate tendrils and realistic leaves to geometric and stylized arrange-
ments. The stamped and crimped floral forms in *L'Oasis* appear to be less
gearlike than the circular forms in *L'Age d'Or*, mainly because they are far
less dense. The presence of all these particular elements and developments
makes the body of work Brandt presented at this pivotal exhibition a
benchmark in the history of ironwork. Considering the large number of
objects that Brandt and his company produced for the 1925 Exposition, it
is remarkable that they achieved such a diversity of expression. It is clear
that Brandt had found a positive formula for rapid execution without los-
ing the sense of luxury, craftmanship, and good taste that had marked his
previous work.

WORKS IN BRONZE:
VESSELS AND SERPENTS

Although the stamp "E.Brandt" is primarily associated with wrought iron, the *ferronnier* produced a body of bronze objects that are worthy of discussion because of their varied motifs and fine quality. Brandt was involved with bronzes from early on in his career. While the potiches may have been the most resplendent bronzes up to 1925, the vases Brandt had produced before them appear to have followed two basic designs: they were either small bronze cachepots like those he made for the exhibition salon of 101 Boulevard Murat (fig. 164) or they were larger, such as hammered bronze vases with snake handles. Several of the small cachepots (c. 1921–22) reflected mural and metalwork motifs from the Villa Boscoreale (1st century A.D.) near Pompeii, which were on view in the Louvre. Faux-porphyry columns (made of marble or stone chips and plaster) embellished with wrought iron were made to display the cachepots, greatly adding to their antique appearance.[224]

Since bronze vessels require modeling and casting as does sculpture, one must assume that Brandt would have followed the work of the great sculptors of his day. Auguste Rodin (1840–1917) loomed above all others as the creator of powerfully rendered sculptures, especially nudes. As the most celebrated sculptor of his day, Rodin was a champion of free expression who broke with academicism and pointed the way toward experimentation and fragmentation of form. Another major French sculptor was Aristide Maillol (1861–1944), who was interested in the formalism of Archaic Greek art. Whereas Rodin's sculptures were often highly textured, Maillol's archetypal women were mainly smooth surfaced.

Brandt and his designers would also have paid particular attention to the metal sculptures of Constantin Brancusi (1876–1957), which were finished with a high gloss. Brancusi's abstraction *Bird in Space* (1919) presaged interest in the late 1920s in chrome, polished steel, and aluminum, new materials that were used for streamlined furniture, cars, and trains. Brandt would also have known the work of Gustave Miklos (1888–1967), whose refined geometricity and stylized forms made a great impact in the mid- to late 1920s. His bronze *Woman's Head* was influenced by Modigliani, as well as by African, Greek, and Byzantine art.

Rodin's pupil Antoine Bourdelle combined the textured surfaces typical of Rodin with a flat ornamentation similar to that of Archaic Greek and Romanesque art. He had seen the frescoes in Pompeii and the classical sculpture in Naples, and they were catalytic to works such as *La Comédie Antique et La Comédie Moderne,* a section of the facade that he sculpted for the Théâtre des Champs-Elysées in 1912.[225] His bronze *Le Centaur*

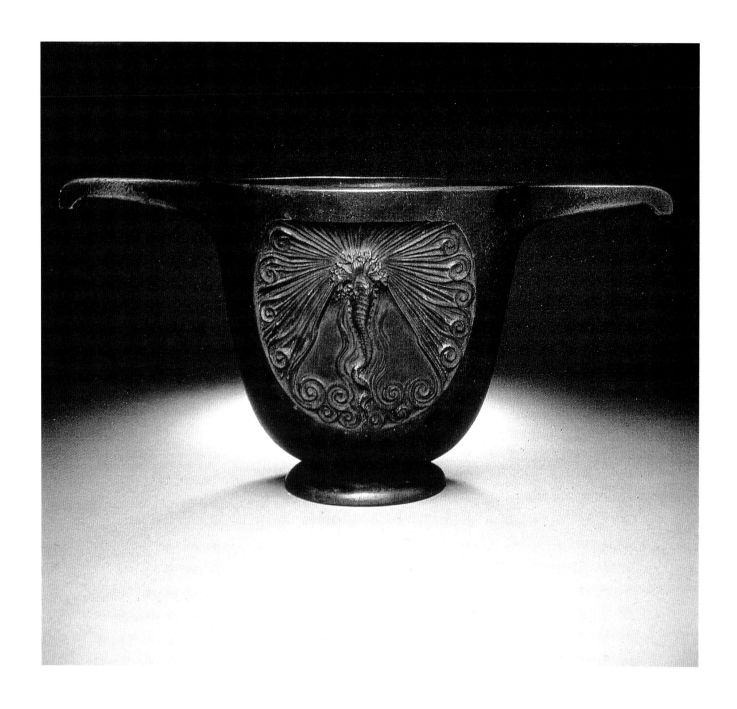

164. Chimera cachepot,
1920. Bronze, 10⅛ x 20¾″.
Exhibited at the 1920 Salon
d'Automne. Courtesy
Christie's Images

Blessé (c. 1914) suggests another inspiration for the stylized modernity of
Brandt's potiche figures. In fact, the two men worked on the Marseilles
Opera House in 1924 and at the 1925 Exposition, where Bourdelle's sculp-
ture *La France* was proudly displayed on the steps of the Grand Palais.

Under the influence of these and other artists, decorative sculpture of
the teens and twenties had become freer, stylized, and sometimes highly
geometric, but most often it aligned itself with neoclassicism. This trend
was also seen in the furniture of Emile-Jacques Ruhlmann, in the paintings

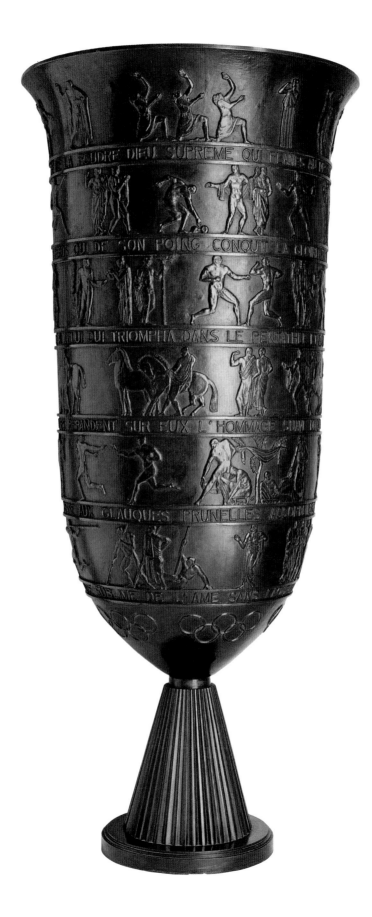

165. *Olympie*. Vase, 1926.
Bronze, 59 x 26¾″ diam. of
neck (21⅝″ diam. of body).
Pedestal not shown. Private
collection

of Jean Dupas, and in the ceramics of Jean Mayodon and René Buthaud. Through many collaborative projects fine and applied artists experienced a cross-pollination of ideas. Antoine Bourdelle addressed the renewal of classic form, while his fellow artists, such as Alfred-Auguste Janniot,[226] Marcel Bouraine, Max Blondat, and Joseph Bernard, also produced works in this neoclassical vein. It is fair to say that Bernard's vision of Greek antiquity would have had the most appeal for Edgar Brandt.

At the Salon d'Automne of 1926 Brandt unveiled a work in which he carried the depiction of neoclassical figures to a new height. The piece, an enormous bronze vase entitled *Olympie,* affords an interesting comparison with the potiches that he had displayed the previous year at the Exposition. A photograph that appeared in the December issue of *Art et Industrie*[227] reveals that *Olympie,* like the potiches, was displayed in a niche, an architectonic device that was especially popular for dining rooms (fig. 165).

Like the potiche, *Olympie* had precedents in ancient art. The potiche was worked in a single register, much like many Archaic Greek and Etruscan red-figure amphorae (6th century B.C.), while *Olympie* is divided into seven registers, following the example of later bronze situlae (pails), which were divided into three or more registers. The bottom register contains the Olympic insignia of five linked circles, each representing one of the five continents and denoting the sporting friendship of the peoples of the world. In the upper six registers, nude or toga-clad athletes are shown participating in various sports, such as boxing, archery, discus throwing, running, javelin throwing, and horsemanship. Between the registers are inscriptive bands that contain an eloquent ode to Zeus and the Muses, imploring them to favor the pancratium and pentathlon athletes of Olympia with glory and victory.[228] Small bands above and below the lettering have a gilt finish that sets off the darker bronze figures. Brandt's orderly sectional vessel follows the tradition of Roman repoussé silver cups, narrative murals, and relief sculpture such as Trajan's column of A.D. 112–13, all of which incorporated pictorial registers in order to tell a story or record a number of events sequentially.

Containing approximately seventy figures in relief, *Olympie* rests on a fluted cone-shaped base which, in turn, sits on a rectangular patinated sheet-iron pedestal that pivots 360 degrees. The rotation of the vase and its conical stand was achieved by an electric motor hidden inside the pedestal. Although the exact history of this vase remains unknown, it is not difficult to surmise. Named after Olympia, the site of the ancient Olympic games, the vase—in its style, themes, and inscription—constitutes a neoclassical evocation of Greek heritage.[229] It seems almost certain that Brandt, like Hephaestus, the Greek god of blacksmiths, was inspired to create *Olympie* on the occasion of an important athletic event, either the VIII Olympic Games, which were held in Paris in 1924, or the first Olympic Winter

Games, which were held in Chamonix, France, in the same year. Another possibility is that the vase was commissioned for the IX Olympiad in Amsterdam or for the II Winter Games (held in Saint-Moritz, Switzerland), both of which took place in 1928. In any event, *Olympie* not only honors the courageous spirit of Olympic competitors but symbolizes hope for the future of humanity. Brandt was exceedingly fond of this work; he kept it near him until the end of his life. In 1932 he placed it in the main foyer of his model factory at Châtillon-sous-Bagneux. After 1936 it was moved to 101 Boulevard Murat, and in 1950 it ended up in Brandt's factory, Construction Mécaniques de Léman, in Geneva.

While both the potiche and the vase are rooted in antiquity, the former vessel, with its large figures and silvered bronze coloring, was a highly stylized expression of neoclassicism. *Olympie,* on the other hand, with its many small-scaled figures and dark patina, was an attempt to imitate an antique bronze. Its shape and arrangement, however, preclude any date other than the 1920s. Both of these vases show the extraordinary range and high quality of metal casting that was done in France during the decade.

Of all the bronze objects fabricated by Brandt, the most commercially successful were his snake lamps. The first of these—a cobra, *Le Serpent Naja*, as in genus *naja*—was introduced before World War I; later it appeared in a 1920 exhibition in the Salon des Lampadaires, where it was purchased by the state. While less successful from a design standpoint than most other Brandt productions, the torchères are still sought after for their fine finishes and their exotic and awesome qualities.

Snakes have always evoked a dual fascination of peril and awe. Visual representations of snakes go back to the Paleolithic period. Worship of the snake was prevalent in many ancient cultures, including those of Egypt and Greece, where snakes had a religious meaning. Egyptian pharaohs wore the uraeus, the figure of the sacred asp or cobra, on their crowns, and uraei were pictured in temples and tombs to ward off enemies. For the decorative artist, snakes offer flexible and imaginative motifs that can be twisted for handles or lengthened for lamps or vases. For Brandt and his designers, the cobra with a dilated throat that appears in so many Egyptian works must have suggested to them not only an appropriate shape for a lamp but also a dramatic form for expression in iron or bronze.

The snake motif was, in fact, ubiquitous in French decorative arts in the 1920s, and had enjoyed a popularity since the nineteenth century. The goldsmith and jeweler Lucien Falize (1839–1897) crafted an Art Nouveau silver teapot whose spout was fashioned as a lizard and whose wide handle was hammered into a snake.[230] René Lalique designed a purse (c. 1901–03) with a silver clasp featuring two menacing snake heads. Their intertwined bodies were embroidered with silver and metallic thread on the bag.[231] For the 1913 Salon des Artistes Décorateurs, Jean Dunand produced an oviform copper vase inlaid with silver and flanked by bronze cobras, while a

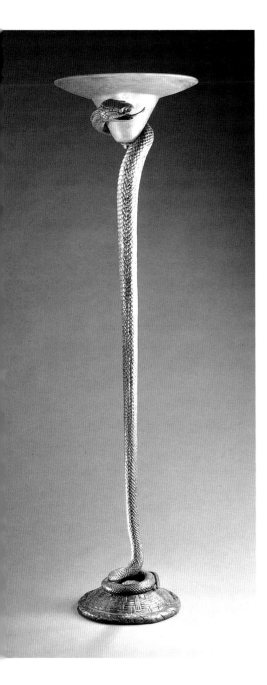

166. *La Tentation.*
Serpent torchère, produced
1920–26. Bronze and Daum
glass, height 66″. Stamped
"E.Brandt"; glass inscribed
"Daum Nancy" with the
croix de Lorraine. Courtesy
Sotheby's, Inc.

pair of copper snake sculptures he made in 1919 explored further his interest in complex shapes and patination.[232] In 1920, the sculptor/designer Albert Cheuret conceived a console table that was supported by three silvered bronze cobras.[233] In 1930 Dunand, in collaboration with the painter Paul Jouve (1880–1973), produced a lacquered metal book cover for Rudyard Kipling's *La Chasse de Kaa*.[234] It featured a coiled cobra, in black, rust, and beige-to-yellow tones on an eggshell background.

Brandt's serpent torchères were cast in two designs. In the first version, the serpent, modeled after the *Boa canina* or *Python reticulatus*, rises up from an inverted basketlike base. At the top, the head's gaping jaw and its flaring tongue wrap around an alabaster or Daum glass shade that is shaped like an inverted hat. This style, *La Tentation*, was made at approximately 66″ high and also in a table-size version, 20″ (fig. 166).[235] The second design, the table-size *Cobra*, was also produced in two heights—approximately 41″ or smaller at 20″ to 21″ (fig. 167). Variations in size had to do with special commissions and differences in the height of the bases. Each cobra shows the tail covering the width of the base in an undulating pattern and then the body rising to wrap sinuously around a very large conical Daum glass shade.[236] Here the menacing head and flashing tongue are larger than in *La Tentation,* and the hooded head faces outward from the lamp rather than nestling around the shade. The patina on the scaly-skinned surface of these lamps was successfully rendered with a chemical oxidation process. The taller lamp body depicts a longer reptile and is therefore straighter and more stylized.[237] The smaller serpent casts are more realistic, appearing to lash out before one's eyes. A 1923 photograph from 101 Boulevard Murat shows bronze vessels displayed among the snake lamps (fig. 168).

These bronzes were made to order, often for clients who were captivated by the exoticism of the model displayed in the showroom. Full-page advertisements were taken out in periodicals such as *Mobilier et Decoration.* Even though Brandt's firm basically emphasized the limited production of wrought-iron objects, he knew when a large edition of bronze torchères was viable. Approximately one hundred of each size were cast. The patina was done by specialists. Variations in the materials for the torchères' shades included alabaster, pâte de verre, metal, and plastic.[238] All four lamp sizes have been seen with both marble or bronze bases and more of the larger-size lamps have surfaced than the others.[239] There are variations in the mold design within each size category: for instance, different arrangements have been seen for the winding and folding of the serpent's tail. It should be pointed out that many reproductions of the serpent lamp are being made today; however, the quality of the patina on these lamps is poor in comparison with the Brandt originals.

A pair of 1926 cobra andirons are among the most robust and satisfying forged objects to come out of the *ferronnier*'s atelier (fig. 169). The face, the hoods (spanning 7″), and the neck were forged from one bar of

156

wrought iron. At the bottom of the long neck they were joined to the undulating tail, which was forged from a second bar. Each cobra was riveted to a base that resembles an ancient footstool. In this piece one can appreciate

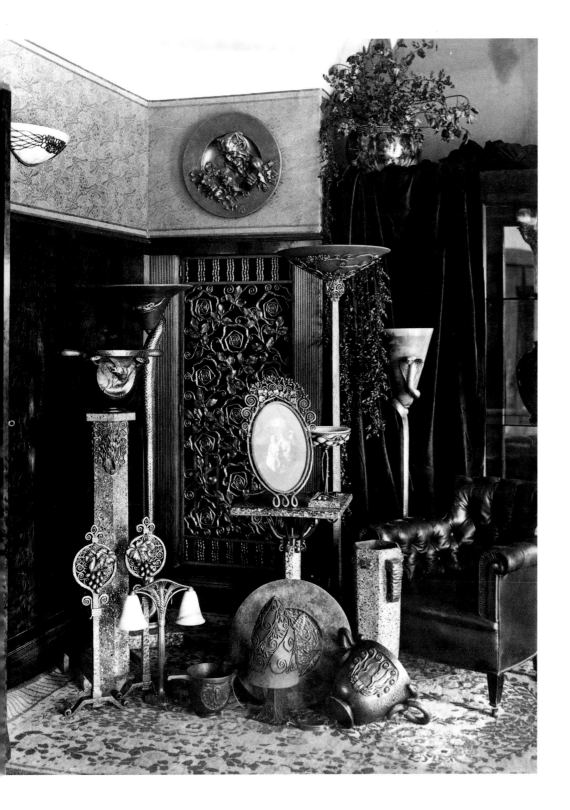

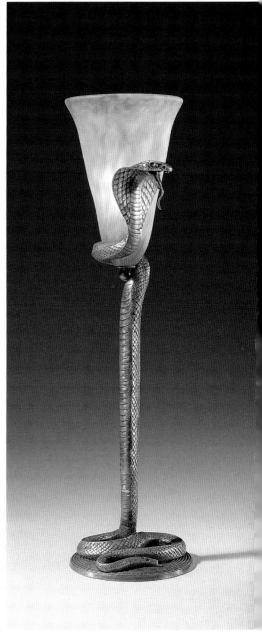

ABOVE:
167. *Cobra*. Table lamp, produced 1920–26. Bronze and Daum glass, height 21¼″. Stamped "E.Brandt" on base; glass inscribed "Daum Nancy France" with the croix de Lorraine. Made in two sizes; larger size (approximate height 41″) sold for $150 in 1925. Courtesy Sotheby's, Inc.

LEFT:
168. *Cobra* and *La Tentation* displayed in Brandt's showroom at 101 Boulevard Murat, c. 1923. Note the crane wallpaper and the faux-porphyry items.

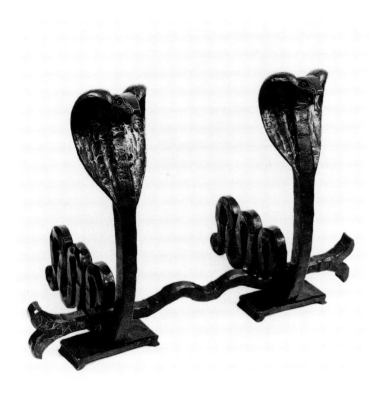

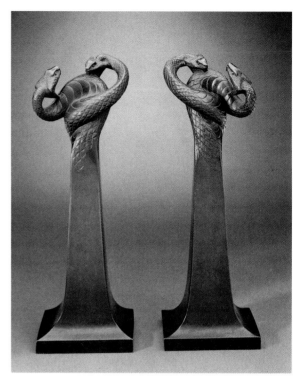

ABOVE LEFT:
169. Pair of cobra andirons,
1926. Wrought iron; andirons
26 x 8½ x 19″, crossbar 5¼ x
36 x 1½″. Stamped "E.Brandt"
on front neck of snakes.
Virginia Museum of Fine Arts,
Richmond, Va. Gift of Sydney
and Frances Lewis

ABOVE RIGHT:
170. Pair of serpent andirons,
c. 1928. Bronze, height 17¾″.
Stamped "E.Brandt".
Courtesy Christie's Images

the importance of the power hammer that was used to pound a larger stock bar of iron (4 x 24″) to the desired width of approximately 14″ for the neck. The power hammer, a means for spreading the material, did the arduous work for the smith and allowed for those marvelous rough hammer marks. Of course, hand hammering and finishing would follow.

Ultimately, Brandt felt that tooling, whether by hand or by machine, was equally important: each method augmented the other. The deep impressions from the hammers and fullering tools accepted the linseed-oil finish. It is also possible that the cobras were heated and then brushed with a brass brush, which would cause certain particles of brass to adhere to the iron, producing a rich brown-gold, almost bronzelike patina that has held up for seventy-three years.[240] Unlike eighteenth-century smiths who wanted clean surfaces, Brandt wanted the roughness of the material to be seen in this piece. The critic Gabriel Henriot felt that this set was worthy of being placed in the Rouen museum alongside iron from the Middle Ages.[241]

In contrast to these early, heavily forged andirons, a pair of later bronze examples offer the stark modernity of two intertwined, attacking serpent heads coming out of tapering supports (fig. 170). In the earlier wrought andirons the hammered effects were prominent; in this example the crosshatched lines on the snake bodies provide contrast with the

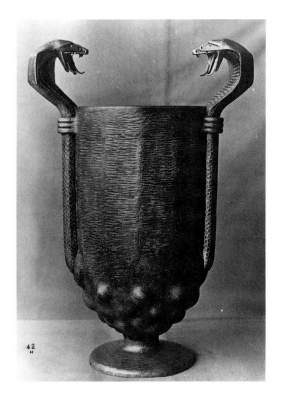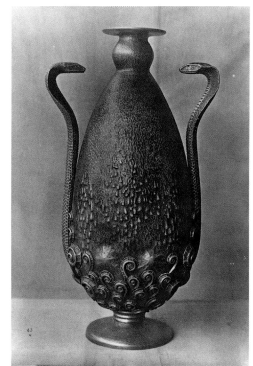

smooth supports. These two sets of andirons seen side by side furnish an opportunity to see how Brandt designed specifically for each material.

Brandt also produced a pair of hammered bronze jardinieres, featuring double cobra-head handles that curved toward the opening of the vessel in much the same manner as the serpent heads Lalique placed on a suede-and-silver purse (fig. 171). Brandt's serpent heads are rendered with a flat angularity, and the overall design of the jardiniere brings to mind the 1913 vessel by Dunand. In comparison, on a slightly later amphora-shaped wrought-iron vase, where the lines are rounder and softer, the serpents appear less fierce as they face each other just below the small rim. The belly of the pot is covered with raised snail forms and bubbles (fig. 172). In both vases the texture of the reptiles' skin is a matchless visual counterpoint to both the heavily hammered and the smoother exterior surfaces.

A striking bronze cachepot used the predatory motif of two serpent handles peering inward toward a central concavity, in which an eagle is nervously perched (fig. 173).[242] Brandt could create elegant beauty from unexpected motifs. An unusual bronze vase, created in 1920, incorporates snakelike eels gracefully wending their way upward on the pot (fig. 174). In a wrought cachepot with snake handles, the reptile bodies have been twisted in an uneven figure eight, allowing the heads to peer out at the central motif of ten snail-like tendrils (see fig. 168). Wrought-iron cobra paper-

ABOVE LEFT:
171. Vase with serpent handles, c. 1921–22. Hammered bronze, 25½ x 18″. Stamped "E.Brandt". Sold for $650 in the 1920s

ABOVE RIGHT:
172. Vase with snake handles, c. 1921–22. Hammered wrought iron, 28 x 16″. Stamped "E.Brandt"

RIGHT:
173. Eagle cachepot with snake handles, c. 1921–22. Gilt bronze, 11 x 10⅛″ diam.; length over handles 19″. Smaller versions made with or without snake handles. Courtesy Sotheby's, Inc.

BELOW:
174. Eel vase, 1920. Bronze, height 25¾″. Stamped "E.Brandt Made in France". Courtesy Christie's Images

BOTTOM LEFT:
175. Serpent paperweight, c. 1921–26. Wrought iron, 4¾ x 3¼″ diam. of base. Stamped "E.Brandt" on lower coil of snake. Private collection

BOTTOM RIGHT:
176. Incense burner, before 1920. Wrought iron, 12 x 10″. Private collection

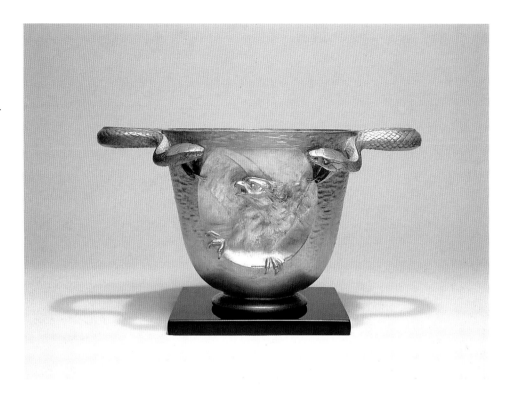

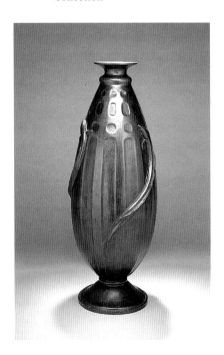

weights mounted on round bases and cobra watch-fob holders with flaring tongues were also among Brandt's reptilian oeuvre (fig. 175). As one of the wily serpents wends his way around an incense burner he conjures up the tale of Cleopatra's demise, as well as the similar death of Nikia in Marius Petipa's ballet *La Bayadère* (fig. 176).[243] Clearly the snake motif had universal appeal, and Brandt's merchandising flair prompted him to take full advantage of the opportunity that fascination represented. Producing a variety of serpent designs, especially the snake lamps, and offering them in a series was something few other ironsmiths did.

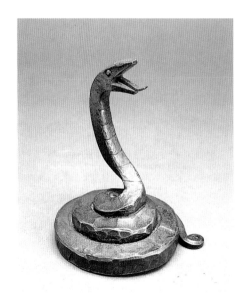

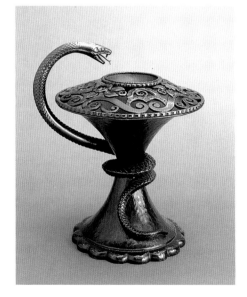

Since 1920, when 101 Boulevard Murat opened, Brandt's customers had been making their way to Auteuil, in the 16th arrondissement of Paris, to view the great variety of works installed in the facility's exhibition gallery.[244] There were drawbacks to this arrangement: a lot of noise emanated from the various workshops, and the establishment was far from the commercial and cultural center of town. In response to these difficulties, in 1925 Brandt opened a showroom for direct sales at 27 Boulevard Malesherbes (8th arrondissement), near the Arc de Triomphe and in the heart of the art gallery district. At his gallery Brandt displayed not only his own *ferronnerie* but the work of his fellow artists with whom he had shared years of exhibits at the Salon d'Automne and the Salon des Artistes Décorateurs.

In a revealing letter of July 22, 1925, to a friend, Edgar Brandt divulged his plans for the new showroom and invited the recipient to become an investor in the gallery, which he intended to set up as a corporation *(société anonyme)*.[245] "I am considering ways in which I might take commercial advantage of the possibilities offered by the considerable flow of foreigners who, more and more, are coming to Paris. . . . I believe the moment is very favorable [for the new gallery] in spite of all the dark political clouds and other problems—there will always be problems." He then asked his friend if he had spoken to their mutual friend Blondat about the project. "Would you then be so kind as to let me know whether I can look forward to your participation in this venture, and if so, what would be the amount of your investment. I am simply bringing together a group of friends around me and it would be most agreeable to count you among them." Lastly, Brandt stated that he felt the gallery would prove to be a commercial success. Once again, in both words and actions, Brandt showed himself to be a prescient planner and promoter who was not afraid to lay out a scheme and follow it up. The decisive qualities of the man that are revealed in this letter make it easy to understand how he was able to design, invent, and oversee a growing enterprise of art and industry.

Brandt's gallery can be compared to Siegfried Bing's shop L'Art Nouveau, which had opened thirty years earlier and where a variety of decorative arts were displayed, each one chosen to reveal the artist's conception of the modern spirit.[246] Most probably Brandt was inspired by the concept of Ruhlmann's "Hôtel d'un Collectionneur" at the exposition. Like the *ébéniste,* Brandt wanted to display his ironwork along with the works of fellow craftsmen that he especially admired.

The 1925 Paris Exposition had ended in October 1925, leaving the public curious and receptive. In effect, it had laid the groundwork for Brandt's next venture. With the inauguration of the gallery on December 9,

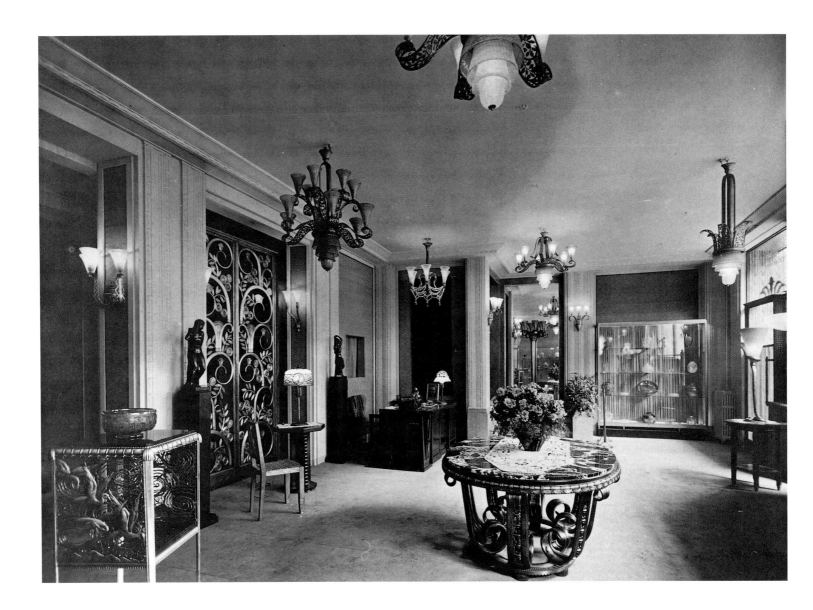

ABOVE:
177. La Galerie Edgar Brandt, main-floor salon, 1926. Henri Favier, architect. Note the Chabert-Dupont lace on the table. The large grille (left) can be seen in fig. 57.

OPPOSITE, TOP:
178. La Galerie Edgar Brandt, second-floor hallway, 1926. Note the serpent vase on the table and the lotus running bands on the walls.

OPPOSITE, BOTTOM:
179. La Galerie Edgar Brandt, second-floor salon, with the grille *Musiciens et Danseurs* at the window, 1926. *La Perse* is in the background along with Joseph Bernard's sculpture *Girl with a Jug*. In the foreground is the Sèvres/Brandt chandelier and Max Blondat's sculpture of a small boy on a ball.

1925, the *ferronnier* provided a venue for interacting with his peers and, at the same time, a prominent locale in which to garner new clients.

The decoration of La Galerie Edgar Brandt was handled by Favier, who ornamented the exterior of the ground floor with a facing of gilded and patinated plaster very much like the walls of Brandt's stand at the 1925 exhibition.[247] The background design of stylized flowers, fauns, and peacocks was subtle and rich in effect. A simple, flat awning led the eye to the wrought-iron letters announcing the gallery's name. To the right of the large display window was the entrance door, on top of which was depicted a crested Egyptian fan in the middle of a frozen fountain.

Inside, the street level accommodated a large central showroom and several smaller rooms, all of which presented a dazzling yet tasteful display. A welcoming bouquet placed on top of a Chabert-Dupont lace scarf graced an oval iron-and-marble-topped table that stood in the center of the room (fig. 177). Around the room off-white pillars and moldings contrasted with

the dark gray walls, which provided a peaceful background for the works of art. The moldings, of both plaster and metal, were decorated with vertical grooves, interspersed with vertical bands of lily and lotus buds and Egyptian lotus fans (fig. 178). Small objects were displayed in simple silk-lined vitrines. Numerous wrought-iron chandeliers hung jewel-like from the ceilings, and a variety of Brandt sconces lit up the walls. A glass table lamp graced the reception desk, one of many such lamps and torchères available. A large window on one side of the room provided the perfect place to display an iron grille or a set of iron doors. The natural daylight enhanced the electric lights and the reflection from the shiny objects in the vitrines, such as picture and mirror frames, and gave the room a resplendent atmosphere (figs. 179, 180). To the right of the reception desk was a stairway leading to the first floor, where customers could visit salons divided by a center hall.

Madame Roblot was the charming, reserved, and capable organizer of the gallery; she saw the clients, sold the

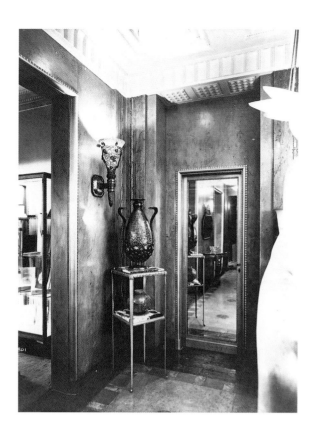

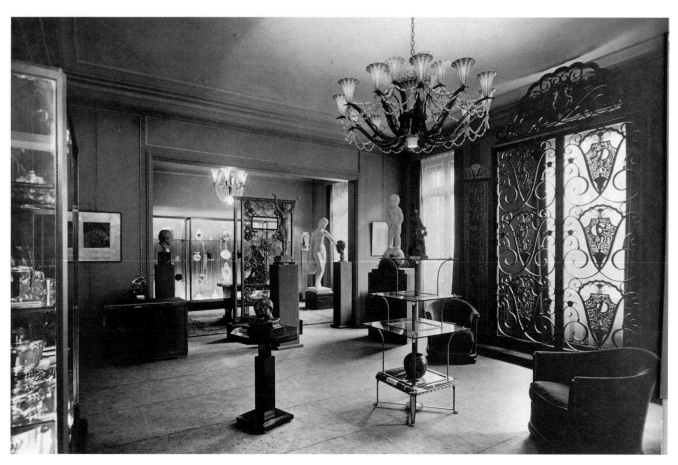

ABOVE:
180. Mirror frame, 1923–24.
Wrought iron, 7½ x 6½".
Stamped "E.Brandt" at base.
Private collection

BELOW LEFT:
181. Bear, c. 1925. Wrought
iron, 2⅞ x 4⅛ x 2½". Stamped
"E.Brandt". Private collection

BELOW RIGHT:
182. Pair of rooster bookends,
c. 1927. Hand-forged wrought
iron, 7¾ x 5⅞ x 3⅞". Stamped
"E.Brandt". Private collection

work, and perpetually replenished the items on display. Often the work of a single artist would be featured for ten days or two weeks, along with the regular presentations. Occasionally Brandt took an interest in talented unknown artisans and would bring them to public attention. One such artist was the Hungarian sculptor Istvan Zador, who was also a fine engraver and a painter of interior views and portraits.[248] A colorful "Bohemian," Zador brought a bit of liveliness to the gallery, usually turning up when he was short of cash. Brandt brought Zador's work into the gallery even though he was outside the regular artistic group, and he purchased Zador's work for his own home.[249] Not all the artists shown were successful. Some works were expensive, others more reasonable, but on the whole it was both pleasurable and profitable to display their work.

Brandt's prestigious name on the front door helped to unite a desirable group of artists, a harmonious ensemble of diverse talents. Jean Dunand's copper vases, Edouard Marcel Sandoz's (1881–1971) sculptures, François Pompon's (1855–1933) bronze animals, René Lalique's glass, and George Jensen's (1866–1935) and Jean Puiforcat's (1897–1945) silver all vied for the attention of astute collectors, the grand bourgeoisie, and the nouveau riche. Also prominent were the paintings of Gustave-Louis Jalumes (1873–1959) and Henry de Waroquier (1881–1970), the ceramics of Emile Decoeur (1876–?), the enameled glass and ceramics of Auguste Heiligenstein (1891–1976), the pâte de verre of François-Emile Décorchemont, the ivory carvings and shell work of Georges Bastard, the lace of Alice Chabert-Dupont, the book bindings of René Kieffer (1876–?), and the sculptures of Joseph Bernard, Charles Despiau (1874–1946), Louis Déjean, Auguste Guénot, and Max Blondat.[250]

Sometimes Brandt would join forces with another artist on a piece conceived especially for the gallery and its clientele. One successful example from about 1930 was a jardiniere that had a scrolling wrought-iron base by Brandt's firm, holding a bronze fish by his friend Edouard Sandoz. Often Brandt made iron mounts for Sèvres porcelain or for the work of Décorchemont. Also at La Galerie Edgar Brandt one could see the furniture

of Jules Leleu, Emile-Jacques Ruhlmann, Francis Jourdain, Léon Jallot, Louis Süe, and André Mare (until 1927), and of DIM (Décoration Intérieure Moderne), as well as the ceramics from the Sèvres and Royal Copenhagen factories. Glass by Daum was found in various forms, as well as individual pieces by Jean Luce (1895–1964), who worked in glass and ceramics. The rugs of Ivan da Silva Bruhns added a richness of texture and color throughout. A visitor touring the gallery in the late 1920s would have been overwhelmed at the plethora of fine objects on which to focus.

Les Artistes Animaliers, a group of designers, sculptors, and painters who focused on the portrayal of animals, held an annual exhibit at La Galerie Edgar Brandt, which delighted the public and was always a great success. Some of the artists who participated were Paul Jouve, François Pompon, Edouard Sandoz, and Charles Artus. The sculptors worked in a variety of materials: wood, marble, and rock crystal, which was a specialty of Sandoz.[251] Brandt himself was also fond of sculpting animals; a very charming small iron bear that he conceived, as well as a pair of rooster bookends, pelican ashtrays and bookends, and the ubiquitous 1920s deer on an iron base, were exhibited in the gallery as part of the animal shows (figs. 181, 182, 183, 184).

During this same period Brandt set up a second atelier at 25 rue du Hameau, in the 15th arrondissement, near the Porte de Versailles.[252] In this studio metalwork, welding, gilding, and stamping techniques augmented the work done at 101 Boulevard Murat. An adjunct to Brandt's growing business, the rue du Hameau atelier, along with the gallery, was part of the expanding realm known as Les Etablissements Brandt.[253]

Unfortunately, at some time in 1933, Pierre Renaud, Edgar Brandt's son-in-law (who had replaced Eugène Grisard as director), recommended that the gallery be closed because it was no longer a viable commercial venture. Business had slackened due to the economic depression. Renée Brandt was opposed to the closing, but Edgar acquiesced so as not to antagonize his daughter Jane, Renaud's wife.[254]

BELOW LEFT:
183. Pelican ashtray, c. 1926–28. Cast wrought iron, 5½ x 4½ x 2¾". Stamped "E.Brandt". Private collection

BELOW RIGHT:
184. Deer, 1927. Wrought iron, 14 x 10" at base. Stamped "E.Brandt". Private collection

AMERICAN EXPOSURE

In the early years of his career, Edgar Brandt often said: "*Il n'y a rien de difficile, il n'y a que des choses qu'on ne sait pas faire*" ["There is nothing that is too difficult, there are only things that one does not know how to do"].[255] This philosophy had brought him to a place of preeminence in France. By the mid-1920s, it was time to reach out across the ocean to tap the American market.

Edgar Brandt was fascinated by the United States and had great admiration for America's technological superiority, for the metalliferous industry of Detroit, Michigan, and especially for Henry Ford's automobiles.[256] Therefore, it is fitting that one of his earliest American clients was from that progressive Midwestern city. George G. Booth (1864–1949), an amateur metalsmith and a lover of art and handcrafts, was an important force in the Detroit art world. As president of the *Evening News,* the Detroit newspaper that had been founded by his father-in-law, James Scripps, the Canadian-born Booth enjoyed great monetary success, and to honor that success he was anxious to give something worthwhile back to his adopted country.[257] His devotion to arts and crafts led him to help found both The Detroit Society of Arts and Crafts (1906) and The Detroit School of Design (1911), and he became a hardworking member and president of the board of trustees of The Detroit Museum of Art (now The Detroit Institute of Art). Beginning in 1915 the Booths donated many works by artist-craftsmen and sculptors to the museum.

The end of November 1921 found George and Ellen Booth at 101 Boulevard Murat, where they enjoyed a visit with Edgar Brandt, who informed them about the latest in contemporary French ironwork. On December 3, 1921, they purchased eighteen items from Brandt, the most important of which was a door with a grapevine motif.[258] In addition, Booth purchased oval and horizontal mirror frames and a variety of small ironwork models ranging in price from $11.50 to $50.00. These samples, such as chestnut, thistle, pine, lily, seaweed, nasturtium, oak, and olive, were intended for display at The Detroit Museum. A letter from Brandt dated May 17, 1922, stated that the wrought iron ordered in December was being sent over on the steamer *Paris,* the ship for which Brandt had made wonderful iron railings two years earlier (see fig. 92).

Brandt's shop director, the loyal M. Grisard, wrote to George Booth again on June 20, 1922. That letter allows a glimpse of the marketing skills that were directed to America (see fig. 95, *Les Cigognes d'Alsace*).

Dear Sir,

We hope you were quite satisfied with your travel to Europe, and when back in America, we trust you found all the iron works you ordered from us and they met with your approval.

Since your last visit, we have been working very hard and have executed a splendid wrought-iron door pane named: "Alsace Storks." The storks are carved bronze. Knowing you take great interest to artistic iron-works, we thought it would please you to have the reproduction of this door, consequently, we are sending you, by post-charged, a photo of it.

On the opening day of the Salon des Artistes Français, the Minister and Director of the "Beaux-Arts" declared this piece of iron-work was the finest of the actual time. (20th century).

Perhaps would you care to make the purchase of this door signed Brandt for your Museum or for a fine building. The price is 40.000 francs, goods taken in Paris. It measures: length 2.00; heith [sic] 2.50. The packing is not included. Would you, Sir, be so kind as to let us know if we may keep this door in store for you. If so, would you give us instructions for sending it.[259]

In his reply of July 7, 1922, Booth declined to purchase the door *(Les Cigognes d'Alsace)*, stating that the Detroit museum buildings were just being constructed, and therefore did not include the proper display space for the work at that time.

Just three years later Booth began to create the Cranbrook Academy of Art in Bloomfield Hills, Michigan, in conjunction with the architect Eliel Saarinen, and he continued to buy items from Brandt. In 1929 Booth purchased the famous 1925 fire screen *Danseur* (see fig. 157), one of the artist's best-known works, for $296.30.[260] As of 1930 the school displayed a forged-iron mirror frame, *Les Roses*, in the court corridor (see fig. 129). The early patronage of George G. Booth gave Edgar Brandt an impressive foothold in the often impregnable world of the American decorative-arts consciousness. He received many North American commissions, principally in Montreal and New York, but the most remarkable of these, indisputably, was the ironwork with which he furnished the Madison-Belmont Building in New York City.

From 1915 to 1940, Samuel Yellin (1885–1940) was America's most lauded practitioner of the Germanic/European blacksmithing tradition. Yellin, of Polish origin, had set up a school and a studio at 5520 Arch Street in Philadelphia. By 1922 he had received a huge commission for the Federal Reserve Bank of New York. He also produced decorative iron for

the Washington Cathedral, and eventually his work decorated public and private buildings in forty-five states. He was called "America's Cellini."[261] However, there was room enough in America for two great wrought-iron stylists.

Yellin's French counterpart, Edgar Brandt, was being called "the Benvenuto Cellini of the Twentieth Century,"[262] and it was not long before he had his first major showing in America. This 1924 East Coast debut came about through Brandt's association with the well-known silk manufacturers Cheney Brothers, which would shortly give Brandt his most prestigious American commission. Henry Creange (1877–1945), the Cheney company's artistic director,[263] explained how the alliance with Brandt came about:

> I saw his work in Paris . . . and I noticed in his work there was something new and something old. A distinct feeling came over me that he had realized the feeling of the past and refused to cast it aside as so many moderns have done. He obtains his inspiration from the ancients and interprets them in forms that are more suggestive of the dynamic force of today. An analysis of his work shows characteristics that are all his own, the tendril, the curl, and the coquille or shell.[264]

Creange had seen Brandt's *fer forgé* at several exhibitions of the Salon des Artistes Décorateurs in the early 1920s. He and the Cheneys were so inspired by Brandt's work that they "made many attempts," according to Creange, to adapt the *ferronnier*'s designs to their textiles. The results of their efforts—"Prints Ferronnerie"—replaced a line of designs that had been influenced by Chinese and Persian art with one characterized by Brandtian spirit and by geometric designs with dotted and plaid effects. "Prints Ferronnerie," the Cheneys' spring 1925 silk line, was reported on in *The New York Times* on September 10, 1924. One month later on October 9, 1924, the Cheneys, in an innovative move, opened their showrooms to their competitors in the silk industry. There were some two hundred attendees or more, all of whom entered the showroom through a Brandt iron door that was draped with silk. Inside they viewed Brandt's fire screens and gates on display along with the silk adaptations. A trade paper, *The New York Commercial,* wrote the following review:

> A new modern art period was launched in America yesterday, when the ironwork of Edgar Brandt, the great French ferronnier, found its expression in silk designs created by Cheney Bros. and shown at their spring opening by Henri Creange, art director of the Company. . . . Iron translated into silk is only one of the results which Brandt's influence will have on Modern art. According to Monsieur Creange,

who predicts that the work of this iron-master, entirely new in its outlines and significance, will have as profound effect upon the arts generally as any of the great periods, such as the Gothic or the Renaissance. He believes that the period which Brandt initiates will be called the Brandt period.[265]

As a result of this venture, two months before the opening of the 1925 Paris exhibition, Cheney Brothers silk was chosen to be among the first American products to be shown in the decorative-arts section of the Louvre. Entitled "Exposition France-États-Unis," the exhibition, which took place in February and March of 1925, displayed the ironwork of Brandt and the Cheney silks that they had inspired. This was a great honor; in the *New York Times* article that reported the exhibition, Brandt is called "the modern Bellini" [*sic* for Cellini].[266] It was stated that in this premier exhibition the Cheney silk, draped over Brandt's ironwork screens, would allow the French a glimpse of the achievements in America's industrial-arts community.

By the time this article appeared, the Cheney firm had already contracted for the first four stories of its showrooms and offices to be decorated by the master smith. The Madison-Belmont Building, a neo–Spanish Renaissance structure then being erected on a major intersection in Manhattan, 34th Street and Madison Avenue, was to be the new headquarters of Cheney Brothers and the site of Brandt's commission for entrance doors, window framing, exterior grilles, interior gates, mirrors, and display mounts, all in patinated wrought iron and gilded bronze.[267] Undoubtedly Creange put Brandt and the Cheneys together; however, the coordination for such a vast project was probably facilitated by Jules Bouy, a French artist who was the director of Ferrobrandt, Brandt's New York branch, located at 247 Park Avenue.[268] All the ironwork was made in France at the Boulevard Murat atelier and shipped to New York. It was a credit to Brandt's ateliers that all fifty tons of iron arrived safely and fit perfectly into the architectural framework. Seventy-four years later the building and its ferrous ornament still provide the finest opportunity for viewing Brandt's work in New York City.

The main entrance to the silk manufacturer was on Madison Avenue. The designs for the door and the transom grille were extrapolations from *L'Oasis* (see fig. 160). The double entry doors are composed of flattened, gearlike flowers and giant tropical leaves very like those of the earlier work (figs. 185, 186). The tiered fountain motif that dominates the transom was copied from the midsection of the five-paneled screen. An electric light was placed behind the transom to illuminate the iron tracery each evening. These rays produced a particularly glowing sheen on the gilded scrolls that surrounded the fountain design. The fountain as a metaphor for a regenerating source was the perfect motif for a modern skyscraper. Partly due to its high visibility on the Madison-Belmont entrance, this detail

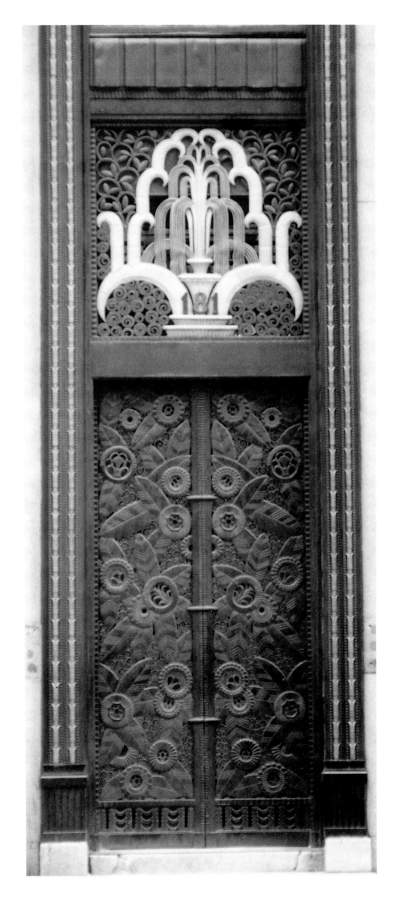

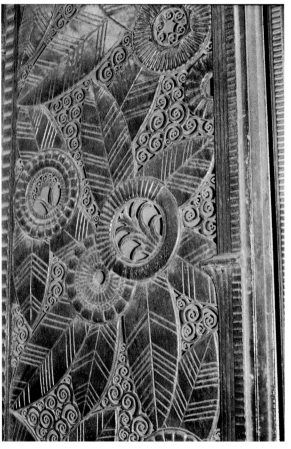

185. Madison-Belmont Building, Cheney Brothers textile showroom, 181 Madison Avenue, New York. Wrought-iron and gilt bronze entry doors by Brandt, 1925

186. Detail of the Madison-Belmont door showing wrought-iron leaves similar to those on the screen *L'Oasis*

launched a trend; the fountain motif was soon ubiquitous on other skyscrapers and American-designed products such as jewelry, ceramics, and silver during the brief period when Art Deco took hold in America.

When the entrance doors are opened each morning, loose hinges swivel, allowing the door panels to swing to the side and become the walls of the vestibule. Special iron frames accommodate the doors as they become the side walls and give them a finished appearance as they rest on glass panels.

Around each door and window frame are pilasters formed of double bands of iron and gilt bronze, the design of the latter resembling a stylized Egyptian lily that appears to hold a bundle of papyrus. In this lily pattern we can once again point to the Egyptian influence: it can be compared, for example, to the center design on the metal chariot from the tomb of Tutankhamen.[269] These ascending bands of bronze and iron can also be likened to ribbons, which echo the flowing yards of silk that were rotated by a motorized mechanism from behind the fourth-floor windows down to the bottom of the street-level windows by means of special mortises built into the floor at each window.[270] To achieve this unique window treatment, possibly the first of its kind, long narrow openings were cut through the flooring at the windows of the second and third floors. When one looks at the Cheney silk adapted from Brandt ironwork and then imagines the cloth rippling down the motorized bolts as sunshine flooded in through the long windows, it must be said that Brandt and the Cheneys had formed the perfect marriage of artistry and technical ingenuity (fig. 187).

Among the outstanding ironworks on the Madison-Belmont Building are the heavily hammered grilles placed under the huge show windows (fig. 188). The design of this curved iron bulkhead grille includes vertical bars and asymmetrical scrolls.

The doors at the 34th Street entrance are very plain, providing the perfect foil for the enormous iron transom grille awash with small scrolls and repeating fountain motifs (fig. 189). The overall effect is subdued in contrast to the gilded, psuedo-Egyptian and Pompeiian, bronze and marble

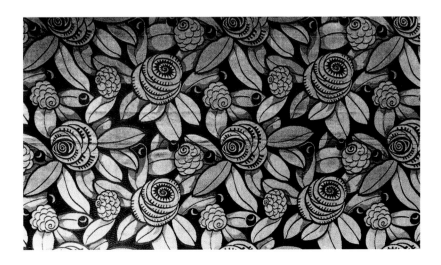

187. A Cheney Brothers textile based on Brandt's ironwork design *Les Roses*. Accession No. 1993.51.12. Wadsworth Atheneum, Hartford, Conn.

BELOW:
188. Bulkhead grilles below
the ground-floor windows of
the Madison-Belmont
Building, New York

RIGHT:
189. Wrought-iron and gilded
bronze transom grille above
the entrance to the Madison-
Belmont Building at 40 East
34th Street

decoration of the Madison-Belmont's lobby, where visitors are greeted by a vaulted ceiling and murals by Brounlet. A door in the lobby led to the Cheney silk salons. In 1925 a third entrance existed, on 33rd Street, but now it is blocked by the adjacent building.

Today, hardly anything remains of the interior decoration Brandt created for the Madison-Belmont; however, during a ground-floor renovation in the summer of 1987 an elevator door of Brandt's 1924 design *Les Cocardes* (see fig. 127) was discovered, and then summarily covered with

sheetrock and once again hidden from view. The only other extant interior ironwork is a set of scrolled grilles that have been painted white and placed in front of the large windows on the second story. Originally they had been used for the display of silk. Photographs reveal that these rectangular gates served as modular elements that surrounded the exhibited bolts of silk and led dramatically to a proscenium-like area where the grandest display was placed. Walking through these wrought-iron gates, passing iron "trees" draped with fabric, and approaching the huge hangings at the other end of the room must have been similar to arriving at the throne of a potentate.

The domed gray ceiling of the Cheneys' street-level salon is gone.[271] No longer are the pink marble pilasters of the octagonal hall visible, or the marble niches in which bolts of silk were draped on Brandt's whimsical wrought-iron "trees." Each of these trees was different; one had feather plumes, another gilded birds and leaves. One charming tree comprised two varieties of stylized Egyptian fan flowers and pea-pod-shaped leaves resting on unevenly placed branches (fig. 190). The flowers are the same as those used for the grille *Diane et la Biche* but the leaves are different (see fig. 136). Another wrought-iron tree took the shape of a branched willow with Oriental lines.[272] Yet another tree featured broad leaves sprouting small cactuslike ovals (fig. 191), while another had tropical fronds with curled ends, perfect for holding cloth. An intricate iron palm tree was fanciful indeed (fig. 192). The imaginative idea of displaying the Cheneys' silk on Brandt's iron trees may have been conceived by Creange or Bouy. It is also possible that it was devised by Brandt himself, who had counseled the Cheneys on their silk display for the Louvre. More likely Brandt was inspired by a sixteenth-century drapery seller's sign in the form of a tree that was shown at the Paris Exposition of 1900.[273]

On October 14, 1925, when the Cheney-Brandt collaboration for the Madison-Belmont Building was completed, an impressive inauguration ceremony led by Herbert Hoover, then secretary of commerce, took place. Hoover praised the French for their recent exhibition, just ending in Paris, and acknowledged Brandt as a master smith who had made an important contribution to American art and architecture. The French minister of commerce sent best wishes and was represented at the ceremonies by several French dignitaries. It was clear that Brandt had indeed fulfilled an important commission—adapting already successful designs such as *L'Oasis, Les Jets d'Eau,* and *Les Cocardes* (see figs. 160, 126, 127) to the commercial needs of an American company—on an appropriate scale, with taste and finesse. In addition, the *ferronnier* had been true to his own statement that the artist must be the first to make the effort to understand the art of the manufacturer. In forging a showcase for the Cheney Brothers, Brandt truly allied utility with beauty, and industry with art.

Horace Bushnell Cheney, the president of the silk company, was delighted with the outcome and wrote Brandt the following letter on October 16, 1925:

RIGHT:
190. Wrought-iron tree with
Egyptian fan and pea-pod
motif, made by Brandt to dis-
play fabric in the Cheney
Brothers New York show-
room, 1925

FAR RIGHT:
191. Wrought-iron tree with
cactuslike leaves for the
Cheney Brothers showroom,
1925

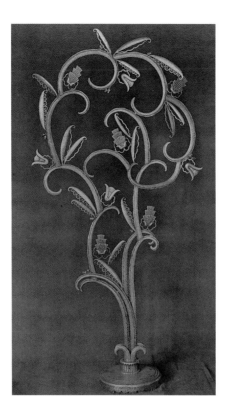

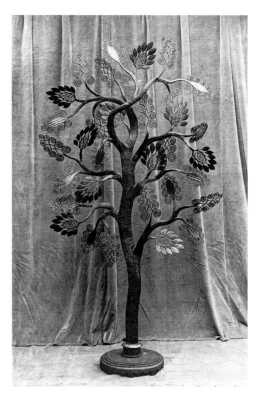

My dear Mr. Brandt:

It was a real regret to me and to my associates, that you and Mrs. Brandt found it impossible to take your contemplated trip to the United States at this time. Cheney Brothers on Wednesday, October 14th, formally opened their new store, which might perhaps as well be called your store. The result is very unique and very beautiful. There were present some 450 people; architects, designers, artists, museum curators and prominent people in manufacture and art. There was unbounded admiration of your work expressed upon all sides. I wished so much that Mrs. Brandt might have been there to enjoy your success.

I hope that your trip here has been only postponed, and that you and Mrs. Brandt, as soon as you are able to clear yourself of your present difficulties, will come over here and see the wonderful results of your work. We shall be most glad to receive you here in Manchester [Conn.] also.

Kindly remember me to Mrs. Brand [sic], that impossible grandmother, and tell her I remember with very great pleasure her kindness to me in Paris.

Sincerely yours,
Horace Bushnell Cheney[274]

Most probably the difficulties alluded to involved the grave illness of Brandt's mother, Betsy Emma Bas, who in fact died later that month.

Horace B. Cheney wrote to Brandt the day after the official closing of the Paris Exposition. As mentioned earlier, the United States failed to participate in the fair because it was felt that America had no decorative arts to display. America's sole claim to fame was the skyscraper. How ironic that at the time of the Exposition an American skyscraper became inexorably linked with French decorative ironwork.

On February 16, 1925, eight months before the opening of the Madison-Belmont Building, *The New York Times* reported that a special commission had been set up by Herbert Hoover to visit and report on the Exposition in Paris for the benefit and enlightenment of American manufacturers. The three major members of the commission of fifty-two delegates were Professor C. R. Richards, director of the American Association of Museums, Henry Creange, and Frank Graham Holmes. By the end of 1926 the committee issued a 103-page report on the Paris fair.[275]

When the report addressed the art and industry of metal, the writers stated that although there was a great deal of forged ironwork at the fair, Edgar Brandt's firm headed the list:

This establishment, notable first of all for the high quality of design represented in its varied productions, is also notable

175

for the fact that it is . . . organized on the factory basis and producing a large product. It represents a striking example of the union of the highest type of artistry and quantity production. . . . Outside the popular appreciation of the work of this establishment it is worthy to note that the Governments of late years have made considered use of its product in public buildings.[276]

It is likely that the committee would have made a special point to single out Brandt's work even if Creange had not been on the commission.

The American committee became aware that the French were striving to provide solid applied-arts education in regional, national, and municipal schools. Whereas Emile Robert had been an artist of individual initiative who learned his craft outside a structured school setting, his pupil, Raymond Subes, had benefited from the opportunity to study at the École Boulle and the École des Arts Décoratifs. The Americans also discerned that the French decorative artists were risk takers. American manufacturers, however, viewed new formulas with suspicion since they often necessitated higher costs. The imperatives of commercialism and the balance sheet dominated American business and product design. Therefore, American manufacturers rarely tried new models and continued to produce historicist forms often of a strange and retardataire nature. Henry Creange wrote a separate chapter in the commission's report entitled "Quantity Production in Art Industries," stressing this discrepancy. Clearly America needed to absorb the message of Brandt's February 8, 1922, speech: artists must be allowed to enter business; artists must be knowledgeable about industry.

The Madison-Belmont Building was not the only setting in which French decorative art made an impact in America. The Schumacher fabric company was also involved with Brandt's ironwork. Pierre Pozier, the Schumacher vice president who had designed the fabric "Les Gazelles au Bois" (inspired by *La Biche dans la Forêt*) and was interested in promoting the firm's chic new fabrics, commissioned a French Art Deco room for its New York showroom in order to introduce Americans to the modern spirit of the 1925 Paris Exposition. Brandt contributed a torchère and a table lamp to the decor. Paul Follot's wallpaper design "Leaves," which had been woven into a green, metallic gold, and black rayon Schumacher brocade, was used for the frieze. Clearly Follot's design was inspired by Brandt's screen *L'Oasis* (fig. 193).[277]

More Franco-American events were available to the public. The ministers of public instruction, foreign affairs, and the Beaux-Arts sponsored a French decorative-arts exhibit of all mediums at the Fifth Avenue gallery of Jacques Seligmann from February 22 to March 20, 1926.[278] The hope was that the superior work of the French imports would influence the approach and taste of American manufacturers. Additionally, in the fall of

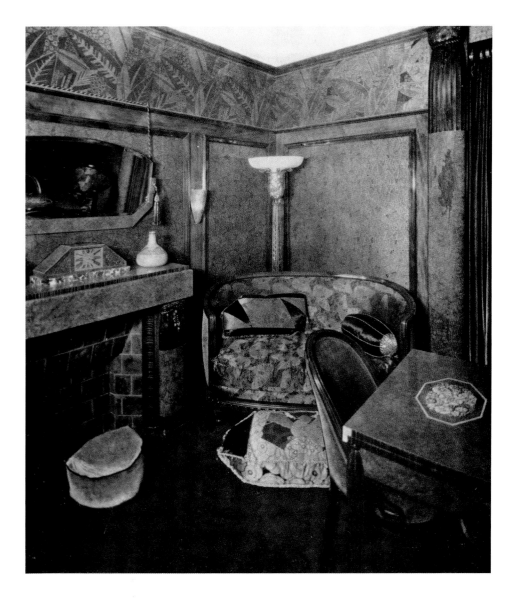

193. An Art Moderne room set up by F. Schumacher and Co. in New York, 1925, for which Brandt made a lamp and a torchère. Note the Schumacher wallpaper "Leaves" designed by Paul Follot. Courtesy Schumacher Archives

1926 the Art in Trades Club put on its fifth annual show of modern interior designs. The venerable firm of W. & J. Sloane displayed modern furniture based on the French work of designers Maurice Dufrène, and Süe and Mare,[279] including a bedroom featuring red-and-gold Cheney damask draperies with a fountain motif that was directly related to Brandt's designs for the Madison-Belmont Building. In March 1926 selected objects from the 1925 Paris Exposition went on view at the Metropolitan Museum of Art. The general public had vacillated in its assessment of the styles shown at the fair; and American manufacturers had rejected all but a few novelties. The Metropolitan show was important because it mainly attracted people who were seriously interested in the decorative arts, and they went to see objects that represented the best that the French had offered.[280] At the museum show visitors took pleasure in Brandt's fire screen *La*

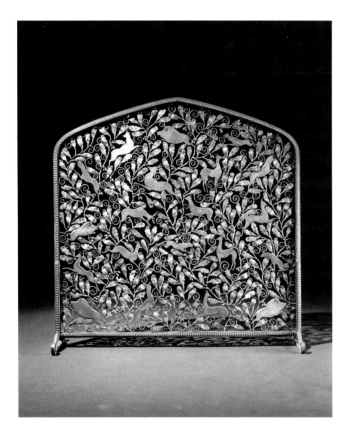

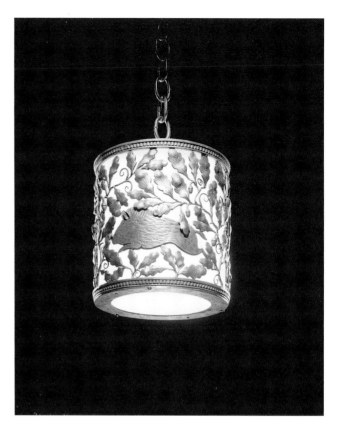

ABOVE LEFT:
194. *La Forêt*. Fire screen,
1925. Wrought iron, 44⅛ x
44⅞″. Exhibited at the
Metropolitan Museum of Art,
New York, in 1926. Courtesy
Christie's Images

ABOVE RIGHT:
195. Wild boar lantern,
c. 1925–26. Wrought iron, 8 x
8″ diam. Stamped "E.Brandt".
Courtesy Christie's Images

Forêt/The Forest, originally made for Robert M. Catts, owner/builder of
the Madison-Belmont Building. It features a variety of gilded, silvered, and
copper-colored stags and boars gamboling through the forest (fig. 194), a
distillation of a sixteenth-century millefleurs tapestry theme. Brandt also
made a lantern with the same motif (fig. 195).

As if to solidify the Brandt/Cheney connection in New York City, in
March 1926 the Cheney Brothers gave the Metropolitan Museum of Art a
wrought-iron fire screen called *Les Jets d'Eau/The Fountain,* which Brandt
had produced in 1924 (see fig. 126).[281] This work became the second
Brandt piece in the museum's collection. The first one, *La Perse* (acquired
1924), a large wrought-iron grille that had originally appeared in the 1923
Salon d'Automne along with *L'Age d'Or,* was distinguished by its Oriental
flavor (see fig. 117).

In February 1929 the Metropolitan Museum called upon many
prominent architects to mount an exhibit of contemporary design and
room settings in which the use of ornamental metals would be highlighted.
Among the most popular designs were Raymond M. Hood's office for an
executive, which included the iron furniture executed by Oscar Bruno
Bach (1888–1957) and metal light fixtures by Walter Kantack (active
1920s–1930s).[282] The influence of French design was also evident the year
before at R. H. Macy and Co.'s "International Exposition of Art and

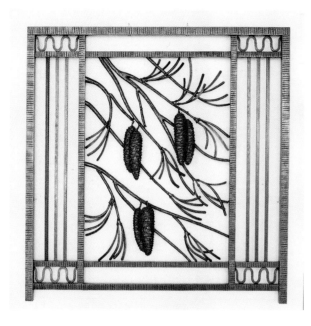
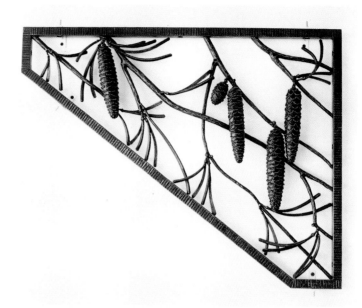

Industry" and a similar exhibit at Lord & Taylor, both of which were catalytic for the advancement of American design (see page 105).[283]

As a result of these efforts the American public was becoming familiar with French design and recognizing the importance of iron and metal alloys for decorative purposes. Edgar Brandt, of course, received other American commissions. Since most of the business records of Ferrobrandt have not been found, the full scope of the American commissions may never be known. We do know Brandt fabricated an entrance facade for a commercial building on West 39th Street. There he reused the beautiful ribbon design that he created for Paul Poiret's fashion house on the Rond-Point des Champs-Elysées in Paris. Another Manhattan commission was for the Thomas Fortune Ryan residence at 32 East 70th Street.[284] For the upstairs oak-paneled library, Brandt adapted the design for his 1922 radiator cover/fire screen *Les Pins* to two floor-to-ceiling radiator covers embellished with pine cones and needles. The patina of the iron matched the oak walls so beautifully that one would think it was carved wood.[285] These pine-bough pieces exhibited Japonisme, a theme that Brandt came back to repeatedly. Similar in spirit are three pine-cone window grilles, made for a London townhouse, which were forged to be seen from both the street and inside the home (figs. 196, 197). Brandt's successful use of the torch for the 1908 Barbedienne pine-cone stairway was a turning point in his career. Therefore, when he made the rare gift of a pine-and-needle paperweight it had special personal significance (fig. 198).

ABOVE LEFT AND RIGHT:
196 and 197. Pine cone and needle grilles (two of three made for a London townhouse), 1926. Wrought iron: (left) 33¼ x 33"; (right) 22½ x 29". Stamped "E.Brandt". Courtesy Moderne Gallery, Philadelphia

BELOW:
198. Pine cone paperweight, c. 1920–26. Wrought iron, 3½ x 6½ x 5¼". Stamped "Brandt 101 B^d Murat Tele P [illegible]". Private collection

In 1926 Miss Agnes Miles Carpenter, a frequent visitor to Paris, became so enamored of *fer forgé* that she ordered an entire dining room from Brandt for her home at 950 Fifth Avenue.[286] Not only were the chairs, consoles, buffets, and lamps of wrought iron but the window treatment imitated drapery panels on three sides, while the center of the window contained a floral grid of scrolls and flowers, probably in imitation of lace.[287]

Although for the most part, in America, traditional historicist wrought iron was being forged in the 1920s, there is no doubt that Brandt's ironwork motifs for the Madison-Belmont Building had a far-reaching impact on both exterior and interior architectural metal designs in the later years of the decade and into the 1930s. Perhaps the most specific adoption of a Brandt design in America can be seen in three sets of nickeled bronze elevator doors that were made for the Waldorf-Astoria Hotel in New York City in 1931.[288] The doors were fabricated by the General Bronze Corporation after cartoons by the Spanish artist-designer Louis Rigal, who borrowed closely from Brandt's 1925 design for the door of the headquarters for the magazine *L'Illustration* (see fig. 150), in which the central medallion featured two women reading periodicals. In his 1930 design Rigal substituted musical instruments for Brandt's magazines. Rigal had painted the ceiling of Ruhlmann's salon in the "Hôtel d'un Collectionneur" and would have known Brandt's work in Paris, particularly at the 1925 Exposition. In fact, the Waldorf is filled with Art Deco motifs that were clearly adapted from Brandt's oeuvre. While working on the Waldorf, Rigal, or any one of a number of other designers and architects, had only to walk over to 34th Street and Madison Avenue to see Brandt motifs first-hand. In viewing the decorative art in the Waldorf, one is reminded of the dictum of Pablo Picasso, who often painted his own versions of earlier masterpieces, that imitation is the highest form of flattery.

The successful Brandt/Cheney collaboration had sown many seeds; however, the stock market crash of 1929 and the subsequent economic depression affected the textile industry. By 1932 the Cheney Silk Company executives found their lease at the Madison-Belmont Building too much to bear and they moved to the Empire State Building. For seven years visitors had enjoyed the Brandt/Cheney displays. Suddenly the wrought-iron trees were bare.

THE CANADIAN CONNECTION

The Canadian architect/engineer Ernest Cormier (1885–1980) was one of many eager young foreigners who studied and worked in Paris before World War I. Between 1908 and 1918 he absorbed the cultural ferment that took place in that city. He returned to work in Montreal emboldened by his training at the École des Beaux-Arts and imbued with everlasting impressions of European decorative arts. Although his most important work, the Université de Montréal buildings, occupied him for twenty-seven years, Cormier was simultaneously involved in other projects. Among them were the Montreal Court House Annex and the Chamber of Commerce Building (with J. E. C. Daoust).[289]

From Cormier's correspondence it is clear that Quebec architect M. David recommended Brandt's firm to execute the ironwork for these projects, probably after seeing the *ferronnier*'s work at a Candian exhibition in November 1923. Cormier contacted Brandt in October 1924.[290] By the end of that year Brandt and his draftsmen were working on the main door, elevator doors and frames, and other accoutrements for the Board of Trade, and plans were in motion for huge bronze doors, lighting fixtures, and torchères for the Court House Annex.

The commission for the Board of Trade took one year and two months to complete. Letters, cables, and numbered renderings showing numerous changes flew back and forth between 101 Boulevard Murat and the Drummond Building (Cormier's office) in Montreal. The cost was adjusted with every architectural change, including a charge for 14 grams of 22-carat gold leaf. The Royal Bank of Canada arranged for credit and Les Etablissements Brandt was paid in FF 72,800. On Christmas Eve 1925 Cormier was informed that La Maison Ramsay was packing all Brandt's ironwork to be shipped to Montreal.

One crate contained the wrought-iron entrance door, made up of classically modern symmetrical panels—the principal motif being repeating turned-down C scrolls that emanated from a stylized lotus bud and fan. In the transom above, two flower-filled cornucopias flank an octagonal medallion in which the Greek god Hermes is seated in profile among his emblems. This gilt-bronze Hermes, divinity of trade, good fortune, and riches, sports the broad-brimmed traveler's hat and winged sandals, and carries the ever present caduceus with its intertwined serpents. Known as Mercury to the Romans, Hermes was a god most familiar to the twentieth-century Vulcan, Edgar Brandt.

Work on the Court House Annex was begun simultaneously with the Board of Trade commission but the project went slowly. In a letter of February 12, 1926, Cormier told Brandt that he would supply all the dimensions but that Brandt should design the Court House door and have everything else

199. The Court House Annex, Montreal, main vestibule, featuring Brandt's bronze torchères, 1926–27. Each 8′11⅞″ x 35⅞″ diam. Ernest Cormier, Louis A. Amos, and Charles J. Saxe, architects

ready for an inauguration to take place the following September. The missive clearly shows the nature of the commission; Cormier describes the setting and gives the specifications for the required objects. For example, the architect asks for eight bronze torchères, each almost nine feet high, to be placed in the main hall, which he designed in the Beaux-Arts Roman style (fig. 199). He also requested eight semicircular and elliptical wall sconces, eight window grilles, and sixty-four additional sconces. Furthermore he requested two bronze torchères, eight feet six inches tall, that were to flank the great bronze entrance doors (figs. 200, 201). Cormier specified that these standing lamps harmonize in color with the patina of the huge doors. M. Grisard, on Brandt's behalf, asked for the following payment schedule: 50 percent in advance, 30 percent at the start of the atelier work, 10 percent when the atelier work was completed, and the balance of 10 percent upon delivery in Montreal. In July the Canadian architects Charles Saxe and Sidney Dawes visited Boulevard Murat to see Brandt's designs. In a letter dated August 3, 1926, Brandt informed Cormier that he had sent off to Montreal a maquette of the Court House door for approval, along with three patina samples.

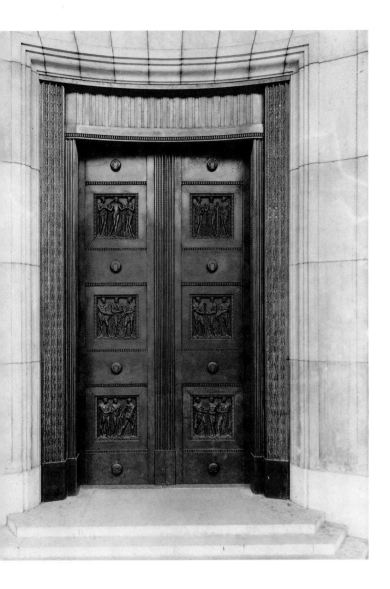

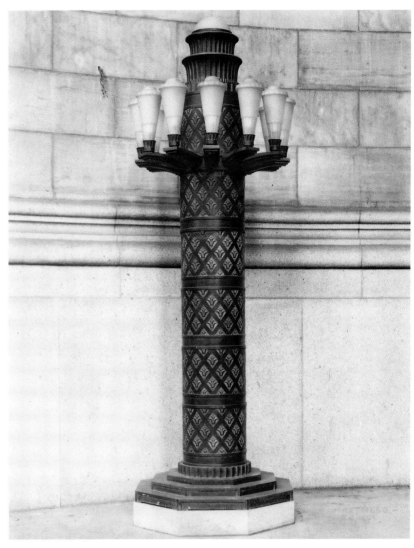

The correspondence reveals that at the time Brandt had accepted these commissions from Cormier, he was well entrenched in the committee work and design obligations for the 1925 Paris Exposition. Only a company that was well staffed and properly organized could have handled the enormous workload. Indeed, Brandt was a workaholic who reveled in his creative pursuits while at the same time keeping pace with his armaments research and inventions for the French government.

Most of the Brandt firm's mail and contracts were handled by M. Grisard, the loyal administrator. However, it is clear that Brandt was the resolute overseer; he was accountable for his employees and obligated to his clients to produce ironwork that reflected his sense of elegance, that incorporated his signature motifs, that was superbly crafted, and most importantly, that filled their needs. He read the contracts, advised the designers, and delegated and divided the responsibilities for each project.

A year and four months after the arrangements were solidified, the contractor who was to assemble the various ironwork, including the great bronze doors for the Court House Annex, wrote to Brandt:

ABOVE LEFT:
200. Bronze entrance door of the Montreal Court House Annex, 1926–27

ABOVE RIGHT:
201. One of a pair of bronze exterior torchères made for the Montreal Court House Annex, 1926–27

Moreover we have had occasion in our workrooms to show to a number of clients and architects, your finished work, large doors, lighting fixtures. We are happy to tell you about all the compliments that were made to us because each one was amazed at the perfection and the fineness of the obtained execution.[291]

Three-quarters of a century later, the great bronze doors for the Court House Annex remain impressive in conception and execution. The panels—with their toga-clad figures and the scales of justice—are outstanding visual symbols of jurisprudence. The two torchères flanking the entrance doors employ Brandt's signature Egyptian fan motifs in a diamond pattern. Light filters upward from a circle of shades, and a fluted tiered crown supports a lighted glass dome. Equally majestic are the Egypto-Grecian torchères in the main hall, whose three-tiered glass shades complement their four-part fluted stems.

The classical heritage was honored in the 1920s collaboration of Brandt and Cormier. The Canadian was so fond of Brandt's work that he ordered a wrought-iron stair railing for his own office located at 175 (now 2039) Mansfield, Montreal.

In May of 1928 Cormier arranged for Brandt to do the ironwork for the Church of St. John the Baptist in Pawtucket, Rhode Island. The commission consisted of a choir screen, eight large chandeliers, four small ones, ten wall sconces, and three doors for the facade. For this work Alphonse Gratton, the priest and treasurer of the church, was to pay $10,420. The total bill came to $12,010, including certain small additions. Of course these numbers do not include shipping charges or taxes, which were added later. Gratton proved very difficult to deal with, and Cormier was mortified by his tardy response. All told, Brandt waited over three years to be paid in full.

On August 10, 1928, Pierre Renaud, Edgar Brandt's son-in-law, wrote to Cormier to thank him for the lovely photographs of the Court House Annex, the Board of Trade Building, and the St. John the Baptist Church that had been sent to Paris. Renaud said that they were particularly happy to see the beautiful views of the work in their proper setting.

Such was the business of iron and bronze: commissions, blueprints, sketches, scale drawings, cables, letters, estimates, maquettes, technical problems and solutions, deadlines, crating, shipping, and hopefully payment for custom work superbly conceived and executed.

BACK IN PARIS: 1926

Once progressive French wrought ironwork had been accepted by many architects as more intrinsically beautiful than cast iron, it ran the risk of being overdone. Brandt and his metalsmiths did not always succeed aesthetically. However, a very high percentage of their pieces were energetically beautiful, often trend-setting, and nearly all were skillfully produced.

Brandt was frequently given official recognition for his contributions to Art Moderne design. In 1923 he received a medal of honor from the committee of applied art for the Société des Artistes Décorateurs. On May 19, 1926, he was named an officer of the Legion of Honor for his artistic ironwork and for decoration in general. No matter how many medals came his way, it seemed that nearly every year he could be depended upon to

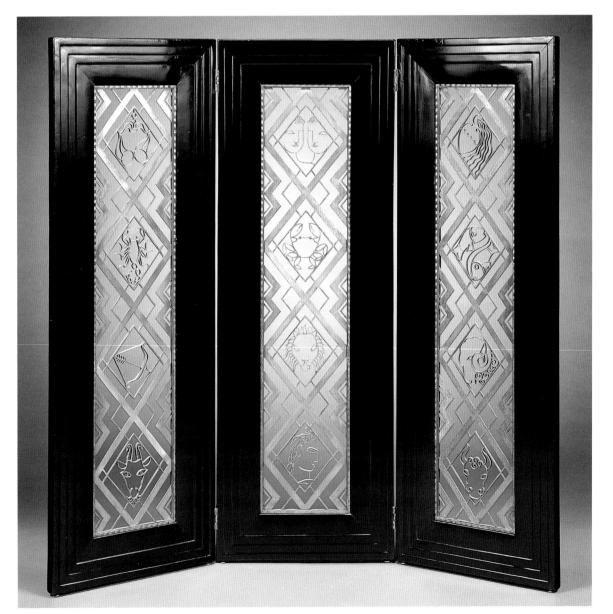

202. Zodiac screen, 1926. Gilded and silvered wrought iron and lacquered wood, each panel 66¾ x 23¼ x 1¾". Ironwork by Brandt; frame by Jean Dunand. Stamped "E.Brandt". Exhibited at the 1926 Salon des Artistes Décorateurs, Paris. Courtesy Christie's Images

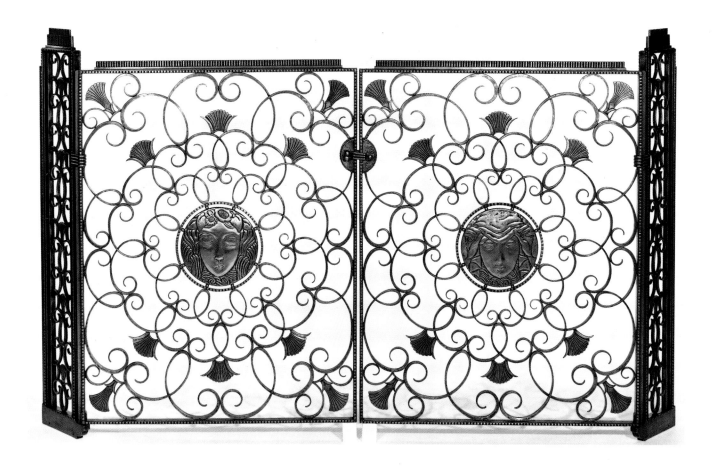

provide a delectation in *fer forgé* for aficionados or devotees of the art form at the seasonal salon showings.[292] Several surprises were in store for viewers at the sixteenth Salon des Artistes Décorateurs. *Zodiac,* an atypical, three-panel screen of gilded wrought iron in a lacquered wood frame by Jean Dunand offered diamond-shaped iron borders surrounding astrological signs (fig. 202). These openwork forms are reminiscent of the metal and wire sculptures of Alexander Calder, Pablo Picasso, and Pablo Gargallo (1881–1934). According to Poillerat, "Gargallo was the only artist that I ever wanted to copy." Perhaps Brandt had the Spaniard in mind when he worked on this screen. Certainly the whimsical works of Gargallo were much admired by metalsmiths of the period.[293]

Two very different interior gates were highlights of the 1926 Salon and represented the apogee of the Brandt style. The execution plans (renderings) for these grilles, conceived by Brandt, resulted from the excellent team effort by Henri Favier, Gilbert Poillerat, Henri Martin, and Pierre Lardin. These may have been the last works overseen by Favier for Brandt and the last ensemble projects that they did for Les Etablissements Brandt.[294] Both gates incorporated impressive symmetrical designs and were finished on both sides. In the first gate each panel contains a concentric pattern composed of double C scrolls that decrease in size from the outermost to the innermost circle (fig. 203). Stylized Egyptian fans were strategically placed along the two larger circles. Repoussé medallions, placed in the center of each panel, were the focal point of this gate (fig. 204). In the tech-

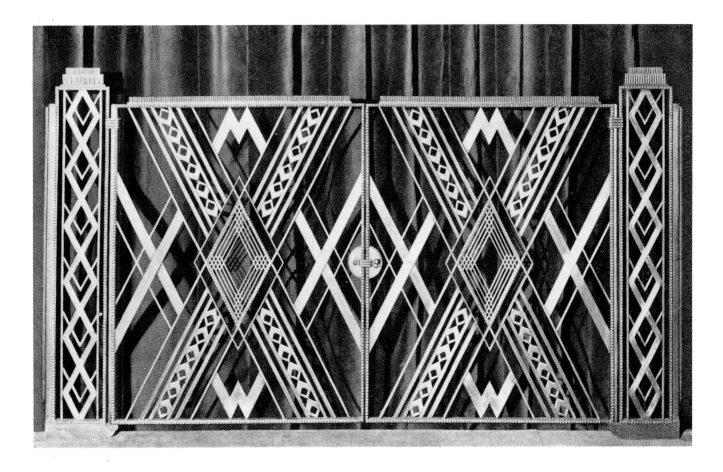

nique of repoussé, after the design is marked on a flat piece of iron it is chased using a fuller and chisels. The iron is worked first from the back while it is sitting on a bed of pitch or lead and then is finished from the front for fine detailing. The medallions depict a pixielike face with open eyes and an enigmatic, hood-framed face with partially closed eyes. Representing dawn and dusk, the gate is called *Aurore et Crépuscule*. This must have been a subtle reference to the sculptures *Night* and *Day* by Michelangelo[295]—Edgar Brandt's favorite sculptor—and in a more general way the figures may be viewed as metaphors for life and death. Since the grille was meant to be seen from both sides, two medallions of each design were gas-welded together and filed smooth. Today's blacksmiths marvel at the way one scrolled iron bar passes over another. This technique is achieved by notching the under bar so that the top bar fits flush into it. The rhythm emanating from the calligraphic scrolling of the iron, which is restated in the side supports, typifies the spirit and mastery of the works produced by Les Etablissements Brandt. Michel Roux-Spitz, a prominent architect, used this grille in his own home. Poillerat felt that this gate was perfectly executed and was among the best pieces to come out of the atelier during the 1920s.

The second gate demonstrates the impact of two very important aesthetic trends on Brandt's work. It is a tour de force of triangles, parallelograms, and diamond shapes, which are overlapped by precise diagonals—neat, punctuated bars of iron that project the power of a considerably larger piece (fig. 205). Here is the machine aesthetic at its very best.[296]

OPPOSITE, TOP:
203. *Aurore et Crépuscule*. Grille, 1926. Silvered wrought iron, 42 x 72". Stamped "E.Brandt" on each side of grille (upper corner near hinge). Virginia Museum of Fine Arts, Richmond, Va. Gift of Sydney and Frances Lewis

OPPOSITE, BOTTOM:
204. Detail of "Aurore" (Dawn) medallion mask seen in fig. 203

ABOVE:
205. Silvered wrought-iron geometric grille, 1926

187

Echoed in this design are the geometric fabrics of Sonia Delaunay (1885–1979) and the linear rug patterns of Da Silva Bruhns (active 1907–58) and Jean Lurçat (1892–1966). Certainly these designers, as well as Brandt, were responding to the ascendant avant-garde architecture of Pierre Jeanneret (1896–1967), Le Corbusier (1887–1965), and Robert Mallet-Stevens (1886–1945)—and to other factors, such as exposure to the art of the French colonies and the work of the Bauhaus school.

As the art of non-European cultures became better known it caused a visual revolution in French design. The Trocadéro Musée d'Ethnographie had roots that went back to the 1830s, but interest in ethnography did not reach its height until the 1920s.[297] The French Colonial Exposition of 1922 influenced artists, textile designers, illustrators, sculptors, and jewelers. French artists and explorers, who became intrigued with the art of Africa and Oceania, helped to stimulate further scholarship. For example, the explorer Bruneau de Laborie traversed Africa on voyages that were sponsored by the French Geographic Society. The March 8, 1924, edition of *L'Illustration* reported on his trip to Libya; one week later the newspaper followed his travels in Cameroon and produced striking photos of the native straw huts with their remarkable geometric patterns. As we have already seen, these images made a significant impression on many artists and designers who were well into planning their displays for the 1925 Paris Exposition.

The trend continued. A few years later at the Colonial Exposition of 1931 in Paris, the geometric architecture of pavilions such as those of Guyana and Togo-Cameroon, African territories under French mandate, were popular attractions. The facade of L. H. Boileau and Carrière's Togo-Cameroon Pavilion, with its rough stucco exterior colored in red, black, and gray triangles over a base of bamboo strips, was a striking mixture of ancient cultural forms and modern decorative embellishments. Bakouba weavings with their intricate geometric elements had a huge impact on the patterns created by contemporary French textile designers. African textile patterns undoubtedly affected the geometrically designed jewels of Raymond Templier, Jean Desprès, and countless others.

At the 1925 Exposition the stripped-down geometric and linear buildings of Le Corbusier (Pavillon d'Esprit Nouveau) and Robert Mallet-Stevens (Pavillon du Tourisme) had been the exception, not the rule. By 1926 the trend toward geometrics and simplification of form had taken hold in the decorative arts and was reverberating throughout the field, influencing the design of carpets, ceramics, silver, furniture, jewelry, textiles, and even lace. Madame Chabert-Dupont, who had reproduced ironwork designs in lace for 101 Boulevard Murat, produced a window curtain in 1927 that appears to have been influenced by Brandt's geometric interior gate, with its rectangles, triangles, and diagonals.

In the mid- to late 1920s in France a more linear style was emerging that contrasted with the classical elegance and grace on which Edgar Brandt's stylistic strength was based. As was apparent in Brandt's gates of

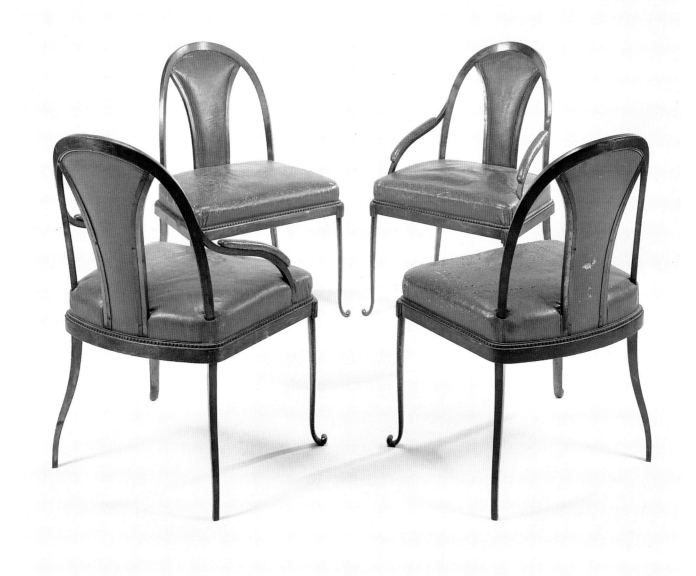

206. Set of chairs, c. 1926.
Wrought and cast iron,
and red leather. Stamped
"E.Brandt France".
Courtesy Sotheby's, Inc.

the period, geometric forms were replacing flora and fauna in design. Never was this new direction more apparent than at the Salon des Artistes Décorateurs of 1927, where audacious furniture, composed of symmetrical and asymmetrical geometric shapes overlapping on tables and desks, was displayed. Cubism, though fully stated by 1914 as a painter's movement, took longer to filter into the decorative arts and was in part responsible for this new plastic expression. The Cubists had revolutionized the way people viewed familiar objects.[298] The critic Louis Vaucelles, taking an opposite view, felt that the change in sensibility was not due to Picasso and Georges Braque but rather to decorative artists who had always worked with geometry and by 1925 were "intoxicated" with it. The designer Pierre Chareau's work was described as Cubist in a 1924 Salon, and these tendencies had shown up in his furniture as early as 1922. By 1925, Cubism had influ-

enced street posters, book covers, jewelry, and fabrics for women's clothes and shoes. Two years later this hard-edged aesthetic, reinforced by the modern precision shown in the design of automobiles and airplanes, led designers to begin earnestly experimenting with new metals, such as aluminum, Monel Metal (a nickel-copper alloy), and stainless steel. Anecdotal, symbolic, or historicist ornament that had already begun to go out of fashion in furniture now also seemed out-of-date in ironwork. When Ruhlmann produced a steel chest for the 1926 Salon des Artistes Décorateurs, it only added to the conflict between those who valued the warmth and inherent decorativeness of wood and those who felt that furniture should be as precise and austere as automobiles or dentist's stools. Wood was still the primary material for furniture in 1927, but the ensuing years would see an increasing use of metal. Marcel Breuer's "Wassily" chair (1925) with its nickel steel frame had already made an impact, and Ludwig Mies van der Rohe's cantilevered steel-framed "Barcelona" chair (1924) would become an important symbol in the controversy of craftsmanship versus industry.

Certain designers, such as Jean Dunand, employed spare, clean lines that showed the glossy lacquered surfaces to best advantage. These pieces complemented metal-trimmed furniture. The increasing popularity of shiny airplane and car bodies had accustomed the public to this look. White metals such as chrome became the rage, as they harmonized with the latest streamlined architecture. Dunand, René Joubert and Philippe Petit, F. & G. Saddier, and Ruhlmann were just a few of the designers who prepared the way for the age of metal furniture. Brandt did not fail to see the changes under way but his decorative ironwork moved slowly toward minimalism.

A set of Brandt furniture that dates from this period has come to light recently. It is a copper-clad dining-room table and twelve chairs in an unusual Gothic-Celtic style, supposedly made for a client's château in the south of France.[299] It is unlike any other known Brandt furniture and does not speak to Brandt's major design inclinations and interests.

Some of his wrought-iron furniture pieces were more graceful and certainly more conservative than those of dedicated furniture designers experimenting with chrome. A set of Brandt leather-and-iron chairs of about 1926 features broad seats, lotus-shaped splats, and rounded backs, whose delicate curves were echoed in the scrolled front legs and the slightly splayed back legs (fig. 206).[300] Brandt's unadorned iron chairs remained true to his established design roots: the formula of classical elegance and strength that had been his trademark for so long.

In 1926 Brandt formed La Société des Etablissements Brandt, a new corporate structure. He continued both his decorative ironwork and his armament production, compartmentalizing each endeavor. The former was his passion; the latter became his obligation.

THE DENOUEMENT

For several reasons, the year 1927 represented a turning point for Les Etablissements Brandt. Henri Favier resigned in August of that year, frustrated by the fact that he was not creating enough large-scale architecture and was not operating out of his own office. A mentor to the less experienced staff, Favier was a *méridional* (southerner), with a relaxed manner, and very much a man of the nineteenth century—old-fashioned in his manners and his taste.

As younger men, Poillerat, Henri Martin, and Pierre Lardin, all colleagues from the École Boulle, were more familiar with the latest artistic trends, whereas Favier, twenty years older and an École des Beaux-Arts graduate, was more inclined toward classicism.[301] Favier followed their lead but nevertheless used his classical spirit to temper the ardor of the younger men. Poillerat recalled that he and his colleagues helped Favier to discover Le Corbusier, Cubism, and Montparnasse, the artistic center of Paris at the time.

Of the three main designers under Favier, Poillerat had been the only one in constant employ. At one point Henri Martin had left to work at Primavera, the department store. Following along, Pierre Lardin[302] went to Cartier for some time during 1924–25. Both men left Brandt in order to earn more money, but returned because of their love for ironwork. Poillerat, a fine artist as well as an ironwork specialist, was content to stay at Brandt's because it allowed him time to draw from live models at La Grande Chaumière art academy in Montparnasse. He also earned extra money designing scarves for the *petite* couture.

Respecting and following the Brandt style of 1920–27 was the work of the École Boulle graduates. Under Favier the Boulle men made large-scale working drawings of Brandt's conceptions. Favier kept the day-to-day work flowing so that the ateliers received the renderings with enough lead time for execution, thus deadlines could be met and commissions fully realized.

As head of the design atelier Favier was as congenial as he was competent. One day Paul Fehér, the designer for Paul Kiss, made an unannounced visit to Boulevard Murat. When Favier recognized who his visitor was, he showed the younger man Brandt's drawings and took him through the exhibition gallery. Fehér's friend, the Czechoslovakian ironsmith Gaspar Szetlak, who worked for Brandt in the early 1920s, also admired Favier.[303] Poillerat said, "Favier tolerated my youthful inexpediency and encouraged my creative spirit."[304]

In 1927 Poillerat married Rosetta Belleli and left Brandt's employ. Within a month he had been hired as the chief designer and administrator for the firm of Baudet, Donon, and Roussel, a company that specialized in making large items such as bridges and steel girders for buildings. It wanted

to add a small wrought-iron atelier to its business to augment its prestige. Poillerat had ten to twelve workers in his workshop, and he never had to worry about financial matters. Under these favorable circumstances Poillerat's original style, which had begun to emerge during his last years with Brandt, came to fruition.

M. Grisard, the director of commerce of Les Etablissements Brandt, was replaced by Pierre Renaud, Jane Brandt's husband. Nevertheless, Grisard stayed with the firm until 1934. According to Poillerat, while these radical personnel changes were going on, Brandt appeared to be less interested in *ferronnerie* and more absorbed in his armaments work. It was true that from that time onward he was obliged to split his time between art and technology. Much to his regret, time constraints forced him to limit his presence at Salon exhibitions. Often he did not get to the design studio until late in the day. In 1926, Brandt had completed a prototype for an 81mm mortar *(mortier à tir courbe)*. The successful adoption by the French army of this model, which bore his name, eliminated competitors from both private industry and the state arsenals.[305] In 1927 Brandt delivered this powerful new mortar to the army; on August 6 of that year he signed a contract with the state that subsequently kept him and La Société des Etablissements Brandt occupied with mortar production.[306] Armaments were more complex to produce than decorative ironwork, but in either case, Brandt experimented and designed with maximal productivity in mind.

Brandt continued exhibiting in the Salons. In a review of the Salon d'Automne of 1926, the critic Pierre du Columbier wrote, in essence, that several artists seemed to be interested in conveying to the public an appreciation of the technical expertise needed for their work.[307] He then went on to praise Brandt, who had created a great niche because he knew all the elements of ironwork and how to obtain results with varied industrial methods. What Lalique had achieved with fire and glass, Brandt had achieved with fire and iron. Both men attained new heights in the use of their materials.

Brandt exhibited at the Salon des Artistes Décorateurs of 1927 and continued to do so until 1932. Surely by 1927, Brandt knew that he had fulfilled the artistic side of his career and felt obliged to devote more time to his armament inventions. There is no doubt that the success of the 81mm mortar had an unanticipated deleterious effect on the future of ironwork. In any case, Brandt had more than enough ironwork commissions and no longer needed a lot of exposure. He managed to put on Salon shows even though his accelerated arms activity, combined with the loss of Favier and Poillerat, probably required him to regroup.

The fact that Brandt continued to achieve approbation for his ironwork in 1926 and until 1939, although he was so immersed in armaments work, was undoubtedly due to the organizational policies that had been in

place for a long time. He set an example of diligence and hard work, stimulating his colleagues and providing an atmosphere of dynamism and solidarity. Nothing escaped his notice. He had designed, forged, and succeeded before Favier and Poillerat; he continued to design, innovate, and deliver finished works after they departed.

Every year on the feast day of Saint Eloi, the patron saint of ironsmiths, Brandt organized a banquet for all his staff.[308] The highlight of the meal came at dessert when a burly, broad-shouldered *ferronnier* named Favereau, who was also a basso, would sing arias. Favereau was honored with the title of "Meilleur Ouvrier de France" during the 1920s. Poillerat designed the pair of andirons that helped to win the prize for the smith. Poillerat's conception of Hercules and the Hydra, a complex, mythological subject, was fraught with technical difficulties. Since the welding gun could not be used in the competition, the Hydra's single, many-headed body was a challenge to execute. For the completed work, Favereau was decorated with the Legion of Honor.[309]

At the Boulevard Murat atelier, Brandt let it be known that he had great respect for each métier, each worker. He considered each one indispensable to the realization of the atelier's large and diverse output. According to his son, François, Edgar Brandt considered it a duty to work, especially if his work could make a contribution to society. François has written about his father: "He believed in his star and that helped him in the struggle to build. He was an optimist, with confidence in himself, and [he was] appreciative of the good fortune that he had."

CHANGE IS IN THE AIR

In the latter half of the 1920s Parisian design circles were inundated with social, economic, and aesthetic changes. Brandt and his colleagues were very aware of the avant-garde work being produced since 1919 at the Weimar Bauhaus under the direction of the architect Walter Gropius. The Bauhaus philosophy of combining the study of craft and building was to lead to what is known today as modern industrial design. As early as 1913 Gropius had stated: "The new times demand their own expression." He called for "exactly stamped form, devoid of all accident, clear contrasts, the ordering of members, the arrangement of like parts in series, unity of form and color." By 1924 Gropius's philosophy was cogent:

> To be capable of giving an object a beautiful form, this is to possess an absolute mastery of all the economic elements, techniques, and aesthetics that condition this object and from which it results organically. The character of the object is the means by which the creator orders the relationship that governs the mass, the material, the colors of the object that is to be created; it's in the relationships of the masses that the spiritual value of the object resides, and not in the exterior added elements destined to decorate these masses or modify its profile.[310]

In general, French designers did not totally adopt the narrow and spartan formula of the Bauhaus. However, progressive design circles in late 1920s Paris appeared to be operating under the dictum of architect Auguste Perret, who said: "Only in very rare cases does an ornament serve any other purpose than to cover up a weakness in construction."[311] By 1927 it was apparent that many decorative artists had embraced this belief. Ornamentation was being put aside in favor of pure geometric form.

Inexorable though these changes were, they occasioned a philosophical battle. Harmony and proportion had become more important than figurative decoration and color. Added to this was the move toward standardization and mass production. Perhaps the new aesthetic was best expressed by László Moholy-Nagy: "What is important . . . [is] not the isolated work, it's not the individual masterpiece, it's the creation of a type of general worth, this is the progress toward standardization."[312]

Edgar Brandt paid careful attention, as he always had, to the changes in the world around him. The world had become smaller due to improved communications. As Brandt later told an interviewer, "*On vit plus vite*"—one lives faster.[313] The slow-paced life of prewar France had disappeared. Speeding trains, faster automobiles, and sleek airplanes were symbolic of modern life. Shiny, silvery aluminum became the hallmark of

194

speed. The French had not forgotten the Great War, but postwar prosperity and power may have created a false sense of security, keeping the government from making badly needed social and economic reforms. The populace wanted to enjoy life again.

The days of the sumptuous private house were gone. People were living in smaller maisonettes or apartments fitted with central heating, which meant that, for the ironsmith, radiator covers and air-duct covers became very saleable.[314] In addition, the modern age called for less cluttered surfaces—carved furniture and accessory-laden tables, after all, were time-consuming to dust. People wanted less fussy abodes that were easier to care for; windows that, without heavy drapes, allowed air and light to invade the interiors, which were outfitted with an inherent sense of elegance and proportion. Consequently, master craftsmen, capable of making fine ornamentation, needed to adapt to the pared-down refinement that was required for public spaces and private homes alike. In many cases skilled craftsmen were superseded by mechanical factory methods. The French became masterful in fashioning modernist rooms incorporating chromium-plated steel, wood, and glass; however, there were usually a few luxurious accessories—rich fabric, colorful porcelain, shiny lacquer, or wrought iron—that softened and personalized the avant-garde style.

Still, the need for serial production and standardization of parts further assured the decline of ornament, and modernism came to stay. In January of 1927, *Art et Industrie* counseled readers to choose for their interiors furniture that had geometric form.[315] The article is illustrated with examples of furniture that had sharp right angles. Designers had gravitated toward parallelograms, circles, triangles, and oblique, overlapping, or imbricated lines that offered a syncopated rhythm. These "syncopées"[316] were found in decorative hardware, jewelry, wallpaper, fabrics, and shawls. While Brandt's work never really fit into this formula, he must have felt the same imperative his colleagues did: to produce ironwork that would blend in with the new lines and shapes of furniture.

The new style was marked by a preoccupation with new materials. By 1928 metals such as chrome, aluminum,[317] studaluminum, and stainless steel were replacing wood, resulting in a new look that was considered "amusing and lively"[318] as well as practical. And these metals were also being combined with wood: as the expanding use of central heating had been adversely affecting the veneer of exotic and costly woods, designers began to affix bands of metal to desks and table rims in order to secure the veneers. The use of tubular steel for furniture was particularly successful and stainless steel, with its fine grain, was resistant to the elements and offered a clean surface. Hammer marks, which formerly had been a treasured part of wrought work, went out of fashion. Precise geometric forms permitted innumerable combinations without using other decorative elements. The metal itself was the decoration. All this presented a direct challenge to Brandt and *fer forgé*.

Furthermore, the rise of manufacturing and the economics of industrialization were making it necessary to simplify design. A plain tubular steel chair, made by unskilled laborers and machines, cost less than a veneered chair with inlay made by skilled artisans using time-consuming methods. The increasing attention to engineering principles, the availability of new materials, the trend toward serial production, and the standardization of parts all contributed to the active redefinition of taste and the marketplace.

The fact that decorative arts at this time were a microcosm of the prevailing architectural style could be seen in the 1927–28 home of the architect Robert Mallet-Stevens, who became a founder of the Union des Artistes Modernes in 1929.[319] The severe planes of the rooms were emphasized by the low fireplace, the Jean Prouvé metal stair railing, the aluminum furniture, the painted geometric-patterned floor, the checkered upholstery fabric, and the polyhedral mirror by Jean and Joel Martel.

The Modernist approach that was favored by Robert Mallet-Stevens, Jean Prouvé (b. 1901), Edouard-Joseph Djo-Bourgeois (1898–1937), René Herbst (1891–1987), and Pierre Chareau (1883–1950) was particularly apparent in the lighting fixtures by the Maison Desny.[320] Brandt's own chromed-metal table lamp is an interesting study of circular forms, and a reflection of this transitional period (fig. 207).

Brandt knew that France was no longer alone in the field of decorative arts, and he cared deeply that she maintain her long-held superiority and that artists continue to play an important role in the economy. But now, with the Modernist ascendancy, decorative artists depended more than ever on their relationship with industry. If anything, Brandt had known this all along—recall his speech of 1922—but now nearing fifty, he felt that artists must take even more initiative. Although he himself had helped to better the rapport between artist and industrialist, he still felt that the two forces generally spoke two different languages. Brandt had succeeded as an artist/blacksmith because he knew the exigencies of fabrication. He did not want young designers and artisans sacrificing their concepts or letting them be bastardized.

It would not be long before the tenor of the times would converge with Brandt's tenets, paving the way for one of the most dramatic moves of his career and a dramatic innovation in French arts and industry. Meanwhile, despite Brandt's beliefs, there was little he could do to slow the rise of internationalism. The same chromium-plated tubular steel chair or table was already being made in several countries. These pieces, because they were cheaper and available to more people, were to become ubiquitous. And although many French designers maintained their "old world" French aesthetic, others became avid proponents of modern metallurgy and sought new outlets for serial production. The Union des Artistes Modernes (U.A.M.), formed in 1929 by a group of followers of the Bauhaus, espoused the mass production of furniture made of metal tubes and bands.

The group, whose motto was "beauty in the useful," was directed by René Herbst, a leader in the use of tubular steel furniture, and included Mallet-Stevens, Chareau, Djo-Bourgeois, Raymond Templier, Le Corbusier, Eileen Gray, and Hélène Henry. These *fonctionnels* had strongly objected to what they saw as the vacuity of decoration that had characterized the works of the Paris Exposition Internationale des Arts Décoratifs in 1925. Their views, which were antithetical to the "ornament at any price" school, caused them to disdain the traditionalism of the Union Centrale des Arts Décoratifs, which, by the way, had rejected a number of them in 1928. And while the utilitarian furniture they championed was aesthetically successful, the financial end of the U.A.M.'s endeavors was not.

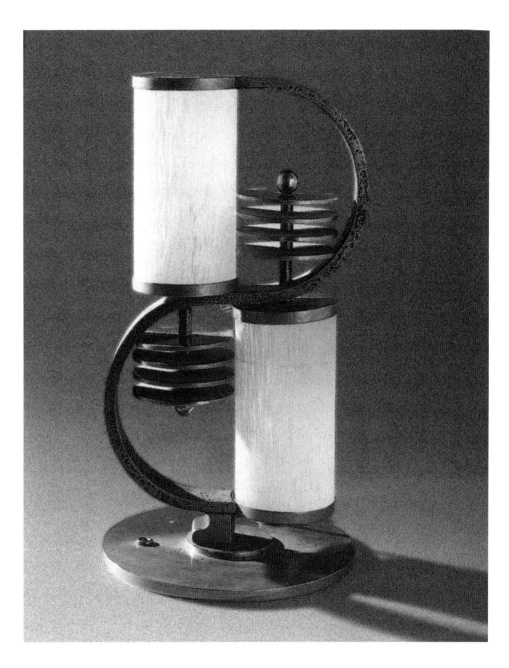

207. Table lamp, c. 1929–30. Chromed metal and frosted glass, height 15⅝". Stamped "E.Brandt". Courtesy Christie's Images

The wheels of change were erratic but their direction was permanent. Economic changes were perhaps the most devastating of all. At this time the cost of the war and the ensuing period of reconstruction, combined with a backlash from the 1929 stock market crash in New York, caused an instability in the franc and by 1931 France experienced a depression. In addition, the formation of the U.A.M. and the closing, three years later, of the influential Viennese design workshops (Wiener Werkstätte) signaled a decline in the luxury-goods market that had flourished in the 1920s. There were always wealthy clients to be had from South America, Egypt, the Middle East, and other places, but the heady spending of an affluent American and English clientele was severely curtailed.

THE CLOSE OF THE DECADE

Despite the atelier's personnel changes, Brandt's great sense of suitability dictated in the late 1920s that his ironwork reflect the new Modernist aesthetic. We can see how he accomplished this if we compare several pieces that show a progression toward abstraction in his firm's work. In the first example, a fire screen (fig. 208, bottom), we see a mixture of old and new forms: the Brandt fan shape with large, winglike leaves set into a stark diagonal grid, which rests on the same folded iron feet that Brandt had used for years. In a later, more simplified version of this design, the Egyptian fan shape appears even further stylized (fig. 208, top). Both screens would have blended well with the latest linear furniture of René Herbst, or Saddier et Fils.

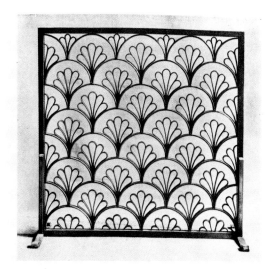

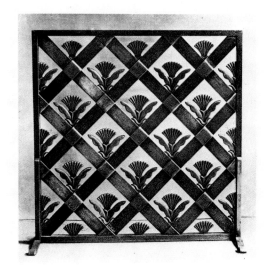

In a radiator cover made for a child's room in 1928,[321] Brandt used the Basque swastika[322] as the base of a geometric theme (fig. 209). (It is important to note that the counterclockwise swastika is an ancient symbol that can be found in artworks by the Greeks, American Indians, Persians, Indians, and Chinese. The swastika adopted later by Hitler as the Nazi party emblem runs clockwise.) Brandt used both types of crosses and alternated them with stylized animals and butterflies, placing bars of iron in between to form a grid. While this piece fulfills the specific needs of the client (featuring animals that would appeal to a child) it has a rigidity that can be ascribed to the geometric penchant of the time.

As so often happens in the history of the decorative arts, the ideas, designs, and motifs of one culture or movement find their way into another. The most striking and direct parallel to the Brandt radiator cover can be found in a Polish kilim executed by the Lad Association, founded in 1926 under the initiative of the Warsaw School of Art (fig. 210).[323] A study of Polish textiles appeared in the *Gazette des Beaux-Arts* in November 1927, confirming that there was interest in the work of the newly formed Polish cooperatives. Surely this kilim or one like it was the catalyst for the 1928 Brandt radiator cover. While the two works are materi-

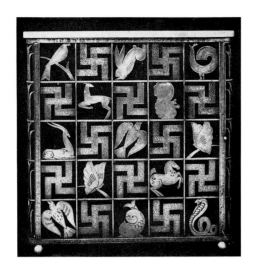

OPPOSITE:
208. (bottom) Fire screen with Egyptian lily and lotus motifs, 1928. Wrought iron, 25½ x 25½"; (top) Fire screen with Egyptian fan motif, 1928. Wrought iron, approx. 25½ x 25½". Courtesy Christie's Images

LEFT:
209. Wrought-iron and marble radiator cover for a child's room, 1928

BELOW LEFT:
210. Polish kilim rug similar in design to the radiator cover in fig. 209

ally and culturally different, they share an iconographical naiveté that is enhanced by repetitive forms.

Since Favier was no longer in charge of the design department, changes were inevitable. One thing is certain, however: the calligraphic style of ironwork that was introduced by Gilbert Poillerat before he left had made its mark. Poillerat was fond of juxtaposing lighthearted repoussé pieces and calligraphic bars with repetitive geometric forms. His influence was seen in a 1927 grille. The fan motifs along the top were vintage Brandt, while its calligraphic design was pure Poillerat (fig. 211).

One of the finest examples of a cogent, abstract Brandt design of the late twenties is a radiator cover that layers triangles over rectangles and double lines (fig. 212). When one compares the heavily hammered bars of this work with the doors that the Brandt firm made in 1925 for the exhibition it is easy to see how the Brandt style had evolved during this three-year

211. Wrought-iron grille with
stylized flowers and calligra-
phy, c. 1927–28

period. The hammering offered the visual playfulness that had formerly
been provided by lacelike C scrolls. A contemporary fire screen, which falls
in between the calligraphic and geometric modes, sums up the stylistic
change at the end of the decade (fig. 213). It features a Brandtian gazelle

with curvilinear horns that blend with the plant form and contrast with the abstracted lotus fan treatment.

There is no doubt that the Brandt pieces from this period were a mélange of the old and the new. For instance, a classic vasiform wrought-

213. Deer fire screen, 1928.
Wrought iron, 33½ x 39½".
Private collection

iron table lamp is beautifully acid-etched with antique figures; however, its sections of linked disks offer a strikingly simple repetitive formula while providing spaces for the light to shine through (fig. 214). The iron midsection was rolled flat, etched (using wax), and then bent cold and welded together. Here is a piece, both useful and beautiful, that combines Brandt's industrial stamping (circles) and his neoclassical artistry (the pictorial band).

Brandt's fellow artisans were also producing work that reflected the ongoing changes, with varying degrees of success. Many of these efforts were shown alongside the highly influential designs of the Deutscher Werkbund when it exhibited as part of the twentieth Salon des Artistes Décorateurs in 1930.[324] One reviewer felt that in comparison with the clear, sharp, and simple designs of the Germans, those shown in the French section seemed to flounder. While individual artists did well, the French displays apparently lacked cohesion and energy.[325] The designs of the French

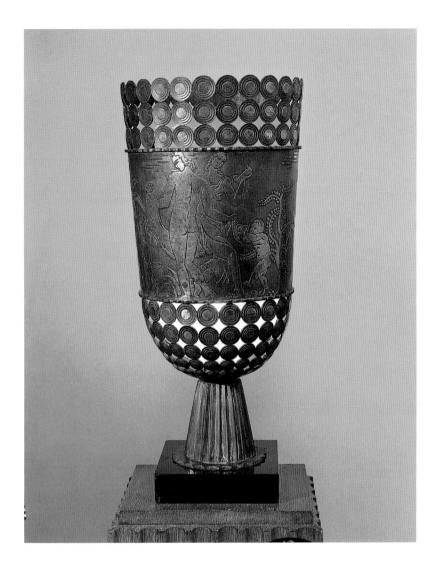

214. Table lamp, c. 1926–28.
Wrought iron with acid-etched
figures, 26 x 11¾″ diam.
Stamped "E.Brandt".
Courtesy DeLorenzo Gallery

were divided between traditionalists like Ruhlmann and individual attempts
at functionalism. The Germans, on the other hand, appeared to have revo-
lutionized the concept of decoration, interpreting it to mean anonymous,
utilitarian beauty. By 1930, the Werkbund's facility with tubular steel for
furniture was overwhelmingly successful. The progressive German design-
ers and architects proselytized intellectual values while focusing equally on
the functional essence of a design, be it for a chair or a house.

The change in focus from iron to other metals or alloys was elo-
quently demonstrated by a review of the Salon d'Automne of 1930.
Whereas formerly a good portion of the yearly Salon critique had been
given over to ironwork, now the only *ferronnerie* praised was Raymond
Subes's gate for Le Musée Permanent (for the Colonial Exposition of the
following year in Paris).[326] Brandt's work was not even mentioned,
although he exhibited a large piece, a collaboration with the artist Paul
Jouve. This work, a huge set of silvered bronze doors depicting elephants,

RIGHT AND OPPOSITE:
215. Pair of elephant panels,
1931. Executed by Brandt
after a design by Paul Jouve
for the Colonial Exposition
of 1931; inscribed "Jouve".
Silvered bronze: 8′11″ x 6′5⅜″;
8′11″ x 6′8¼″. Courtesy
Sotheby's, Inc.

was too large to go unnoticed (fig. 215).[327] Each startling panel shows the
frontal view of an elephant charging toward the viewer with ears extended.
The beasts, walking forward through a dense jungle, bring to mind power-
ful Assyrian bas-reliefs. The tropical leaves and flowers are reminiscent
of those on the 1925 screen *L'Oasis* (see fig. 160). Jouve's design, which
would be overwhelming in any other medium, is mitigated by the subtle
relief and patina of the bronze. The critics may have passed over this
Brandt piece because they saw it as being more representative of Jouve's

animalier art than of the *ferronnier*. But one wonders whether they would have made the same decision five years earlier.

Cogniat, the reviewer of the Salon d'Automne who spoke of metal as triumphing there, either alone or in conjunction with wood, glass, leather, or fabric, was more focused on the new metals and alloys than on bronze or iron. It is not that wood and wrought iron were forgotten materials; they were simply in competition with a mélange of metals that needed to be explored for their exciting possibilities. This experimental time was

216. Drawing of an oval
table from the Brandt atelier,
c. 1930–33. Collection Robert
Zehil, Monaco

summed up by the designer Paul Fehér, who said in 1988: "The French
were crazy for anything new."

Howard S. Cresswell, an American writing for *Good Furniture and
Decoration,* commented on the ongoing developments in Parisian decora-
tive arts:

> What is really happening is that nothing is actually being
> abandoned as a material; rather the proper use of each sub-
> stance is being studied out. Whereas, some five or six years
> ago we found the different decorators rather fed up with
> wrought iron, we now find them adjusting themselves to the
> use of chromium nickel. To avoid the criticism of "hospital
> furniture" we find chromium nickel used with wood or dis-
> creetly covered with upholstery. . . . The different materials so
> well known to the artisan seem to be all having a real struggle
> for existence, at times robbing each other of their glory only
> to have another element rob them in turn.[328]

In 1933 another prominent critic, Marcel Zahar, examined the *fer
forgé* displayed at the Salon des Artistes Décorateurs. He praised a mount-
ed grille of Poillerat's as being light and spirited. However, he disapproved
of the methodical hammering technique used by Szabo to decorate a con-
struction designed by the architect M. Montier. And so the aesthetic debate
of ornament versus pure design continued.[329]

To some it must have seemed that the artist-blacksmith was becom-

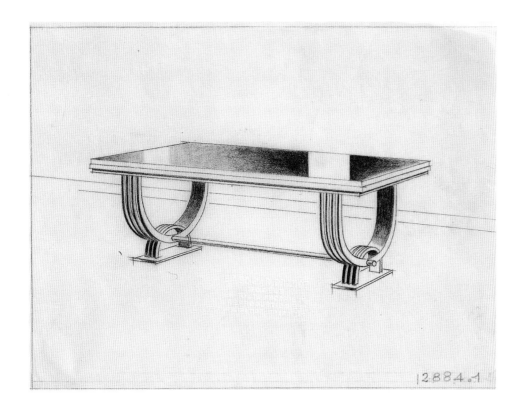

217. Drawing of a dining table with U-shaped legs from the Brandt atelier, c. 1930–33. Collection Robert Zehil, Monaco

ing obsolete. Yet, although scientists were creating new materials for artistic and industrial use, the artist was still essential—to infuse these materials with spiritual expression. This had been a more natural process when the material was malleable like wrought iron. Now the whole tenor of ironwork had changed with the addition of chromed or nickeled metal, aluminum, Duralumin, studaluminum, Monel, rivalum (a cast material for interiors or exteriors), and similar alloys that could be smelted refined, cast, injected, or extruded.[330] Brandt embraced the new metals for many projects in the 1930s. For a monumental door for the Hydroelectric Society of Savoie in 1934 he used tubes and bands of studaluminum. Wrought work did not disappear but its halcyon days were over. The designers and craftsmen who stuck it out had to readjust to a faltering economic climate, a changing society, and enormous challenges to the very nature of their craft.[331]

Poillerat, Raymond Subes, and other smiths adapted by using steel more often than wrought iron. The latter had superior qualities for welding but steel was stronger; like iron it could be shaped into plates and bars at the rolling mills. Bars of steel were pulled through forms that compacted it. These extrusions were similar to those used for turning out wooden hand railings. The steel came out of the form or mold with a shine, whereas a forged piece of iron had to be hand-patinated, a job that was time-consuming. Extruded steel had the sleek, austere look that the designers were after.

In 1922 Brandt had said: "Today can do what yesterday did, but the reverse can never exist." For his part, Brandt never returned to the old ways. In fact, he probably received more and better commissions at this

RIGHT AND BELOW:
218. U-shaped table, 1933.
Gilded steel and marble,
38½ x 47½ x 17½". Stamped
"E.Brandt". Detail shows
stamped geometric pattern.
Private collection

OPPOSITE:
219. Arc welding during the
assembly of window frames at
Brandt's factory at Châtillon-
sous-Bagneux, c. 1935

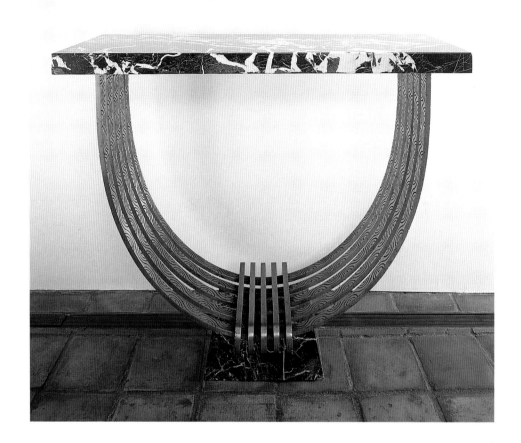

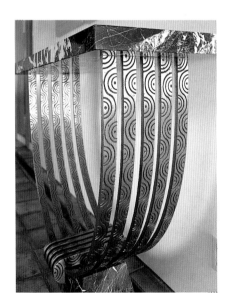

time than some of the smaller ironwork operations. He continued to take on the work, offering his interpretation of the new pared-down aesthetic (figs. 216, 217). In 1930 he contributed to the remodeling of the great hall at the Gare Saint-Lazare, which included setting marble walls with chromed stainless-steel moldings, larger ticket booths, and grilles. By early 1933, his firm had come out with a distinctly modern look: bars of iron were stamped with a design of cascading circular rings that appear to undulate on the surface. The concept of using stamped designs was particularly effective on a U-shaped console table (fig. 218), as well as on desk accessories. This type of decoration offered less labor-intensive, yet practical and au courant pieces, thus making the transition to a new phase of production.

In February 1933 *Art et Industrie* ran two advertisements that reveal how the last gasp of *ferronnerie* was in competition with the myriad metal alloys. On a single page, Brandt's drop-stamped design is advertised next to a Studal Aluminum notice offering a free luxurious album documenting Studal's uses for architects, entrepreneurs, decorators, *ensembliers,* and window dressers. Clearly the sun was setting on the great art of iron forging.

In his career Brandt had gone through a metamorphosis: he began by lock-
smithing and hand-forging pendants and brooches; he graduated to unique
designs of grilles and gates; and he went on to industrialize production but
never at the cost of expert design or the elimination of hand finishing. He
had proven over and over that the machine could be a successful adjunct to

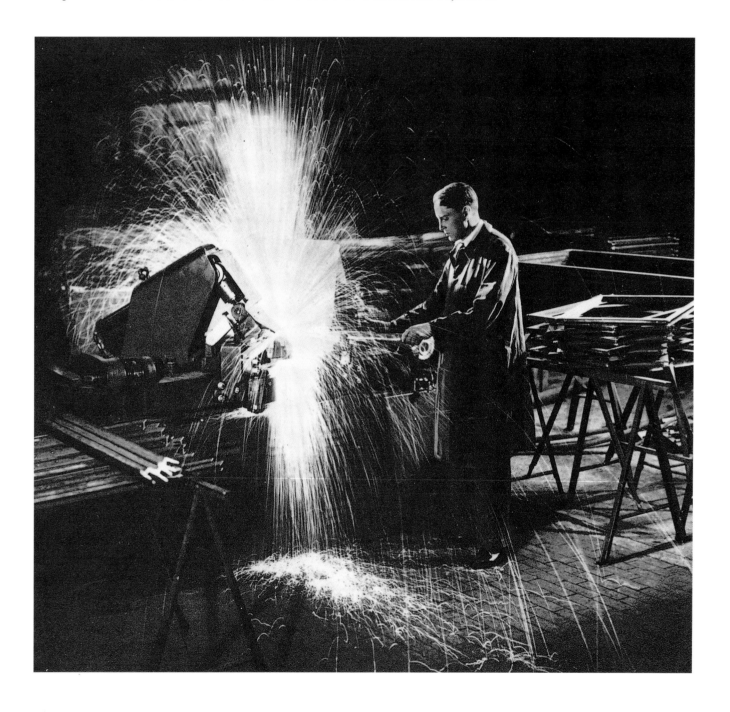

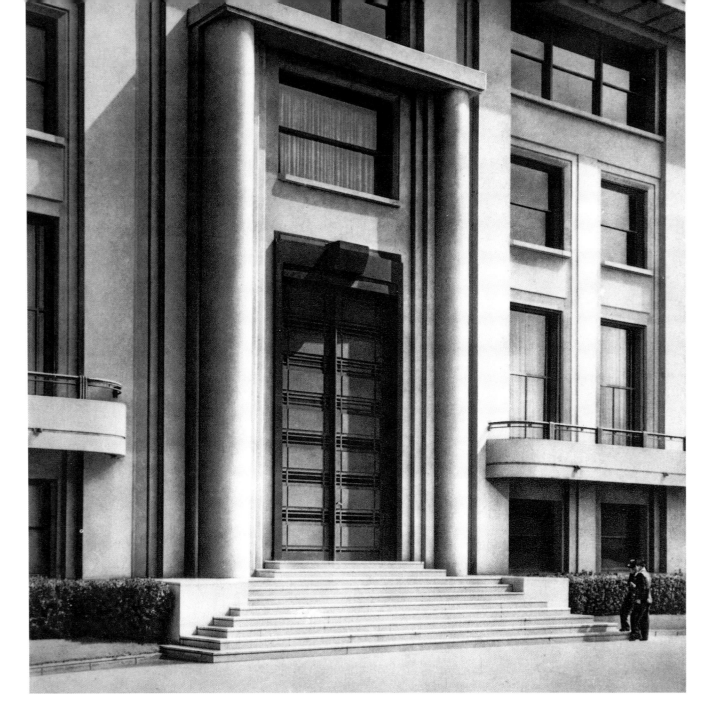

220. The facade of the administration building of Brandt's factory at Châtillon-sous-Bagneux, c. 1935. Cassan and Plousey, architects

works of art if it was used intelligently. Now, his extraordinary foresight and energy would lead him through another transformation.

Brandt knew well that steel had become a very important commodity. He also recognized that whether used for cars, trucks, trains, planes, or armaments, it had to pass through the hands of a metalworker. Iron, he felt, was the principal element of work; along with coal it was the pivot around which all the world's industries united. The question was where might the artist fit in all this? In 1930 he told an interviewer, Maurice Hamel, "the industrial arts without artists gives an image similar to the chemical industry without laboratories."[332] Yet as he continued to express the need for cooperation between artists and manufacturers, the products being made appeared more manufactured and less conventionally artistic.

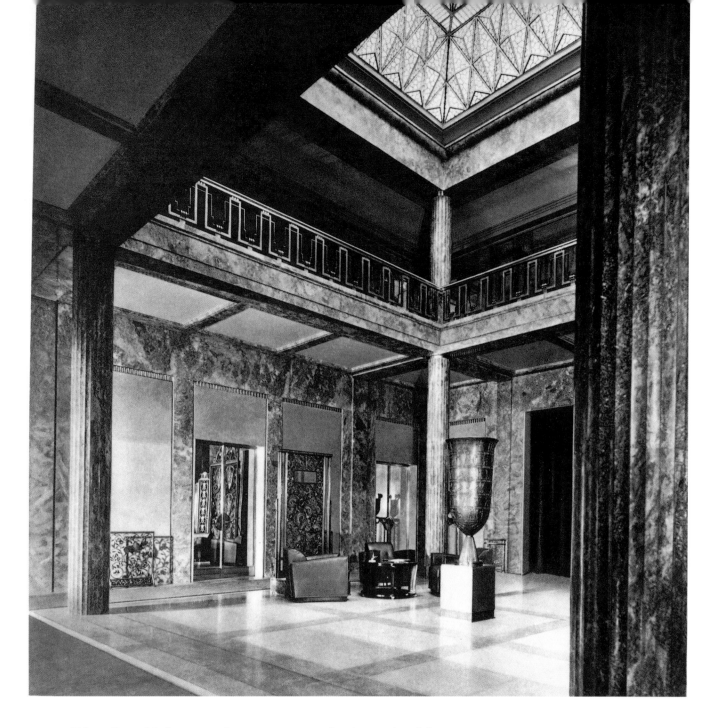

221. Entrance hall of the administration building at the Châtillon factory, c. 1935. Brandt's vase *Olympie* can be seen in the foyer.

Edgar Brandt's latest goal was to answer the demands of the Modernists, remain flexible, and expand his business. It was in response to this challenge that he conceived of a huge, multifaceted factory that opened in 1932 after four years of planning and construction at 12 rue Béranger, Châtillon-sous-Bagneux. This nine-acre complex, not far from Paris, allowed for not only the production of ironwork, but also for *menuiserie métallique,* which dealt with the construction of steel doors and window frames, and for the manufacture of large and small metalwork pieces and locks (fig. 219). In addition, a corps of designers worked on decorative iron, interior decoration, and furniture for large projects, such as hotels, apartments, and theaters. Lastly, a separate section was planned for the manufacture of armaments—60mm, 81mm, and 120mm mortars and their

ammunitions (propelling charges)—and for a research-and-development
department. Although Châtillon became a supreme model for a state-of-
the-art factory, its conglomerate of shops reflected the philosophy that the
human hand was often the best tool of all. And while the manufactory
opened its doors with approximately one thousand workers, Châtillon
eventually accommodated three thousand workers.

The factory's architects, Urbain Cassan and Walter Plousey, designed
a Moderne yet classically inspired administration building. Just as the
facade and wrought-iron decoration of 101 Boulevard Murat were evoca-
tive of 1920, the Châtillon facade addressed the streamlined geometric sim-
plicity of the 1930s (fig. 220). The plain iron railing along the curved
balcony and the rectilinear double-height doors were the epitome of under-
statement, a far cry from the elaborate Art Deco floral motifs executed
twelve years earlier for the Boulevard Murat establishment.

The strong vertical lines on the exterior of the building were carried
out inside, particularly in the rectangular two-story entrance hall (fig. 221).
Fluted *Lunel fleuri* marble columns without capitals or bases supported the

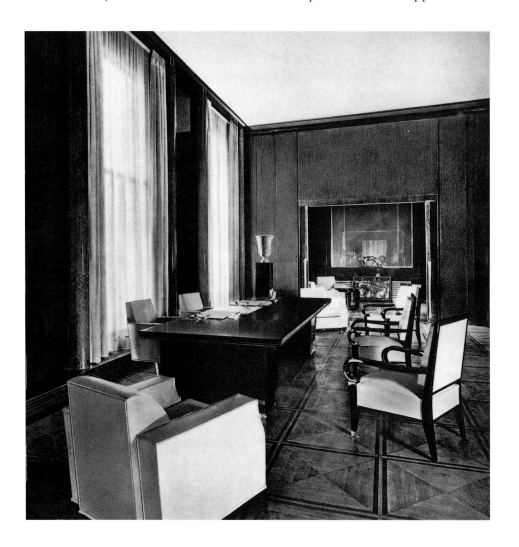

223. Edgar Brandt (in front, at right) and eight colleagues in front of the administration building at the Châtillon factory, 1933. Courtesy the Brandt family

balcony, which was bordered by a stainless and polished steel railing in a simple pattern of open rectangles. A feeling of serenity permeated the atrium, due in great measure to the light emanating from Cassan's crackled glass skylight, which was lit up at night. In the center of the hall stood the great bronze vase *Olympie* (see fig. 165), along with many seminal pieces of *ferronnerie*. Visitors to the building spoke of the harmonious mixture of marble, stainless steel, stone paving, wrought iron, and glass. Henri Clouzot reported that the hall, the directors' offices, the waiting rooms, and the gallery were marked by a luxurious sobriety.

Brandt himself designed the decoration of his office and antechamber as well as the offices of the directors and administrators. For the walls of his office he chose varnished parchment enlivened with gilded moldings. The doors, the mantelpiece, and baseboards were Macassar ebony, as was the furniture. Chabert-Dupont's handwoven straw-colored and gold curtains and velvet drapes provided a fine background for the Macassar ebony desk, which was embellished by gilt bronze hardware and stood on a rust-and-ivory carpet. The lacquered chairs were upholstered in natural cream-colored leather. Electrified Sèvres vases were set on stands and reflected a soft light toward the ceiling. All the directors' offices were equally elegant and refined (fig. 222). Brandt's sophisticated furniture for these rooms was a world away from his early examples of 1904. The entire headquarters, a mélange of rich woods, marble, and stainless steel, yielded an atmosphere both magisterial and welcoming. Edgar and eight of his closest colleagues gathered for a group portrait on the front steps in 1933 (fig. 223).

The scale of the factory's operations was immense. Competent foremen and excellent planning allowed the firm to complete large projects, such as the four million francs' worth of ironwork for the Théâtre National

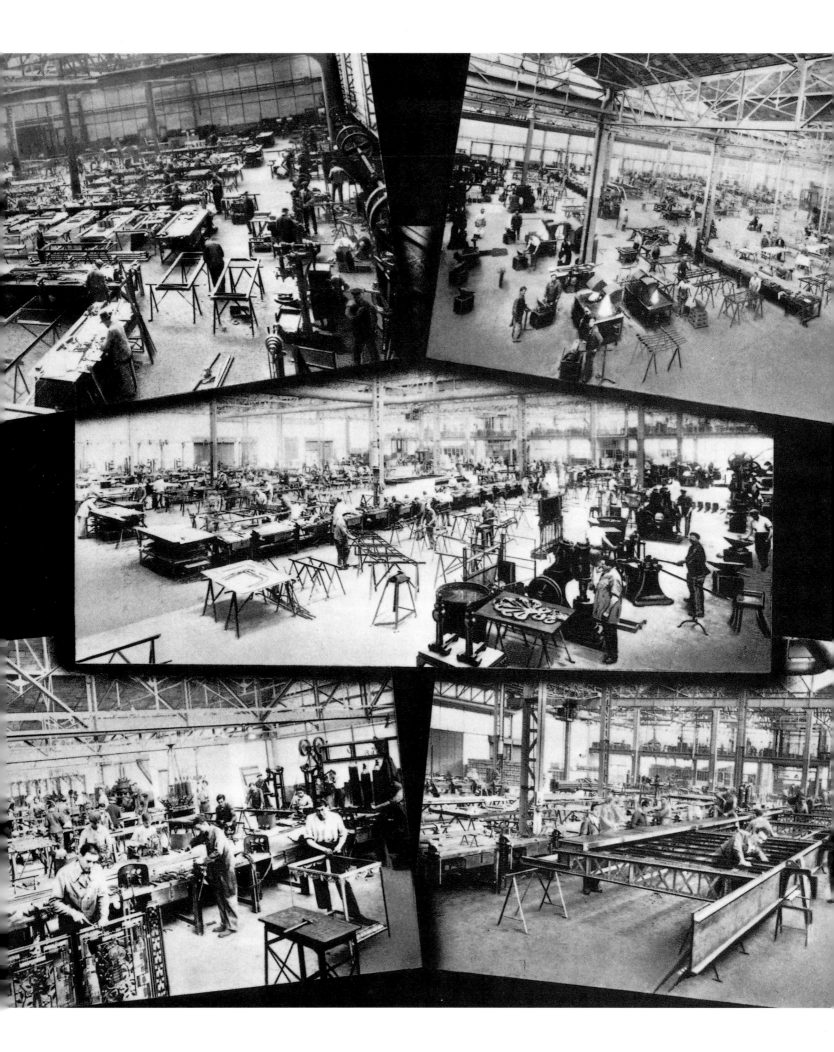

de Mexico in three months, and the Villa-des-Fleurs auditorium in Aix-les-Bains (Savoie) in less than eight weeks.[333] At this time ironwork was made to decorate the United States Embassy in Paris. Several *ferronnerie* specialists from 101 Boulevard Murat were transferred to Châtillon along with some machinery (power hammers, forges, anvils, polishing and cutting machines) in order to work on these commissions. Brandt had more than fulfilled his dream of integrating art and industrial methods (fig. 224).

In the facility devoted to armaments, an assembly-line system was initiated, with the workers divided into teams.[334] They stood in rows and the material came to them on conveyer belts. Foremen surveyed the activity from observation towers. Important foreign visitors were always amazed by the innovative and precise machinery. Most of the armaments, principally the casings for projectiles, were sent on to another factory at Vernon (Eure), about fifty miles from Paris, where they were filled with explosives. The fields of Vernon were used to demonstrate the mortars to foreign buyers. In all, fifty-two countries adopted Brandt's 81mm mortar between 1927 and 1939. The American army, for example, manufactured the 81mm under license in the United States. Not only in the Châtillon arms division but also in the *menuiserie métallique* department, Brandt adopted mass-production methods based on those used in American automobile manufacture.[335]

For its time Châtillon was a progressive factory, providing workers with dining-room facilities, an infirmary, showers, bicycle racks, and car service to Paris. While Les Etablissements Brandt at 101 Boulevard Murat had been exemplary for its artistic production, it was not the only well-equipped factory in Paris.[336] In contrast, the Châtillon-sous-Bagneux complex combined both artistic and technical production in a unique, ultramodern facility. Châtillon's remarkable equipment included two thousand machine tools, many of which came from America.[337]

This hub of activity ran successfully despite France's ongoing economic slump, the prevailing lack of confidence in the franc, and the problem of unemployment. However, within a few short years financial and political turmoil worked to wrest control of this impressive complex away from Brandt. As Hitler took over Germany, French governments came and went, each one struggling to solve the country's economic plight and the political problems inherent in Germany's growing rearmament. In 1936, Léon Blum, the first Socialist prime minister, and his Popular Front regime came to power. Their policies included the nationalization of armaments. Before long, the workers went out on strike. Châtillon, along with Brandt's ateliers and trial fields at Vernon, were taken over by the sit-in strikers and their work was halted in the name of the French government.[338] Losing Châtillon was a great blow to Brandt—he never got it back—and today it still belongs to the government.

Ever adaptive, Brandt opened smaller factories at La Ferté-Saint-Aubin (1938), Tulle, Nantes, and Jurançon—in an effort to replace the

OPPOSITE:
224. Assembling decorative wrought ironwork at the Châtillon factory, c. 1935

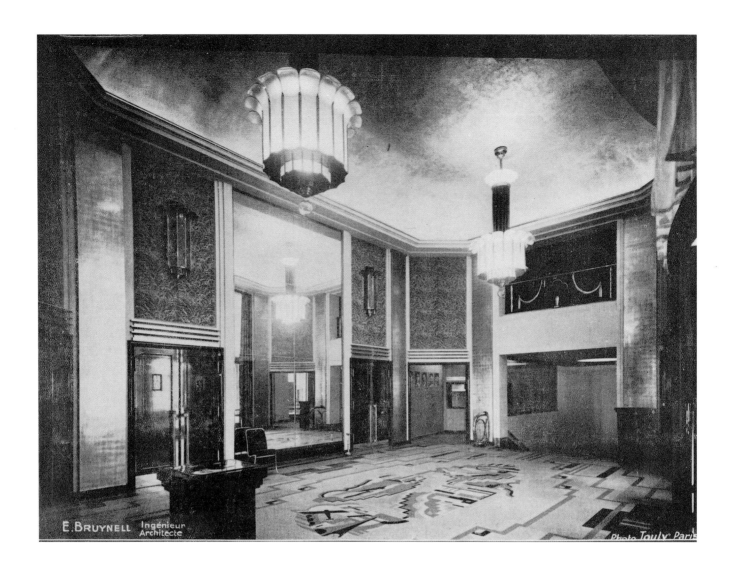

225. Entrance foyer of the Cinéma Marignan Pathé-Natan, Avenue des Champs-Elysées, Paris. Wrought-iron railings by Brandt. E. Bruynell, architect. From *La Construction Moderne* (June 18, 1933)

armament-production section of Châtillon. The *ferronnerie* atelier of Châtillon remained open, as did the section that exported armaments to foreign countries.[339] François Brandt remembers that his father appreciated the fact that 101 Boulevard Murat was not nationalized by the state, as it was a symbol of his early artistic and technical success. Brandt enlarged the factory space at Boulevard Murat, where he continued the ironwork and the armaments production.

At the same time that Châtillon was set up in 1932, Brandt installed a *ferronnerie* department on the rue du Hameau in Paris. In 1933 Brandt opened offices at 52 Avenue des Champs-Elysées, a central location for his expanding enterprises, known as La Société Nouvelle des Etablissements Brandt. Brandt's fifth-floor office was set on an angle and gave him a view of the Arc de Triomphe nearby. The research and development of armaments carried out in these offices played an increasingly important role in the destiny of France and would eventually affect the security of many

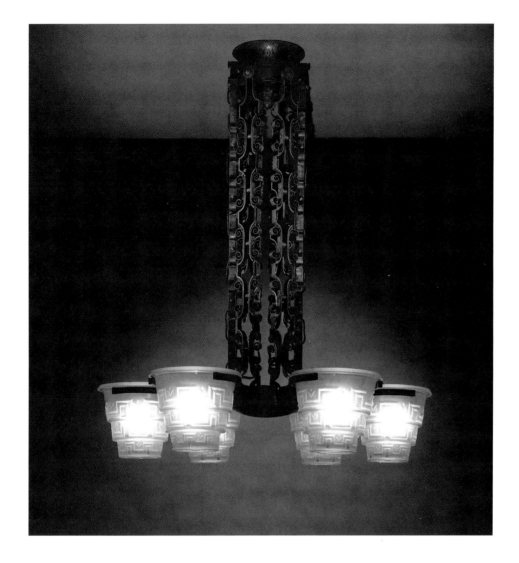

226. Chandelier, c. 1930.
Wrought iron and frosted
glass, 36 x 30″. Stamped
"E.Brandt". Courtesy
Christie's Images

countries. Brandt's work was now divided between armaments and iron-
work, with an increasing emphasis on the former. In both cases his preoccu-
pation was to improve the production process in order to reduce prices.

For the most part, detailed wrought-iron lamps and chandeliers were
out of fashion in the 1930s. Decorators now favored the white metals.
Brandt made lamps and chandeliers that were simpler, geometric in shape,
and had limited decoration. However, wrought iron continued to be very
popular for banks, apartment houses, department stores, and theaters. For
instance, in 1933 the Brandt firm completed the wrought-iron decoration
for the popular Art Moderne, 1,758-seat Marignan Pathé-Natan movie the-
ater at the corner of rue Marignan and the Avenue des Champs-Elysées in
Paris.[340] This prestigious commission included metal-and-glass double
doors with elongated silvered-metal handles and railing supports for the
entrance foyer (fig. 225); and wrought-iron and gilt railings that surround-
ed the curved orchestra pit and complemented the pattern in Ruhlmann's

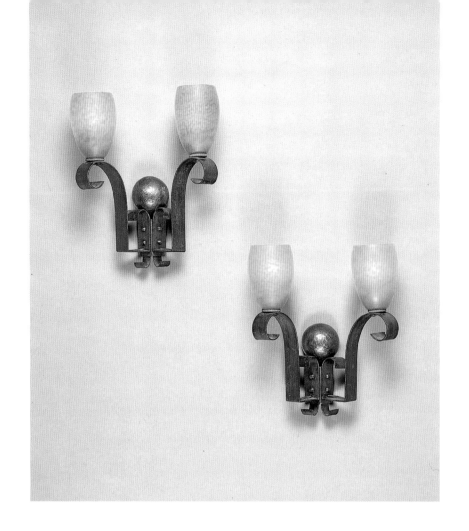

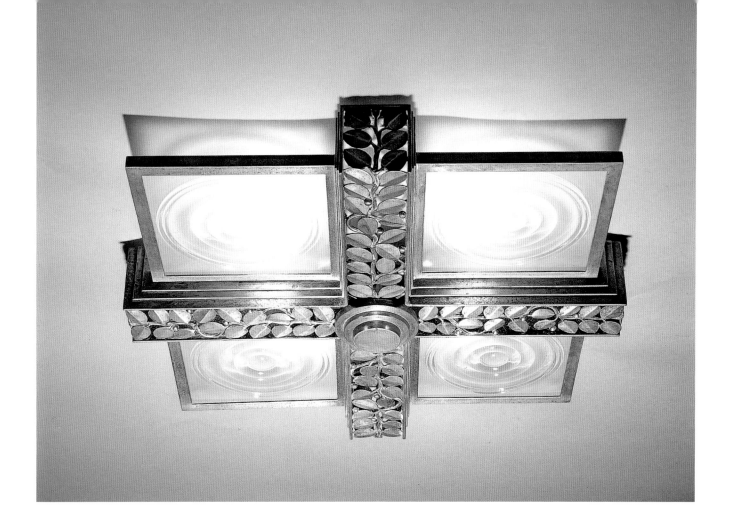

garnet-red damask walls and theater curtain.[341] Unfortunately, this iron-work, with its two-tone swags and fan shapes, has disappeared.

Commissions came from every direction. In the summer of 1932 a monument was raised at Turckheim, in Alsace, to the glory of Vicomte de Turenne (1611–1675), the French marshal-general who saved Alsace from the Germans and then died twenty-two days later. The pyramidal stone monument was decorated with forged- and gilded-bronze laurel garlands and fleurs-de-lis by Brandt. From memorials to theaters to exhibitions, all were within the ken of the ironsmith. For the exhibition of 1937 Brandt worked on the iron entrance door for the city hall of Vincennes (Quarez and Lapostolle, architects), in which six Brandtian vase forms held inflorescent pine cones and a rectangular transom bore a classical female holding a violin.

Certainly the construction of the Châtillon complex coincided with a major refocusing in the decorative arts. Brandt was prescient in this regard. He saw the changing times, recognized them, and decisively changed the focus of his business. From 1929 into the 1930s Brandt gravitated toward less complicated objects, such as bookends, ashtrays, lamps, andirons, fire screens, and hanging or platform chandeliers, which often accommodated the newer taste in materials. These pieces could be made, for example, of forged iron or alloys, or of iron pieces combined with other metals such as

OPPOSITE, TOP:
227. Pair of sconces, 1929. Wrought iron and Daum glass, 15 x 12″. Stamped "E.Brandt"; glass inscribed "Daum Nancy France". Courtesy Christie's Images

OPPOSITE, BOTTOM:
228. Wrought-iron pelican bookends, ashtray, and lamp, and mistletoe paperweight, c. 1929–31

ABOVE:
229. Platform chandelier, c. 1931. Wrought iron and glass, 21½ x 21½ x 3″. Stamped "E.Brandt". Courtesy Christie's Images

polished steel, bronze, copper, and aluminum (figs. 226, 227, 228, 229).

With the building of Châtillon-sous-Bagneux, it would have seemed that Brandt was prepared for all contingencies. The sumptuous entrance hall of the administrative building had been planned to display Brandt *ferronnerie* in all its splendor. Brandt's fine wrought-iron console tables were still sought after. Those made in the early 1930s were simple U-shaped forms. Although shorn of detailed moldings, they employed stamped decoration and retained their authoritative and elegant style. Not only could Brandt satisfy people who were still interested in commissioning these unique, luxury wrought-iron objects but he was also equipped to provide quickly made multiples of door and window frames in special or standard sizes, and he was furnishing munitions for his country and its allies. But for all his foresight in 1932, he could not have definitively predicted nationalization or the eventual eruption of World War II.

During the 1930s it became apparent that Brandt's Art Moderne ironwork had distinctly influenced the decorative arts and architecture in America, England, and other countries. Around 1930 he designed the ironwork for the University of Fribourg (Switzerland) in a calligraphic style. Through his offices in Paris, New York, and London,[342] Brandt fulfilled countless commissions from Cairo to Montreal, and even on the high seas. His chrome-plated serving pieces (1932, collaboration with Georges Bastard), yet another aspect of Brandt's output, were used by the diners on the ship *Normandie*.[343] In cities throughout the world, many homes, offices, and public buildings were enhanced by the *ferronnerie* of Brandt. Innumerable artists and designers were inspired by his motifs, while craftsmen followed Brandt's quest for a modern methodology: all respected his art, his ingenuity, and his example.

In 1939 Brandt, his wife, Renée, and their son, François, booked passage on the *Normandie* and visited the United States and Canada. One would think that the *ferronnier* would have enjoyed seeing firsthand com-

missions such as the Madison-Belmont Building in New York and would be pleased to see variations of his iron motifs emulated on building facades in Montreal, New York, Cincinnati, and other cities. Characteristically, the humble Brandt did not seek out these sites; he did not show them to his wife or his son. Instead, Brandt traveled to Washington, D.C., where he had appointments with government officials concerning contracts for the 81mm mortars and grenades that he had sold to the United States army (fig. 230). François Brandt adds: "Edgar appreciated all the more the American army's decision to adopt (and manufacture under license) his 60mm and 81mm mortars in that his ironwork designs back in 1925–26 had been so successful in the U.S.A. and Canada." He was particularly pleased to visit the Ford plant in Detroit and the Bethlehem Steel plant in Pennsylvania because of his interest in mass production. In the midst of this exhilarating trip, however, he received a telegram summoning him home because war was imminent.

OPPOSITE:
230. Brandt (left) and his colleagues Colonel Delalande and Abner Leech on L Street in Washington, D.C., 1939. Courtesy the Brandt family

BELOW:
231. Brandt (right) and his brother, Jules, in Geneva, 1946. Courtesy the Brandt family

In view of the impending hostilities, even more of Brandt's time now went into armament invention and production. Because of his acumen in this field, he was a valuable man—and perhaps in danger as a result. By 1942 he felt that he and his family were at risk. François Brandt reports, "We moved to Switzerland in order to escape the Nazis, who wanted to exploit his talent and make him work for them against the Allies."[344] For the next thirteen years, Brandt continued his research on armaments, designed ironwork for his home, and traveled. He always enjoyed visiting with his brother, Jules (fig. 231). In 1955 he reassembled some of his old ironworkers in order to restore the six monumental wrought-iron grilles at the Château de Versailles—decorative and defensive arcades of the Queens and Ambassadors wings that face each other in the Cour de Marbre. This project involved 4,000 feet of hand-forged iron, 7,000 sheets of gold leaf, and twelve blacksmiths working for over two years.[345] The inau-

232. Brandt at age seventy-three, 1953. Courtesy the Brandt family

guration of these gates took place on June 26, 1956. This was the iron-smith's gift to his country. It is perhaps ironic that Brandt, the forward-thinking twentieth-century *ferronnier,* as one of his last works, should be involved in reconstitution of the seventeenth-century designs of Jules Hardouin-Mansart (1646–1708) and Pierre Lepautre (1648–1716). One year after the restoration, he was named Commander of the Legion of Honor by General Georges Catroux for his lifelong artistic and technical contributions (fig. 232). After a long illness, Brandt died on May 8, 1960, in Geneva.

THE LEGACY

The protean sculptor August Rodin once said: "Art that has life does not repeat the works of the past, it continues it." That sentiment provides a fitting summary for what Edgar William Brandt accomplished for the art of ironwork.

In a sense Brandt can be compared to Sergey Diaghilev, the ballet impresario, who introduced classical Russian ballet to the West in 1909. In fact, the careers of the two men were most fruitful during the same period of time. For twenty years Diaghilev chose the best dancers to bring alive the choreography of Michel Fokine, Vaslav Nijinsky, and Léonide Massine. Intuitively, he selected such artists as Henri Matisse, Georges Braque, André Derain, and Pablo Picasso to create sets and costumes. The atonal music of Igor Stravinsky and the modernism of Erik Satie were daring and exciting choices. In a similar fashion Edgar Brandt embraced the ancient blacksmith's techniques and augmented them with modern machine methods, the finest materials, excellent collaborators, and an instinct for getting important commissions and publicity.

Another parallel may be drawn with the choreographer Georges Balanchine, a Diaghilev protégé, who carried the great heritage of the Maryinsky Theatre School into the formation of American ballet. Balanchine never abandoned traditional ballet technique; rather, he sought to modernize it. He used the time-honored ballet positions but with a new creative emphasis that was faster, sharper, and plotless. Likewise, Edgar Brandt embraced the groundbreaking example of Emile Robert but sought to modernize it. As the beneficiary of Robert's ironwork revival Brandt created a signature style—at once elegant and vivacious—that came to represent the best of Art Deco.

Brandt rejuvenated and contemporized metal craft by broadening the scope of the blacksmith's genre and making it a more industrial art. Once he became secure in his knowledge and technique Brandt was able to widen his view, thus setting himself apart from others. In a quiet but systematic fashion, he succeeded in making his name synonymous with Art Deco wrought iron. The Egyptian fan motif, the Grecian fluting, the stylized animals and flowers, the jets of water, the potato peelings, the flat, folded iron scrolls used as bases, the scalloped edges, the incised running bands and beading were all favorite motifs that contributed to Brandt's inexhaustible formula. Subtly embracing the cultural heritages of Egypt, Assyria, Persia, Greece, Africa, China, and Japan, Brandt managed to incorporate traces of the past and turn them into something new and refreshing. For more than fifteen years, his was the most sought-after product in French ironwork.

François Brandt compiled a list of words that have most often been used to characterize the *ferronnerie* of his father: *equilibrium, harmony, presence, life, character, allure,* and *grace* were appropriate descriptions of the work in the 1910s, 1920s, and 1930s, and they are still correct descriptions of the work today. By contrast François remembers the words that his father used to describe work that was not pleasing to him: *heavy, banal, aggressive, cold, spiritless, old-fashioned, overworked, affected.* The words disclose the design standard that Edgar Brandt revered and the qualities for which this renaissance man strove.

The master smith produced a prodigious number of artistic works and technical inventions. Obviously he had the ability to focus on many projects at once and was never satisfied with the status quo. One family incident in 1932 reveals much about the man. Edgar, his wife, Renée, and their son, François, were driving south from Paris in his Lincoln sedan. After traveling along for about sixty miles they heard a large bang like a gunshot, and the motor began to vibrate. A look under the hood revealed that the rotor blade had broken off and with centrifugal force had pierced the hood of the engine compartment. The broken blade was lodged in the hood. The chauffeur, reducing his speed to a crawl because of the unbalancing of the fan, drove to the nearest village and pulled into a garage.[346] Everyone got out of the car as the mechanic attempted to reweld the rotor blade. Edgar quickly realized that the man did not know what he was doing; his welding torch was too small. Edgar removed his jacket and proceeded to take down a larger welding torch that he spied hanging on the wall. To the astonishment of the *garagiste* in no time he welded the rotor blade, returned the torch to the wall, and then, in a friendly manner, handed the mechanic twenty francs—twice as much as was required. The mechanic appreciated the money and was visibly impressed with the welding. The car started up immediately and off they drove. The rotor blade never needed to be repaired again.

It is fitting to end this examination of Brandt's life and career with his own words: "*Ne vous occupez pas de ma vie, des circonstances de mon chemin, mais regardez ce que j'ai fait, ce que j'ai pondu, ce que je laisse.*"[347] ("Do not concern yourself with my life, the circumstances of my existence, but look at what I did, what I produced, and what I leave.")

Edgar Brandt created every kind of metalwork—a comprehensive oeuvre resulting from his progressive thoughts and determined actions. He left a heritage of inspiration for future generations of blacksmiths, artisans, collectors, and art appreciators. Although he efficiently and ingeniously made repeated use of many of his best designs, Brandt himself, as an artist, inventor, and entrepreneur, was one of a kind.

All quotes were translated from the French by the author.

Nineteenth-Century Ironwork: Emile Robert Relights the Fire

1. Georges-Eugène Haussmann, a civil servant, was prefect of the Seine department from 1853 to 1870. In a vast program of public works, he created, with the emperor, the modern city of Paris, including parks, streets, water supplies, markets, and the Opéra. Both cast and wrought iron were used to decorate the city. See Benevolo, *History of Modern Architecture*, vol. 1 (Cambridge, Mass., 1971), 61–95.
2. Frank, *Old French Ironwork* (Cambridge, Mass., 1950), 26, 128. The name "Biscornette"—Twin Horns—came about because it was said that only the devil could produce such elaborate ironwork. See J. Starkie Gardner, *Ironwork* vol. 1 (London, 1978 [1927]), pl. 20.
3. Pierre Boulanger (1813–1891), Larchèveque, and Ducros were among the few blacksmiths working during the 1867 Paris Exhibition.
4. *Paris International Exhibition of 1878* (London, 1878), 66–84.
5. "La Décoration Moderne, Robert, ferronnier," *L'Art et Les Artistes* 5 (Apr.–Sept. 1907): 27–29.
6. Letter to the author from Jean Manceau, the Mayor of Mehun, on behalf of the families of Larchèveque and Robert, Dec. 8, 1989. Ernest Larchèveque (born Sept. 10, 1843, in Mehun-sur-Yèvre) won a bronze medal at the Exhibition of 1867 and was part of every important exhibition through 1886. His atelier at Mehun excelled in locksmithing and ironwork (grilles for Bourges Cathedral). Not only did he influence Emile Robert, but ironically he played a part in Brandt's life as well. He was one of the founders of the École Nationale Professionelle de Vierzon, Edgar Brandt's alma mater.
7. Harlor, "Emile Robert," *Gazette des Beaux-Arts* 10 (Nov. 1924): 298.
8. The Englishman Henry Bessemer's converter process enabled tons of quality steel to be made in minutes at one-third the cost of crucible steel. Almost simultaneously William Kelly developed this process in the United States.
9. Iron or Fe on the periodic table of elements is abundant in the earth. It is extracted by the method of smelting oxide ores in a blast furnace. Pig-iron bars are made from the molten material, which can then be refined into wrought iron, a fibrous forgeable material. Pig iron can be converted to steel by the open hearth or Bessemer process. Steel has a composition that lies somewhere between cast and wrought iron.
10. Calmettes, "Un Maître Ferronnier, Emile Robert," *Art et Décoration* 23 (Jan.–June 1908): 92, 94.
11. Harlor, "Emile Robert," 300.
12. The Galerie des Machines was 400 meters long. It was a cavernous hall that contained machinery from many countries. Four steam generators were in operation to work the machinery, electric cars, and elevated viewing platforms on tracks that took visitors around the building. Charles Dutert (1845–1906) was the architect and Victor Contamin (1840–1893), Pierron, and Charton were the engineers. For the 300-meter tower, Eiffel collaborated with the architect Stephen Sauvestre and the engineers Koechlin and Nouguier.

13. Harlor, "Les Fers Forgés d'Emile Robert," 8.
14. Calmettes, 94. Some iron objects from the collection of the Musée Le Secq des Tournelles were on view at the Exposition of 1900.
15. Thomson, ed. *The Paris Exhibition of 1900* (London, 1901), 316.
16. William Morris (1834–1896) was educated at Oxford University, where he discovered art and architecture. He worked in the office of architect G. E. Street (1856) and was later influenced by John Ruskin. He became a crusader for reforming the minor arts. In 1862 the cooperative decoration firm of Morris, Marshall, and Faulkner that he founded (1861) exhibited many examples of their decorative work, including furniture, wallpaper, metalwork, and textiles. Later carpets and tapestries were added. Morris was attracted to simple, medieval materials such as iron. Because he favored handwork over the machine, the cost of his products was high, making them affordable primarily to the wealthy. He approved of the machine as long as it did not interfere with craftsmanship. The formation of guilds was part of the crusade against shoddy machine-produced materials that were among the unfavorable by-products of the English Industrial Revolution.
17. Early collectors of Oriental art were Siegfried Bing; Arthur Lasenby Liberty (1843–1917), the founder of Liberty & Co.; and Louis Comfort Tiffany (1848–1933) whose work at the 1878 Exhibition showed Japanese and proto–Art Nouveau influences. France had many collectors and aficionados of Japonisme, including the jeweler Henri Vever (1854–1942) and Louis Gonse (1846–1921). The latter's book *L'Art Japonais* (1883) is still considered a major work on the subject. See Weisberg, *Art Nouveau Bing* (New York, 1986).
18. See Borsi and Godoli, *Paris 1900* (New York, 1978), 65–80.
19. Aubry, "Emile Robert: La Ferronnerie à l'Exposition Universelle de 1900," *Revue des Arts Décoratifs* 20, no. 7 (July 1900): 216.
20. Dervaux, "La Ferronnerie Moderne," *La Renaissance de l'Art Français et des Industries de Luxe* 2, no. 2 (Feb. 1919): 75. It is worth noting that Raymond Subes and Jean Prouvé were students.

Childhood and Schooling

21. Betsy had been an exchange student in Bristol, England, staying with the silversmith Mr. Fear and his family in order to learn English. Charles and Betsy were married in Bristol because her mother did not approve of the marriage. Conversation with Edgar Brandt's niece Suzanne Brandt, May 15, 1988, in Crosne.
22. According to Suzanne Brandt, the daughter of Jules Brandt, her grandfather Charles did not have a diploma but he operated as an engineer for his company. Conversation of May 15, 1988.
23. Charles and Betsy Brandt lived in Orléans from 1886 to 1898. From 1898 to 1913 Charles and his wife lived in Paris. As of 1913 Charles returned to Orléans as director of La Maison Guillot-Pelletier. In 1919 Charles and his wife retired to Boissy Saint-Léger, east of Paris (Seine-et-Oise), and lived on the property of Edgar Brandt. Conversation with François Brandt, Oct. 30, 1987.
24. Zeldin, *France 1848–1945, Ambition and Love* (Oxford, 1979 [1973]). See the chapters entitled "Marriage and Morals," "Children," and

"Women," 285–362.
25. Adolphe Monticelli (1824–1886), from Marseilles, created realistic portraits and still lifes. He also painted mystical scenes using impasto that was much admired by Vincent van Gogh.
26. Régamey, "Le Ferronnier d'Art, Edgar Brandt," *Archives Alsaciennes de l'Histoire de l'Art* (Strasbourg, 1924), 150. The names of these schools have since been changed to Lycées Techniques d'État. In March 1987 the Lycée de Vierzon, now called Lycée d'État D'Enseignement Générale et Technologique Henri Brisson, celebrated its one-hundredth anniversary.

Life at Vierzon: Edgar Brandt's Training

27. Bernard-Jean Daulon, who studied at Vierzon in 1911–14, furnished the author with the scholastic program and information about daily life at the school. He had many professors in common with Edgar and Jules Brandt.
28. During the 1920s Matila C. Ghyka's book *Le Nombre d'Or* was widely read. Supposedly, Claude Debussy (1862–1918) composed *La Mer* using the golden section.
29. Jules Brandt became the director of the Edison telephone company in Paris before starting his own commercial electricity business. He produced cables, circuit breakers, and hundreds of other items. Letter from Suzanne Brandt to the author, Mar. 9, 1988. On Dec. 31, 1927, he was made chevalier of the Legion of Honor for his work as vice-president of the Syndicat General of French Electrical Industries.
30. Dormoy, "Le Fer Forgé Moderne," *L'Amour de l'Art*, 283–88.
31. This is the opinion of Bernard-Jean Daulon, who had some of the same professors as Edgar Brandt at Vierzon. Letter from Daulon to the author, June 13, 1988.
32. The study of mechanics: properties of materials; strengths, stresses, and strains; cold working versus hot working. Technology was the study of different materials from books rather than by hand.
33. Edgar Brandt, "L'Art et le Fer," lecture to the graduates of the Écoles Professionelles de France, Feb. 10, 1922. Bibliothèque des Arts Décoratifs, doc. Br. 6659, 151.
34. Jules Brandt was at Vierzon from 1895 to 1898. Conversation with Suzanne Brandt, May 1987, Crosne.

The Seeds of a Philosophy

35. Edgar Brandt, "L'Art et le Fer." These names were mentioned by Edgar Brandt in his lecture on Feb. 10, 1922, to the graduates of the Écoles Professionelles de France.
36. Unlike John Ruskin, William Morris approved of machinery but did not want to see men standing guard over machines while they turned out inferior designs. He wanted people to get pleasure from the objects they used.
37. Edgar Brandt, "L'Art et le Fer," 151.

1900: A Career Begins

38. Blomfield, *Three Hundred Years of French Architecture 1494–1794* (Freeport, N.Y., 1970 [1936]), 94–106. The architect of Place Stanislas was Emmanuel Héré de Corny, born in 1705. The Prince, a passionate builder, commissioned Place

Stanislas to commemorate the reattachment of Lorraine to France. Stanislas was the father of Marie Leszcznska (1702–1768), who married Louis XV in 1725.

39. See Brogan, *The Development of Modern France 1870–1939*, vol. 2 (Gloucester, Mass., 1970), for an overview of the period; see Schug, *Art of the Twentieth Century* (New York, 1969), for an artistic view of the period.

40. Hitchcock, *Gaudí* (New York, 1957). Gaudí, the son of a coppersmith, was influenced by Viollet-Le-Duc, the Parisian designer and restorer of Notre-Dame and many Gothic buildings. Gaudí was working on the Calvet and Batlló houses between 1898 and 1905. Well versed in metalwork, Gaudí used cast and wrought iron for many of his extraordinary organic designs. In 1910 there was a Gaudí exhibition in Paris, which Brandt certainly might have seen.

41. Plumet, "L'Art Décoratif au Salon," *L'Art et Les Artistes* 5, no. 26 (May 1907): 173. In the second paragraph of this article Lalique, Robert, and Brandt are mentioned as important personalities.

42. Sheafer, "French Interior Decoration," *Arts and Decoration* (Mar. 1911): 203.

43. For a photograph of this lamp see Uecker, *Art Nouveau and Art Deco Lamps and Candlesticks* (New York, 1986).

To See and Be Seen: The Salon Exhibitions

44. See "Exhibitions," *Encyclopedia of World Art* vol. 5 (New York, 1959–87), 290–92.

45. Brunhammer, *Cent Chef-d'Oeuvres du Musée des Arts Décoratifs* (Paris, 1964), 8. The purpose of the Union Centrale des Beaux-Arts was to conserve objects. The purpose of the Union Centrale des Arts Décoratifs was to stimulate production and to educate both manufacturers and consumers through exhibitions of wonderful objects from the past. The Musée des Arts Décoratifs began in 1863.

46. Chavance and Verne, *Pour Comprendre l'Art Décoratif Moderne en France* (Paris, 1925), 10.

47. The principal decorative arts salons were produced by the Société des Artistes Français, the Société des Artistes Décorateurs, the Société du Salon d'Automne, and the Société Nationale des Beaux-Arts. For a long time Henri Clouzot directed the Musée Galliera.

48. Mauclair, "Où en est notre Art décoratif?," *Revue bleue* 8 (Apr. 24, 1909): 520–24.

49. Owen Jones was superintendent of the works of the Great Exhibition of 1851 in London. When the Crystal Palace was moved to Sydenham, Jones provided the decor for the Egyptian, Greek, and other courts. Jones believed that objects should be designed by artists and be fit for their purpose. See Pevsner, *Academies of Art Past and Present* (New York, 1973 [1940]), 253–55.

50. Majorelle, who trained as a painter, took over his father's furnishings business and became a major designer in the Art Nouveau mode. His career bridged more than four decades, from Art Nouveau to Art Moderne, and his work was marked by the use of fine materials and attention to detail.

51. The Salon des Artistes Décorateurs was founded in 1901 by René Guillère. Some of the more experienced members were Eugène Gaillard, Eugène Grasset, and Hector Guimard; Francis Jourdain, Maurice Dufrène, Pierre Chareau, René Herbst, and Paul Follot joined later. In 1906 the shows began to be held at the Pavillon Marsan in which the designers exhibited individual works. In 1908 Jean Dunand became secretary of the S.A.D. In 1923 the format changed and entire room ensembles were exhibited, mostly to show off the suites produced by the department-store ateliers, who could pay for such elaborate displays.

52. Renée Myriam Felise Largaud (born Nov. 15, 1883, Carpentras-Vaucluse), died in Geneva in 1963. Her mother was Myriam Jeanne Montel from

Montpellier (1863–1883). Her father, Dr. François Largaud (1855–1916) was also from Montpellier. Aline Bas (1861–1942) married Dr. Largaud, by then a widower, when Renée was an infant. Aline Largaud often received visits from her sisters and brothers. Betsy Bas Brandt, Aline's older sister, came with her husband, Charles, and their sons, Edgar and Jules. The two families met often and the children spent many vacations together. Aline Largaud, who had been a stepmother to Renée, later became like a grandmother to Edgar and Renée's three children, Jane, Andrée, and François.

53. de Félice, "L'Art Appliqué au Salon d'Automne," *L'Art Décoratif* 6 (July–Dec. 1904): 216.

54. de Souza, "Oeuvres Diverses d'Edgar Brandt," *L'Art Décoratif* 6 (July–Dec. 1904): 145–50.

55. Plumet was an architect and furniture designer and Selmersheim was a decorator; both men were highly regarded. They encouraged Emile-Jacques Ruhlmann early on in his career.

56. Furthering Morris's mission to revive craftsmanship in England, in 1861 his firm began to produce unified but multifaceted crafts under its sole auspices. Josef Hoffmann (1870–1956) was a professor of architecture in the School of Applied Arts in Vienna. The Wiener Werkstätte was a diverse applied-arts group that was patterned after Charles Robert Ashbee's (1863–1942) Guild of Handicraft, which had exhibited in Vienna in 1900 at the Secession Exhibition.

57. Waddell, ed., *The Art Nouveau Style* (New York, 1977). This publication wrongly attributes figures 2, 3, 8, 16, 51, and 86 to Paul Brandt. The six objects in question were all made by Edgar Brandt between 1903 and 1908. Paul Emile Brandt was a Swiss who trained in Paris. Later his shop was on the rue des Saint Pères. Misattributions have occurred because few people knew that Edgar Brandt began his career as a jeweler.

58. The ginkgo-biloba is a tree found originally in China, Japan, the south of France, and more recently in the United States. See Wilford, "Ancient Tree Yields Secrets of Potent Healing Substance," *The New York Times*, Mar. 1, 1988, C 3.

59. Verneuil, "L'Architecture et l'Art Décoratif aux Salons de 1905," *Art et Décoration* 18 (July 1905): 204.

60. Molinier, "Les Objets d'Art aux Salons," *Art et Décoration* 9 (June 1901): 187.

61. Verneuil, "L'Art Décoratif au Salon des Artistes Français," *Art et Décoration* 21 (June 1907): 216.

62. Monod, "L'Exposition du fer forgé, du cuivre, et de l'etain," *Art et Décoration* 17, supp. (Nov. 1905): 1–2.

63. Uhry, "Edgar Brandt," *Art et Décoration* 25 (Feb. 1909): 51. The architect of the Barbedienne commission was M. de Belleix.

The Weld That Held: The Oxyacetylene Torch

64. The oxyacetylene torch is used to weld together a variety of metals. It is also used for braising and spot heating.

65. Uhry, 50. Ferdinand Barbedienne (1810–1892), the founder of the firm, was succeeded by a former associate, his nephew Gustave Leblanc-Barbedienne.

66. Hale, *Welded Sculpture* (New York, 1968), 13; Trager, ed., *The People's Chronology* (New York, 1979), 657, 693.

67. For the welding of steel and iron, no flux is needed; however, in the case of welding copper, brass, or bronze alloys it was necessary to apply boric acid or borax with water before welding. See C. Cutler, "Autogenous Welding," *Cassier's Magazine* (Sept. 1907).

68. Letter to the author from Gilbert Poillerat, Dec. 5, 1987.

69. Blum, "Le Bijou au Musée Galliera," *Art et*

Décoration 24 (Sept. 1908): 87.

70. Blum, "Une Maison de Campagne par M. M. Sauvage et Sarrazin," *Art et Décoration* 24 (Nov. 1908): 170. Plans for this house were displayed at the Salon d'Automne.

71. In 1908 the S.A.F. awarded a third-place medal to ironsmith A. Szabo; Nic Frères received honorable mention.

72. Heskett, *German Design 1870–1918* (New York, 1986), 119–36. The Deutscher Werkbund was founded in 1907 in Germany. This association of craftsmen, architects, and manufacturers approved both machine-made and handmade products but emphasized cultural reforms and the cooperation of artists and industrialists. With this operative concept Werkbunds and design schools blossomed all over Germany and brought attention to German design through exhibitions and conferences.

73. See Blum, "Le Salon d'Automne et l'Exposition munichoise," *Art et Décoration* 28 (Nov. 1910): 129–60. See *Deutsche Kunst und Dekoration* 33 (Oct. 1913–Mar. 1914). The Darmstadt show of 1914 included the work of Karl Bertsch. See vol. 34 (Apr.–Sept. 1914) for furniture and jewelry of the Wiener Werkstätte and the Werkbunds.

74. Verneuil, "Le Salon d'Automne de 1911," *Art et Décoration* 30 (Oct. 1911): 329–44. Verneuil appreciated the 1910 decorative arts of Munich but felt that the French needed their own style.

75. These thoughts were expressed by Brandt at a lecture organized by the under secretary of technical education, Gaston Vidal, on Feb. 10, 1922. See Edgar Brandt, "L'Art et le Fer," 1–19.

76. Ibid., 5.

77. Quoted in Anscombe, "Emile-Jacques Ruhlmann: Art Deco Ébéniste," *Art and Antiques* 4 (Mar.–Apr. 1981), 85.

78. Bury, *France: The Insecure Peace* (New York, 1972), 36. Bury quotes a phrase to express the French ideal: "My glass is small, but it is my glass that I drink from," 35. As of 1931, sixty percent of the French worked in firms of fewer than twenty people. Zeldin, 57. France was an oligarchy with 215 industrial firms having one thousand or more workers each in 1906; there were 421 firms in 1931.

79. For a synopsis of Laborde, see Pevsner, 249–51.

80. The entire quote reads: "Suppose that an architect of the twelfth or thirteenth century were to return among us, and that he were to be initiated into our modern ideas; if one put at his disposal the perfections of modern industry, he would not build an edifice of the time of Phillip Augustus or St. Louis, because this would be to falsify the first law of art, which is to conform to the needs and customs of the times," Viollet-le-Duc, 1863. See Curtis, *Modern Architecture Since 1900* (Englewood Cliffs, N. J.: 1982), 14. In his *Entretiens sur L'Architecture* (1863–72) Viollet-le-Duc was an advocate for iron construction.

81. Saunier, "Le VIe Salon de la Société des Artistes Décorateurs" *Art et Décoration* 27 (Mar. 1910): 109. Georges Chedanne was both a classicist and a functionalist. His building for the newspaper *Le Parisien Libéré* on the rue de Réaumur was cased in sheets of iron and exposed rivets.

82. Maignan, "À Propos du Salon des Artistes Décorateurs," *L'Art Décoratif* 25 (Apr. 1911): 189.

83. *Chronique des Arts,* Sept. 13, 1890, 235. A complaint was registered in the museum bulletin: "The hideous plaster banister edged with yellow arabesques on the Escalier Mollien must be replaced by a superb wrought-iron stair railing."

84. Ministère de la Culture, de la Communication et des Grands Travaux, doc. F/21/6242.

85. Aulanier, *Histoire du Palais et du Musée du Louvre* (Paris, 1953), 34.

86. Brandt also made an elevator door as part of this commission.

87. In 1904 Jules Brandt, working for the Edison Telephone Company, was making a large annual

salary of eleven thousand francs. He left to start his own electrical business on the rue Tandou. One year later he moved to 23 rue Cavendish. His Paris firm, Brandt et Fouilleret, was highly successful. The Brandt brothers always conferred and helped one another. Conversation with Suzanne Brandt, May 15, 1988.

88. Brogan, 405. France was basically an agricultural country with industrial emphasis on luxury items such as perfume, cosmetics, cars, and jewelry. As of 1906 French-grown silk was the largest single export, followed by wine, fruit, flowers, and sweetmeats.

89. The exception was certain bronzes. Bronze serpent lamps would be made in editions of fifty or 100. According to Gilbert Poillerat, a wrought-iron design, if repeated at all, would always be changed in some details.

90. Vogt, *Le Théâtre à Nancy depuis ses origines jusqu'en 1919* (Nancy, 1921), 165.

91. J. Starkie Gardner, 74.

Iron of a Different Kind

92. Letter to the author from Colonel Neuville, Musée de L'Armée, Hôtel National des Invalides, Mar. 15, 1988.

93. Correspondence with François Brandt, Oct.–Dec. 1987; Sept. 1997. Brandt credited Léon Gaumont (1864–1946) for helping him achieve his early prototypes for the army. The head of Gaumont Studios and an industrialist, Gaumont was the first to experiment with talking pictures before 1900 and was a forerunner in the development of color film.

94. Five hundred 60m mortars using 500,000 shells (allowing 1,000 rounds per mortar) were made for the French army from Dec. 1915 to Dec. 1916, when three thousand mortars and 3 million rounds of ammunition were ordered by the state. The 1916 model was a portable cannon that could be carried by one man. It was rapid and precise; it made no noise, no smoke, and no light. The army increased its orders. Letter from François Brandt, May 30, 1989.

95. François Brandt and Pierre Bouniol, *Le Figaro*, May 12, 1980, in celebration of the centennial of Edgar Brandt.

96. France had lost 1.5 million men in the war. Afterward an influx of foreign workers helped offset the loss of skilled manpower. See Tint, *France Since 1918* (New York, 1980), 9. Ironworkers came from Hungary, Belgium, Italy, and Germany.

97. Kemp, *The French Economy 1913–1939* (New York, 1972). "Speaking of the metallurgical industry. . . . experts were sent abroad, notably to America, to study the best ore-mining, coke oven, blast furnace and steel mills practice," 69.

98. A book of testimonials is in the possession of the Brandt family. Letter from François Brandt, Dec. 1987.

101 Boulevard Murat

99. Mathieu, *Guide to the Musée D'Orsay* (Paris, 1987), 8. Henri Favier studied with Victor Laloux (1850–1937), professor of architecture at the École des Beaux-Arts.

100. A center punch is a hand-held punch in the form of a short steel bar with a conical point at one end that marks the centers of iron parts for drilling holes.

101. Weisberg, 37.

102. Dawes, *Lalique Glass* (New York, 1986), 10.

103. Dormoy, "Les Points-de-Nice de Madame Chabert-Dupont," *Art et Décoration* 39 (Jan. 1921): 24. Inspired by the flora and fauna of the Côte d'Azur, Chabert-Dupont drew designs on precut pieces of fabric that actually became her loom. Her patterns, based on circles, squares, triangles, and other geometric shapes, were all woven in one piece according to a preplanned calculation.

Chabert-Dupont's atelier was at 103 rue d'Erlanger, around the corner from 101 Boulevard Murat, and she probably stopped by often to see the latest ironwork designs.

104. Pascal, "La Dentelle Moderne au Musée Galliera" *Mobilier et Décoration* 3, no. 11 (Mar. 1931): 112. Chabert-Dupont's work displays an affinity and a familiarity with Brandt's. The former's lace dress collars (Pascal, 112) compare in form with the stylized flowers of Brandt's grilles, e.g. *L'Age d'Or* (see fig. 114).

105. By 1909 Ford was using assembly line production, while in France Renault, Peugeot, and Citröen followed this method.

106. The author is indebted to Bernard-Jean Daulon, Gilbert Poillerat, Gary Griffin, Nol Putnam, and Tom Ryan for sharing technical information.

107. Two men later opened their own businesses; Martin designed and made furniture, Lardin specialized in engraved glass. Poillerat continued designing ironwork for Baudet, Donon et Roussel.

108. Goissaud, "Un Ferronnier Moderne, Edgar Brandt" *La Construction Moderne* 41 (May 9, 1926): 382.

109. Follot, [Correspondence], *L'Art et Les Artistes* no. 76 (Oct. 1926): 34.

110. Made of iron or steel, a *bigorne* is a small stake tool used for light hammering and shaping of iron or sheet metal. Drawings and explanations of the *bigorne* were provided by Gilbert Poillerat in a conversation of Nov. 6, 1987.

111. The decorative compositions of Nicolas Pineau (1684–1754) and the engravings of Juste-Aurèle Meissonier (c.1693–1750) prevailed as models for woodwork, plasterwork, and silver. Many great houses had grottoes whose walls were made of rocks and shells.

112. Verneuil, "La Mer," *Art et Décoration* 27 (Jan. 1910): 1–20; (May 1910): 141–52; 28 (Dec. 1910): 161–76.

113. Hourticq, "Au Salon des Artistes Décorateurs," *Art et Décoration* 36 (May–June 1919): 37.

The War Memorials

114. The idea for transferring the coffins of several unidentified French soldiers to the Panthéon was originally proposed to Prime Minister Georges Clemenceau in 1918.

115. *Monuments Commémoratifs et Arcs de Triomphe* (Paris, 1921).

116. According to François Brandt the door was entirely designed by his father.

117. Alphandery, *Monument de la Tranchée des Baïonnettes*, Nov. 1, 1921, n.p. [commemorative book].

118. Rethondes is a parish in the department of the Oise, and in the district of Compiègne, seventy kilometers from Paris.

119. The author is grateful to Digby Thomas for pointing out the differences between the broadsword and the saber.

120. The inscription was written by the author Jean Binet-Valmer (b. 1875), a World War I veteran.

121. In 1940, the Germans came upon the World War I monument at Rethondes and dismantled it. Later allied troops found the pieces in packing crates near the Russian zone. In 1945 the monument was reassembled and put in place near the area where the armistice was signed in 1918. It was rebuilt in 1950.

Progress Comes With Peace: Forging Art in the Early 1920s

122. Janneau, "Le Mouvement Moderne Jonchée d'Objets d'Art," *La Renaissance de l'Art Français et des Industries de Luxe* 3, no. 7 (July 1920): 513.

123. Vaucelles, "Art décoratif," *L'Amour de l'Art* 2

(1921): 307. "The days are over when the arms of a canapé look like a crushed tomato or when one sits down next to a hedgehog . . . or leans one's back against a bed that looks like a squatting monster . . . or too near where Dante is buried."

124. An example was the AEG Turbine Factory, designed by Peter Behrens (1869–1940) in 1909. Behrens, a founding member of the Deutscher Werkbund, was responsible for the architecture as well as the products: fans, lamps, and tea kettles.

125. "Bulletin de la Chambre Syndicale des Artistes-Décorateurs Modernes," *Art et Décoration* 41 (Jan.–June 1922): 11–12.

126. *Deutsche Kunst und Dekoration* 50 (Aug. 1922): 277–82.

127. Edgar Brandt, "L'Art et le Fer," 6, 7.

128. Sedeyn, "Le XIIe Salon des Artistes Décorateurs," *Art et Décoration* 39 (June 1921):112.

129. Janneau, "Le Mouvement Moderne: Le douzième Salon des Artistes Décorateurs," *La Renaissance de l'Art Français et des Industries de Luxe* 4 (1921): 283.

130. de Félice, "Appareils d'Éclairage," *Art et Décoration* 38 (Aug. 1920): 47.

131. Michel Fokine's *Shéhérezade* was first produced at the Théâtre National de l'Opéra, Paris, on June 4, 1910.

132. D'Allemagne, *Histoire du Luminaire Depuis l'Époque Romaine jusqu'au XIX Siècle* (Paris, 1891): 64. Early examples were made of wood, silver, copper, and bronze and were suspended invariably from three chains.

133. Locquin, "Edgar Brandt et la Maison d'un Ferronnier," *Art et Décoration* 39 (Mar. 1921): 74. King Recceswinth (ruled A.D. 649–672) was a Visigothic ruler in Toledo, Spain, who abolished Roman law in A.D. 654.

134. Saunier, 112.

135. After doing a set of fashion illustrations for Paul Poiret, Paul Iribe (1883–1935) set up a decorating firm. With Pierre Legrain as his assistant, he designed a home for the couturier Jacques Doucet. For a while he worked in the United States.

136. A similar gate *La Perse* (1923) uses the spiral technique for cloudlike formations rather than for flowers, as in fig. 85. *La Perse* has been in the collection of The Metropolitan Museum of Art since 1924.

137. Kahr, "Gilbert Poillerat: A Half-Century of Ironwork Design," *Metalsmith* 12, no. 3 (summer 1992): 30–35. According to Gilbert Poillerat (1902–1988), these curled bars of iron were called *épluchures des pommes de terre*. After graduating from the École Boulle, Poillerat worked as a designer for Brandt from 1921 to 1927. He went on to create an entirely new style of *ferronnerie* and continued to work until the 1970s.

138. The Paul Iribe and Georges Lepape roses were both influenced by Léon Bakst's colorful decor for the ballet *Shéhérezade*. Paul Poiret used them as well.

139. Persian and Arabian rug makers often copied old wrought-iron gate designs, and conversely ironsmiths often copied from older carpet patterns. Conversation with Paul Fehér, Oct. 29, 1988.

140. Rosenthal, "Le Paquebot *Paris*," *Art et Décoration* 40 (Sept. 1921): 65–80. The *Paris* had been planned in 1913; however, the war delayed construction until 1918. It was christened in 1921.

141. Kjellberg, *Art Déco* (Paris, 1986). 197.

Japonisme and Other Motifs

142. For more information see Weisberg.

143. Quoted in Verneuil, "Etoffes Japonais," *Art et Décoration* 27 (Feb. 1910): 38. Poillerat talked at length about Gonse while showing the author his copy of *L'Art Japonais* (1883) in Nov. 1987.

144. The Treaty of Versailles in 1919 redressed the suffering of the French people after the Franco-

Prussian War (1870–71) and ceded Alsace-Lorraine back to France.

145. "L'Exposition Japonaise au Salon de la Société Nationale" *L'Art et Les Artistes* 5, no. 25 (Mar.–July 1922): 352.

146. Campbell, *Ironwork* (London, 1985), 47. According to Campbell, a former assistant keeper in the department of metalwork at the Victoria and Albert Museum, in 1928 Brandt delivered four pairs of elevators containing three panels each of *Les Cicognes d'Alsace*. When Selfridge's was remodeled in 1971, the Brandt panels were removed and distributed among several museums in England.

147. Raymond Subes (1893–1970) was the artistic director of E. Borderel et Robert, the ironworks business that had been founded by his mentor, Emile Robert (Robert went into partnership with Borderel from 1909 to 1914). Subes began his studies at the École Boulle in 1906 and by 1911 he had joined the firm. He became the principal designer of the firm and an able competitor of Brandt's.

148. In 1924–25 this radiator cover cost $450.

149. Richard Bouwens de Boijen and Roger-Henri Expert were the principal architects of the famous French liner the *Normandie* in 1932–35. Brandt and George Bastard provided chromed metal vases and coffee and tea sets for the *Normandie*. All were stamped "CGT" for La Compagnie Général Trans-Atlantique. Brandt also worked on the following ships: the *De Grasse*, the *Florida*, the *Champlain*, and the *Île de France*.

150. Eugène Merle was the son of an Italian immigrant named Merlo, which means blackbird in Italian.

151. "Chronique," *Art et Décoration* 44 (Aug. 1923): 1.

152. Chavance, "Le XIVe Salon des Artistes Décorateurs," *Art et Décoration* 43 (Jan.–June 1923): 192.

153. The author visited the Au Bon Marché department store in May 1988 and was told that the ironwork balconies had been dismantled in 1983–84. At present, sections of the staircase railing of Au Bon Marché can be seen reassembled at the Doral Saturnia International Spa Resort in Miami, Florida.

154. An American client ordering *Les Fleurs* in 1925 would have paid $350.

155. Davies, *At Home in Manhattan* (New Haven, 1983), 17.

156. Slavin, *Opulent Textiles* (New York, 1992), 144. Orinoka Mills also wove the fabric "Gazelle en Fer" based on Brandt's screen. Cheney Bros. Silk Co. and their connection with Brandt will be discussed in a later chapter.

157. Ibid., 145. Conversation with Richard Slavin, curator of the Schumacher archives, May 18, 1998.

158. *La Fontaine* fire screen was donated to the Metropolitan Museum of Art in 1924 by the Cheney Brothers. It was displayed in the show "Art Deco," which took place at the Finch College Museum of Art (Oct. 14–Nov. 30, 1970) and at the galleries of the Cranbrook Academy of Art (Jan. 19–Feb. 28, 1971).

159. Paris, "International Exposition of Modern Industrial and Decorative Art in Paris," *Architectural Record* 58, no. 4 (Oct. 1925), n.p. In 1925 *Les Fruits* could be ordered from Ferrobrandt (Brandt's New York office) for $180. In 1935 it was purchased by John Woodman Higgins for the Higgins Armory Museum in Worcester, Massachusetts, where it is still on view (acc. no. 2260).

160. Davies, 12, points out that *La Biche dans la Forêt* was used for the cover of the 1926 book *The Romance of Design* by Garnet Warren in collaboration with Horace B. Cheney.

161. Brunel, "Une Exposition d'Art Moderne Appliqué Organisée à New York," *La Renaissance de l'Art Français et des Industries de Luxe* 11 (Nov. 1928): 398–99. The United States, France, Italy,

Austria, Germany, and Sweden participated.

162. From 1932 to 1958, Dorothy Shaver was the head of fashion and decoration at Lord and Taylor. She played a major role in promulgating the decorative arts of France.

Two Sides of the Drawing Board: 1923–1924

163. In 1909 Guimard married the American artist Adeline Oppenheim and began their home at 122 Avenue Mozart. Guimard was the architect of many buildings in the Auteuil section of Paris where Brandt lived and worked. Unquestionably, Brandt and his design staff knew well the superb ironwork on Guimard's Castel Béranger (14 rue La Fontaine), his Hôtel Mezzara (60 rue La Fontaine), and the Trémois Apartments (11 rue Francois-Millet), to name just three. Brandt would have passed the Villa Flore and the Hôtel Guimard every day on his way to and from 101 Boulevard Murat.

164. The wrought-iron frames for these 1921 vases were made at 101 Boulevard Murat and then sent to Nancy where the glass was blown into the frame by Daum Frères.

165. Max Blondat, born in Crain (Yonne), France, went to Paris at age fourteen to study wood sculpture at the École Germain Pipon. He was admitted to the École des Beaux-Arts and studied in the department of Mathurin Moreau. In 1904 he won a first-class medal for a fountain, *Jeunesse*. In 1905 he became a member of the jury of the Société des Artistes Français. Information provided to the author by Mme. Claude Max Blondat, the sculptor's daughter, Dec. 5, 1988.

166. Clouzot, "Quinzième Salon de la Société des Artistes Décorateurs," *La Renaissance de l'Art Français et des Industries de Luxe* 7 (July 1924): 387.

167. Robert, "L'Apprentissage des Métiers d'Art," *Art et Décoration* 34 (July 1913): 46.

168. The same balls (with and without mistletoe) were made into electrified table lamps that were sometimes patinated in chrome, c. 1924. See fig. 76 on page 82.

169. *Les Acanthes* sold for $900 in 1925.

170. In 1925 *Les Cocardes* sold for $2300 in the United States.

171. Badovici, *Harmonies: Intérieurs de Ruhlmann* (Paris, 1924), 7.

172. The smaller version of *Altesse* appeared in the Ferrobrandt catalogue. A four-legged version was seen in an advertisement for the Beaux-Arts Shade Company of New York in the Sept. 1927 issue of *Arts and Decoration* (U.S.), 109. See also *Mobilier et Décoration d'Intérieur* (Nov. 1924), 14.

173. Denoinville, "Quelques Ferronneries d'Edgar Brandt," *Mobilier et Décoration d'Intérieur* 4 (Aug.–Sept. 1924), 9.

174. Clouzot, "Deuxième Exposition d'Art Décoratif Contemporain au Pavillon Marsan," *La Renaissance de l'Art Français et Industries de Luxe* (April 1924): 196.

175. Ibid., 204.

The Exposition of 1925: Background

176. "Silk Delegates to the Paris Exposition," *American Silk Journal* 44, no. 6 (June 1925): 40.

177. Rambosson, "Le Mouvement des Arts Appliqués," *L'Amour de l'Art* no. 3 (Nov. 1922), 365.

178. Quoted in Fortuny, "Les Décorateurs Allemands à Paris en 1924?" *L'Amour de l'Art* 3 (June 1922): 53–63.

179. "Chronique: Le Werkbund Allemand au Salon des Décorateurs," *Art et Décoration* 57 (Mar. 1930): I–III. It was not until 1930 that the Germans were invited to exhibit in the French Salon des Artistes Décorateurs.

180. Paris, 371. The spot reserved for the United States was taken over by Japan.

181. Read, "The Exposition in Paris," *The International Studio* no. 342 (Nov. 1925): 93–97; no. 343 (Dec. 1925): 160–65.

182. The discovery was widely reported in all the newspapers and magazines. Pictures of the objects caused a mania for Egyptiana. See Morand-Verel, "L'Organisation des Fouilles en Egypte," *L'Amour de l'Art* 6 (1925), 34–35.

183. Tutankhamen reigned from 1361 to 1352 B.C.

184. The formation of an Egyptian section in the Louvre goes back to 1823. On July 15, 1868, the Louvre purchased 120 objects of the Rousset collection of Egyptian artifacts, which gave the museum an outstanding base in this field. See Bénédite, "La Formation du Musée Égyptien du Louvre," *Revue de l'Art* 43, no. 244 (1923), 161–72. On the reopening, see *L'Intransiegeant*, Jan. 7, 1919, 2.

185. Courtellemont, "Les Bijoux dans L'Egypte Antique," *L'Amour de l'Art* 2 (1921): 264–66. This article featured the jewels of the Princesses Ita and Knoumit of the twelfth dynasty. The photographs included a pin and a necklace of lotus blossoms.

186. Lee, . . . *the grand piano came by camel—Arthur C. Mace, the neglected Egyptologist* (Edinburgh and London, 1992), 101.

187. Richards, et al., *Report of the United States Commission on the International Exposition of Decorative and Industrial Art in Paris, 1925* (Washington D.C., 1926), 19–20.

188. Paris, 371.

Beaucoup Brandt: Everywhere at the Fair

189. Henri Navarre (1885–1970) was multitalented, working as a sculptor, glassmaker, and architect. He also worked on the main gate for the Colonial Exhibition of 1931 in Paris.

190. Considered one of the best designers in Edgar Brandt's enterprise, Gilbert Poillerat worked on the renderings of the central gate of the Porte d'Honneur following the general composition conceived by Brandt. Conversation of Nov. 8, 1987.

191. D'Allemagne, "Le Fer Forgé à l'Exposition des Arts Décoratifs et Industriels Modernes," *Bulletin de La Société d'Encouragement pour l'Industrie Nationale* (Dec. 1925): 824. The staff was sculpted by M. Auberlet and M. Laurent.

192. Paris, 384; conversation with Gilbert Poillerat, Nov. 12, 1987.

193. Denoinville, 9.

194. "The International Exposition of Modern Decorative Art in Paris," *Vogue Magazine* (May 15, 1925): 37.

195. Deshairs, *L'Hôtel d'un Collectionneur: Exposition des Arts Décoratifs de 1925* (Paris, 1925), 11.

196. Diana was associated with the earth's wildlife, fertility, and childbirth. Her Greek counterpart Artemis was a virgin huntress and a symbol of fertility and birth. The Diana/Artemis theme was used by many 1920s artists.

197. Archival records reveal that this door sold for 7,500 francs, or $110, in 1925–26.

198. Because the lotus opened its flowers in the morning and closed them at night, it reminded the Egyptians of the creation myth, day and night, and Tefnut, the spirit of moisture.

199. Conversation with Dr. Dorothea Arnold of The Metropolitan Museum of Art, Sept. 8, 1994. When shown Brandt's work of 1924–25 Dr. Arnold said, "He was Egyptianizing."

200. The ideogram for the papyrus plant with buds bent down is very similar to the hieroglyphics for the lotus flower, and sometimes in decorative usage the two might have been mistaken for one another. See Sir Alan Gardiner, *Egyptian Grammar* (London, 1957), 480–81.

201. Keimer, "Bouquets Montés," *American Journal of Semitic Languages and Literatures* 41, no. 3 (April 1925): 145–61.

202. This dog-collar plaque by René Lalique is in

the collection of the Calouste Gulbenkian Museum in Lisbon, inv. no. 1133.

203. Jones, *The Grammar of Ornament* (New York, 1986), 31–36. In the Egyptian section see plates IV, V, VI, VII. In the section on Nineveh and Persia see plates XII and XIV.

204. The Benito book was *La Dernière Lettre Persane,* ed. Fourrures Max (Paris: c. 1919–20). The owner Madame Leroy used Benito's drawing for magazine advertisements. Conversation with Georges Mathysen-Gerst, Nov. 3, 1997. The Ruhlmann-Brandt collaboration was confirmed by a 1925 photograph.

205. Henry Wilson, "Metalwork Section," *Reports on the Present Position of the Industrial Arts* (London, 1925), 122.

Brandt's Stand: A Treasury of Fer Forgé

206. James Breasted (1865–1935), a prominent Egyptologist from the University of Chicago, published two earlier editions of *A History of Egypt* in 1905 and 1909.

207. This *Diane et la Biche* is similar to the one that Brandt made for the "Hôtel d'un Collectionneur." That grille was photographed from the back, with the female facing away from the viewer. Another version, with double gates, was sold at William Doyle Galleries, New York, on June 10, 1987.

208. In Sept. 1925 *Les Plumes* could have been purchased for 3,700 francs or $740.

209. Bibliothèque des Arts Décoratifs, Paris. Box 312, Grilles 14. The very same screen was employed to drape Cheney silk at the American exhibit at the Louvre in Feb. 1925.

210. A similar door turned up in Nov. 1986 at the Modernism show at the Seventh Regiment Armory, New York City. The dealer who owned this work reported that Brandt had been commissioned in Paris to make it for a friend's home in Englewood Cliffs, New Jersey. Conversation with Evan Blum, Oct. 3, 1988.

211. *L'Oasis* was missing until Nov. 1986 when it turned up in a South American home. Robert Zehil bought the screen and called in Paul Fehér to oversee the cleaning and waxing. For a long time it was believed that one man had purchased the Brandt stand en masse. This has proven incorrect.

212. Gilbert Poillerat executed the basic sketches of the roses which were to ornament the panels of the great *L'Oasis* screen conceived by Edgar Brandt. Poillerat claimed that a maquette of *L'Oasis* was never made. Dealer Anthony DeLorenzo owned a small version of *L'Oasis* in 1984, which he has since come to believe was made as a window display. Several sections were lacquered in red and black. It could have been made by anyone after the 1925 Exposition. Poillerat felt that the concept of copying Chinese paper screens and translating the concept into iron was impractical. He said: "if the iron screen ever fell over it would kill several people." Conversation of Nov. 5, 1987.

213. Electrolysis is the reductive deposition of metal ions on a negative electrode.

214. From Apr. to Nov. 1922 a Colonial Exhibition was held in Marseilles, the gateway to Morocco and the Orient. There was a strong postwar movement toward colonialism.

215. "Chasing a Rainbow, The Life of Josephine Baker," documentary on P.B.S., aired Mar. 5, 1989.

216. This bottle and its cardboard box were on display in the "L'Art de Vivre" exhibition at The Cooper-Hewitt Museum in 1989. See *L'Art de Vivre: Decorative Arts and Design in France 1789-1989* (New York, 1989). See Lefkowith, *The Art of Perfume* (New York, 1994), 145, for a photograph of the bottle and box, model no. 598.

217. Hautecoeur, "Le Salon d'Automne," *Gazette des Beaux-Arts* 10 (July-Dec. 1924): 351.

218. Clouzot, "Les Arts Appliqués au Salon d'Automne," *La Renaissance de l'Art Français et des Industries de Luxe* 8 (Jan. 1925): 6. The art critic Henri Clouzot was a reporter and a committee member for Class 4 (metalwork), along with the industrialist Jules Puech and Edgar Brandt.

219. Exekias, the finest painter of Attic black-figure vases (550–520 B.C.), was a master of engraved detail and painting. See Boardman, *Greek Art* (New York, 1978 [1973]), 82–85, 95.

220. Kenneth Lynch, an ironsmith who worked for Brandt in the early 1920s, correspondence with the author, Nov. 18, 1985 and Jan. 27, 1986.

221. Jean Wiart, vice president of Les Metalliers Champenois USA, restored the Statue of Liberty in 1985. He examined the potiche on Mar. 20, 1997.

222. An amalgam is an alloy of mercury with other metals such as tin or silver.

223. Bernard's frieze, *La Danse*, from Ruhlmann's "Hôtel," was eventually purchased by the French government. He also sculpted the facade of Charles Plumet's pavilion at the 1925 Exposition with *La Frise de la Danse,* which was adapted from a marble version that he sculpted in 1912–13. Bernard's *Girl with a Jug* appeared in the famous 1913 New York Armory show. See Leclère, "Joseph Bernard," *Art et Décoration* 45 (Jan. 1924): 19–28.

Works in Bronze: Vessels and Serpents

224. Other faux porphyry objects combined with iron included tables, paperweights, and umbrella stands.

225. Gsell, "Un Maître de l'Art Monumental, Antoine Bourdelle," *La Renaissance de l'Art Français et des Industries de Luxe* 7 (June 1924): 374–75.

226. Alfred-Auguste Janniot (1889–1969) provided the freestanding sculptures for the garden of Ruhlmann's "Hôtel." One sculpture, *À la gloire de Jean Goujon,* depicted three neoclassical women and a deer.

227. "Le Salon d'Automne," *Art et Industrie* no. 9 (Dec. 1926): 35.

228. The pancratium was an ancient Greek athletic contest involving boxing and wrestling.

229. The Olympic games began around 776 B.C. The most important building in Olympia was the Temple of Zeus, built in 460 B.C. Inside the Temple was a gold-and-ivory statue of Zeus by the sculptor Phidias (c. 430 B.C.), thus the references to Zeus and Olympia in the poem on Brandt's vase.

230. This Art Nouveau teapot was on view at the Exposition Universelle of 1889 and appeared in Bouilhet, *L'Orfèvrerie Française au XVIIIe et XIXe Siècles* (1908–12). See Purcell, "Catering for Every Taste: The Falize Family of Goldsmiths," *Apollo* 133, no. 348 (Feb. 1991): 94–98.

231. Mourey, *L'Art Décoratif en France* (Paris, 1923–25), 181.

232. Sedeyn, "Jean Dunand," *Art et Décoration* 36 (Sept.–Oct. 1919): 118. The Metropolitan Museum of Art purchased a pair of bronze cobras by Dunand in 1970. See McClinton, "Jean Dunand: Art Deco Craftsman," *Apollo* 116, no. 247 (Sept. 1982): 178.

233. See Sotheby's, New York, *Important 20th-Century Decorative Arts* (June 20, 1986), auction sale no. 5476, item 133.

234. Ibid., item 271.

235. The 65" lamp sold at auction in 1988 for $35,000; see Sotheby's, New York, *Twentieth-Century Decorative Arts* (Mar. 19, 1988), auction sale no. 5694. *La Tentation* sold for $43,700 in 1995; see Christie's, New York, *Important 20th Century Decorative Arts* (April 1, 1995), auction sale no. 8148.

236. This lamp has also been seen with an oxidized metal and plastic shade in two colors. See McClinton, "Edgar Brandt: Art Deco Ironworker 1880-1960," *Connoisseur* no. 202 (Sept. 1979): 8. In 1925 the *Cobra* lamps cost $200 and $150 respectively.

237. While some tall serpent lamps vary in height from 64⅛" to 70⅛", the difference often involves the height of the base.

238. Information provided by Anthony DeLorenzo.

239. Christie's auction house offered a table-size serpent lamp with a green marble base (height 36½"). See Christie's, New York, *20th Century Decorative Works of Art* (Oct. 4, 1980), item 336.

240. The author is grateful to the blacksmith Tom Ryan for information about this process.

241. Henriot, "Ferronneries Nouvelles d'Edgar Brandt," *Mobilier et Décoration* 7, no. 5 (Apr. 1927): 112.

242. See Sotheby's, New York, *Important 20th Century Decorative Arts* (Dec. 6, 1986), sale no. 5525, item 250; it sold for $22,000. In 1925 this piece sold for $650. It came in a smaller size as well.

243. Marius Petipa (1822–1910), the French-born dancer and choreographer who worked in Russia from 1847, created *Don Quichotte* (1869), *Bayadère* (1875), *Sleeping Beauty* (1890), and *Swan Lake* (1895) with Lev Ivanov.

La Galerie Edgar Brandt

244. Brandt had worked in virtually the same location since 1903. His first atelier at 76 rue Michel-Ange extended through the block to Boulevard Murat.

245. A *société anonyme* is a private company made up of a group of seven or more associates who put up either money and/or goods. Brandt's *société anonyme* was capitalized at 5,700,000 francs. In the summer of 1925 the franc was 4.74 to the dollar.

246. Weisberg, 43–95. Bing opened his shop at 22 rue de Provence on Oct. 1, 1895.

247. Goissaud, "Un Ferronnier Moderne," 383.

248. Benezit, *Dictionnaire des Peintres, Sculpteurs, Dessinateurs, et Graveurs* vol. 10 (Paris, 1976), 864. Zador, born in Nagykanizsa, Jan. 15, 1882, studied in Budapest, at the École des Beaux-Arts, and in Paris and Florence.

249. Conversation with François Brandt, Oct. 31, 1987. M. Brandt knows that his father helped many other artists who presented themselves and their work at the La Galerie Brandt, hoping to be exhibited there.

250. *L'Art et Les Artistes* 63 (Jan. 1926): 140.

251. Lissim, "Les Artistes Animaliers à La Galerie Edgar Brandt," *Mobilier et Décoration* (1931): 555–60. With their small-scale sculptures the *animaliers* were following nineteenth-century French tradition, as seen in the work of Antoine-Louis Barye. The Sandoz-Brandt jardiniere was made in 1927.

252. Conversation with the Brandt family, Oct. 31, 1987. Pierre Renaud had been a journalist with L'Agence Havas. He left journalism to work for Edgar Brandt.

253. Brandt was following in the footsteps of other artist-manufacturers. For example, Emile-Jacques Ruhlmann's counterpart to Brandt's 101 Boulevard Murat were his offices and display space at 27 rue de Lisbonne. His partner Pierre Laurent operated out of 10 rue Maleville. In addition, Ruhlmann had another factory at 14 rue d'Ouessant, which he purchased in 1919. By 1927, Ruhlmann had divided this space into Atelier A and Atelier B. See Camard, *Ruhlmann* (New York, 1984), 200, 205, 208–10.

254. On Apr. 9, 1926, La Société des Etablissements Brandt became the official name for Brandt's varied enterprises: ironwork, locksmithing, lighting fixtures, commercial metalwork, the gallery, and armaments manufacture. At the same time the company owned patents for decorative iron and armaments, and commissions for both came from all over the world.

American Exposure

255. Chavance, "Edgar Brandt et l'Art du Fer," *L'Art et Les Artistes* 5, no. 25 (Mar.–July 1922): 278.

256. Brandt admired the huge stamping press and the systematization at Ford's River Rouge plant, the largest industrial complex in the world at that time. Conversation with François Brandt, Nov. 2, 1987.

257. See Clark, et al., *Design in America: The Cranbrook Vision 1925–1950* (New York, 1983), 35–45.

258. Cranbrook Academy of Art archives, Bloomfield Hills, Michigan. Bill of sale from E. Brandt to G. Booth. Booth spent $1,605 and paid in cash from his traveling expense money.

259. Letter provided by Mark Coir, archivist, Cranbrook Academy of Art archives.

260. A number of Brandt's wrought-iron pieces were sold at the Cranbrook auction at Sotheby's in 1972. An octagonal mirror is still owned by the Cranbrook Academy; it was cleaned in 1992 by Gary S. Griffin, head of metalsmithing. On May 2, 1972, *Danseur* sold for $1,000; on Dec. 9, 1989, it was auctioned for $30,800 at Christie's, New York.

261. See "Career of Yellin, America's Cellini," *Art Digest* 16 (Dec. 15, 1941): 9. Review of a retrospective exhibition organized by the Architectural League of New York. Yellin's commissions included the Pierpont Morgan Library Annex, The Cloisters of The Metropolitan Museum of Art, and the Cathedral of St. John the Divine.

262. Eisenbrey, "Brandt, Master Ironworker," *The International Studio* (Dec. 1924): 257.

263. Henry Creange was born in France but later became an American citizen. He was director of style and art adviser to the Cheney company from 1918 to 1934, and from 1925 to 1934 he ran the Paris office of the firm. He was internationally recognized as an expert on industrial economics. See *The New York Times*, Aug. 15, 1945.

264. *American Silk Journal* (Nov. 1924): 59–60.

265. *New York Commercial*, Oct. 10, 1924, 3.

266. "Our Silk Designs for Paris Exhibit," *The New York Times*, Feb. 16, 1925.

267. Formerly at Fourth (now Park) Avenue and 18th Street, Cheney Brothers occupied the basement and the first four stories of a nineteen-story skyscraper at 181 Madison Avenue (40 East 34th Street). Begun in 1836, by 1924 Cheney Brothers had grown to employ 4,500 people at its mills on 36½ acres in South Manchester, Connecticut. Cheney products comprised dress silks, upholstery silks, velvets, cravats, hosiery, mufflers, belts, and silk yarns. The Cheney family was of French origin. Cheney archives, The University of Connecticut at Storrs.

268. Ferrobrandt opened sometime in 1925 and closed between the summer and fall of 1927.

269. The chariot in question is in the Cairo Museum. See Jones, chap. 2, pl. 6, nos. 14 and 12. Similar lotus bud forms can be found under "Greek Art," chap. 4, pl. 18, nos. 13 and 21. See also "Persian Art," chap. 3, pl. 14, no. 4.

270. Clouzot, "Une Oeuvre d'Edgar Brandt à New York," *La Renaissance de l'Art Français et des Industries de Luxe* 9 (Jan. 1926): 18.

271. "Cheney Bros. Move into Their New Headquarters," *The Decorative Furnisher* 49, no. 2 (Nov. 1925): 101.

272. One of these trees, with scrolling branches and six leaves (height 41⅜"), sold at auction for $7,150. See Sotheby's, New York, auction catalog (Mar. 7, 1987), item 172. Another tree (height 49¼") sold at the same house on Nov. 19, 1994, for $17,250; item 361.

273. An example of a sixteenth-century dry tree drapery sign is in the collection of the Musée Secq des Tournelles, Rouen. See D'Allemagne, *Histoire du Luminaire*, pl. 168.

274. Cheney archives, The Hartford Historical Society, Hartford, Conn.

275. Richards, et al., 5. See also Solon, "The Report on the Exposition in Paris," *Architectural Record* 61, no. 2 (Feb. 1927), 181–86.

276. Richards, et al., 44–45.

277. The furniture for the Schumacher room was by Dubocq with accessories by Lalique, Chabert-Dupont, Jean Mayodon, Jean Luce, Brandt, Follot, and Raoul Van Maldere. Conversation with Richard Slavin, curator of the Schumacher archives, Oct. 21, 1997.

278. "Chronique," *Art et Décoration* 49 (Jan.–June 1926): n.p. Some of the artists shown at the gallery included: Jean Puiforcat (silver); Jean Serrières (enamel); Jean Dunand and Claudius Linossier (metal vases); René Lalique and Maurice Marinot (glass objects); Emile Deoeur and Jean Mayodon (ceramics); Marie Monnier (embroidery); and Pierre Legrain (book covers). Also featured were the sculptures of François Pompon, Rembrandt Bugatti, and Joseph Bernard.

279. Park, *New Backgrounds for a New Age* (New York, 1927), 181–86.

280. The 1926 exhibition was "A Selected Collection of Objects from the International Exposition of Modern Decorative and Industrial Art in Paris." The museum had been doing shows of contemporary art industries since 1917. In 1922 it began receiving funds from Edward C. Moore, Jr., for the purpose of buying modern decorative arts with an emphasis on furniture. Many French items were purchased for the museum before the 1925 Exposition. The Metropolitan Museum of Art archives.

281. *Design* 27, no. 10 (1925): 185–88. *Jets d'Eau* cost $420 in 1924–25.

282. *The Metal Arts* 2, no. 2 (Feb. 1929): 107. Other participants were Eugene Schoen, Eliel Saarinen, and Joseph Urban.

283. In the late 1920s, R. H. Macy & Co. and John Wanamaker's ordered wrought-iron objects from Gilbert Poillerat and Paul Kiss, respectively. Conversation with Gilbert Poillerat, Nov. 10, 1987.

284. Thomas Fortune Ryan (1851–1928) was a financier of great wealth who owned one of the largest collections of Limoges enamel in the world.

285. The author examined these grilles in situ in 1990. They were in excellent condition and the patina was untouched.

286. Ms. Carpenter, a Francophile, donated French clothes and Worth gowns to the Costume Institute of the Metropolitan Museum of Art in the 1940s. Correspondence with Jennifer Loveman of the Costume Institute, Mar. 7, 1995.

287. Cresswell, "New Ideas in Decorative Wrought Iron," *The Good Furniture Magazine* 28, no. 2 (Feb. 1927): 70.

288. Schultze, "The Waldorf-Astoria Hotel," *Architecture* 64, no. 5 (1931): 251.

The Canadian Connection

289. The Montreal Court House Annex (Annexe au Palais de Justice) was designed by Cormier, L. Amos, and Charles Saxe. It is located at 100 Notre-Dame East. The Board of Trade (Chambre de Commerce) is located at 17 St. Jacques.

290. According to documentation in the Cormier papers, Canadian Centre for Architecture, Montreal.

291. Letter to Brandt from Atlas Construction Company, 37 Belmont Street, Montreal, Feb. 22, 1927. Canadian Centre for Architecture.

Back In Paris: 1926

292. Brandt first displayed his work at the 1903 S.A.D. and later at the Salon d'Automne of 1904. He submitted work to the Salon des Artistes Français (medaled in 1905 and 1907) and the Société des Artistes Décorateurs in 1904. He was allowed to display his work *hors concours* after being awarded jury membership at the S.A.F. in 1908. He was a jury member of the S.A.D. and the Salon d'Automne. In 1923 he won the S.A.F. medal of honor. Brandt won grand prizes at the exposi-

tions in Brusssels (1910), Turin (1911), and Marseilles (1922). In addition he was a member of the Comité Supérieur Technique des Beaux-Arts and a technical adviser of the Musée National du Conservatoire des Arts et Métiers.

293. "L'Exposition d'Art Appliqué au Musée Galliera," *Art et Industrie* 3, no. 1 (Jan. 1927): 24. The Zodiac screen was shown at the annual exhibit at the Musée Galliera.

294. Favier and Poillerat left Brandt's employ in 1927. Conversation with Gilbert Poillerat, Nov. 9, 1987.

295. Michelangelo's "The Times of Day" sculptures (*Night, Day, Dawn,* and *Dusk,* 1519–34) were commissioned for the tombs of the Medici family in the New Sacristy, San Lorenzo, Florence.

296. Richard Guy Wilson, et al. *The Machine Age in America* (New York, 1986), 47. "Machine-styled art and design of the 1920s appear to have been influenced by the perception of the machine as a combination of parts. . . . The moderne (or 'modernistic,' or more recently 'Art Deco') style took as its primary clue the multiple geometrical elements of machines arranged in a decorative pattern."

297. Louis Philippe created an ethnology museum in the 1830s. Eventually the Institut d'Ethnologie (1925), which was part of the Trocadéro museum, came under the guidance of Dr. Marcel Mauss, the founder of modern French anthropology. In 1937, the Trocadéro became the Musée de l'Homme. See introduction by Jean Guiart to Vogel and N'Diaye, eds., *African Masterpieces from the Musée de l'Homme* (New York, 1985), 13–17.

298. For the 1912 Paris Salon d'Automne, Raymond Duchamp-Villon designed and constructed a facade model for a Maison Cubiste, and André Mare and twelve collaborators produced three interiors. This project was begun with a cubist point of view, but the rooms were more colorful than cubist. More successful, however, was the architecture and furniture produced in Czechoslovakia in the early 1910s. See von Vegesack, ed., *Czech Cubism* (New York, 1992).

299. This set of furniture, made of copper over wood (with excellent workmanship), was displayed by the Primavera Gallery at the Modernism show at the Seventh Regiment Armory, New York, Nov. 22, 1986.

300. These chairs were in the auction of the Andy Warhol collection at Sotheby's, New York, Apr. 23, 1988. The armchairs sold for $28,600 and the side chairs for $19,250. According to Barbara Deisroth, of Sotheby's, Warhol bought these chairs in Paris in the late 1960s or early 1970s. Dealer Anthony DeLorenzo has had similar chairs by Brandt.

The Denouement

301. Gilbert Poillerat: "In the Brandt atelier I was with three colleagues (École Boulle) who were familiar with the artistic and social events of the day. Favier, who came out of the École des Beaux-Arts as a classical architect (1900), followed us in our work. His classical spirit tempered our eagerness—in exchange we helped him discover Le Corbusier and Cubism. He was a very good man." Letter from Poillerat to the author, July 12, 1987.

302. Pierre Lardin also worked as a designer for Emile-Jacques Ruhlmann for a while.

303. Gaspar Szetlak trained in Budapest. After working for Brandt, he set up his own ironwork shop in Paris. Conversation with Gilbert Poillerat, Nov. 7, 1987.

304. Favier, a widower, did continue his career and eventually married a woman who ran a health spa, Milles des Bains, in Provence. Conversation with Gilbert Poillerat, Nov. 11, 1987.

305. Edgar Brandt, "Writings of Edgar Brandt," unpublished work written in 1937, 1. Shown to the author by François Brandt.

306. In 1938 Brandt opened another armaments

factory, La Ferté Saint-Aubin, which was followed by those in Nantes, Tulle, and Jurançon. Between 1928 and 1958, a considerable number of mortars and projectiles were produced by Brandt's company. Conversation with François Brandt, Oct. 31, 1987.

307. du Columbier, "Le Salon d'Automne," *Art et Décoration* 50 (July–Dec. 1926): 177–78.

308. St. Eloi or St. Eligius (A.D. 588–660), the patron saint of smiths, metalworkers, and farriers, was born in Chaptelat, near Limoges. He was apprenticed to a goldsmith. His talents as an engraver and a smith took him to the court of King Clothaire II in Paris, where he was made master of the mint. He carried on his skills during the reign of Dagobert I and Clovis II. He made coins, chairs of state, and reliquaries. He founded a monastery and a nunnery. He was consecrated Bishop of Noyon and Tournai in 641. He was one of the most famous Merovingian saints in France. His feast day, commemorating the day of his death (Dec. 1, 660) was celebrated in northwestern Europe for centuries. See Butler, *Butler's Lives of the Saints* (New York, 1956), 455–58.

309. Letter from Gilbert Poillerat to the author, Sept. 21, 1987.

Change is in the Air

310. Quoted in Salmon, "Exposition du Werkbund au XXe Salon des Artistes Décorateurs," *Art et Décoration* 58 (July 1930): xiii.

311. Quoted in Mourey, "A Great French Furnisher: J. E. Ruhlmann," *The Studio* 92 (July–Dec. 1926): 246.

312. Quoted in Salmon, 17. László Moholy-Nagy (1895–1940) was a Hungarian painter and photographer who set up the first American school based on the German Bauhaus.

313. Hamel, "Un Grand Artiste Alsacien: Edgar Brandt," *L'Alsace Française* 19, no. 484 (Apr. 20, 1930): 313–15.

314. Brandt also designed cast-iron radiators that were manufactured by La Société des Hauts-Fourneaux et Fonderies de Brousseval (Haut-Marne). In 1926 several Brandt radiators employed fan motifs.

315. "Le Mobilier d'un Fumoir," *Art et Industrie* 3, no. 1 (Jan. 1927): 36.

316. Werth, "Le XVIIIe Salon des Artistes Décorateurs," *Art et Décoration* 51 (June 1927): 166.

317. "À l'Exposition de Liège," *Art et Décoration* 58 (Sept. 1930): I, II. An international exposition at Liège demonstrated the many applications of aluminum from architecture to furniture to sculpture. The French presentation was directed by René Herbst, an architect who designed with tubular steel and other materials.

318. "Au Salon des Décorateurs," *L'Art et Les Artistes* 22, no. 89 (June 1928): 320.

319. Werth, "L'Architecture Intérieure et Mallet-Stevens," *Art et Décoration* 55 (June 1929): 177, 188. The glass was by Barillet, the smoking table by Francis Jourdain, the textiles by Hélène Henry, the rug by Fernand Léger, and the bureau by Pierre Chareau.

320. The firm of Ivan Desny, with offices on the Champs-Elysées, specialized in all forms of decorating skills. It was in operation from 1927 to 1933. See Kjellberg, 49–50.

The Close of the Decade

321. Martinie, "Nouvelles Ferronneries de Brandt," *Art et Décoration* 54 (Nov. 1928): 153.

322. François Brandt states that some swastikas here are typically Basque. In a drawing that he made for the author, he pointed out the difference between this cross and that used by the Nazis. Conversation with François Brandt, Nov. 2, 1987.

323. Waroniecki, "Les Kilims et les Tissus de Lin Modernes en Pologne," *Art et Décoration* 57 (Feb. 1930): 61. Polish textiles were on view at the 1925 Exposition.

324. Salmon, 17.

325. Cheronnet, "La Section Française du XXe Salon des Artistes Décorateurs," *Art et Décoration* 58 (July 1930): 2.

326. Courthion, "L'Architecture à l'Exposition Coloniale," *Art et Décoration* 60 (Aug. 1931): 38. Le Musée Permanent became Le Musée des Colonies. See Cogniat, "Salon d'Automne," *Art et Décoration* 58 (Dec. 1930): 186. Wrought-iron work destined for the 1931 exhibition was being made by Brandt, Poillerat, Schenck, Baguès, and Prouvé.

327. Varenne, "Le Musée Permanent des Colonies," *Art et Décoration* 60 (Aug. 1931): 59–68. After 1931 the elephant doors, along with other Brandt ironwork such as balconies and railings, were installed at the headquarters of the Société Française d'Afrique Sociale on the rue de Téhéran in Paris. The Brandt-Jouve doors were offered for sale at Sotheby's, New York, on Dec. 7, 1985, and on Mar. 19, 1994.

328. Cresswell, "The Spring Salon," *Good Furniture and Decoration* 37, no. 1 (July 1931): 46.

329. Zahar, "Salon des Artistes Décorateurs," *Art et Industrie* 9 (July 1933): 14.

330. Chromed and nickeled metal is obtained by successive baths. Poillerat said that at first this method was unstable but it improved after 1931. Duraluminum (invented in 1909) contains aluminum, brass, manganese, and magnesium. Studaluminum does not corrode and takes a high polish. Aluminum, the most modern metal in the 1930s, could be welded or cast into bars, rods, tubes, and strips. It was prized for its silver color, its ability to be worked hot or cold, and its resistance to air. The problem of iron corrosion due to the elements was solved by stainless steel. At 40 francs a kilo in 1932, it was expensive; it became cheaper as its use increased.

331. During a prosperous year in 1928, industrialization rose to a new high, the stock market was healthy, and the French public was optimistic for the first time since before the war. However, the following year was less favorable as Europe felt the effects of the American stock market crash. The French were producing and consuming more but exporting less. Between 1930 and 1931 many bankers and industrialists were ruined. See Koch, "L'Economie

Française en 1929," *L'Alsace Française* (May 11, 1930): 379.

Into the Future

332. Hamel, 314.

333. Clouzot, "Quand un Grand Ferronnier s'installe," *Le Figaro Illustré* (July–Aug. 1933). François Brandt states that this work has disappeared. Letter to the author, Nov. 22, 1989.

334. At Châtillon diverse materials of war and munitions were made for the infantry, the artillery, the air force, and the navy. These included small-caliber explosives, motors, grenades, gas generators, breech casings, and airplane bombs; mortars were the principal production.

335. Edgar Brandt was an admirer of Henry Ford whose life was serialized in *Le Quotidien* in 1924. Later Ford's memoirs appeared in French, *Henry Ford, ma vie et mon oeuvre*. During his trip to the United States in 1939 Brandt visited the Ford Motor Works in Detroit. See Green, *Léger and the Avant-Garde* (New Haven, 1976), 245–46.

336. The factory at 101 Boulevard Murat continued its production as usual even after Châtillon-sous-Bagneux was in operation.

337. Pascal, "L'Usine d'Edgar Brandt à Châtillon-sous-Bagneux," *La Gazette des Beaux-Arts* no. 28 (July 14, 1933): 4. François Brandt provided information about the American connection in a letter of Oct. 31, 1987.

338. Also in 1936 workers took over the Renault car factory. They wanted a forty-hour week, paid vacations, freedom to join trade unions, and the right to collective bargaining. See Kemp, *The French Economy 1913–1939* (New York, 1972).

339. Moret, *1938–1988: 50 ans à l'Usine de "Chevau"* (Paris, 1988), 6, 7.

340. Eugène Bruynell was the engineer and chief architect for the Pathé company. A 1983 catalogue commemorated the fiftieth anniversary of this landmark theater where all the great films were shown.

341. Goissaud, "Le Cinéma Marignan Pathé-Natan" *La Construction Moderne* (June 18, 1933): 571–80.

342. The London office was at 3 George Street, Hanover Square, West Kensington.

343. See Sotheby's, New York, *20th Century Decorative Works of Art* (Mar. 17–18, 1995), lots 435–436. La Compagnie Générale Trans-Atlantique's *Normandie* began New York–Le Havre service in 1935.

344. Letter from François Brandt to the author, Dec. 15, 1987.

345. Moret, 11.

The Legacy

346. Brandt always admired American cars, owning a Lincoln and a Plymouth. Years later he drove a Hudson; he also owned two convertibles, a Ford and a Graham Page, his favorite. Conversation with François Brandt, Oct. 31, 1987.

347. Quoted in a letter from François Brandt to the author, Sept. 10, 1987.

BIBLIOGRAPHY

"À l'Exposition à Liège." *Art et Décoration* 58 (Sept. 1930).

Alexandre, Arsène. "Les Arts Décoratifs au Salon d'Automne." *La Renaissance de l'Art Français et des Industries de Luxe* (July 1924).

———. "Le Quinzième Salon de la Société des Artistes Décorateurs." *La Renaissance de l'Art Français et des Industries de Luxe* (July 1924).

Alphandery, E. A. *Monument de la Tranchée des Baïonnettes.* Commemorative book. Paris: L'Ambassade des Etats Unis. Nov. 1, 1921.

Amaya, Mario. *Art Nouveau.* New York: Schocken Books, 1985.

"American Iron, Steel, Monel, Bronze, Copper, & Brass." *Good Furniture and Decoration* 35, no. 6 (Dec. 1930).

American Silk Journal. Monthly, 1920s.

Anscombe, Isabelle. "Emile-Jacques Ruhlmann: Art Deco Ébéniste." *Art and Antiques* 4 (Mar.–Apr. 1981).

Arc de Triomphe et Monuments Commémoratifs. Vol. 79. Paris: Bibliothèque des Arts Décoratifs, n.d.

L'Art de Vivre: Decorative Arts and Design in France 1789–1989. New York: Vendome Press, 1989.

L'Art et Les Artistes [announcement] no. 63 (Jan. 1926).

Arwas, Victor. *Art Deco.* New York: Harry N. Abrams, Inc., 1980

———. *Berthon & Grasset.* London: Academy Editions, 1978.

Aston, James, and Edward Story. *Wrought Iron.* 3rd ed. Pittsburgh: A. M. Byers Co., 1936.

Aubry, Louis. "Emile Robert: La Ferronnerie à L'Exposition Universelle de 1900." *Revue des Arts Décoratifs* 20, no. 7 (July 1900).

Aulanier, Christiane. *Histoire du Palais et Musée du Louvre: Le Nouveau Louvre de Napoléon III.* Paris: Musée nationaux, 1953.

"Au Salon des Décorateurs." *L'Art et Les Artistes* 22, no. 89 (June 1928).

Badovici, Jean. *Harmonies: Intérieurs de Ruhlmann.* Paris: Editions Albert Morance, 1924.

Battersby, Martin. *The Decorative Thirties.* New York: Collier Books, 1971.

Beaux-Arts Shade Company [advertisement]. *Arts and Decoration* (Sept. 1927).

Bénédite, Georges. "La Formation du Musée Égyptien du Louvre." *Revue de l'Art* 43, no. 244 (1923).

Benevolo, Leonardo. *History of Modern Architecture.* Vol. 1. Cambridge, Mass.: M.I.T. Press, 1971.

Benezit, E. *Dictionnaire des Peintres, Sculpteurs, Dessinateurs, et Graveurs.* Vol. 10. Paris: Librairie Grund, 1976.

Besnard, Charles. "Quelque Nouveaux Meubles de Ruhlmann." *Art et Décoration* 45 (1924).

The Blacksmith's Craft. 1st ed. New York: Macmillan, 1987.

Blomfield, Sir Reginald. *Three Hundred Years of French Architecture 1494–1794.* Freeport, N.Y.: Books for Libraries Press, 1970 [1936].

Blum, René. "Le Bijou au Musée Galliera." *Art et Décoration* 24 (Sept. 1908).

———. "Le Salon d'Automne et l'Exposition munichoise." *Art et Décoration* 28 (Nov. 1910).

———. "Une Maison de Campagne par M. M. Sauvage et Sarrazin." *Art et Décoration* 24 (Nov. 1908).

Boardman, John. *Greek Art.* New York: Oxford University Press, 1978 [1973].

Bollinger, Joseph Walter. *Elementary Wrought Iron.* Milwaukee: The Bruce Pub. Co., 1930.

Boney, Thérèse. *Buying Antique and Modern Furniture in Paris.* New York: Robert M. McBride & Co., 1929.

Borsi, Franco, and Ezio Godoli. *Paris 1900.* New York: Rizzoli, 1978.

Bouilhet, Henri. *L'Orfèvrerie Française au XVIIIe et XIXe Siècles.* n.p., 1908–1912.

Brandt, Edgar. "L'Art et le Fer." Lecture to the graduates of the Écoles Professionelles de France, Feb. 10, 1922. Bibliothèque des Arts Décoratifs, doc. Br. 6659.

[Brandt, Edgar]. Obituary. *Le Monde.* May 12, 1960.

Brandt, François, and Pierre Bouniol. *Le Figaro.* May 11, 1980.

Breasted, James Henry. *A History of Egypt.* London: Hodder & Stoughton, 1925.

Brogan, Denis William. *The Development of Modern France 1870–1939.* Gloucester, Mass.: Peter Smith Pub., 1970.

———. *The French Nation from Napoléon to Pétain 1814–1914.* New York: Harper and Row, 1957.

Brooks, Arthur. "The Romance of Wrought Iron." *Arts and Decoration* (1918).

Brunel, Georges. "Une Exposition d'Art Moderne Appliqué Organisée à New York." *La Renaissance de l'Art Français et des Industries de Luxe* 2 (Nov. 1928).

Brunhammer, Yvonne. *Cent Chef-d'Oeuvres du Musée des Arts Décoratifs.* Paris: Musée des Arts Décoratifs, 1964.

———. "Jean Dunand and Jean Goulden." Exposition Galerie de Luxembourg, Paris, May–July 1973.

———. *Le Style 1925.* Paris: Baschet et Cie., 1980.

"Bulletin de la Chambre Syndicale des Artistes-Décorateurs Modernes." *Art et Décoration* 41 (Jan.–June 1922).

Bury, J. P. T. *France: The Insecure Peace.* New York: American Heritage Press, 1972.

Busquet, Camille. *La Fabrication de la Fonte Malléable.* Paris: Dunod, 1929.

Butler, Alban. *Butler's Lives of the Saints.* Vol. 4. New York: Kennedy, 1956.

"By Courtesy of Leading London and Paris Decorators." *The Good Furniture Magazine* 28, no. 3 (Mar. 1927).

Calmettes, Pierre. "Un Maître Ferronnier, Emile Robert." *Art et Décoration* 23 (Jan.–June 1908).

Camard, Florence. *Ruhlmann.* New York: Harry N. Abrams, Inc., 1984.

Campbell, Marian. *Ironwork.* London: Her Majesty's Stationery Office, 1985.

"Career of Yellin, America's Cellini." *Art Digest* 16 (Dec. 15, 1941).

"Carnarvon Collection of Egyptian Antiquities." *The Good Furniture Magazine* 28, no. 4 (Apr. 1927).

Cassou, Jean. "L'Art Sous-Marin." *Art et Décoration* 59 (Jan.–June 1931).

Catalogue Général Officiel Exposition des Arts Décoratifs et Industries Modernes, Avril-Octobre 1925 Paris: Imprimerie Vaugirard, 1925.

Chappat, C. M. J. "L'Art et le Fer." *Art et Industrie* 5, no. 8 (Aug. 1929).

Chatelain, E. *Soudure Autogène et Aluminothermie.* Paris: Imprimerie Gauthier-Villars du Bureau des Longitudes, de l'Ecole Polytechnique, 1909.

Chavance, René. "L'Art Décoratif Contemporain au Pavillon de Marsan." *Art et Décoration* 43 (Jan.–June 1923).

———. "Edgar Brandt." *L'Art et Les Artistes* 5 (1922).

———. "Edgar Brandt et l'Art du Fer." *L'Art et Les Artistes* 5, no. 25 (Mar.–July 1922).

———. "Ferronnerie Français." *Art et Décoration* 9 (1948).

———. *Jean Lamour et la Ferronnerie d'Art.* Paris: Publications Techniques, 1942.

———. "Le XIVe Salon des Artistes Décorateurs." *Art et Décoration* 43 (Jan.–June 1923).

———. "Raymond Subes et la Technique de la Ferronnerie." *Mobilier et Décoration.* 18 (Dec. 1938).

Chavance, René, and H. Verne. *Pour Comprendre l'Art Décoratif Moderne en France.* Paris: Librairie Hachette, 1925.

"Cheney Bros. Move into Their New Headquarters." *The Decorative Furnisher* 49, no. 2 (Nov. 1925).

Cheronnet, Louis. "Boutiques Nouvelles à Paris." *Art et Décoration* 55 (Jan.–June 1929).

———. "La Section Française du XXe Salon des Artistes Décorateurs." *Art et Décoration* 58 (July 1930).

Christie's, New York. Auction catalogues, 1980–98.

"Chronique." *Art et Décoration* 44 (Aug. 1923).

"Chronique." *Art et Décoration* 49 (Jan.–June 1926).

Chronique des Arts (Sept. 13, 1890).

"Chronique: Le Werkbund Allemand au Salon des Décorateurs." *Art et Décoration* 57 (Mar. 1930).

Clark, Robert Judson, et al. *Design in America: The Cranbrook Vision 1925–1950.* New York: Harry N. Abrams, Inc., in association with The Detroit Institute of the Arts and The Metropolitan Museum of Art, 1983.

Clouzot, Henri. "Les Arts Appliqués au Salon d'Automne." *La Renaissance de l'Art Français et des Industries de Luxe* 8 (Jan. 1925).

———. *Les Arts du Métal.* Paris: Librairie Renouard, 1934.

———. "La Décoration des Appartements et Les Appareils de Chauffage Central." *La Renaissance de l'Art Français et des Industries de Luxe* 9 (Feb. 1926).

———. "Deuxième Exposition d'Art Décoratif Contemporain au Pavillon Marsan." *La Renaissance de l'Art Français et Industries de Luxe* (Apr. 1924).

———. *La Ferronnerie Moderne à l'exposition des Arts Décoratifs.* Paris: Editions d'Art Charles Moreau, 1925.

———. *La Ferronnerie Moderne, 2e Série.* Paris: Editions d'Art Charles Moreau, n. d. [1927].

———. *La Ferronnerie Moderne, 3e Serie.* Paris: Editions d'Art Charles Moreau, n. d. [1928].

———. "Une Oeuvre d'Edgar Brandt à New York." *La Renaissance de l'Art Français et des Industries de Luxe* 9 (Jan. 1926).

———. "Quand Un Grand Ferronnier s'installe." *Le Figaro Illustré* (July–Aug. 1933).

———. "Quinzième Salon de la Société des Artistes Décorateurs." *La Renaissance de l'Art Français et des Industries de Luxe* 7 (July 1924).

Cobban, Alfred. *A History of Modern France 1871–1962.* Vol. 3. 13th ed. Harmondsworth: Penguin Books, 1984.

Cogniat, Raymond. "Les Portes et La Ferronnerie." *Art et Décoration* 61 (Feb. 1932).

———. "Salon d'Automne." *Art et Décoration* 58 (Dec. 1930).

———. "Le XXIe Salon des Artistes Décorateurs." *Art et Décoration* 60 (Aug. 1931).

"Cotton and Metal." *Good Furniture and Decoration* 35, no. 5 (Nov. 1930).

Courtellemont, Gervais. "Les Bijoux dans l'Egypte Antique." *L'Amour de l'Art* 2 (1921).

Courthion, Pierre. "L'Architecture à l'Exposition Coloniale." *Art et Decoration* 60 (Aug. 1931).

Cresswell, Howell. "The Autumn Salon." *The Good Furniture Magazine* 28 (Jan.–June 1927).

————. "New Ideas in Decorative Wrought Iron." *The Good Furniture Magazine* 28, no. 2 (Feb. 1927).

————. "The Spring Salon." *Good Furniture and Decoration* 37, no. 1 (July 1931).

Le Curieux. "Le Carnet d'un Curieux." *La Renaissance de l'Art Français et des Industries de Luxe* no. 4 (June 1918).

Curtis, William J. R. *Modern Architecture Since 1900*. Englewood Cliffs, N.J.: Prentice Hall, 1982.

Cutler, F. C. "Autogenous Welding." *Cassier's Magazine* (Sept. 1907).

D'Allemagne, Henry-René. *Histoire du Luminaire Depuis l'Époque Romaine Jusqu'au XIX Siècle*. Paris: Alphonse Picard, 1891.

————. "Le Fer Forgé à l'Exposition des Arts Décoratifs et Industriels Modernes." *Bulletin de la Société d'Encouragement pour l'Industrie Nationale* (Dec. 1925).

————. *Le Musée de ferronnerie Le Secq des Tournelles, Tour Saint-Laurent, Rouen*. (Paris: J. Schemit, 1924).

Dauvergne, Christian. "L'Esthétique Automobile." *Art et Industrie* 3, no. 1 (Jan. 1927).

Davies, Karen. *At Home in Manhattan*. New Haven: Yale University Art Gallery, 1983.

Dawes, Nicolas M. *Lalique Glass*. New York: Crown, 1986.

[Editorial]. *The Decorative Furnisher* 49, no. 6 (Mar. 1926).

"La Décoration Moderne, Robert, ferronnier." *L'Art et Les Artistes* 5 (Apr.–Sept. 1907).

de Félice, Roger. "Appareils d'Éclairage." *Art et Décoration* 38 (Aug. 1920).

————. "L'Art Appliqué au Salon d'Automne." *L'Art Décoratif* 6 (July–Dec. 1904).

Delarue-Madrus, Lucie. "L'Art Décoratif en Croatie." *Art et Industrie* 4 (Jan. 1928).

Denoinville, Georges. "Quelques Ferronneries d'Edgar Brandt." *Mobilier et Décoration Intérieur* 4, no. 5 (Aug.–Sept.1924).

Deolé, Philippe. "La Ferronnerie." *Le Journal des Beaux-Arts* no. 18 (1932–34).

Dervaux, Adolphe. "La Ferronnerie Moderne." *La Renaissance de l'Art Français et des Industries de Luxe* 2, no. 2 (Feb. 1919).

Deshairs, Léon. *L'Hôtel d'un Collectionneur: Exposition des Arts Décoratifs de 1925*. Paris: Editions Albert Levy, 1925.

————. "Le XVe Salon des Artistes Décorateurs." *Art et Décoration* 45 (June 1924).

————. "Le Mobilier et les Arts Décoratifs au Salon d'Automne." *Art et Décoration* (Dec. 1929).

de Souza, Robert. "Oeuvres Diverses d'Edgar Brandt." *L'Art Décoratif* 6 (July–Dec. 1904).

Design 27, no. 10 (1925).

Deutsche Kunst und Dekoration 50 (Aug. 1922).

Dormoy, Marie. "Edgar Brandt." *L'Amour de l'Art* 1 (Jan. 1925).

————. "Le Fer Forgé Moderne." *L'Amour de l'Art* 8 (1927).

————. "Les Points-de-Nice de Madame Chabert-Dupont." *Art et Décoration* 39 (Jan. 1921).

————. "Rideaux de Vitrage." *Art et Décoration* 51 (Jan.–June 1927).

Drexler, Arthur, ed. *The Architecture of the Ecole des Beaux-Arts*. New York: The Museum of Modern Art, 1977.

Driscoll, Daniel M. *Architectural Iron Design and Detailing*. New York: Van Nostrand Co., 1926.

Du Bercel, Jean. "Ferronnerie et Architecture." *Art et Industrie* 5, no.11 (Nov. 1927).

————. "Petites Tables." *Art et Industrie* 3, no. 9 (Sept. 1927).

Duby, Georges, and Robert Mandrou. *A History of French Civilization*. New York: Random House, 1964.

du Columbier, Pierre. "Le Salon d'Automne." *Art et Décoration* 50 (July–Dec. 1926).

Duncan, Alastair. *American Art Deco*. New York: Harry N. Abrams, Inc., 1986.

————. *Art Deco Furniture*. New York: Holt, Rinehart and Winston, 1984.

du Pasquier, Jacqueline. "La Ferronnerie au début du XX siècle: exemples bordelais." *Métiers d'Art* no. 18/19 (Apr. 1982).

du Puigaudeau, C. "Dentelles et Broderies." *La Renaissance de l'Art Français et des Industries de Luxe* 4 (1919).

Les Echos d'Art. "Les Métaux dans l'Art au Musée Galliera." *Art et Décoration* 61 (1931).

Eisenbrey, Paul. "Brandt, Master Ironworker." *The International Studio* (Dec. 1924).

Encyclopedia of World Art. New York: McGraw Hill, 1959–87.

Encyclopédie des Arts Décoratifs et Industriels Modernes au XXe Siècle. Vol. 3. Imprimerie Nationale, Office Central d'Editions de Librairie, 1925. Reprint. New York: Garland Publishing, 1977.

Escholier, Raymond. "Au Salon d'Automne." *Art et Décoration* 43 (Jan.1923).

"L'Exposition d'Art Appliqué au Musée Galliera." *Art et Industrie* 3, no. 1 (Jan. 1927).

"L'Exposition Japonaise au Salon de la Société Nationale." *L'Art et Les Artistes* 5, no. 25 (Mar.–July 1922).

Fanelli, Giovanni. *Il Tessuto Art Deco gli Anni Trenta*. Florence: Cantini Edizione d'Arte SpA, 1986.

Faroux, Charles. "Le Salon de l'Automobile." *La Renaissance de l'Art Français et des Industries de Luxe* 12 (Sept. 1929).

Ferrobrandt, Inc. [Catalogue]. New York, 1926.

Follot, Paul. [Correspondence]. *L'Art et Les Artistes* no. 76 (Oct. 1926).

Fortuny, Pascal. "Les Décorateurs Allemands à Paris en 1924?" *L'Amour de l'Art* 3 (June 1922).

Frank, Edgar B. *Old French Ironwork*. Cambridge, Mass.: Harvard University Press, 1950.

Gallotti, Jean. "Goût du Jour." *Art et Décoration* 57 (Jan. 1930).

Gardiner, Sir Alan. *Egyptian Grammar*. London: Oxford University Press, 1957.

Gardner, J. Starkie. *Ironwork*. Vol. 1. London: Printed Under the Authority of the Board of Education, 1927. 4th ed. Reprint. Crown Copyright, 1978.

Gautier, Maximilien. *Le Corbusier*. Paris: Les Editions Denoël, 1944.

Geerings, Gerald R. *Metal Crafts in Architecture*. New York: Charles Scribners & Sons, 1929.

Goissaud, Antony. "Le Cinéma Marignan Pathé-Natan." *La Construction Moderne* (June 18, 1933).

————. "Un Ferronnier Moderne, Edgar Brandt." *La Construction Moderne* 41 (May 9, 1926).

Gonse, Louis. *L'Art Japonais*. Vols. 1 and 2. Paris: A. Quantin, 1883.

Googerty, Thomas F. *Decorative Wrought Ironwork*. Peoria, Ill.: The Manual Arts Press, 1937.

Green, Christopher. *Léger and the Avant-Garde*. New Haven: Yale University Press, 1976.

Gsell, Paul. "Un Maître de l'Art Monumental, Antoine Bourdelle." *La Renaissance de l'Art Français et des Industries de Luxe* 7 (June 1924).

Hale, Nathan Cabot. *Welded Sculpture*. New York: Watson-Guptill, 1968.

Hamel, Maurice. "Un Grand Artiste Alsacien: Edgar Brandt." *L'Alsace Française* 19, no. 484 (Apr. 20, 1930).

Hammond, Barbara, and John L. Hammond. *The Rise of Modern Industry*. London: Methuen & Co., 1925.

Harlor, Theodore. "Emile Robert (1816–1924)." *Gazette de Beaux-Arts* 10 (Nov. 1924).

————. "Les Fer Forgés d'Emile Robert." Retrospective exhibition, Musée des Arts Décoratifs, Palais du Louvre, Pavillon de Marsan, Paris. Feb.–Mar. 1925.

Hart, Harold H., ed. *Weapons and Armor*. New York: Dover, 1978.

Hautecoeur, Louis. "Le Salon d'Automne." *Gazette des Beaux-Arts* 10 (July–Dec. 1924).

Hawley, J. E. *The Blacksmith & His Art*. Phoenix, Ariz.: J. E. Hawley, 1976.

Henriot, Gabriel. *Ferronnerie du Jour*. Paris: Ch. Massin et Cie, 1929.

————. "Ferronneries Nouvelles d'Edgar Brandt." *Mobilier et Décoration* 7, no. 5 (Apr. 1927).

Heskett, John. *German Design 1870–1918*. New York: Taplinger, 1986.

Hitchcock, Henry-Russell. *Gaudí*. New York: The Museum of Modern Art, 1957.

Hobbs, Douglas B. "Aluminum: A Decorative Metal." *Good Furniture and Decoration* 35, no. 2 (Aug. 1930).

Hourticq, Louis. "Au Salon des Artistes Décorateurs." *Art et Décoration* 36 (May–June 1919).

————. "Les Héros de Paul Landowski." *La Revue de l'Art* 48, no. 267 (June 1925).

"The International Exposition of Modern Decorative Art in Paris." *Vogue Magazine*, May 15, 1925.

Janneau, Guillaume. *Le Fer: Etudes de l'Art Décoratif Contemporain*. Paris: F. Contet, 1924.

————. *Le Fer à l'Exposition Internationale des Arts Décoratifs Modernes*. Paris: F. Contet, 1925.

————. *Ferronnerie d'Aujourdhui*. 2nd series. Paris: Editions d'Art Ch. Moreau, n. d. [1940s].

————. "Le Mouvement Moderne du Salon d'Automne à l'Exposition de 1924." *La Renaissance de l'Art Français et des Industries de Luxe* (Jan. 1922).

————. "Le Mouvement Moderne: Le douzième Salon des Artistes Décorateurs." *La Renaissance de l'Art Français et des Industries de Luxe* 4 (1921).

————. "Le Mouvement Moderne Jonchée d'Objets d'Art" *La Renaissance de l'Art Français et des Industries de Luxe* 3, no. 7 (July 1920).

Jervais, Simon. *Dictionary of Design and Designers*. London: Penguin Books, 1984.

Jones, Owen. *The Grammar of Ornament*. [1856]. New York: Portland House, 1986.

Jordan, David P. *Transforming Paris: The Life and Labors of Baron Haussmann*. New York: The Free Press, 1995.

Kahr, Joan. "Gilbert Poillerat, A Half-Century of Ironwork Design." *Metalsmith* 12, no. 3 (summer 1992).

————. "Paul Fehér 1898–1990: Master Ironwork Designer." *Metalsmith* 18, no. 3 (summer 1998).

Keimer, Ludwig. "Bouquets Montés." *American Journal of Semitic Languages and Literatures* 41, no. 3 (Apr. 1925).

Kemp, Tom. *The French Economy 1913–1939*. New York: St. Martin's Press, 1972.

Kjellberg, Pierre. *Art Déco: Les Maîtres du Mobilier, Le Décor des Paquebots*. Paris: Les Editions de L'Amateur, 1986.

Klein, Dan, et al. *In the Deco Style*. New York: Rizzoli, 1986.

Klingaman, William. *The Year Our World Began: 1919*. New York: St. Martin's Press, 1986.

Koch, Marcel. "L'Economie Française en 1929." *L'Alsace Française* (May 11, 1930).

Lake, Carlton, and Robert Maillard, eds. *Dictionary of Modern Painting*. New York: Paris Book Center Inc., 1956.

Leclère, Tristan. "Joseph Bernard." *Art et Décoration* 45 (Jan. 1924).

Lee, Christopher. *. . . the grand piano came by camel—Arthur C. Mace, the Neglected Egyptologist*. Edinburgh and London: Mainstream Publishing, 1992.

Lefkowith, Christie Mayer. *The Art of Perfume*. New York: Thames and Hudson, 1994.

Lesieutre, Alain. *The Spirit and Splendour of Art Deco*. New York: Paddington Press, 1974.

Levainville, Jacques René. *L'Industrie du Fer en France*. Paris: A. Colin, 1922.

Lissim, Simon. "Les Artistes Animaliers à la Galerie Edgar Brandt." *Mobilier et Décoration* (1931).

Locquin, Jean. "Edgar Brandt et la Maison d'un Ferronnier." *Art et Décoration* 39 (Mar. 1921).

Maignan, M. "À Propos du Salon des Artistes Décorateurs." *L'Art Décoratif* 25 (Apr. 1911).

Maguolo, George. "Metals and Alloys in Modern Building." *Metalcraft* 7, no. 5 (Dec. 1931).

Malmstrom, L. L. "This Trend to White Metals." *Metalcraft* 8, no. 3. (Mar. 1932).

Martinie, Henri. *La Ferronnerie: Exposition des Arts Décoratifs*. Paris: Librairie Centrale des Beaux-Arts, 1925.

———. "Gilbert Poillerat, Ferronnier." *Art et Décoration* 57 (1930).

———. "Nouvelles Ferronneries de Brandt." *Art et Décoration* 54 (Nov. 1928).

Mathieu, Caroline. *Guide to the Musée d'Orsay*. Paris: Editions de la Réunion des Musées Nationaux, 1987.

Mauclair, Camille. "Où en est notre Art décoratif?" *Revue bleue* 8 (Apr. 24, 1909).

Maurois, André. *La Grande Guerre*. Paris: La Guide Internationale du Disque, n.d.

McClinton, Katherine Morrison. "Edgar Brandt: Art Deco Ironworker 1880–1960." *Connoisseur* no. 202 (Sept. 1979).

———. "Jean Dunand: Art Deco Craftsman." *Apollo* 116, no. 247 (Sept. 1982).

The Metal Arts 2, no. 2 (Feb. 1929).

Migennes, Pierre. "La IIIe Exposition de la Décoration Française Contemporaine." *Art et Décoration* 55 (Jan.–June 1929).

Mignot, Claude. *Architecture of the Nineteenth Century in Europe*. New York: Rizzoli, 1984.

"Le Mobilier d'un Fumoir." *Art et Industrie* 3, no. 1 (Jan. 1927).

Moliner, Emile. "Les Objets d'Art aux Salons." *Art et Décoration* 9 (June 1901).

Monod, François. "L'Exposition du fer forgé, du cuivre, et de l'étain au Musée Galliera." *Art et Décoration* 17 (Nov. 1905).

Monuments Commémoratifs et Arcs de Triomphe. Vol. 79. Paris: Bibliothèque des Arts Décoratifs, 1921.

Moore, Thomas. *The Smith and Forgeman's Practical Handbook*. London: E. & F. N. S. Ltd., 1906.

Morand-Verel, M. "L'Organisation des Fouilles en Egypte." *L'Amour de l'Art* 6 (1925).

Moret, Claude. *1938–1988: 50 ans à l'Usine de "Chevau" La Ferté St. Aubin*. Paris: Thompson, 1988.

Morrell, D. J. *The Iron and Steel Exhibits at the Universelle Exposition of 1878*. Philadelphia: The American Iron & Steel Association, 1879.

Mourey, Gabriel. *L'Art Décoratif en France*. Paris: Librairie de France, 1923–25.

———. "Edgar Brandt, The French Ironworker." *The Studio* 91 (Jan.–June 1926).

———. "A Great French Furnisher: J. E. Ruhlmann." *The Studio* 92 (July–Dec. 1926).

Moussinac, Léon. "Le Salon d'Automne." *Mobilier et Décoration d'Intérieur* (Nov.–Dec. 1922).

Norberg, Pierre. "La Peinture aux Salons." *Art et Décoration* 24 (1908).

"Now It Can Be Seen." [Editorial]. *The Decorative Furnisher* 49, no. 6 (Mar. 1926).

Olmer, Pierre. "Edgar Brandt." *Mobilier et Décoration d'Intérieur* (July–Aug. 1922).

"Our Silk Designs for Paris Exhibit." *The New York Times* (Feb. 16, 1925).

Paris Exposition Internationales des Arts Décoratifs et Industriels Modernes, 1925. Paris: Librairie Hachette, 1925.

Paris International Exhibition of 1878. London: Virtue 7 Co., 1878.

Paris, William Franklyn. "International Exposition of Modern Industrial and Decorative Art in Paris." *Architectural Record* 58, no. 4 (Oct. 1925); 61, reel 11 (July 1925–June 1927).

Park, Edwin Avery. *New Backgrounds for a New Age*. New York: Harcourt, Brace and Company, 1927.

Pascal, Georges. "La Dentelle Moderne au Musée Galliera." *Mobilier et Décoration* 3, no. 11 (Mar. 1931).

———. "L'Usine d'Edgar Brandt à Châtillon-sous-Bagneux." *La Gazette des Beaux-Arts* no. 28 (July 14, 1933).

Perrin, G. M., ed. *La Ferronnerie Française Contemporaine*. Paris: Editions G. M. Perrin, 1961.

Petrie, Sir Flinders. *Egyptian Decorative Art*. New York: Benjamin Blom, Inc. 1972.

Pevsner, Nicolas. *Academies of Art Past and Present*. [1940]. New York: Da Capo Press, 1973.

Phillips Son & Neale Auctions Limited. Auction catalogues, 1997–98.

Plumet, Charles. "L'Art décoratif au Salon." *L'Art et Les Artistes* 5, no. 26 (May 1907).

Poillerat, Gilbert. *Ferronnerie d'Aujourd'hui*. Paris: Editions d'Art Ch. Moreau. n.d. [1950s].

———. "[Métal] Arts du" pp. 14–23. *Encyclopedia Universalis*. Paris: Encyclopedia Universalis, 1975.

———. "Le XXe siècle," *Métiers d'Art* no. 18/19 (Apr. 1982).

"Printed Fabrics for Spring Selling." *The Good Furniture Magazine* 28, no. 6 (Mar. 1927).

Purcell, Katherine. "Catering for Every Taste: The Falize Family of Goldsmiths." *Apollo* 133, no. 348 (Feb. 1991).

"Quelque Meubles." *Art et Industrie* 4, no. 3 (Mar. 1928).

Quenious, Gaston. *Les Arts Décoratifs Modernes*. Paris: Librairie La Rousse, 1925.

Rambosson, Yvonhoë. "Les Artistes Décorateurs au Salon des Artistes Français." *Art et Décoration* 41 (Jan.–June 1922).

———. "La Ferronnerie d'Art." *Les Echos d'Art* 57, no. 55 (Feb. 1930).

———. "Le Mouvement des Arts Appliqués." *L'Amour de l'Art* no. 3 (Nov. 1922).

———. "Le XIIIe Salon des Artistes Décorateurs." *Art et Décoration* 41 (Jan.–June 1922).

Read, Helen Appleton. "The Exposition in Paris." *The International Studio* no. 342 (Nov. 1925); no. 343 (Dec. 1925).

Régamey, Raymond. "La Ferronnerie d'Art, Edgar Brandt." *Archives Alsaciennes de l'Histoire de l'Art* 3 (1924).

Reid, William. *Arms Through the Ages*. New York: Harper & Row, 1976.

Remon, Georges. "Edgar Brandt à l'Exposition Internationale des Arts Décoratifs." *Mobilier et Décoration d'Intérieur* no. 8. (July 1925).

Richards, Charles R. *Art in Industry*. New York: Department of the State of New York, 1922.

Richards, Charles R., Henry Creange, and Frank Grahm Holmes. *Report of the United States Commission on the International Exposition of Modern Decorative and Industrial Art, Paris 1925*. Washington D.C.: United States Government, 1926.

Rivière, Georges Henri. "Les Tissus Péruviens à l'Exposition des Arts Anciens en Amérique." *Art et Industrie* 4 (June 1928).

Robert, Emile. "L'Apprentissage des Métiers d'Art: la Ferronnerie." *Art et Décoration* 34 (July 1913).

Rockett, Frank H. "Torch." *Encyclopedia of Science and Technology*. Vol. 18. New York: McGraw Hill, 1976.

Rosenthal, Léon. "Le Paquebot *Paris*." *Art et Décoration* 40 (Sept. 1921).

Rubin, William, ed. *Primitivism in the 20th Century*. New York: The Museum of Modern Art, 1984.

Russell, Frank, ed. *Art Nouveau Architecture*. New York: Rizzoli, 1979.

Sacks, Maurice. *The Decade of Illusion: Paris 1918–1928*. New York: Alfred A. Knopf, 1933.

Salmon, André. "Exposition du Werkbund au XXe Salon des Artistes Décorateurs." *Art et Décoration* 58 (July 1930).

"Le Salon d'Automne" *Art et Industrie* no. 9 (Dec. 1926).

Sarrazin, Paul. "À Propos d'une Vitrine." *Art et Décoration* 31 (Jan.–June 1912).

Saunier, Charles. "Le VIe Salon des Artistes Décorateurs." *Art et Décoration* 27 (Mar. 1910).

Scarlett, Frank, and Marjorie Townley. *Arts Décoratifs 1925*. New York: St. Martin's Press, 1975.

Schäfer, Heinrich. *Principles of Egyptian Art*. Oxford: Clarendon Press, 1974.

Schmirler, Otto. *Werk und Werkzeug des Kunstschmieds*. Tübingen: Verlag Ernst Wasmuth, 1987.

Schug, Albert. *Art of the Twentieth Century*. New York: Harry N. Abrams, Inc., 1969.

Schultze, Leonard. "The Waldorf-Astoria Hotel." *Architecture* 64. no. 5 (1931).

"Schumacher & Co. Bring Paris Art to New York." *The Decorative Furnisher* (Oct. 1925).

Sedeyn, Emile. "Jean Dunand." *Art et Décoration* 36 (Sept.–Oct. 1919).

———. "Le XIIe Salon des Artistes Décorateurs." *Art et Décoration* 39 (June 1921).

Seguy, E. A. "Rythmes Naturels, Métaux et Bois." *Art et Décoration* 59 (Jan.–June 1931).

Serrurerie Moderne et Ferronnerie de Bâtiment. Paris: Ch. Moreau, 1931.

Sheafer, Frances B. "French Interior Decoration." *Arts and Decoration* (Mar. 1911).

"Silk Delegates to the Paris Exposition." *American Silk Journal* 44, no. 6 (June 1925).

Slavin, Richard E., III. "F. Schumacher and Company and the art moderne style." *The Magazine Antiques* 135, no. 4 (Apr. 1989).

———. *Opulent Textiles: The Schumacher Collection*. New York: Crown Publishers Inc., 1992.

Sollar, Fabien. "Les Métaux dans l'Art au Musée Galliera." *Art et Décoration* 61 (Sept. 1932).

———, ed. "Notre Enquête: Evolution ou Mort de l'Ornement?" *Art et Décoration* 62, various issues (Apr.–Nov. 1933).

Solon, Louis V. "The Report on the Exposition in Paris." *Architectural Record* 61, no. 2 (Feb. 1927).

Sotheby's, New York. Auction catalogues, 1979–98.

Subes, Raymond. *Ferronnerie Moderne*. Paris: Editions Vincent Fréal et Cie., n.d.

Surnom, Georges. *Modèles de ferronnerie*. 3rd ed. Paris: Eyrolles, 1962.

Terrier, Max. "Meubles Métalliques." *Art et Décoration* 57 (Feb. 1930).

Thomson, D. Croal, ed. *The Paris Exhibition of 1900*. London: The Art Journal Office, H. Virtue and Co. Limited, 1901.

Tijou, Jean. *A New Book of Drawings invented and designed by Tijou*. Reprint. London: B. T. Batsford, 1896.

Tint, Herbert. *France Since 1918*. New York: St. Martin's Press, 1980.

Tisserand, Ernest. "Le XVIIe Salon des Artistes Décorateurs." *L'Art et Les Artistes* no. 79 (July 1927).

Trager, James, ed. *The People's Chronology*. New York: Holt, Rinehart and Winston, 1979.

Le Travail du Fer Pratique. Vol. 382. Paris: F. Nathan, 1931.

Tschudi-Madsen, Stephan. *Art Nouveau*. New York: McGraw-Hill Book Co., 1967.

Tull, Richard. "Welding Architectural Alloys." *Metalcraft* 7, no. 1 (July 1931).

Uecker, Wolf. *Art Nouveau and Art Deco Lamps and Candlesticks*. New York: Abbeville Press, 1986.

Uhry, Edmond. "Edgar Brandt." *Art et Décoration*

25 (Feb. 1909).

Uldry, Renée Moutard. "L'U.A.M. au Salon d'Automne." *Art et Décoration* 65 (1936).

Union Centrale des Arts Décoratifs. 2nd ed. Paris: Armand Guérinet, n.d.

Varenne, Gaston. "Le Mobilier et L'Art Décoratif." *Art et Décoration* 40 (Dec. 1921).

———. "Le Musée Permanent des Colonies." *Art et Décoration* 60 (Aug. 1931).

———. "Oeuvres Récentes de R. Subes." *Art et Décoration* 73 (Nov.–Dec. 1938).

Vaucelles, Louis. "À Propos du Salon des Décorateurs." *L'Amour de l'Art* 3 (1922).

———. "Art décoratif." *L'Amour de l'Art* 2 (1921).

Verneuil, M. P. "L'Architecture et l'Art Décoratif aux Salons de 1905." *Art et Décoration* 18 (July 1905).

———. "L'Art Décoratif au Salon des Artistes Français." *Art et Décoration* 21 (June 1907).

———. "Ce que doit être l'Etude de la Nature." *Art et Décoration* 29 (Jan.–June 1911).

———. "Etoffes Japonais." *Art et Décoration* 27 (Feb. 1910).

———. "La Mer." *Art et Décoration* 27 (Jan.–May 1910); 28 (Dec. 1910).

———. "Le Salon d'Automne de 1911." *Art et Décoration* 30 (Oct. 1911).

———. "Au Salon des Artistes Décorateurs." *Art et Décoration* 36 (July 1914–July 1919).

Vogel, Susan Mullin, and Francine N'Diaye, eds. *African Masterpieces from the Musée de l'Homme.* New York: The Center for African Art and Harry N. Abrams, Inc., 1985.

Vogt, Armand-Paul. *Le Théâtre à Nancy depuis ses origines jusqu'en 1919.* Nancy: Imprimerie Grandville, 1921.

von Vegesack, Alexander, ed. *Czech Cubism.* New York: Princeton Architectural Press, 1992.

Waddell, Roberta, ed. *The Art Nouveau Style.* New York: Dover, 1977.

Waroniecki, Edouard. "Les Kilims et les Tissus de Lin Modernes en Pologne." *Art et Décoration* 57 (Feb. 1930).

Watelin, L.-C. "Les Possibilités de Notre Art Décoratif en 1925." *L'Art et Les Artistes* 8, no. 40 (Oct. 1923–Feb. 1924).

Wattenmaker, Richard J. *Samuel Yellin in Context.* Flint, Mich.: Flint Institute of Arts, 1985.

Wauthier, Herbert, ed. "Some Notes on the Paris Exposition." *Artwork* 2, no. 5 (Oct.–Dec. 1925).

Weber, Eugene. *Peasants into Frenchmen.* Stanford: Stanford University Press, 1976.

Weisberg, Gabriel P. *Art Nouveau Bing.* New York: Harry N. Abrams, Inc., and SITES, 1986.

"Le Werkbund Allemand au Salon des Décorateurs." *Art et Décoration* 57 (Mar. 1930).

Werth, Léon. "L'Architecture Intérieure et Mallet-Stevens." *Art et Décoration* 55 (June 1929).

———. "Le XVIIIe Salon des Artistes Décorateurs." *Art et Décoration* 51 (June 1927).

"What Shall We Do About This New Art?" [Editorial]. *The Decorative Furnisher* 49, no. 2 (Nov. 1925).

Whittick, Arnold. *European Architecture in the Twentieth Century.* London: Crosby Lockwood & Son Ltd., 1950.

Wilford, John Noble. "Ancient Tree Yields Secrets of Potent Healing Substance." *The New York Times* (Mar. 1, 1988).

Williams, Trevor, ed. *A History of Technology.* Vol. 6. Oxford: The Clarendon Press, 1978.

Wilson, Henry. "Metalwork Section." *Reports on the Present Position of the Industrial Arts.* London: Department of Overseas Trade, 1925.

Wilson, Richard Guy, et al. *The Machine Age in America.* New York: Harry N. Abrams, Inc., in association with the Brooklyn Museum, 1986.

Wiser, William. *The Crazy Years, Paris in the Twenties.* New York: Atheneum Press, 1983.

Wood, Alan. *Alan Wood Iron and Steel Company* 18, no. 1 (1920).

Zahar, Marcel. "Nouvelles Ferronneries de Gilbert Poillerat." *Art et Décoration* 65–66 (1936–37).

———. "Salon des Artistes Décorateurs." *Art et Industrie* 9 (July 1933).

Zeldin, Theodore. *France 1848–1945, Ambition and Love.* Oxford: Oxford University Press, 1979 [1973].

INDEX

Numbers in *italics* refer to figure numbers.

238

ACKNOWLEDGMENTS

In early 1985 I discovered the beauty of French iron-work and, at the same time, I became frustrated by the lack of scholarship about the subject. While seeking to fill this void, I met many memorable people.

Since July of 1987, François Brandt has been most generous, not only in sharing memories of his father, but in helping to uncover sources of information. He has been an ally and a friend, along with his wife, Marie-Thérèse. Likewise, Charles Brandt, my first contact with the Brandt family, graciously gave me a tour of some landmarks that figured in his grandfather's life. My heartfelt gratitude to Digby Thomas, who so ably translated the text for François Brandt, and offered cogent points to Monsieur Brandt and myself.

During the course of my research on French iron-work, it has been my privilege to meet two men who were directly involved in the artistic life of Paris in the 1920s and to correspond with two others. Gilbert Poillerat was a fine artist and designer, a noteworthy correspondent and raconteur, and a special friend. He and his wife, Liliane, were gracious hosts when I visited them in Paris. Poillerat worked for Edgar Brandt for six years and was an eyewitness to the formation of Art Deco style.

Paul Fehér, designer for La Maison Paul Kiss and the man who brought the Art Deco metalwork style to projects in America, was a lively and joyful man. In his nineties, he was the possessor of an incredible memory and an infectious spirit. It was my privilege to spend time with Paul at his home in California and to learn firsthand about his life as an artist and designer. At age 100 Bernard-Jean Daulon was actively writing about his relative, Joan of Arc. He attended the same school as Edgar Brandt, and his informative recollections concerning French technical education were invaluable. Metalsmith Kenneth Lynch worked for Edgar Brandt in the early 1920s. He shared his reminiscences of the Brandt atelier and his work in Paris and Munich.

I remain grateful to the following people who have been instrumental in the progress of my reseach and in the preparation of the book: Morton Abromson, Noel Allum, Dr. Dorothea Arnold, Gabriel Austin, Pierre Richard Bernier, Claude Max Blondat, Marthe Delamare de Boutenville, Alexis Brandt, Ariane Brandt, Edgar Jérémie Brandt, Suzanne Brandt, Xavier Brandt, Yvonne Brandt, Janet and Gary Calderwood, David Cann, Robert Capassela, Elizabeth Castano, Patricia and James Cayne, Mark Coir, Roger Crépin, Warren Cresswell, Nicolas Dawes, Barbara Deisroth, Nancy Delin, Anthony DeLorenzo, Louise Désy, Vinnie DiPrima, John Dittmeier, Marie Durand, Donna Evleth, Leonard Fox, Adriana Friedman, Audrey Friedman, Philippe Garner, Daniéle Georges, Bill Gichner, Peggy Gilges, Donna Goldstein, Gary S. Griffin, Claire Gunning, Alec Hemer, Clarice Henry, Anne Herme, Isabelle Hild, Christina Japp, Randall Jimerson, Paul Jokelson, Gerald Kaminsky, Walter Karcheski, Jr., Bud Konheim, Carol Krute, Patricia L'Hote, Jennifer Loveman, Jean Manceau, Frank Maraschiello, Jeff Mason, George Mathysen-Gerst, Nancy McClelland, Frances Besner Newman, Julie Nord, Serge Pascal, Rosalind Pepall, Michel Perrin, Liliane Poillerat, Michel Précoul, Nol Putnam, Françoise and Jean-Pierre Puydesseau, Margaret Richards, Blanche Robert, Peter Rohowsky, Dr. Joseph Romano, Véronique Rostas, Michel Roth, Tom Ryan, Rene and Mike Silverstein, Richard Slavin III, Kevin Stayton, Rita and Richard Stevens, Matthew K. Stevens, Usha Subramaniam, John Sutherland, Eric Turner, Stephen Van Dyk, Richard Wattenmaker, Colleen Weis, Jean Wiart, Gerard Widdershoven, Christopher Wilk, and Robert Zehil.

I am indebted to David Smith of the New York Public Library for his assistance over many years. A special note of gratitude is due to the fine staff of the Hewlett-Woodmere Public Library. Many people helped this project come to fruition. The fact that they are too numerous to mention in no way diminishes their contributions. Therefore, I offer a collective acknowledgment to the numerous librarians and curators in museums, libraries, and institutions in France, Switzerland, Canada, and the United States.

The staffs of Christie's and Sotheby's in New York have not only provided enthusiastic support for the book but also generously lent many of the superb photographs reproduced in these pages. David Hayes of the photography department at Sotheby's deserves special mention for his fine reproductions.

Several kindred spirits encouraged me to carry on with this work; however, I shall never forget the unflinching support of Robert Aibel, Gregory Kuharic, and Constantine Photopoulos.

To my principal advocate—my husband, Robert—the fulcrum of my life, thank you for "living" with me and "Edgar" these many years. For their sustaining jokes and good humor, I thank my children, Brett and Janna; for their patience above and beyond the call of duty, I thank my children, Bart and Ann.

I am most grateful to Paul Gottlieb, president of Harry N. Abrams, Inc., for publishing this book. A thousand thanks to my editor, Elisa Urbanelli, who provided wise counsel and a fortifying calmness. Her belief in my work, along with her enthusiasm for the material, was most welcome. Elisa and her excellent assistant, Julia Gaviria, made the step-by-step evolution of the book an enriching experience, one that I shall never forget. The design of the book was accomplished beautifully by Dirk Luykx with skill and style.

This book was written, in part, because of my fortunate exposure to two professors: Dr. Yvonne Korshak, whose erudite teaching of art history enriched my life and pointed me in a new direction; and Derek Ostergard, a true ambassador of the decorative arts, whose knowledge and love of the subject has been a great inspiration to me. This research is a tribute to the memory of all the fine artisans working in France in the 1920s and 1930s. Finally, to artists-blacksmiths everywhere who are helping to keep this ancient, magical craft alive, forge on, *forgerons.*

Joan Kahr
June 18, 1998

PHOTOGRAPH CREDITS

key: t=top, b=bottom, l=left, c=center, r=right

© Albin-Guillot-Viollet: 13; Noel Allum: 137; Courtesy of Art and Architecture Collection. Miriam and Ira D. Wallach Division of Art, Prints and Photographs. The New York Public Library. Astor, Lenox and Tilden Foundations: 40t, 40c, 93; © 1997, The Art Institute of Chicago, All Rights Reserved: 26b, 27b, 29t, 30t, 36c; © Boyer-Viollet: 62, 63; Courtesy the Brandt family: 15, 21t, 22, 36t, 44, 45 (Albin-Guillot), 50 (Gérard Ronzel, F-01.220 Grilly, France), 51, 52t, 113 (Sebastian Devenish), 114t, 153 (Sebastian Devenish), 213 (Gérard Ronzel, F-01.220 Grilly, France), 220, 221, 222 (Gérard Ronzel, F-01.220 Grilly, France); Courtesy Calderwood Gallery, Philadelphia: 26tl (Gary Calderwood), 26tr (Gary Calderwood), 37t, 88tl; Phototypie Catala frères, Paris: 136; Collection Centre Canadien d'Architecture/Canadian Centre for Architecture, Montreal. Photographs S. J. Hayward: 182, 183; Chevojon: 78, 123, 124, 132l; Courtesy Christie's Images: 56, 68, 69b, 82tc, 82bl, 82br, 88bl, 89, 103tr, 116, 117b, 126b, 133, 135l, 142r, 152, 158r, 160bl, 178, 185, 197, 198, 217, 218t, 219; Courtesy DeLorenzo Gallery. © Anthony Israel Photography: 148, 149, 203; The Detroit Institute of Arts: 127; Ed. Bourdier-Hélio Ch. Rouget, Paris: 125, 132r, 139t; A. George © 1994. Inventaire Général—ADAGP: 48; F. Harand: 40b, 46, 47, 69tl, 70, 84l, 100l, 100r, 104, 112bl, 115t, 115br, 128, 134r, 141, 162, 174; © Harlingue-Viollet: 75; Alec Hemer: 28bl, 28br, 65, 80r, 97, 112t, 114b, 135r, 160bc, 160br, 164, 165, 179, 202, 208; Joan Kahr: 42–43, 109tr, 109br, 170, 172; M. Marchais: 72; Courtesy Phillips Auctioneers: 81l; Photo Plat: 199b; A. Salaun: 54, 157l; Courtesy Schumacher Archives: 103b, 177; © Sotheby's, Inc: 80l (© 1989), 81r (© 1996), 82tr (© 1990), 88tr (© 1995), 92 (© 1991), 103tl (© 1991), 108–9 (© 1991), 131br (© 1986), 143 (© 1997), 156 (© 1990), 157r (© 1997), 160t (© 1986), 189 (© 1988), 204–5 (© 1994); Touly Paris: 216; Copyright © 1999 Virginia Museum of Fine Arts: 158l, 186 (Katherine Wetzel); Collection Wadsworth Atheneum, Hartford, Conn. Purchased from David Harris Cohen Estate through the J. Herbert Callister Fund: 171; Courtesy Robert Zehil, Monaco: 96, 117t, 144–45, 206, 207

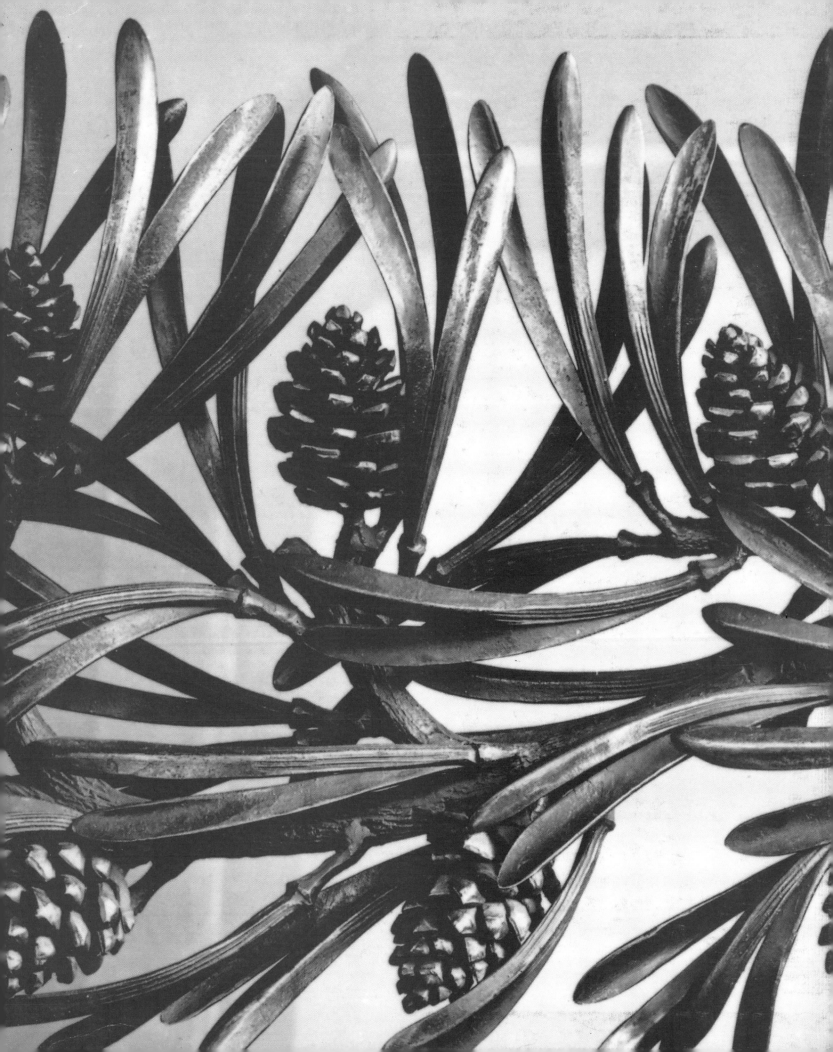